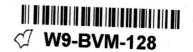
JEWEL RIVERS
Japanese Art from The Burke Collection

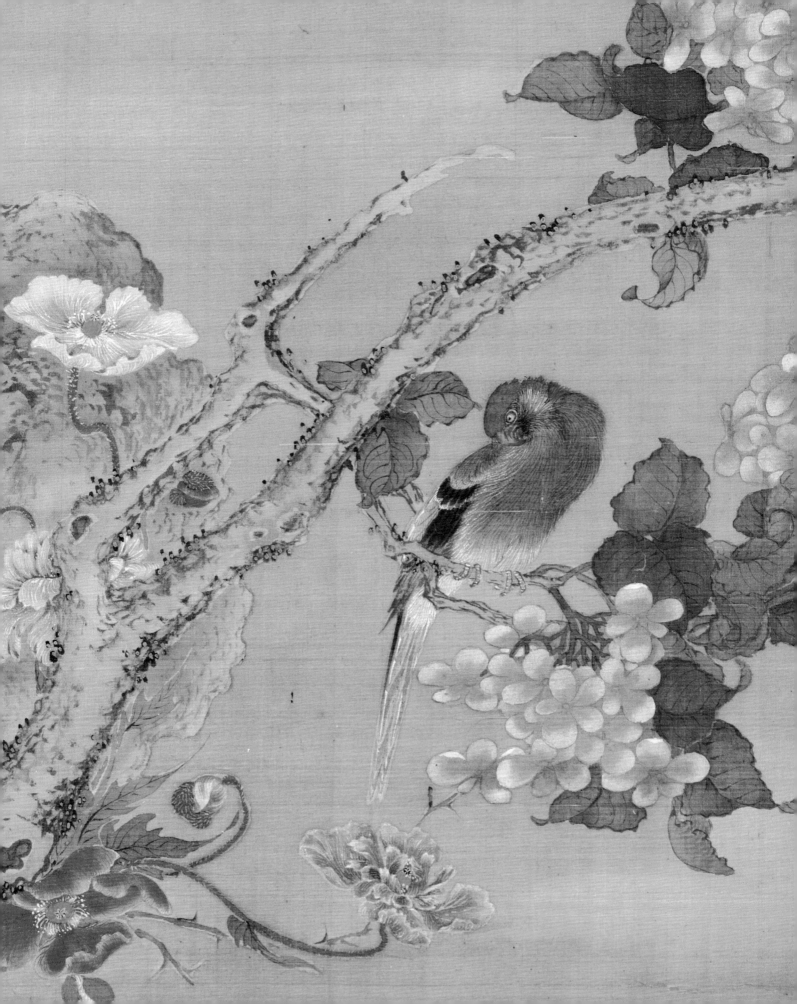

JEWEL RIVERS
Japanese Art from The Burke Collection

BY MIYEKO MURASE

with Selected Catalogue Entries by
Gratia Williams Nakahashi and Stephanie Wada

VIRGINIA MUSEUM OF FINE ARTS, RICHMOND
in cooperation with the Mary and Jackson Burke Foundation

Jewel Rivers: Japanese Art from The Burke Collection was made possible by a generous grant from the Mary Livingston Griggs and Mary Griggs Burke Foundation, and was published by the Virginia Museum of Fine Arts, Richmond, as a companion book to a touring exhibition of the same title, organized by the Virginia Museum, and shown in the following locations:

Virginia Museum of Fine Arts
Richmond, Virginia
October 25, 1993–January 2, 1994

Santa Barbara Museum of Art
Santa Barbara, California
February 26–April 24, 1994

The Minneapolis Institute of Arts
Minneapolis, Minnesota
October 14, 1994–January 1, 1995

CONTRIBUTING AUTHORS FOR THIS PUBLICATION:
Gratia Williams Nakahashi, *Curator, The Burke Collection*
Stephanie Wada, *Associate Curator, The Burke Collection*
Gen Sakamoto, *Bibliographer*
Michio Hayashi, *Glossary-Writer*

PRODUCTION STAFF FOR THIS PUBLICATION:
Monica S. Rumsey, *Editor-in-Chief*
Rosalie A. West, *Project Editor*
Anne Lew, *Assistant Editor and Indexer*
Manuscript preparation in Wordperfect 5.1:
 Best Secretarial Services, Richmond, Virginia
Sarah Lavicka, *Art Director*
Bruce Campbell, *Graphic Designer*
Anandaroop Roy, *Production Assistant*

PHOTO CREDITS
All images by *Carl Nardiello*, except as follows:
Otto E. Nelson, cat. nos. 9–11, 15, 18, 22, 23, 34, 36, 37, 43
Lynton Gardiner, cat. nos. 3, 4 (detail), 64, 66, 67, 69, 70 (color detail), 73, 75
Roman Szechter, cat. nos. 35, 70
Ron Jennings, cat. nos. 37, 43 (both details)
Kazumasa Ichikawa, cat. no. 1

Map by Anandaroop Roy

Type was set in Bembo by Jean Genoud SA
Color Separations and Printing by Jean Genoud SA,
 Lausanne, Switzerland
Printed on Phoenix Imperial Natura dull-coated, 170 gms
Binding by Mayer et Soutter SA, Lausanne

LIBRARY OF CONGRESS CATALOGING-IN-PUBLICATION DATA
Virginia Museum of Fine Arts.
 Jewel Rivers: Japanese Art from The Burke Collection / by Miyeko Murase; with contributions to the catalogue by Gratia Williams Nakahashi and Stephanie Wada.
 p. cm.
 "Virginia Museum of Fine Arts, Richmond, Virginia, October 25, 1993–January 2, 1994; Santa Barbara Museum of Art, Santa Barbara, California, February 26–April 24, 1994; The Minneapolis Institute of Arts, Minneapolis, Minnesota, October 14, 1994–January 1, 1995"—T.p. verso.
 Includes bibliographical references.
 ISBN 0-917046-35-8
 1. Art, Japanese—Exhibitions. 2. Burke, Jackson, 1908–1975—Art collections—Exhibitions. 3. Burke, Mary—Art collections—Exhibitions. 4. Art—Private collections—Virginia—Richmond—Exhibitions. 5. Art—Virginia—Richmond—Exhibitions. 6. Virginia Museum of Fine Arts—Exhibitions. I. Murase, Miyeko. II. Nakahashi, Gratia Williams. III. Wada, Stephanie. IV. Santa Barbara Museum of Art. V. Minneapolis Institute of Arts. VI. Title.
N7352.V57 1993
709'.52'07473—dc20 93-29682
 CIP

FRONT COVER: Detail, Scroll 4, *Jewel River at Ide;* BACK COVER: Detail, Scroll 5, *Jewel River at Kinuta.* Both are from the series *Mu-Tamagawa: Scenes of Six Tamagawa (Jewel Rivers),* by Sakai Ōho. See catalogue no. 39.

FRONTISPIECE: Sō Shiseki, Detail, *Parakeets among Flowers* (catalogue no. 23).

Contents

Foreword

Mary and Jackson Burke first began collecting Japanese art in 1963. As the collection grew in the ensuing years, it was guided by their unerring sense of the greatest quality and their appreciation of Japanese history and culture. In 1975, a significant exhibition and catalogue of the Burke Collection was produced by the Metropolitan Museum of Art, New York. Sadly, Jackson Burke died shortly before that exhibition opened. Now, nearly two decades later, this exhibition and catalogue present objects since collected by Mrs. Burke. This new presentation allows the opportunity to appreciate her singular accomplishments as a collector.

The Burke Collection now represents one of the most important private collections of Japanese art in America. The scope and quality of these objects offer visitors—at the Virginia Museum of Fine Arts, the Santa Barbara Museum of Art, and the Minneapolis Institute of Arts—a view of Japanese visual culture that would be impossible to match without borrowing from one of the most comprehensive public collections.

Mrs. Burke's extensive study of Japanese culture has led her to recognize works of art not as isolated masterpieces but as objects very much a part of the cultural context within which they were created. To capture the resonance of these deeper relationships, she has collected objects in a wide range of media, from prehistoric terracotta vessels to refined handscrolls, from the bold and dramatic to the subtle and intimate. Such breadth not only increases the richness of her collection, but also presents Japanese art in a way that gives all viewers of this ancient and enduring culture the experience of its beauty and greatness.

This exhibition celebrates Mrs. Burke's interests and achievements in collecting. With her taste for elegant and refined yet emotionally powerful works, she has assembled a collection that illuminates the human quality and expressiveness of Japanese art.

One measure of the excellence and renown of the Burke collection is the frequency with which loans are requested by Japanese museums. Yet Mrs. Burke's long-standing relationship with American art museums continues in this exhibition and its accompanying catalogue, which would not have been possible without generous funding from the Mary Livingston Griggs and Mary Griggs Burke Foundation.

It has been a joy to collaborate with Mary Burke and her staff, whose high standards and professionalism have made the collaboration a pleasure. The opportunity to share in Mary Burke's knowledge and enthusiasm for these wondrous objects has been a great reward, which is now expanded to those who view the exhibition and who read this catalogue.

Katharine C. Lee
Director
Virginia Museum of Fine Arts

Paul N. Perrot
Director
Santa Barbara Museum of Art

Evan H. Maurer
Director
The Minneapolis Institute of Arts

Preface

BY MARY GRIGGS BURKE

This catalogue by Miyeko Murase, with contributions by Gratia Williams Nakahashi and Stephanie Wada, contains objects acquired since 1975-1976, when the Mary and Jackson Burke Collection was displayed at the Metropolitan Museum of Art, the Seattle Art Museum, and the Minneapolis Institute of Fine Arts. Dr. Murase, whose invaluable advice has long influenced the direction of my collecting, was also the author for the catalogue of that first traveling exhibition. Her choice of objects for the present show—opening at the Virginia Museum of Fine Arts, Richmond, and proceeding to the Santa Barbara Museum and the Minneapolis Institute of Fine Arts—favors recent additions to the collection, some of which have never been exhibited in the United States. I am happy to state that some of the works of art most meaningful to me have been featured in this catalogue. As a collector who has not only accepted professional advice but has tended to follow a number of personal whims and obsessions, I take great satisfaction in its pages.

I do not believe it would be possible to exhibit selections from my collection without including some pieces which celebrate episodes from the famous early novel of the Heian period, *The Tale of Genji*. This literary masterpiece had a tremendous influence on Japanese art, and examples of *Genji* illustration may be found in many formats and a variety of media. *Genji* scenes appear on handscrolls, hanging scrolls, albums, and screens. Even useful objects, such as lacquerwares and ceramics, were often decorated with motifs taken from the tale. This exhibition contains five pieces which represent my involvement with the Shining Prince: two fan paintings (nos. 36 and 37), two fragments of a handscroll (no. 38), and a *tebako*, or box for personal accessories and toiletry articles (no. 69).

My interest in Japanese culture is not limited to the visual arts. When I first visited Japan in the 1950s I was captivated by the theater, both Kabuki and Noh, and attended many performances of these "dance dramas." The arts of Japan, of course, intertwine; paintings illustrate not only great literary works like the *Genji* but also aspects of the performing arts—the theatricals and dances presented in the city streets and the countryside. I can relive my pleasure in Japanese dance and drama by contemplating several objects displayed in this exhibition. The very recently acquired pair of seventeenth-century screens illustrating scenes from the Noh play *Takebun* (no. 52) manages to convey the excitement of the dramatic episodes involved. The pair of two-fold screens by Shibata Zeshin (no. 54) depicts a scene from a well-known legend of the demon Ibaraki, who lost an arm in a clash with the noted warrior assigned to kill it; the lively screen image is based on a votive tablet painted earlier by the same artist. This tablet was evidently so vivid and startling in appearance that it inspired a script for the Kabuki stage some thirty years after it was painted. The painting is so alive, active, and frightening that I once used it as the centerpiece of a costume party at which every guest was asked to appear as a Japanese demon or mythological creature. I had been told that the Kabuki play written about this demon Ibaraki included a special demon dance, so I invited the Japanese dancer Sachiko Itō to perform it for my guests. Although she did not use the original dance, Ms. Itō choreographed a short piece just for the occasion which evoked the dramatic overtones of the Zeshin screens.

Another recent addition to the collection which I find both beautiful and entertaining is a pair of six-fold screens (no. 50) depicting cherry-blossom viewing at Itsukushima and Yoshino. Among other things, these genre screens attest to the popularity of various dance forms in early seventeenth-century Japan. At least seven separate instances of dance may be found in these images, from the large, well-organized circle of elaborately costumed festival performers on the first two panels of the right-hand screen to the various informal groups of dancers scattered over the remaining panels of both screens. On the stage in the center of the Itsukushima Shrine, professional dancers or actors perform before spectators visiting the sacred Shinto precinct.

Although I have a special fondness for objects painted or decorated with themes from Japanese literature, or images which permit me to identify with dancers, actors, and demons, I must mention pieces which—in addition to being beautiful and rare—were acquired under interesting circumstances which resulted in the reuniting of different parts of a larger work of art. Among these are two wooden sculptures of *hiten*, or *apsarasas* (heavenly beings), dating to the Late Heian period (no. 3). I had searched for many years for an example of these charming, airborne deities, which often surround large Buddha figures in both sculpture and painting. *Hiten* sail through the air, seated or standing on curling clouds, trailing diaphanous scarves and sometimes playing ancient musical instruments. I prefer them to Christian angels as they do not need large, cumbersome wings to propel themselves into the air. They float with such absolute grace!

In the pages of this catalogue Dr. Murase recounts how the collection acquired the two *apsarasas*: one was found in Japan, the other, five years later, in Germany. Amazingly, both figures may have adorned the mandorla, or halo, of the same large Buddha figure in the ancient temple of Jōruriji. This series of events has all the excitement of a detective story. How wonderful to reunite at least some parts of a work of art which have been separated over time due to carelessness, greed, or other less negative factors. The sometimes selfish business of collecting now has a higher

purpose; collecting at its best does not represent mere acquisitiveness. When the collector has as his on her main purpose the discovery of the relationship between objects— their meaning and place in a particular culture—then it appears to me that the pursuit of beautiful works of art attains a higher level and a true justification.

Another object in this exhibition, a set of six small handscrolls by Sakai Ōho depicting the *Mu-Tamagawa*, or Six Jewel Rivers (no. 39), also required some detective work to reveal its full significance. When I first saw these scrolls I desired them primarily because of their beauty and their flawless condition. Their purchase also seemed justified in that they were excellent examples of "famous-place paintings," something dear to the hearts of the Japanese for many centuries. It was not until I read Dr. Murase's discussion of the paintings that I understood the unique position this theme occupied in the light of Edo-period social history. It appears that the fame of these six rivers could very well date from around 1654, when one of the Tamagawas—the Tamagawa of Musashino—was used in an engineering project commissioned by the Tokugawa shogunate to bring water to Tokyo by means of an aqueduct. In all probability the Tokugawa government was anxious to record this successful endeavor, and in 1659 may have commissioned Kano Tany'ū to paint scenes of these six rivers on interior walls and screens of Edo castle. In any event, Dr. Murase discovered a body of evidence which attests to the popularity of the "Six Jewel Rivers" theme from the late seventeenth century on. Allusions to the rivers appear in essays and poems by haiku poets, in *ukiyo-e* prints, in musical compositions, and in song and dance pieces. Dr. Murase also did extensive research on Kano Osanobu's nineteenth-century copies of Tan'yū's no longer extant wall paintings. The copies were made by Osanobu at about the same time that Ōho painted his *Mu-Tamagawa* scrolls. These fascinating historical facts have opened up new areas for investigation, and it is this kind of research that adds another dimension to the pleasure of collecting.

Ōho's beautiful depiction of the six rivers also exemplifies the water theme that runs through the

present exhibition. Other "watery" images abound in this catalogue. Mountain streams, for example, have always been an important staple of Japanese landscape painting. They can end in the crescendo of a waterfall (no. 31 by Bōsai) or in a peaceful river or lake (no. 30, images of the four seasons by Baiitsu), or in a haven for fishermen in small boats (the screens by Goshun, no. 32). Water can dominate a design, as in the screen paintings of scenes from the Noh play *Takebun*, where most of the dramatic action takes place upon the high seas. On the lyrically beautiful seventeenth-century screens of an autumn landscape (no. 51), a river meanders over several panels, growing larger as it falls from mountain regions to the plain below. A calm body of water supports the Chinese scholar Chou Tun-i as he contemplates a lotus blossom (no. 22), and water occupies much of the surface of the Itsukushima and Yoshino screens.

In the *Genji* images we find views containing water, from small, carefully designed gardens (nos. 36 and 38) to the great sweep of ocean beaches (nos. 37 and 69). These create dramatic backgrounds for individuals portrayed in narrative painting or pictorial motifs used to represent different chapters. The ocean also serves as a dramatic backdrop for the brine maiden of the Noh play *Matsukaze* (no. 46), who hangs her dead lover's cloak on a pine tree by the sea. A swirling stream among rocks and blossoms is featured in the enchanting underpainting for Ogata Sōken's beautiful calligraphy (no. 35), and

moving water adds drama to Kano Shōei's images of pheasants (no. 19).

Water also often appears, subtly depicted, in Chinese-influenced ink paintings (nos. 12, 21, and 25), and even in Buddhist images such as the richly colored *Shaka Triad and Sixteen Rakan* (no. 6). The Zen-inspired diptych of two eccentric monks (no. 9) standing on a river bank with their bizarre attributes also bears testimony to the importance of water in Japanese painting.

Several of the functional decorative objects in this catalogue also have designs characterized by river motifs. The (Arita) Shoki-Imari celadon dish presents a chrysanthemum floating on a swirl of water (no. 61), and a delicate incense box (no. 64) exhibits an ancient design of cart wheels in a stream.

At least one third of the works of art shown here display images of water, but to me the most beautiful is Ōho's *Mu-Tamagawa* scrolls. Thin gold lines trace ripples and waves on the vibrant blue of the rivers, giving them a sparkling quality and sense of movement. These rivers truly can be described as jewel-like, and the scenery and figures along their banks provide an atmosphere of nostalgia and melancholy. In the search for an appropriate title for this exhibition, the images presented in Ōho's paintings carried much weight. To me, *Jewel Rivers* perfectly expresses the vision of glistening water in a poetic setting, which can be seen in so many of the artworks in this exhibition.

Acknowledgments

A selection of paintings and objects from the Burke Collection first came before the American public in 1975 at the Metropolitan Museum of Art, New York. This exhibition (with an addition of several newly acquired pieces) then proceeded to the Seattle Art Museum and the Minneapolis Institute of Arts; in 1985 it began a tour of Japan at the Tokyo National Museum, an honor never before accorded to a foreign private collection of Japanese art. The same exhibition, again with the addition of a few new pieces, made its European debut at the Schirn Kunsthalle in Frankfurt, Germany, in 1990.

The present selection of paintings, sculpture, lacquerware, and ceramics does not duplicate the earlier exhibition in any way. It includes works of art that have never before been displayed in public, as well as many objects that have been added to the collection in recent years. Several pieces were acquired so recently as to barely allow time for catalogue photography and research. Altogether, the works displayed here add a new dimension to public perception of the Burke Collection and reflect the indefatigable inquisitiveness with which Mrs. Burke has pursued her interest in all of the visual arts of Japan. Students of Japanese art history are particularly grateful to Mrs. Burke for her unwavering commitment to the cause of furthering scholarship in the field. Once again, the cultural life of this country has been enriched by her desire to share her pleasure in the beautiful objects she has gathered together.

The staff of the Exhibitions and Publications departments of the Virginia Museum of Fine Arts provided invaluable assistance in the preparation of this exhibition and the lovely catalogue for printing. We would like to thank Richard Woodward, Exhibitions Manager; Lisa Hancock, Registrar; Maureen Morrissette, Assistant Registrar; and of course Dr. Joseph Dye, curator of Asiatic Art. We also note the expert efforts of Monica Rumsey, Publications Manager; Sarah Lavicka, Chief Graphic Designer for Publications; Michelle Wilson, Executive Secretary for Publications; Rosalie West, freelance editor for the Virginia Museum; and Anne Lew, freelance proofreader and indexer. We also thank Bruce Campbell, for his elegant catalogue design, and the expert collaboration of Daniel Frank of the printing firm Jean Genoud in Lausanne, Switzerland.

On the New York end of exhibition preparation, we are grateful to Mitsuhiro Abe, Master Restorer in the Department of Asian Art, the Metropolitan Museum of Art, for his painstaking conservation work on a number of the paintings included here. Shinichi Doi, Assistant Conservator in Objects Conservation at the Metropolitan, saw to the needs of the lacquers, ceramics, and other three-dimensional works of art. Noelle King O'Connor, Research Assistant in the Metropolitan's Department of Asian Art, helped in the organization of catalogue and condition report photography. Carl Nardiello, Otto E. Nelson, Roman Szechter, Kazumasa Ichikawa, and Lynton Gardiner produced superb color and black-and-white photographs. We also wish to thank Elizabeth Corbo, Mrs. Burke's secretary, who put many hours into typing manuscript material, and are grateful to David Kamen for his expertise in Japanese language word-processing.

We also owe a debt of gratitude to Michio Hayashi and Gen Sakamoto, both Ph. D. candidates and budding art historians in the Department of Art History and Archaeology, Columbia University, who stepped in at the last stage of catalogue preparation to

compile the glossary (Mr. Hayashi) and bibliography (Mr. Sakamoto).

Miyeko Murase is extremely grateful to Gratia Williams Nakahashi for serving as liaison between the catalogue authors and the staff of the Virginia Museum, and for coordinating all aspects of exhibition scheduling. She would also like to express particular thanks to Stephanie Wada, who was always willing to spruce up, edit, and enrich several of her entries and introductory essays when Stephanie herself was under enormous pressure to complete her own catalogue entries. From the initial stage of this project, she put many hours into working with and directing photographers, and at the final stage of catalogue production she compiled the Chinese-Japanese character index with the assistance of Mr. Kamen. Miyeko Murase would also like to express her deepest thanks to the editors who assisted her with her catalogue entries: William Spindle (a graduate student in the School of International Affairs, Columbia University), Patricia Allen, and Georgette Felix.

All involved in the creation of *Jewel Rivers: Japanese Art from The Burke Collection* are grateful to Bayliss Griggs, Eleanor Briggs, and Gale Davis for granting us their permission to include objects belonging to the Burke Foundation, and to Marvin Pertzik of the Mary and Jackson Burke Foundation. Mr. Pertzik never lost his objective and balanced perspective on a project of such large dimensions and provided invaluable assistance and advice on practical matters. MM

A Note to the Reader

* Japanese and Chinese personal names appear in traditional style, with family names preceding given names.

* The Wade-Giles style is used for romanization of Chinese words.

* Catalogue entries written by contributing authors are indicated by the author's initials at the end. GWN is Gratia Williams Nakahashi; SW is Stephanie Wada. All other entries are by Miyeko Murase.

* The objects featured in this catalogue are the property of the Mary and Jackson Burke Foundation, except for the following, which are the property of Mary Griggs Burke: Catalogue nos. 2, 5, 8, 12, 15, 18, 20, 22, 23, 25-29, 31, 32, 35, 40, 42-44, 50, 53, 61, 63, 64, 68, 69.

Chronology

CHINA

Hsia Dynasty (unconfirmed)	circa 2100 B.C. - circa 1500 B.C.
Shang Dynasty	circa 1500 B.C.- circa 1045 B.C.
Chou Dynasty	circa 1045-256 B.C.
Spring and Autumn period	722-481 B.C.
Warring States period	481-221 B.C.
Ch'in Dynasty	221-206 B.C.
Han Dynasty	206 B.C.-A.D. 220
Three Kingdoms	220-265
Southern Dynasties	317-589
Northern Dynasties	386-581
Sui Dynasty	581-618
T'ang Dynasty	618-906
Liao Dynasty	907-1125
Five Dynasties	907-960
Sung Dynasty	960-1279
Northern Sung	960-1127
Southern Sung	1127-1279
Chin Dynasty	1115-1234
Yüan Dynasty	1260-1368
Ming Dynasty	1368-1644
Ch'ing Dynasty	1644-1911

JAPAN

Paleolithic	200,000(?)-10,500 B.C.
Jōmon	10,500-400 B.C.
Yayoi	400 B.C.-A.D. 300
Kofun	300-circa 600
Asuka	538-645
Hakuhō	645-710
Nara	710-784
Heian	794-1185
Early Heian	794-897
Late Heian (Fujiwara)	897-1185
Kamakura	1185-1333
Nambokuchō	1333-1392
Muromachi	1392-1573
Momoyama	1573-1615
Edo	1615-1868
Meiji	1868-1912
Taishō	1912-1926
Shōwa	1926-1989
Heisei	1989-

KOREA

Three Kingdoms	37 B.C.-A.D. 668
Koguryo	18 B.C.-A.D. 668
Paekche	18 B.C.-A.D. 663
Old Silla	57 B.C.-A.D. 668
Unified Silla Dynasty	668-935
Koryŏ Dynasty	918-1392
Choson Dynasty	1392-1910

Introduction

The Japanese archipelago is a chain of islands stretching for 2800 kilometers (about 1740 miles) in an elongated crescent off the coast of the Asian mainland. In addition to four large islands—Honshū, Shikoku, and Kyūshū to the south, and Hokkaidō in the north—there are several hundred smaller satellite islands scattered close by in the Pacific Ocean and the Sea of Japan. The name "Japan" is actually an appellation derived from "Jih-pen," the Chinese reading of the name that the Japanese applied to their own country: Nihon, or Nippon (literally, "where the sun rises"). Life has never been easy for the inhabitants of these islands, which are lacking in natural resources and studded with mountains, many of which are volcanic. Only about one-sixth of the land is arable, much of this in coastal areas.

During the Pleistocene age, the level of the Japan Sea was much lower than it is today and Japan was wholly integrated with the Asian continent. Roughly 20,000 to 18,000 years ago, as thick glacier ice began to melt, the inhabitants of the eastern rim of Eurasia gradually became isolated from the mainland; ethnological and linguistic studies indicate that the early settlers of the archipelago were immigrants from either Northern or Southeast Asia. Faced with the vast expanse of the Pacific Ocean, these people could advance no further east, but the four seas around them also insured their safety from hostile foreign aggression. Prior to the Second World War, only one attempt was made to invade Japan, by Chinese and Korean armies in the thirteenth century. In this extremely insular nation, cultural trends and movements shifted and swung back and forth like a pendulum. Natives periodically withdrew into the comfortable cocoon of their island habitat, rejecting all contact with the outside world. At other times, acutely aware of other cultures beyond the seas that surrounded them, they longed to be part of the larger Asian community. Present-day Japanese tourists who roam the world acquiring souvenirs are doing so not solely from material greed but out of an insatiable curiosity about other civilizations, so different from their homogeneous society, with which they yearn to form ties.

Throughout their history, the Japanese kept close watch on artistic developments in mainland Asia, and made frequent and relentless attempts to emulate them. Three great waves of continental influence helped give direction to main currents in the visual arts of Japan. The first was the introduction of Buddhism from Korea in the mid sixth century; thereafter, for hundreds of years, the Japanese looked to China and Korea as their cultural models. Subsequent influences from the mainland were provided by Zen Buddhism, imported during the thirteenth century, and the rapid assimilation of the Chinese "literati" concept of painting in the eighteenth. The former brought with it the philosophy and technique of ink monochrome painting; the latter was the result of artists' efforts to emulate the more scholarly aspects of the Chinese painting tradition.

These intermittent adoptions of elements of Chinese culture undoubtedly encouraged the Japanese to strive for higher goals in all aspects of their civilization. However, even as they endeavored to take their place within the world beyond their borders, no foreign culture ever totally dominated them. Periods of intense borrowing from the continent always alternated with periods of retrenchment, during which the Japanese took advantage of what they had learned from abroad, adapting it according

to their own needs and sensitivities, and altering or adjusting it to suit their natural environment. Some mainland values and aesthetics were completely rejected. The high-minded, philosophical ideals and sometimes sober restraint that characterized much of the Chinese approach to life and art were for the most part ignored in favor of an emotional response to the beauties of nature or the intricacies of human affairs. Although almost all aspects of Chinese art were emulated in Japan, each was modified by native preferences and taste. The result was unexpectedly rich variations on continental models that enable us to distinguish Japanese works from the objects that inspired them.

This traditional attitude toward the outside world has been vividly demonstrated in our own times. Emerging from an entrenched feudal social order in the late nineteenth century, the Japanese have eagerly been assimilating Western technology and aspects of Western culture. With incredible ingenuity and perseverance they have been modifying what they borrowed to fulfil their national aspirations. Their achievements during the past century have been clearly in keeping with the recurrent trends of the past.

The fluctuating rhythm of Japan's cultural development forms the basis for the grouping of objects in this exhibition catalogue. Chapter 1 comprises sculpture, painting, and other objects created for the worship of Buddhas, Bodhisattvas, and other lesser deities that make up the Buddhist pantheon. Also included in this group are a small number of pieces intended to pay homage to Japan's indigenous Shinto gods and goddesses. In Chapter 2, a selection of paintings reflects the impact made by Zen Buddhism on all facets of Japanese life; other paintings, *nanga*, celebrate the accomplishments of masters who attempted to assimilate aspects of Chinese scholar-gentlemen art into their work. Even in these the unmistakable effects of Japanese modification are obvious; one example is the strongly decorative element visible in ink monochrome hanging scrolls and screens.

The handscrolls, hanging scrolls, and screens in Chapter 3 represent the triumphal assertion of native taste and themes. In these works, Chinese influences do occasionally appear, since both the techniques and materials of painting were originally brought to Japan from mainland Asia. However, the Japanese were adept at transforming these into something entirely their own.

Chapter 4 is made up of ceramics and lacquerware, generally treated in the West as mere "decorative" pieces or examples of "the minor arts." Some were made for the service of the dead; others were produced to honor Buddhist or Shinto deities. In Japan, objects in these media were often elevated to the status of "fine art," particularly as they were incorporated into the world of *chanoyu*, or tea ceremony, and used to serve food and sweetmeats or to hold incense or flowers.

Segment from a handscroll depicting an episode from "Sakaki" ("Sacred Tree"), the tenth chapter of the *Genji Monogatari* (see catalogue no. 38).

1
Reflections of Faith

Ancient Japan had no organized religion. A popular set of beliefs and ritual practices called Shinto, or "The Way of the Gods," is usually identified as the country's indigenous faith, although it is not a religion in the true sense of the word. It has no founder, no sacred texts, no teachers, patriarchs, or saints, and no well-defined pantheon of deities. Shinto never developed a moral code or priestly hierarchy, nor did it strive to achieve salvation after death for its followers. The early Japanese saw nature itself as the manifestation of a "divine" presence. All lofty peaks, for example, were thought to be sanctified by the presence of mountain gods; similarly, rivers, trees, and rocks could be identified as "gods" of polytheistic Shinto.

Native Shinto was profoundly affected by Buddhism, the powerful religion introduced to Japan from the Korean kingdom of Paekche in A.D. 538. This faith, which had already shaped the lives of millions of people in Eastern and Southeast Asia, originated in India in the fifth century B.C. with the life and teachings of its founder, the Buddha, or "Awakened One." Born to the Śākya clan on the border of Nepal in 563 B.C., this spiritual leader, also known as Śākyamuni (Sage of the Śākyas), taught that all life is painful and that human misery is rooted in an excessive attachment to the self and the ephemeral delights of the senses. The cure for this universal malady, he insisted, lay in suppression of the ego and escape from the cycle of reincarnation—the inexorable pattern of birth, death, and rebirth to which all sentient beings were believed to be destined. This escape would enable one to achieve a permanent liberation from the sorrows of corporeal existence.

The adoption of Buddhism, a foreign religion, was an event of singular importance in Japan's early cultural history and signals the beginning of the country's first historical era, the Asuka period. Named for the region, near Nara, where the court resided, it witnessed the building of numerous temples in honor of the new gods. It was during the Asuka period that the Japanese were awakened to the existence of a higher level of civilization on the Asian continent, and it is likely that they experienced a form of culture shock. They came to the realization that embracing Buddhism meant assuming a totally new and different way of life. The basis of the new faith and the system that supported it was the social organization and governmental bureaucracy of China. These served as models for the organization of Japan's governmental structures and social order, and thus affected virtually every aspect of day-to-day life. The Japanese hastened to acquire all the paraphernalia of Chinese culture, and all continental art forms employed in the worship of the new gods were welcomed.

The adoption of Buddhism did not result in the abolition of Shinto, which never lost its role as state religion and continues to this day to control many of the traditional observances important to the national identity of Japan. This peaceful coexistence of creeds was due, at least in part, to the loosely structured nature of Shinto beliefs. At the same time, the accommodating attitude of early Buddhist converts, who continued to recognize their indigenous deities,

enabled the Japanese to avoid the exclusivity associated with other religions of the world. Anthropomorphic representations of gods had been unknown in Japan prior to the Asuka period, but Buddhist art provided Shinto with a precedent for representing its own gods and goddesses in sculpture and painting (no. 5).

One of the most significant acquisitions from mainland Asia was the Chinese system of writing. The Japanese had no written language of their own, and relied on mentors from Paekche and Silla, another Korean kingdom, to introduce the superior culture of China to its upper class. Direct contact with China proper was soon established by the Japanese, and Chinese characters were quickly adopted as the vehicle for written expression.

Many different sects of Buddhism, among them Esoteric Buddhism (*Mikkyō*) and the cult of Amida Buddha, were introduced from the continent and practiced in Japan long after their influence had dissipated in China and Korea. Included in this exhibition is a small number of objects and paintings reflecting the manifold aspects of Buddhist and Shinto beliefs, many of which dominated the lives and thought of the Japanese until recent times. These items were made either for iconic purposes or as ancillary images. Notable exceptions are two ink monochrome paintings (nos. 8 and 9) that were created not as objects of worship but as aids in Zen meditation. Zen Buddhism and its significance in the arts are discussed in Chapter 2, *Evocations of China*.

1.

Clay Relief Tile Depicting a Buddhist Triad

Hakuhō period, second half of the seventh century
Earthenware with traces of polychrome
H. 24.5 x W. 19.6 x D. 3.7 cm (9¹¹⁄₁₆ x 7³⁄₄ x 1⁷⁄₁₆ inches)
PUBLISHED: Hongnam Kim, *The Story of a Painting: A Korean Buddhist Treasure from The Mary and Jackson Burke Foundation* (New York: The Asia Society Galleries, 1991), 4, no. 38.

Clay relief tiles known as *senbutsu* (literally, clay tile Buddha) have been discovered in diverse regions of Japan. The excavation sites extend, for example, from as far east as Fukushima prefecture in the Tōhoku region of Honshū to Ōita prefecture in the westernmost island of Kyūshū.[1] This example depicts the Buddha seated in front of a bodhi tree[2] as part of a triad with two attendant Bodhisattvas. The term *senbutsu*, however, is also used to refer to clay relief tiles representing pentads and single Buddha figures.

Some of the most important discoveries of *senbutsu* have been made in the Asuka region south of Nara, once the ancient capital. Of particular significance was the 1974 excavation at the site of Kawaradera (or Kawaharadera, also known as Gufukuji) in Asuka village, where *senbutsu*, fragments of clay statues, bronze statuettes, and metal ornaments were discovered in a large pit behind the foundations of the temple structures.[3] Directly opposite Kawaradera is the site of Tachibanadera, to which the Burke *senbutsu* is attributed. The raised rim along the edge of the latter is characteristic of tiles associated with this site.[4] Among the numerous extant examples of *senbutsu*, those from Tachibanadera are considered to be the oldest and were found at the former location of the *kondō* (main hall) of the temple.[5] The traditional dating for the establishment of Tachibanadera appears in the document *Hōryūji Ruki Shizaichō*, dated 747, which states that the temple was founded during the tenure of Shōtoku Taishi (574–622) as prince regent.[6] On the basis of dates established for the temple's stone foundations, however, scholars posit that Tachibanadera was established later during the Tenchi era (662–671).[7] The extant square triad and single-figure tiles, which were variously decorated with

gold leaf and pigments, are believed to have functioned as wall decorations in the main halls, lecture halls, and pagodas of temple complexes long since destroyed. There is in fact no extant temple that preserves this ancient method of ornamentation. Some have speculated that these tiles were arranged side by side and affixed to walls with nails inserted through small holes, features visible on the Burke tile.[8]

The manufacture and function of *senbutsu* have direct sources in the Chinese artistic tradition. Clay relief tiles of a closely related type (only slightly smaller than the Japanese versions) were produced in China as private devotional plaques in the seventh century.[9] The T'ang dynasty examples, which have rounded upper corners that join in an arch at the top, display pictorial features similar to the square tiles as well as to Japanese *senbutsu* that are classified as flame-shaped (a form comparable to the Chinese examples). This configuration, which would not have allowed the placement of tiles flush at all corners, implies that the flame-shaped *senbutsu* were not attached to walls; instead they may have been inserted in some form of small shrine.[10] In Japan, all types of *senbutsu* were fashioned by impressing clay in negative clay molds to produce an image in low relief. The unbaked tile was extracted from the mold by means of a material that would ease separation, possibly ash made from burned wood or straw, and then fired.[11] Considering the substantial quantity of extant tiles, relatively few molds have survived,[12] a result perhaps of repeated use for mass production. Moreover, the manufacture of *senbutsu* is also related to the production of gilt copper repoussé Buddhist plaques (also produced in T'ang China), known as *oshidashi* (literally, pushed out) *butsu*,

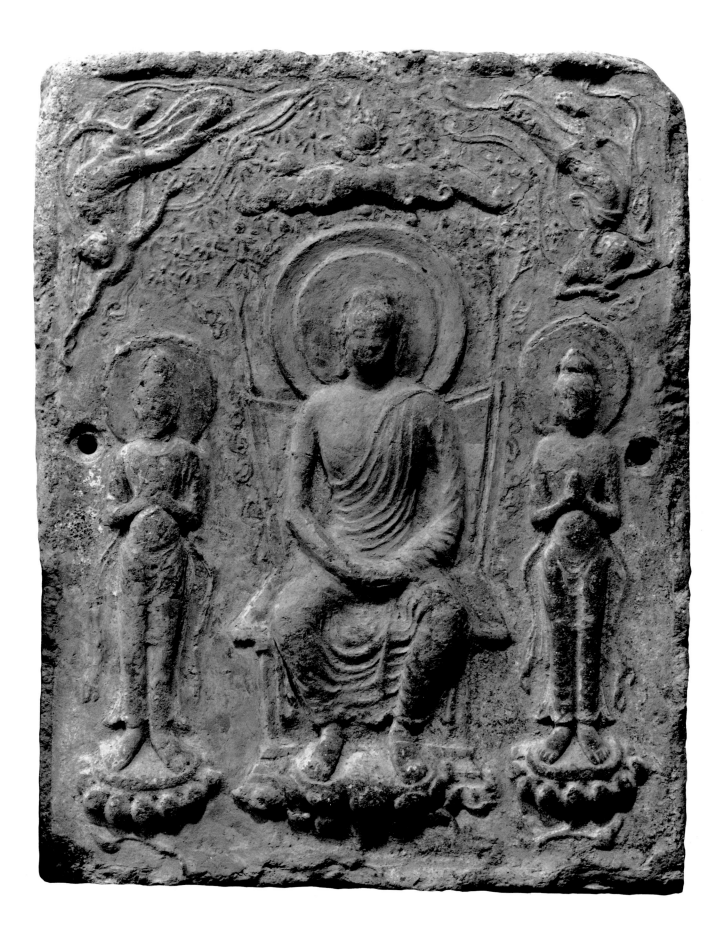

for use in miniature shrines.[13] It has been theorized that some repoussé plaques (which were made by hammering sheets of copper over a positive metal matrix) and *senbutsu* were produced from common original molds, which accounts for the striking similarity in the compositions and styles of many examples of both.[14]

A triadic formation, as represented by the Burke tile, is a fundamental and pervasive grouping in the Buddhist pictorial tradition. Although some details vary, the basic compositional elements of the Chinese and Japanese (square and flame-shaped) triad tiles are similar. Each includes a figure of the Buddha seated with pendant legs on a high-backed throne and with hands held in the *jōin* mudra (hand gesture), which symbolizes a state of concentration.[15] Flanking the Buddha on either side are two standing Bodhisattvas whose hands are joined in an attitude of prayer; these figures are supported by lotus pedestals that emanate from a single stem of the lotus blossom beneath the Buddha. Above the head of the Buddha is an umbrella-like canopy with pendant jewels.[16] Japanese square *senbutsu* triads, however, are further enhanced by the depiction in the upper corners of *hiten* (flying Bodhisattvas; in Sanskrit, *apsarasas*, no. 3) whose upturned hips and twisted bodies suggest their descent from the heavens to attend the Buddha. The iconographic scheme of Japanese *senbutsu* triads is ambiguous.[17] Usually, if a Buddha is depicted seated on a throne with pendant legs, this posture implies that the deity could be identified as Miroku, the future Buddha.[18] Some triad fragments excavated at Kawaradera, however, were incised on the back with characters for the names of different Buddhas, including Shaka, the historical Buddha; Amida, the Buddha of the Western Paradise; and Miroku.[19] This evidence suggests that the seated figure depicted in these tiles is a generic representation of multiple manifestations of the Buddha, a fundamental concept in Mahāyāna Buddhism. And the attendant Bodhisattvas, who do not bear attributes, cannot be specifically identified.

The stylistic features of *senbutsu* reveal aspects of an early T'ang mode. The fleshy quality of the upper torso of the Buddha, whose corporeal form is subtly implied through the thin folds of drapery rendered in delicate relief, reflects the origins of characteristics further developed slightly later in the T'ang. This style is exemplified in larger scale by the famous early eighth-century stone reliefs of Buddhist triads (some of which also display figures of *hiten*)[20] from Pao-ch'ing-ssu in Sian.[21] In comparison with the latter, however, not only is the seated Buddha less naturally conceived, but the entire composition is naively executed (as is true also of the early T'ang flame-shaped tiles) in a split perspective; the upper parts of the figures' bodies are represented from the head to the waist in a direct frontal position, whereas the lower halves of the bodies (as well as the lotus pedestals) are tilted downward, which creates a diagonal perspective from above.[22] Given that the Japanese and Chinese tiles were both manufactured in the seventh century and share comparable pictorial features, the adoption of this decorative technique in Japan must have occurred soon after the production of the Chinese prototypes.[23] *Senbutsu* may have been introduced by immigrant artisans from the continent who were working in Japan. It is also possible that Chinese *senbutsu* were brought back to Japan by emissaries returning from imperially sponsored missions to China in the second half of the seventh century.[24]

In forming wall displays with square *senbutsu*, artisans were able to provide a setting for the main sculptures in a temple hall that would create an atmosphere evocative of the Buddha's realm. Therefore, what the Japanese were apparently trying to replicate with some tiles, albeit on a smaller scale, was the monumental splendor of the decorated interiors of Chinese Buddhist cave temples such as those at Tun-huang (located at the eastern end of the Silk Route in northwest Kansu province) and Yün-kang in northern China.[25] *Senbutsu* were produced in Japan, however, for a relatively short period extending from the second half of the seventh century to the early eighth century. After that time, this type of temple decoration declined in popularity and the production of *senbutsu* ceased. GWN

NOTES

1. Kuno Takeshi, ed., *Oshidashibutsu to Senbutsu* (*Oshidashibutsu* and *Senbutsu*), Nihon no Bijutsu no. 118 (Tokyo: Shibundō, 1966), 59.
2. Nara National Museum, ed., *Asuka no Senbutsu to Sozō* (Buddhist Clay Relief Tiles and Clay Statues from the Asuka Area) (Nara: Nara National Museum, 1976), 4.

3. These objects were apparently buried in the pit after a fire that probably occurred sometime in the early eighth century. See Matsushita Taka'aki, *Kawaharadera Urayama Iseki Shutsudohin ni tsuite* (The Relics Excavated from the Site on the Hill behind Kawaharadera), Josei Kenkyūkai Hōkokusho Bukkyō Bijutsu Kenkyū Ueno Kinen Zaidan (Committee on Research, The Ueno Memorial Foundation for the Study of Buddhist Art), no. 4 (Kyoto: Kyoto National Museum, 1977), 2. This report details the findings of symposia held after the 1974 excavation. Also, an exhibition that focused on the archaeological finds from Kawaradera was held at the Nara National Museum; see Nara National Museum, *Asuka no Senbutsu to Sozō*.

4. Mitsumori Masashi, "Senbutsu Zatsu Sōkan" (Miscellaneous Views concerning *Senbutsu*), in Suenaga Sensei Beiju Kinenkai, ed., *Suenaga Sensei Beiju Kinen Kentei Ronbunshū* (Studies Dedicated to Dr. Masao Suenaga on the Occasion of his Eighty-Eighth Birthday) (Nara: Nara Meishinsha, 1985), 2:1532; and an inscription by Ishida Mosaku, which was also on the storage box for the Burke tile, attributes the tile to Tachibanadera.

5. Kuno, *Oshidashibutsu to Senbutsu*, 58, 60.

6. Ibid., 60. The complete title of this document is the *Hōryūji Garan Engi narabi ni Ruki Shizaichō* (The Origin of the Hōryūji and Record of Its Treasures).

7. Kuno, *Oshidashibutsu to Senbutsu*, 60.

8. An artist's rendering of a possible reconstruction of the interior of Yamadadera (another site located in the Asuka region) and the manner in which *senbutsu* may have been displayed is reproduced in Hirata Yutaka, *Nara Bukkyō* (Nara Buddhism), vol. 1 of *Zusetsu Nihon no Bukkyō* (Illustrated Japanese Buddhism) (Tokyo: Shinchōsha, 1989), 60-61. A small-scale related version of this arrangement is suggested by a seventh-century bronze plaque in the collection of the Hasedera temple (Nara prefecture) that features Buddhist triads surrounded by multiple single figures of the Buddha; see Kuno, *Oshidashibutsu to Senbutsu*, 49.

9. Kuno, *Oshidashibutsu to Senbutsu*, 63-65. This type of Chinese tile is associated with the temple Ta Tz'u-en-ssu in Sian, first built in 652; see Alexander C. Soper, "Some Late Chinese Bronze Images (Eighth to Fourteenth Centuries) in the Avery Brundage Collection, M. H. De Young Museum, San Francisco," *Artibus Asiae* 31, no. 1 (1969): 35-36.

10. Mitsumori, "Senbutsu Zatsu Sōkan," 1534-35; for reproductions of flame-shaped tiles, see Nara National Museum, *Asuka no Senbutsu to Sozō*, 27, and Kuno, *Oshidashibutsu to Senbutsu*, 14.

11. Mitsumori, "Senbutsu Zatsu Sōkan," 1548-49.

12. Mitsumori, "Senbutsu Zatsu Sōkan," 1538; an example of a clay mold for a flame-shaped tile is reproduced in Nara National Museum, *Asuka no Senbutsu to Sozō*, 27, no. 86.

13. One example of a copper plaque that was made for a small shrine is in the collection of the temple Hōryūji; see Kurata Bunsaku, *Hōryūji: Temple of the Exalted Law*, trans. W. Chie Ishibashi (New York: Japan Society, 1981), 43, no. 5.

14. A detailed study of the various theories regarding the use of clay and metal molds for *senbutsu* and *oshidashibutsu* is presented in Mitsumori, "Senbutsu Zatsu Sōkan," 1538-47; see also Ōwaki Kiyoshi, "Senbutsu to Oshidashibutsu no Dōgenkei Shiryō: Natsumehaiji no Senbutsu o Chūshin toshite" (Data on *Senbutsu* and *Oshidashibutsu* Having Common Original Molds: A Focus on Senbutsu from the Temple Ruins of Natsumehaiji), *Museum* 418 (January 1986): 4-25.

15. E. Dale Saunders, *Mūdra: A Study of Symbolic Gestures in Japanese Buddhist Sculpture*, Bollingen Series no. 58 (1960; reprint, Princeton: Princeton University Press, 1985), 85-93.

16. The pictorial tradition of depicting a canopy above the head of the Buddha was derived from sutras that describe his miraculous power, which transformed offerings of flowers, parasols, and other precious objects into a canopy; see Lucie Ruth Weinstein, "The Hōryūji Canopies and Their Continental Antecedents" (Ph. D. diss., Yale University, 1978), 1-3.

17. The late Alexander C. Soper set forth one interpretation of the iconography of the Chinese triad tiles by suggesting that this composition represents the second of three aspects of the Buddha's body, in which he manifests himself to a multitude of Bodhisattvas, as expressed by the concept of the Three Body doctrine. See "Late Chinese Bronze Images," 34-38; see also Angela Falco Howard et al., *Chinese Buddhist Sculpture from the Wei through the T'ang Dynasties* (Taipei: National Palace Museum of History, 1983), 156-57.

18. Saunders, *Mūdra: A Study of Symbolic Gestures*, 129.

19. Nara National Museum, *Asuka no Senbutsu to Sozō*, 7.

20. Matsubara Saburō, *Chūgoku Bukkyō Chōkokushi Kenkyū* (Research on the History of Chinese Buddhist Sculpture), rev. ed. (Tokyo: Yoshikawa Kōbunkan, 1966), vol. 2, no. 259a.

21. Ōhashi Katsuaki, "Kawaradera no Zōbutsu to Hakuhō Chōkoku no Jōgen ni tsuite" (Production of Buddhist Sculptures at Kawaradera and the Earliest Buddhist Sculpture Made in the Hakuhō Period), *Bukkyō Geijutsu* 128 (January 1980): 13.

22. Ibid., 17.

23. Although the Chinese tiles extant in Japan were apparently imported after the Meiji era (see Kuno, *Oshidashibutsu to Senbutsu*, 56) a small bronze T'ang-dynasty pentad was recently excavated at the site of Yamadadera (see no. 8). This object is a positive mold that was used for repoussé plaques and provides evidence of a T'ang prototype, generally related to the production of *senbutsu*, that was extant in Japan from ancient times; see Nara Kokuritsu Bunkazai Kenkyūjo, ed., *Asuka, Fujiwara-Gū Hakkutsu Chōsa Gaihō* (Summary of Excavation Research for Asuka and Fujiwara Palace Sites), no. 21 (May 1991): 81.

24. Ōhashi, "Kawaradera no Zōbutsu," 13.

25. For example, in Cave 244 at Tun-huang, dated from the late Sui to early T'ang, the wall paintings behind the central icons include triads, one example of a pictorial prototype for the composition of *senbutsu*; see Tun-huang Research Institute, ed., *Tonkō Bakkōkutsu* (The Rock-Cut Caves at Tun-huang) (Tokyo: Heibonsha, 1981), vol. 2, no. 177. Other generic large-scale prototypes are the carved reliefs in stone cave temples dating from the fifth century at Yün-Kang, which represent triads surrounded with multiple figures of single Buddhas; see Shinkai Taketarō and Nakagawa Tadayori, *Rock Carvings from the Yün-Kang Caves* (Tokyo, Bunkyūdō, and Peking: Yamamoto Photographic Studio, 1921), pl. 190.

Hyakuman-tō *(Miniature Pagoda) and* Darani *Scroll*

Nara period, ca. 767
Wood (*hyakuman-tō*); ink printed on paper (*darani* scroll)
H. 22 cm (8⅝ inches) (*hyakuman-tō*); H. 5.8 x W. 46.4 cm
(2¼ x 18¼ inches) (*darani* scroll)

This miniature wooden pagoda,[1] only 22 centimeters in height, is identical to the thousands of wooden pagodas displayed today at the Treasure House of Hōryūji temple in Nara,[2] which owns a total of 26,054 pagoda spires and 45,755 bases.[3] These pagodas were among the one million produced in one of the most unique projects in the history of Japanese Buddhist art. At the same time, they serve as a vivid reminder of an ignominious episode in the history of ancient Japan.

Historical information on the small pagodas is found in two sources: the *Shoku Nihongi* (*History of Japan Continued*) of 797[4] and the *Tōdaiji Yōroku* (*Chronicles of Tōdaiji*) of 1106.[5] According to these documents, the project of producing one million miniature pagodas was conceived by the Empress Kōken (reigned 749–758), perhaps as penance for her grave misconduct. Kōken was the daughter of Emperor Shōmu—one of the most devout rulers in the history of Japan—and his equally devout consort, Kōmyō. Kōken was enthroned twice, the second time as Empress Shōtoku (reigned 765–769), and it was during her second reign that she allied herself with a notorious young monk named Dōkyō. She promoted him to a series of politically powerful positions, an unprecedented situation for a Buddhist monk, and it was widely rumored that he was her paramour (a belief still held in Japanese popular history).[6] Dōkyō himself evidently nurtured ambitions to become emperor. In 764 the empress's uncle, the true power behind the throne, engineered an unsuccessful coup d'etat, and shortly after this incident Empress Shōtoku commissioned the production of the one million miniature pagodas. Each was to enshrine a tiny scroll of printed Buddhist incantations known as *darani* (*dhāraṇī* in Sanskrit), which were believed to have magical powers. In this way the empress may have hoped to appease the ecclesiastical community.

The possible significance of this two-part commission—the execution of the pagodas and the printing of the *darani*—has been explored a number of times.[7] Four *darani* chosen for printing—the *Konpon Darani, Jishin'in, Sōrin,* and *Rokuhara*—were drawn from the *Mukujōkō Daidarani-kyō* (*Vimalanirbhāsa-sutra*).[8] This sutra promises aid in the expiation of sins, the termination of strife, and the accumulation of religious merit through the construction of pagodas and the copying of sutras. It has been suggested, too, that Empress Shōtoku was attempting to rival with this project her father's monumental commission for construction of the Tōdaiji temple and its great bronze Buddha.[9]

The *darani* in the Burke Collection was printed on a strip of paper that measures 5.8 cm in height and 46.4 cm in length. It contains thirty lines of text, printed from either woodblocks or metal plates.[10] The titles of the sutra and the *darani* precede the text, which is arranged in columns of four and five characters with intralineal glosses. This short scroll is one of many that have been dispersed to public and private collections (in Japan and elsewhere), and only some four thousand printed *darani* remain within their wooden pagodas at Hōryūji. Until fairly recently these *darani* scrolls were regarded as the oldest extant examples of printed text in the world. No earlier works survived in China, where the printing technique was most likely invented. However, in 1966 a printed scroll version of the *Mukujōkō Daidarani-kyō* was discovered at the Pulguk-sa temple in Kyongju, South Korea, in a stupa known to have been sealed in 751.[11]

There is no way to determine whether the Burke Collection *darani* was originally placed inside the Burke Collection pagoda. When rolled up, it fits perfectly inside the cavity in the base of the pagoda; the method by which both base and cavity were produced

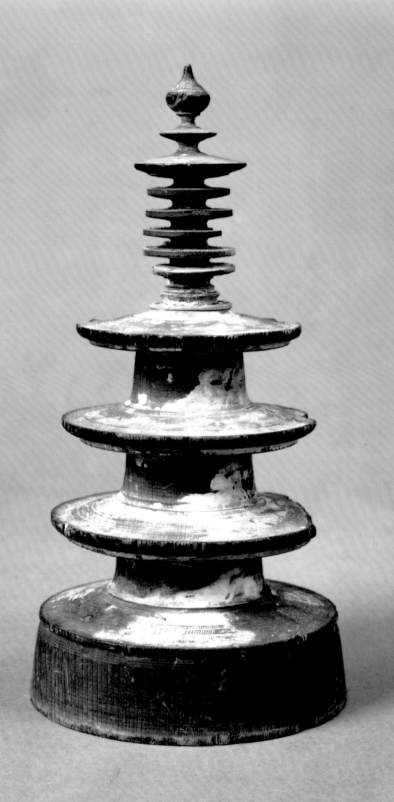

has been reconstructed in a recent study.[12] Like most of the one million miniature pagodas at Hōryūji, the pagoda itself consists of two parts, a three-storied base and a five-ringed finial.[13] Only two of the Hōryūji wooden pagodas are larger in size: one, known as *Ichimansetsu-tō* (the 10,000th-marker pagoda), has seven stories, and the other, called *Jūmansetsu-tō* (the 100,000th-marker pagoda), has thirteen stories. These may have been made to commemorate different stages of the project.[14]

Like most of the smaller examples, known as *hyaku-man-tō*, the Burke Collection pagoda has a base made from *hinoki* (Japanese cypress) wood, while the spire is constructed in *sakaki* (*cleyera japonica*) wood, a material better suited for fine detail. The entire surface was coated with lead-white, and some brownish patina (which appears green, or other colors, on other examples) can also be seen. The lead-white coating was also applied to the interior of the cavity made in the base as a receptacle for the *darani*. The base was finished on a lathe and also shows marks of a chisel; five incised marks on the bottom, made as the piece was fitted on the lathe, are still visible.[15] At the bottom of the spire is a small "belly button," another trace of the lathe.

Many of the *hyakuman-tō* at Hōryūji have been found to have inscriptions, some of which appear on the base, others on the spire. These notations, hidden under the white coating, read "left" or "right," suggesting that the craftsmen who produced them were organized into two groups. Other inscriptions include dates and the names of individuals. The exact location of the workshop where the pieces were created is not known, but it may have been situated somewhere within the capital, where a number of what seem to be discarded pagodas have been unearthed.[16] From the inscriptions the names of about two hundred and fifty persons, thought to have been temporary workers, have been identified. These industrious craftsmen were probably drafted specifically for the empress's project, for which they were paid by the number of pieces they executed. Altogether they seem to have made approximately twelve hundred bases and an equal number of spires each day, not counting rejected sculptures.

The inscriptions also suggest that the majority of the pagodas were produced between 767 and 768. Certain simplifications were introduced into the sculpting technique along the way. For example, the cavities in the bases of the pagodas were painted with white pig-

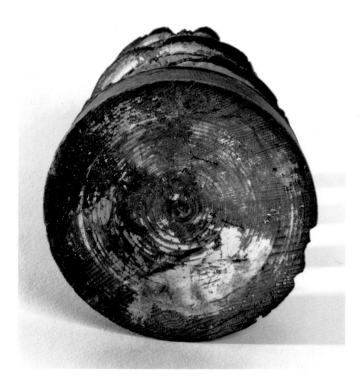

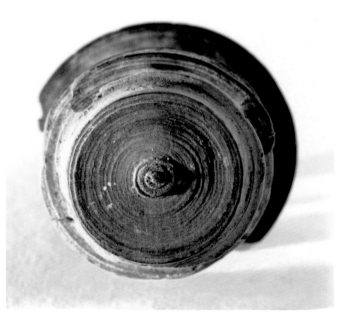

ment until the eighth month of 767, after which date the practice was discontinued. The tiny "belly button" left on the bottom of the spire of the Burke Collection piece was broken off on the majority of pieces; only about one quarter of the pagodas at Hōryūji retain this little protuberance left by the carving process.

The entire project was completed by the fourth month of 770, at which time Empress Shōtoku had 100,000 darani scrolls and pagodas distributed to each of the ten major temples in the capital. Although these temples are not identified in any records, the *Tōdaiji Yōroku* lists them as Tōdaiji, Daianji, Gangōji, Kōfukuji, Gufukuji, Hōryūji, Shitennōji, Sūfukuji, Saidaiji, and Yakushiji.[17] Surprisingly, only Hōryūji still possesses these royal gifts, and even there only about one half of the original 100,000 are preserved; no doubt the other *hyakuman-tō* were lost or destroyed over time. It is ironic, however, that today a large number of them are dispersed far beyond the area of the old Nara capital. Many are currently in Western collections, including those of libraries and museums, where the *darani* scrolls are treasured as specimens of early printing. The pagodas and their scrolls are also valued as a reminder of the religious fervor of an ancient Japanese ruler.

The pagoda in the Burke Collection lacks an inscription, but it may have been made by an artisan from the "right" group, which appears to have used both chisel and lathe, most notably during the year 767. As the cavity in its base is painted with lead-white, a practice that was abandoned after the eighth month of that year, it may be safe to date its production to the early part of 767.

NOTES

1. A pagoda, an East Asian version of an Indian stupa in its full or miniature scale, is considered a receptacle for Shaka Buddha's relics.
2. Hōryūji Shōwa Shizaichō Henshū Iinkai, ed., *Shōwa Shizaichō* (Shōwa-era Record of Temple's Assets), vol. 5 of *Hōryūji no Shihō: Hyakumantō, Daranikyō* (Treasures of Hōryūji) (Tokyo: Shōgakkan, 1991), 9–11.
3. In the past it was erroneously reported that only one hundred miniature pagodas remain at the temple. This misunderstanding was due to the government's designation, in 1908, of one hundred of the pieces as Important Cultural Properties.
4. Kuroita Katsumi, ed., *Shintei Zōho Kokushi Taikei* (Newly Revised Edition of the Survey of Japanese History) (Tokyo: Yoshikawa Kōbunkan, 1935), vol. 2; or Imaizumi Tadayoshi, ed., *Kundoku Shoku Nihongi* (Sequel to the Annals of Japan in Japanese Reading) (Kyoto: Rinsen Shoten, 1986), 635–770.
5. Tsutsui Eishun, ed., *Tōdaiji Yōroku* (Digest Record of Tōdaiji) (Osaka: Zenkoku Shobō, 1944).
6. For a vivid summary of the events, see also Mimi Hall Yiengpruksawan, "One Millionth of a Buddha: The Hyakumantō Darani in the Scheide Library," *The Princeton University Library Chronicle* 48, no. 3 (Spring 1987): 225–38.
7. Yiengpruksawan, "One Millionth," 231–33.
8. For this sutra, see Takakusu Junjirō and Watanabe Kaigyoku, eds., *Taishō Shinshū Daizōkyō* (The Taishō Edition of the Tripitaka) (Tokyo: Society for the Publication of The Taishō Edition of the Tripitaka, 1928), vol. 19, no. 1024, 717–21.
9. Yiengpruksawan, "One Millionth," 233.
10. *Shōwa Shizaichō*, 116.
11. David Chibbett, *The History of Japanese Printing and Book Illustration* (Tokyo, New York, and San Francisco: Kodansha International, 1977), 29.
12. *Shōwa Shizaichō*.
13. Some are made of many small parts.
14. *Shōwa Shizaichō*, 112.
15. Similar marks appear on approximately 19 percent of the pieces remaining at Hōryūji.
16. *Shōwa Shizaichō*, 102.
17. *Tōdaiji Yōroku*, 25–26.

3.

Two Hiten (Apsarasas) *Mounted on Disks*

Late Heian period, late eleventh to early twelfth century
Lacquered and gilded *hinoki* (Japanese cypress) wood
H. including cloud: 28 cm (11 inches) (A); 27.5 cm (10¹³⁄₁₆ inches) (B)
PUBLISHED: Koizumi Sanshin, *Kain Shōja Shinkan* (True Mirrors
of Kain Shōja) (Tokyo: Ōtsuka Kōgeisha, 1926), pl. 29 (B), pl. 30 (A).

These two lovely statuettes represent *hiten* (*apsarasas* in
Sanskrit), Bodhisattvas who are usually seated (although
they sometimes stand) on flying clouds fluttering
around the figure of a Buddha. These attendants, also
known in Japan as *Unchū Kuyō Bosatsu* (Bodhisattvas
among the clouds in adoration of a Buddha), are often
represented playing musical instruments, as does *Hiten* A
depicted here. Both figures are carved in high relief,
their heads rendered almost completely in the round,
and each is attached to a disk. The disks and the rather
fussy ribbons that create a strong suggestion of move-
ment are later additions. Both statuettes suffered
noticeable damage on their bodies, as will be described
in detail below. Nevertheless, their faces have not been
seriously damaged, and even the restorations and addi-
tions do not detract from the gentle beauty of these
elegant, youthful-looking deities.

The two *hiten* were not reunited until 1992, and this
occurred under rather unusual circumstances. Until
then, the Burke Collection owned only *Hiten* A (which
was acquired in 1987). In the 1920s this statuette was
part of the renowned collection of Koizumi Sakutarō
(1872-1937, also known as Sanshin Koji), an influential
politician, journalist, and essayist of the late Meiji and
Taishō periods. In 1926, it was included along with
Hiten B in the published catalogue of his collection of
sculptures, many of which were subsequently desig-
nated as either National Treasures or Important
Cultural Properties.¹ The statuettes seemed to belong
together because of their similar dimensions and
sculptural style.

Both statuettes were identified in the 1926 catalogue
as originally being attached to the main Buddha figure
in the temple of Jōruriji, south of Kyoto, dating to
the Late Heian period. This temple is famous for its

unusual display of nine statues of Amida Buddha
(Amitābha in Sanskrit) on one long podium in a large
Amida Hall. The nine Amida Buddhas represent the
nine grades of *raigō*, Amida's descent to this world to
accept his followers into his Western Paradise, a con-
cept that enjoyed great popularity at that time. Among
the nine Amida Buddhas, only the main figure in the
center, the largest of the group, is backed by a huge
mandorla adorned with four *hiten* flying on clouds.
The statue and the mandorla are truly enormous—the
seated buddha is 221 cm (87 inches) high and the man-
dorla is 244.5 cm (96¼ inches); they are placed atop a
tall pedestal that is 115.2 cm (45³⁄₈ inches) high. The *hiten*
appear minuscule in this arrangement. Because data on
the present state of preservation and dimensions of the
hiten remaining on the mandorla are not available, it is
difficult to verify the claim, made in the 1926 cata-
logue, that *hiten* A and B once belonged to this set. At
least as far back as the late 1950s, however, it was
reported that the mandorla of the central Amida in this
temple was adorned originally with a statuette of
Dainichi (Buddha Mahāvairocana in Sanskrit) and
twelve or fourteen flying *hiten*, as was common on
many Amida statues, and that all except four had been
lost.² More recent reports on this Amida statue attested
that the mandorla filled with tiny statuettes of seated
Buddhas is, largely, a recent replacement, while the
four remaining *hiten* are contemporary with the statue
of Amida and the temple.³

In the summer of 1992, a report was received that a
hiten resembling Burke *Hiten* A (similarly mounted
on a disk) was in a private collection in Germany.
A quick visit verified that this *hiten* had indeed once
been part of the Koizumi collection. Its new owner was
Herr Mohr, a German mining engineer, who had been

employed by the Japanese government in the 1950s. At the time of his departure from Japan, Herr Mohr was given *Hiten* B as a token of gratitude from the Bureau of Mining. The statuette remained with the Mohr family until the fall of 1992, when it was acquired by the Burke Collection and reunited with *Hiten* A after a separation of almost half a century.

Hiten, or Bodhisattvas flying on clouds, were almost indispensable as elements in the depiction of the Buddha and his world. They are placed on the rim of mandorlas behind statues of Buddhas, around the interiors of Buddha halls, and are included in paintings of various Buddhas. Numerous examples of *hiten* can be cited from the earliest periods of Buddhist art in Japan, Korea, and China. They may play musical instruments, or be shown as adoring figures; on rare occasions they appear to be giving offerings. Yet, unlike Christian angels, the *hiten* of East Asia seem never to have acquired spiritual functions, nor are their iconography and genealogy always clear. Nagahiro Toshio's monograph[4] shows that while *hiten* of East Asian Buddhism are wingless, Indian and Central Asian Buddhists occasionally represented youthful, winged deities, which may be rightfully identified as angels similar to those that inhabit the Christian world. Such "angels" or "putti" could have evolved from the concept of winged deities in ancient Iran, and it is likely that the idea spread eastward to Asia. Yet the flying deities of Indian Buddhism, often identified as *apsarasas*, are not always winged.

The best-known winged youth to come from the Buddhist world can be found in Miran in Central Asia; the figure in the painting looks exactly like a Christian angel. The Indian *apsaras* in pre-Buddhist incarnation is thought to have been the goddess of water, the wife of Gandharva—a guardian deity and bird king, represented as a hybrid of a human and a bird, who is also a celestial musician.

Some Chinese Taoist immortal beings were occasionally represented with feathery wings and fantastic-looking cloud formations that symbolized air and the celestial regions. This made it easy for Chinese Buddhists to accept the idea of aeronautical creatures fluttering in the upper regions of the Buddha's world, and they made their debut in painting and sculpture soon after this foreign faith was accepted. Yet the Chinese

Buddhist versions of the airborn deities were in most instances wingless, and their ability to fly was suggested by their elegant, fluttering scarves, their body postures, or their placement in the celestial regions within the Buddha's realm.

In the earliest period in the history of Japanese Buddhist art, such figures in flight adorned the images and interiors of Buddhist temple halls. Among the most famous examples from early periods in Japan are those at Hōryūji in Nara. The upper walls inside the Golden Hall (Kondō) of this temple are decorated with paintings of *hiten*, and the large wall paintings below them, representing Buddhist paradises (lost in the tragic fire of 1949), featured *hiten* flying around the Buddha figures. The cast-bronze Shaka (Śākyamuni in Sanskrit) Triad of 623, the central icon in the Golden Hall, is backed by a large mandorla that originally bore a group of *hiten* fluttering about its rim. Small, delightful *hiten* carrying musical instruments also adorn the canopies that hang above the Shaka Triad and the two other Buddhas who share the platform here. A slightly later example of a wall decoration in clay, which includes the figures of airborn Bodhisattvas, is also included here (no. 1).

A large number of Bodhisattvas often accompany Amida Buddha in his *raigō*. However, the iconographic connection, if there is any, between the Bodhisattvas of *raigō* and the early *hiten* is unclear. Like *hiten*, the Bodhisattvas accompanying Amida Buddha ride on cloud formations; some play musical instruments, and others are shown in attitudes of adoration. The most famous example of such Bodhisattvas can be found in the 1053 Phoenix Hall (Hōōdō) of Byōdōin at Uji. While relief sculptures of Bodhisattvas with musical instruments hover on the walls above the Amida statue carved by Jōchō (d. 1057), smaller Bodhisattvas are attached to the large mandorla behind the Amida. Just as Jōchō's Amida provided the canon for later generations of Buddhist sculptors, the decoration of the Amida's mandorla also became the standard to be followed in the eleventh and twelfth centuries.[5] The decorative scheme for such a mandorla is said to have been perfected by Jōchō and is known as *hiten kō*, short for *hiten kōhai* (mandorla, *kōhai*, with *hiten*). The leaf-shaped mandorla usually includes a statuette of Dainichi at its tip; this deity is seated among swirling

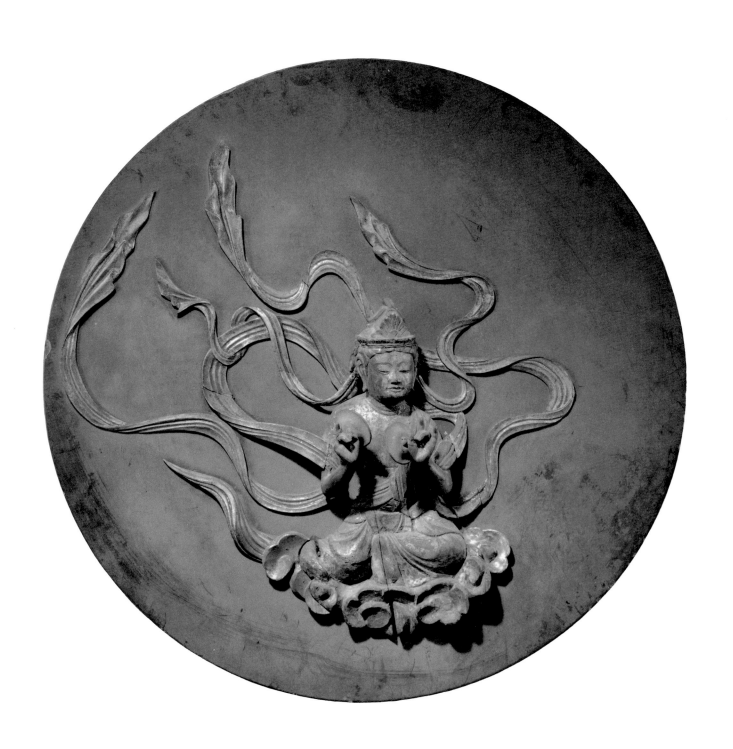

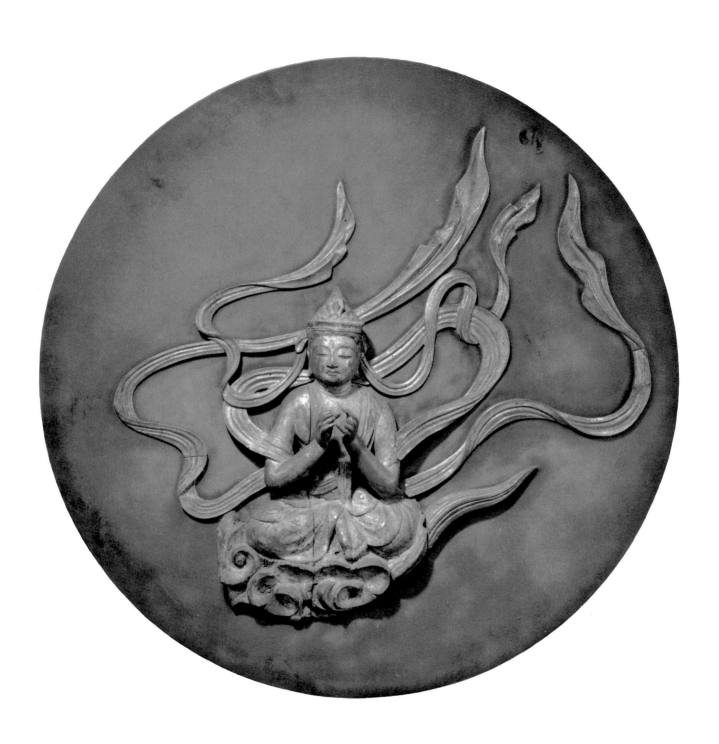

clouds and flanked by a group of twelve or fourteen *hiten*, arranged on either side of the mandorla.

As indicated above, the two *hiten* in the Burke Collection, dated on stylistic grounds between the late eleventh and the early twelfth century, were identified in the 1926 catalogue as having been separated from the Amida statue in the temple of Jōruriji. This Amida figure is an outstanding example of a sculpture closely based on Jōchō's canon. The outer area of its enormous mandorla, also derived from Jōchō's model, is filled with tiny statuettes of seated Buddhas, and flying among them are four charming *hiten* who ride on their own small cloud-shaped vehicles with sinuous ribbons fluttering about them. This large mandorla is believed to be a 1688 replacement of the original, including the miniature seated Buddhas.[6] It is generally agreed that the four *hiten* belonged to the lost original halo, which must have had a statuette of Dainichi at the top, flanked by six or seven *hiten* on either side. The temple record states[7] that a new building to house nine Amida statues was built in 1107 in the temple that had been constructed for its main icon, Yakushi (Bhaisajyaguru in Sanskrit), the Buddha of Healing.[8]

If the extant Amida statue and its four *hiten* were indeed made in 1107 as documentary material states, it is quite possible that the two *hiten* in the Burke Collection, dated on stylistic grounds to the same period, belong to the Amida. The dimensions of the four extant *hiten* have not been published, but it is privately reported[9] that the example at the top right measures 34 cm (13³⁄₈ inches), including the cloud, while the figure at the lower right measures 32 cm (12⁵⁄₈ inches); measurements of the ones at the left are not available. Like the two in the Burke Collection, all four *hiten* at Jōruriji are made of lacquered and gilded *hinoki* (Japanese cypress) wood. These four are seated on cloud vehicles, and some of their arms appear to be restored. The dimensions of the two Burke *hiten* are slightly smaller than those reported for the two in the temple. Judging from the difference of two centimeters in measurements of the two *hiten* in the temple, it is quite possible that Burke *Hiten* B—whose cloud suggests a leftward movement and whose measurements are four centimeters smaller than the second piece on the right—could have originally been at the viewer's right, below the two remaining *hiten* and a lost third, as the

fourth *hiten* from the top. Burke *Hiten* A, which turns its head slightly toward the viewer's right, may have been the fourth one at the left.

Still, an attempt to find the original placement of the Burke Collection pieces should be based on a closer stylistic comparison of all the statuettes in question. Burke *Hiten* A, which is in a better state of preservation than Burke *Hiten* B, nevertheless has lost both forearms; therefore, its gesture and the instrument it holds may not reflect the original arrangement. Burke *Hiten* B has likewise lost its left forearm, as well as its entire right shoulder and arm, while the lacquer and gilding on the right side of its face have also suffered damage. The ribbons that flutter around and above the four in the temple may be later restorations. Despite the obvious areas of damage and replacement, the two *hiten* in the Burke Collection bear an unmistakable resemblance to one another, and, to some extent, to the four remaining. Burke *hiten* A and B have small topknots as part of their coiffures; their crowns have triangular floral decorations, their low bands have fluted designs, and ribbons hang behind both ears. On the four *hiten* in the temple, however, all of these features are concealed behind ornate metal crowns that could be of a later date. As in Burke *hiten* A and B, there are slight stylistic differences among the four Jōruriji *hiten*. Yet all six share small, youthful, round faces with gentle features and fully formed upper lips. The upper torsos, although not sculptured in the round, suggest fullness with wide shoulders and sharply tapering waists. Both pieces in the Burke Collection display bent knees and reveal the sole of one foot, in a manner very similar to the top right *hiten* at Jōruriji. The edges of their apron-like outer skirts are folded out. Judging from their postures, the four in the temple may very well have held musical instruments, as does *Hiten* B.[10] These characteristics follow the general trend observed in sculptures of the period after Jōchō's Phoenix Hall Amida was accepted as a model in the late eleventh and early twelfth centuries. It is impossible to ascertain whether the two *hiten* in the Burke Collection were detached from the mandorla behind the central Amida in Jōruriji, but what is certain is that when compared to other detached mandorla figures of the late eleventh or early twelfth century,[11] the *hiten* in Jōruriji resemble the two Burke sculptures most closely. Although

their provenance is still in doubt, these two statuettes remain outstanding examples of *hiten* from the Late Heian period.

NOTES

1. Sanshin Koji, *Kain Shōja Shinkan* (True Mirrors of Kain Shōja) (Tokyo: Ōtsuka Kōgeisha, 1926), pls. 30 and 29, respectively.
2. Inoue Tadashi, "Jōgon-in Amida Nyorai Zō ni tsuite" (On a Buddhist Image of Amitābha in the Jōgon-in Temple), *Kokka* 791 (February 1958): 47.
3. Ōta Hirotarō et al., eds., *Yamato Koji Taikan* (Survey of Ancient Temples of Yamato) (Tokyo: Iwanami Shoten, 1978), 7:85.
4. Nagahiro Toshio, *Hiten no Geijutsu* (A Study of *Hiten* or Flying Angels) (Tokyo: Asahi Shimbunsha, 1949); see also Hamada Takashi et al., *Hiten* (Nara: Asuka Shiryōkan, 1989).
5. Nishikawa Shinji, ed., *Byōdōin Taikan* (Survey of Byōdōin) (Tokyo: Iwanami Shoten, 1987), 2:41–43.
6. Nishikawa Kyōtarō et al., eds., *Kokuhō* (National Treasures) (Tokyo: Mainichi Shimbunsha, 1984), no. 32.
7. Ruki no Koto (Records of Temple History) is quoted in Ōta, *Yamato Koji*, 7:64.
8. Some scholars, like Inoue, favor 1047 as the date for the central Amida; see Inoue Tadashi, "Jōruriji Kutai Amida Nyorai Zō no Zōryū Nendai ni tsuite" (On the Date of Production of the Nine Images of Amitābha in the Jōruriji Temple), *Kokka* 861 (December 1963): 7–20.
9. I am grateful to Mr. Tada Tsuguo of the Iwanami Shoten who helped me to acquire information on measurements as well as good photographs.
10. Inoue, "Jōruriji Kutai Amida," 18.
11. For these Amida statues, see Inoue, "Jōgon-in Amida," 39–51.

4.

Pair of Guardian Lion-dogs

Kamakura period, mid thirteenth century
Lacquer, gold-leaf, and polychrome on *hinoki* (Japanese cypress) wood
H. 45.8 cm (18 1/16 inches) (open mouth); H. 42.4 cm (16 11/16 inches) (closed mouth)
PUBLISHED: Gunhild Avitabile, ed., *Die Kunst des Alten Japan: Meisterwerk aus der Mary and Jackson Burke Collection, New York* (Frankfurt: Kulturgesellschaft Frankfurt mbH, 1990), no. 6.

Traditionally, a pair of *koma-inu* (lion-dogs) is placed within, or at the entrance to, the sanctuary of a Shinto shrine or shrine complex to serve as an apotropaic symbol. Early depictions of imaginary lions, possible ancestors of *koma-inu*, were first represented in Japan in the context of Buddhist imagery. In the Nara period, lions depicted in stone or bronze reliefs as part of temple decorations belong to a pictorial tradition that can be traced back to the religious art of India and China. Many Indian and Chinese sculptures of the seated Buddha, for instance, include lions situated to the right and left of a pedestal or throne to emphasize the majesty of the deity and to protect him. The broad relationship between guardian lions and *koma-inu* is obvious, although the latter did not appear in Japanese art until the Heian period. In the past, the subject of *koma-inu* sculptures has received rather cursory treatment. However, recently the topic has been more thoroughly examined by Itō Shirō, whose studies have elucidated important sources for the depiction of *koma-inu*.[1]

The term *koma-inu*, as it applies to sculptures and other representations of lion-dogs, has ambiguous and complex roots. The literal translation of *koma-inu* is "Korean dog," which suggests a Korean prototype; however, in visual terms these images appear to stem primarily from Chinese sources. The term itself was first noted in early shrine and temple documents of lion masks (generically identified as Chinese), musical instruments, and other items related to Bugaku, a type of ancient court dance. Bugaku was performed with music and incorporated various continental Asian

elements, including dance forms from India, China, Korea, and Central and Southeast Asia.[2] The *Tado Jingūji Shizaichō* (*Registry of the Tado Shrine and Temple*), compiled in 801, is the earliest extant record in which the word *koma-inu* was used to refer to a Bugaku mask that may have represented an imaginary lion head.[3] In this instance, *koma* was written with two characters—rather than the single character more commonly used—which can also be read as *Kōrai* (Koryŏ in Korean). This may imply that there was a specific Korean source for *koma-inu*, as yet unidentified.[4] A later document, the *Anjōji Shizaichō* (*Registry of the Anjōji Temple*) of 871, lists a pair of *koma-inu* masks along with the "skins" and "tails" that comprised the costumes worn by the two or three performers who represented one animal in a lion dance.[5] The only extant document to mention a distinguishing feature of a lion mask is the *Saidaiji Shizaichō* (*Registry of the Saidaiji Temple*), dated 780.[6] This registry lists a lion "head" with a horn, which implies that this iconographic detail appeared on Bugaku masks as early as the Nara period. One lion mask from a Late Heian-period pair preserved in the collection of Hōryūji (near Nara) does indeed feature a short horn on the top of the head. It is possible, therefore, that the pair of *koma-inu* masks cited in the *Anjōji Shizaichō* was similar in appearance.

By the Early Heian period, images of a lion and a horned lion-dog, for which there are no precise descriptions, were paired and standardized under the general term *koma-inu*.[7] No document offers a specific explanation for the combination of lionlike elements with a canine form, a basic characteristic of extant *koma-inu* sculptures. In various Heian, Kamakura, and Nambokuchō examples of *koma-inu*, a single or split horn is found on one animal in the pair; this attribute seems to be related to the mask mentioned in the *Saidaiji Shizaichō*. Even though this feature is missing from the Burke sculpture, there is a small oval outline on the head of the "closed-mouth" *koma-inu*, which suggests that a horn may once have been attached. Another consistent aspect of *koma-inu* iconography is the *a-gyō* ("open-mouth") lion-dog, customarily placed on the right, and the *un-gyō* ("closed-mouth") counterpart on the left. It is the *un-gyō* lion-dog that always features the horn. These attributes were perhaps inspired by

Niō, Buddhist guardian figures, which also have open and closed mouths. "A" represents the first letter of the Sanskrit alphabet, while "un" is the last letter; together they symbolize the beginning and ultimate end of all things.

The *Engishiki* (*Procedures of the Engi Era*), an early tenth-century compendium of court administrative activities, may illuminate one fundamental aspect of the original function of *koma-inu* sculptures. The *Engishiki* records the practice of using a single image (perhaps a sculpture) of a cowlike horned beast for national ceremonies, such as enthronements and New Year's Day celebrations, and placing it in front of the Kaishōmon, an inner gate of the Heian (present-day Kyoto) palace.[8] The Japanese version of this mythical animal may have been derived from an imaginary cow or oxlike beast, represented in ancient Chinese tomb guardian sculptures that resemble the description in the *Engishiki*.[9] The custom of using this animal form—a possible precursor of the horned *koma-inu*—during major court events appears to be linked with the use of lion-dogs as shrine guardians. However, there is certain evidence in several Heian-period writings that small metal sculptures of lion-dogs were used as weights to secure standing screens from the wind in private palace apartments. These may also have functioned as guardians. In Chapter 6 of the eleventh-century *Eiga Monogatari* (*A Tale of Flowering Fortunes*, a historical tale that details the activites of the celebrated aristocratic Fujiwara family), *koma-inu* weights are described as follows: "The Fujitsubo [palace apartment] was now supplied with a dining bench, as well as a Korean dog and lion in front of the curtain dais—appurtenances that made a splendid sight."[10] Since many activities that took place at the Imperial court had a major influence on Shinto ceremonies and customs, the practice of employing *koma-inu* in some form as guardian images within the palace complex may have been transferred to Shinto shrines.

The method of manufacture used for the Burke sculptures is *yosegi-zukuri* (assembled woodblock construction); one block was carved for the head, main body, and front legs with separate pieces attached for the hindquarters and rear legs as well as thick, twisting tails, which are no longer extant. On the "closed-mouth" *koma-inu* a tenon is exposed, where the missing

right rear leg was attached, which illustrates the type of joinery method employed for these sculptures. Originally, both sculptures were covered with polychrome as well as gold-leaf applied over lacquer in a technique known as *shippaku*; however, only traces of these materials remain. The heads of *koma-inu* with abundant manes that augment a powerful appearance have roots in early Chinese depictions of imaginary lions. And the volumetric bodies with their straightforward stance represent a continuation of the Heian-period conception of lion-dogs. However, these later examples of *koma-inu* with heads turned slightly are more expressive than some of their Heian prototypes and reflect aspects of the Nara-period realistic mode—revived during this time—that parallel the expression seen in Kamakura-period Buddhist sculptures. The diversity of style among the extant sculptures of these ingratiating creatures is remarkable. Many *koma-inu* exhibit unconventionalized stylistic qualities that seem to reflect the individualistic expressions of different sculptors. Although the Burke sculptures also suggest an individualistic manner, they do bear some resemblance to a pair of lion-dog sculptures preserved at the Taihō Shrine in Shiga prefecture.[11] The rounded curls of the manes, the deeply furrowed brows, and broad chests of the former may have been derived from a generic type as represented by the Taihō examples.

GWN

NOTES

1. Itō Shirō, *Koma-inu* (Lion-dogs), Nihon no Bijutsu no. 279 (Tokyo: Shibundō, 1989); Kyoto National Museum, ed., *Koma-inu* (Lion-dogs) (Kyoto: Kyoto National Museum, 1990).
2. Nishikawa Kyōtarō, *Bugaku Masks*, trans. Monica Bethe (Tokyo: Kodansha International, 1978), 20.
3. Itō, *Koma-inu*, 44.
4. Related to the notion of some Korean connection with *koma-inu* is the legend that dogs were used to lead the Empress Jingū's army in an expedition to Korea in the third century. See Kageyama Haruki, *The Arts of Shinto*, trans. Christine Guth (New York, Tokyo: Weatherhill-Shibundō, 1973), 62-63 (see also no. 7).
5. Itō, *Koma-inu*, 44.
6. Ibid.
7. A twelfth-century handscroll known as the *Shinzei Kogakuzu* (Shinzei's Illustrations of Ancient Music) provides an idea of the appearance of dancers, performing in pairs, as *koma-inu* in Bugaku performances. Although not identified as such, one illustration depicts performers dressed as creatures that resemble the lion-dog with an open mouth, and others are costumed as horned animals with closed mouths. See Kyoto National Museum, *Koma-inu*, 21-22. See also Nishikawa, *Bugaku Masks*, 95. Bugaku dances have been traditionally classified as "dances of the Left" for pieces that originated in China and India and "dances of the Right" for those from Korea and Central Asia; see Donald Keene, *Nō: The Classical Theater of Japan* (Tokyo: Kodansha International, 1966), 36. It is possible that the term *koma-inu* may have been applied to what appear to have been lion-dogs represented in Bugaku performances, as also suggested by the temple records of lion-head Bugaku masks that may have been used for a type of Korean dance (see Kyoto National Museum, *Koma-inu*, 21-22), and thus derived perhaps from the latter.
8. Itō, *Koma-inu*, 45.
9. See Itō, *Koma-inu*, 27; Albert E. Dien et al., *The Quest for Eternity: Chinese Ceramic Sculptures from the People's Republic of China* (Los Angeles: Los Angeles County Museum of Art, 1987), 116.
10. Itō, *Koma-inu*, 46; William H. McCullough and Helen Craig, *A Tale of Flowering Fortunes* (Stanford: Stanford University Press, 1980), 1:225.
11. Kageyama Haruki and Christine Guth Kanda, *Shinto Arts: Nature, Gods, and Man in Japan* (New York: Japan Society, 1976), 60-61.

5.

Mandala of the Four Deities of Mount Kōya

Edo period, seventeenth century
Hanging scroll; ink, color, and gold on silk
H. 103.7 x W. 50.9 cm (40¹³/₁₆ x 20¹/₁₆ inches)
PUBLISHED: Stephen Little, *Visions of the Dharma: Japanese Buddhist Paintings and Prints in the Honolulu Academy of Arts* (Honolulu: The Honolulu Academy of Arts, 1991), 128.

In this painting, four deities are conceived as ancient court aristocrats, each of whom is seated on a dais in front of a three-panel screen. The screens are placed within an architectural framework that represents the entrance to a Shinto shrine. This pictorial format was inspired by a syncretic form of Buddhist-Shinto beliefs associated with a religious cult centered at Mount Kōya (south of Osaka), the headquarters of the Shingon (True Words) sect of Esoteric Buddhism.

This *Mandala of the Four Deities of Mount Kōya* is one example from a generic group of religious paintings classified as *suijaku mandara* (in Sanskrit, mandalas). The concept that Shinto gods are "native Japanese incarnations" (*suijaku*) of their original form (*honji*) as "universal Buddhist deities" is reflected in this type of religious imagery.[1] The theoretical basis for these beliefs originated with the introduction of Buddhism to Japan in the sixth century. The early phase of this effort to harmonize the two religions is referred to as *shimbutsu shūgō* (unification of gods and Buddhas), which evolved into the *honji-suijaku* theoretical system.[2] This theory and the corresponding representation of Shinto gods and Buddhist deities in their respective manifestations were stimulated in large part through the influence of the esoteric doctrines of Tendai and Shingon Buddhism in the Late Heian period. The term mandala, borrowed from the esoteric tradition, refers to schematic illustrations of Buddhist deities that were used by monk-practitioners during meditative exercises and rituals. This format was adopted and modified for *honji-suijaku* paintings of native gods and their Buddhist counterparts, individually or together in different hierarchical arrangements. The two *suijaku* figures in the upper register of this composition are Niu Myōjin,

the female deity on the right, and Kariba (Hunter) Myōjin (also known as Kōya Myōjin),[3] the male deity on the left; sometimes the two Myōjin (Gracious Deities) are related as either mother and son, or husband and wife.[4] Through the influence of esoteric thought, these native gods were believed to be manifestations of Dainichi (Great Illuminator), the cosmic Buddha who is the central figure of worship in Shingon teachings. Dainichi presides over two realms, the *Taizōkai* (Womb World), the world of logic, and the *Kongōkai* (Diamond World), the world of wisdom; Niu represents Dainichi in the former, whereas Kariba Myōjin is a manifestation of Dainichi in the latter.[5] In this way, each native deity is envisioned as corresponding to one of the two aspects of the cosmic Buddha. In Buddhist painting this concept is represented in the fundamental Shingon mandala compositions, the *Taizōkai* and *Kongōkai* mandalas, with Dainichi the focus of each surrounded by other Buddhas and Bodhisattvas.

In their Shinto context, the exact origins of Niu and Kariba are obscure. They seem to be connected with local folk customs and beliefs associated with the shrines of clan groups who resided in Yamato (present-day Nara prefecture) and Kii (present-day Wakayama prefecture) provinces.[6] As is true with other syncretic cults, the worship of local deities became integrated with Buddhist concepts, and native gods and their Buddhist counterparts became tutelary deities of shrines and temples. Niu and Kariba are mentioned in a legend that appears in compilations of brief narratives, often Buddhist in content, related to the establishment of Mount Kōya as a monastic center for the study of Shingon doctrine by the celebrated monk Kūkai (774-835, posthumously known as Kōbō Daishi). Various

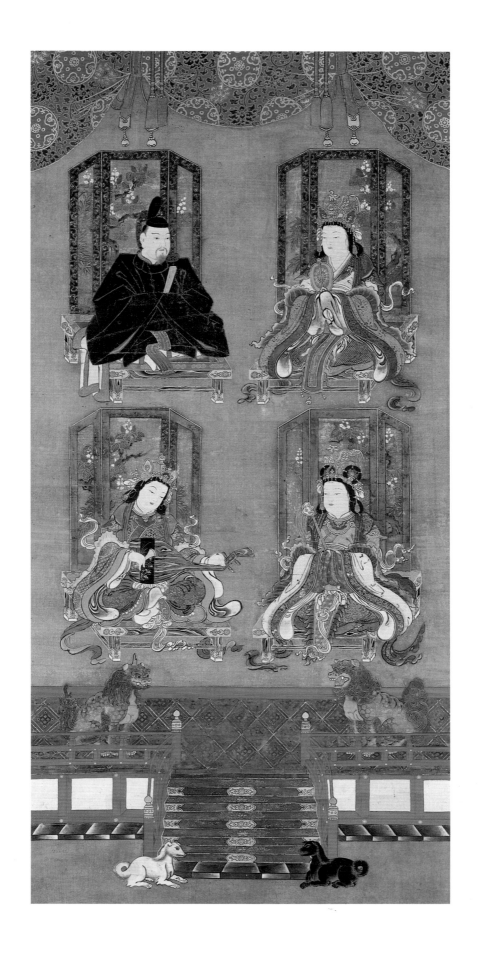

narratives, including the *Konjaku Monogatari* (*Tales of Times Now Past*), traditionally dated to the eleventh century, describe Kūkai's legendary encounter with these deities in 816 while he was searching for a site to build the temple Kongōbuji.[7] The basic legend (which varies in some details depending on the text consulted) can be extracted from the *Konjaku Monogatari* narrative, which begins with Kūkai's meeting Kariba, described as a hunter who is exceptionally tall, while wandering in the mountains of Yamato province.[8] The latter, who is followed by two black dogs (according to some versions of the story there is one black and one white dog),[9] introduces himself as a breeder of *nanzan* (southern mountain) dogs.[10] The description of Kariba Myōjin as a mountain rustic in superhuman form alludes to his true nature as a god who has appeared in an earthly manifestation.[11] And Kariba's incarnation as a hunter may have derived from the worship of a local god by itinerant mountain inhabitants.[12] Handscrolls illustrating the life of Kūkai portray this episode of the narrative with Kariba depicted in the common garb of a hunter who is accompanied by two dogs.[13] The pair of dogs placed at the shrine entrance in Kōya mandalas is a pictorial reference to this aspect of the legend.[14]

The narrative continues with Kūkai's entry into Kii province where he again encounters the hunter's dogs, who guide him to Mount Kōya.[15] Upon his arrival he meets Niu Myōjin, who announces that she is "sovereign of the mountain" and resides at Amano Shrine.[16] Subsequently Niu dedicates her domain to Kūkai at the place where Kongōbuji is eventually established. Niu, whose name consists of the Chinese character that is read either as *ni* or *tan* (meaning vermillion) and forms part of the compound for the word cinnabar (*tanshu*), a principal source of mercury, is linked with various shrines in the Wakayama region and appears to have originated as a guardian deity worshipped by clans involved in the mining of mercury in this area.[17]

Amano Shrine (known today as Niutsu Hime Jinja), which is situated at the foot of Mount Kōya, is in a prominent location as part of the pilgrimage route to the temple complex. Since this legend about Kūkai, which reflects the Japanese penchant for transforming historical figures into hagiological ones, developed in connection with the founding of Mount Kōya, Kariba

and Niu were enshrined at Amano Shrine as local tutelary deities. Also affiliated with this shrine are the other two deities represented in the lower register of the Burke painting. The one on the right is Kehi, the guardian deity of a shrine of the same name located in Echizen province (present-day Fukui prefecture). Facing Kehi on the left is Itsukushima Myōjin, the tutelary deity of Itsukushima Shrine, which is situated on the island of Miyajima (near Hiroshima) and celebrated for its scenic beauty (see no. 50). The inclusion of these two deities from distant locales in the iconographic schemata resulted from the 1208 visit to Amano Shrine by Taira (also known as Hōjō) Masako (1157–1225; see no. 33), wife of Minamoto no Yoritomo, founder of the Kamakura shogunate, who was on a religious pilgrimage to the Kumano Shrine located in the same region.[18] In response to two Buddhist monks who solicited funds to repair Amano Shrine, Masako "invited" Kehi and Itsukushima Myōjin to join the other two deities already enshrined at Amano.[19] Presumably through the beneficence of these gods funds would be forthcoming.[20] Masako's selection of Itsukushima Myōjin (and by association Kehi, who was a spiritual companion of the latter) is connected with the worship of this deity as a military god by members of the Taira (also known as the Heike), her familial clan.[21] The Taira family's patronage of the Itsukushima Shrine is referred to in the *Heike Monogatari* (*The Tale of the Heike*), a famous thirteenth-century war tale that narrates the rise and fall of this clan.[22] The oldest extant example of this type of *suijaku* picture is a Muromachi-period painting preserved at the temple Shōrinji in Osaka prefecture.[23]

In Kōya mandalas, Kehi's *honji* form is usually the Senju (Thousand Armed) Kannon.[24] The Buddhist identity of Itsukushima Myōjin, however, has been variously linked with Monju, with Kannon, and, since Muromachi times, with Benzaiten, the godess of learning and music.[25] In earlier examples of Kōya mandalas (including the Shōrinji version), Itsukushima Myōjin is shown as a young girl playing a *biwa* (Japanese lute) and identified as an incarnation of Kannon.[26] The lute is also a standard feature of the iconography of Buddhist images of Benzaiten, who was incorporated into various types of *suijaku* mandalas.[27] By the Edo period, Benzaiten had become the conventional *honji* for

Itsukushima Myōjin, who was transformed into an adult female deity in Chinese dress resembling the other two female gods in Kōya mandalas.[28]

The style of dress in which Shinto gods are rendered is evocative of another aspect of the religious environment that inspired the production of *suijaku* paintings. From early times, members of the nobility supported shrines, and elements of court ceremonies and rituals were incorporated into Shinto practices and imagery. The figure of Kariba Myōjin holding a scepter in the Burke painting is attired in the robes of a Japanese court noble. The female deities, however, are shown in long-sleeved garments with collars tapered at the shoulders, which reflects a Chinese mode of the Sung dynasty.[29] The latter contrasts with some examples of *suijaku* paintings in which female gods are dressed in the layered robes of Japanese court women.[30] Further references to Shinto practices and the nobility are the pair of *koma-inu* (lion-dogs), which often guard the entrances to shrines (see no. 4), and the screens behind the deities, which are embellished with the design of a paulownia tree, a decorative motif symbolic of courtly status since ancient times.

Stylistically, this Kōya mandala is derived from an earlier religious pictorial idiom used to represent iconic images of Buddhas and Bodhisattvas. This idiom, which reached its maturity in the Late Heian and Kamakura periods, was characterized by opaque color applied within ink outlines to define figures, whose facial features were sometimes drawn in thin, red brushstrokes (in a manner similar to those that appear in this picture) and accented with fine gold lines for the delineation of textile and other decorative details. Although the pictorial features of this *suijaku* mandala are generally consistent with Muromachi period examples of the same theme, which incorporated aspects of earlier Buddhist figure painting,[31] the stylized execution of figures suggests that it is a later work. And considering the escalation in production of Kōya mandalas in the Edo period,[32] which may have effected conventionalized renderings, it is likely that the Burke painting was produced around this time, possibly in the seventeenth century. G W N

NOTES

I am grateful to Masako Watanabe for assistance in translating a section of the *Kōya Shunjū Hennen Shūroku* (see n. 18).

1. Kageyama Haruki and Christine Guth Kanda, *Shinto Arts: Nature, Gods, and Man in Japan* (New York: Japan Society, 1976), 18.
2. Ibid.
3. In some primary sources as well as most discussions of Kōya mandalas, Kariba Myōjin is also referred to as Kōya Myōjin. However, according to an annotated edition of the *Konjaku Monogatari*, which includes a section describing the founding of Mount Kōya, Kōya Myōjin is actually an alternate name for Niu Myōjin; see *Konjaku Monogatari Shū* (Collection of Tales of Times Now Past), vol. 24 of *Nihon Koten Bungaku Taikei* (Compendium of Japanese Classical Literature) (Tokyo: Iwanami Shoten, 1961), 106. This discussion, however, will follow the usual identification since no textual authority is cited in the *Konjaku Monogatari Shū* for Niu's alternate name. The latter may be recorded in one or more of numerous original manuscript texts related to the origins of Mount Kōya available only in temple and special library collections in Japan.
4. Kageyama Haruki, "Kōyasan ni okeru Niu Kōya Ryō Myōjin" (Niu and Kōyā Myōjin of Mount Kōya) *Bukkyō Geijutsu* 57 (March 1965): 83.
5. Ibid.; for a general discussion of the influence of esoteric thought on *suijaku* art, see Sekiguchi Masayuki, ed., *Mikkyō* (Esoteric Buddhism), vol. 2 of *Zusetsu Nihon no Bukkyō* (Illustrated Japanese Buddhism) (Tokyo: Shinchōsha, 1988), 352-56.
6. Kageyama, "Niu Kōya Ryō Myōjin," 76.
7. Kageyama, "Niu Kōya Ryō Myōjin," 75.
8. *Konjaku Monogatari Shū*, 106.
9. Kageyama, "Niu Kōya Ryō Myōjin," 75.
10. *Konjaku Monogatari Shū*, 106; *nanzan* is an allusion to Mount Kōya, which is also known by this name.
11. Kageyama Haruki, *The Arts of Shinto*, trans. Christine Guth, no. 4 of *Arts of Japan* (New York, Tokyo: Weatherhill-Shibundō, 1973), 72.
12. Kageyama, "Niu Kōya Ryō Myōjin," 76.
13. An example of this scene is found, for example, in the Hakutsuru Museum version of the *Kōya Daishi Gyōjō Zuga* (Illustrated Biography of the Patriarch of Mount Kōya), which is an undated copy consisting of ten scrolls after an original in the tradition of a fourteenth-century version; see Umezu Jirō, ed., *Kōbō Daishi Den Emaki* (Narrative Scroll of the Biography of Kōbō Daishi) (Tokyo: Kadokawa Shoten, 1983), 30. A Kamakura period painting of Kariba as a single figure in the guise of a hunter is preserved in the collection of Kongōbuji; see Nakano Gishō, ed., *Kōyasan* (Mount Kōya), vol. 7 of *Hihō* (Treasures) (Tokyo: Kodansha, 1978), pl. 42.
14. The coloration of the dogs may also carry symbolic meaning related to Shinto practices. At shrines associated with Niu, for instance, where offerings were made in times of drought and rain, black horses were given to procure the latter whereas an offering of a white horse was believed to ensure fair weather; see Richard Ponsonby-Fane, *Studies in Shinto and Shrines* (Kyoto: The Ponsonby Memorial Society, 1962), 267.

15. *Konjaku Monogatari Shū,* 106. The *Konjaku Monogatari* does not mention Kūkai's second encounter with the dogs, but this variant of the tale is represented in narrative handscrolls; see Umezu, *Kōbō Daishi Den Emaki,* 110.

16. *Konjaku Monogatari Shū,* 106.

17. Kageyama, "Niu Kōya Ryō Myōjin," 79.

18. Ibid., 79-80; the textual source that records this event is the *Kōya Shunjū Hennen Shūroku* (chronological history of Mount Kōya), an important document for the history of Mount Kōya that was compiled in the Edo period; see *Dai Nihon Bukkyō Zensho* (The Collected Works of Japanese Buddhism) (Tokyo: The Suzuki Research Foundation, 1972), 87:165.

19. Kageyama, "Niu Kōya Ryō Myōjin," 80. Another textual source for the four deities of the Kōya mandala cited by Kageyama is the *Kii no Kuni Zoku Fudoki* completed in 1830 (supplementary topography of Kii province); other references, however, list the title without *kuni;* see Yamaguchi Keizaburō, "Kōya Shisho Myōjin kankei no Kaiga" (Paintings of the Four Deities of Mount Kōya) in *Shinto oyobi Shintoshi* (Shinto and Shinto History) (Tokyo: Kokugakuin Daigaku, 1968), 14, and *Nihon Koten Bungaku Daijiten* (Dictionary of Japanese Classical Literature) (Tokyo: Iwanami Shoten, 1984), 2:99, which lists the names of the gods enshrined at Amano along with their *honji* counterparts; see Kageyama, "Niu Kōya Ryō Myōjin," 86.

20. This can only be inferred from the *Kōya Shunjū Hennen Shūroku* (see n. 18), which does not provide further details regarding Masako's response to the request for funds.

21. Yamaguchi, "Kōya Shisho Myōjin," 4.

22. Helen Craig McCullough, trans., *The Tale of the Heike* (Stanford: Stanford University Press, 1988), 104-105.

23. Kageyama, "Niu Kōya Ryō Myōjin," 85-86. The Shōrinji version is similar to a Kamakura period painting (destroyed by fire) which provided evidence that the four deities were incorporated into the iconography relatively soon after Masako's visit to Amano. The former also includes Sanskrit characters that represent one version of the names of the *honji* forms of these native gods; see also Yamaguchi, "Kōya Shisho Myōjin," 11.

24. Kageyama, "Niu Kōya Ryō Myōjin," 86.

25. Kageyama, "Niu Kōya Ryō Myōjin," 86; Yamaguchi, "Kōya Shisho Myōjin," 14-15. A Kōya mandala comprised of Sanskrit characters (instead of figures), dated 1557, which is preserved at Ninnaji in Kyoto, for example, records the *honji* form of Itsukushima Myōjin as Benzaiten (see Kageyama, "Niu Kōya Ryō Myōjin," 87).

26. Kageyama, "Niu Kōya Ryō Myōjin," 85-86. Kageyama identifies the figure of Itsukushima Myōjin in the Shōrinji version of the Kōya mandala (see n. 23) as a *dōjo* (young girl), although in textual references the term *dōji* appears, meaning child or young boy.

27. Nedachi Kensuke, *Kichijōten, Benzaiten,* Nihon no Bijutsu no. 317 (Tokyo: Shibundō, 1992), 79-80.

28. Yamaguchi, "Kōya Shisho Myōjin," 16.

29. This garment reflects the influence of Sung styles in Japanese painting (also adopted for sculptures of female deities), which began during the Kamakura period and was perpetuated in later times; see Karen Brock, "Chinese Maiden, Silla Monk: Zenmyō and Her Thirteenth-Century Japanese Audience," in Marsha Weidner, ed., *Flowering in the Shadows: Women in the History of Chinese and Japanese Painting* (Honolulu: University of Hawaii Press, 1990), 195-6. See also Hayashi On, "Kyū Jōruriji Kichijōten Zushi-e shoson o meguru Mondai" (A Few Problems Centering on Images of Buddhist Deities Painted on Panels of a Shrine, Containing a Statue of Kichijōten, Formerly in the Collection of the Temple Jōruriji), *Bukkyō Geijutsu* 169 (November 1986): 66-67.

30. For example, a Kamakura-period painting of Niu dressed as a Japanese court lady is preserved in the collection of Kongōbuji; see *Kōyasan,* pl. 43.

31. For Muromachi-period examples of Kōya mandalas see Tokyo National Museum, ed., "Butsuga Hen" (Buddhist Paintings) in *Tokyo Kokuritsu Hakubutsukan Zuhan Mokuroku* (Illustrated Catalogues of the Tokyo National Museum) (Tokyo: 1987), 116, nos. 124, 125.

32. Yamaguchi, "Kōya Shisho Myōjin," 16.

6.

Shaka Triad and Sixteen Rakan

Late Kamakura–early Nambokuchō period, fourteenth century
Hanging scroll; ink, color, and gold on silk
H. 143 x W. 75.5 cm (56⁵/₁₆ x 29¹/₄ inches)
PUBLISHED: Gunhild Avitabile, ed., *Die Kunst des Alten Japan: Meisterwerke aus der Mary and Jackson Burke Collection, New York* (Frankfurt: Kulturgesellschaft Frankfurt mbH, 1990), no. 7; Miyama Susumu, ed., *Kamakura Bukkyō* (Kamakura Buddhism), vol. 4 of *Zusetsu Nihon no Bukkyō* (Illustrated Japanese Buddhism) (Tokyo: Shinchōsha, 1988), fig. 68.

The basic composition of this painting focuses on the triad consisting of Shaka, the historical Buddha (Śākyamuni in Sanskrit); and two Bodhisattvas, Fugen (Samantabhadra in Sanskrit) on an elephant, and Monju (Mañjuśrī in Sanskrit) on a lion. Below the triad are sixteen *rakan*, advanced disciples of the Buddha (*lohan* in Chinese; *arhat* in Sanskrit). Their depiction in a dense landscape represents a Buddhist pictorial tradition that has its origins in Chinese prototypes. There are various examples of paintings in which a so-called Shaka triad is combined with sixteen *rakan*, who were also depicted in groups of eighteen and five hundred. In the Mahāyāna Buddhist tradition, these disciples were believed to have relinquished their opportunity to achieve Nirvana and chose instead to remain in the world to protect the Buddhist Law until the appearance of the future Buddha, Miroku (*Maitreya* in Sanskrit). The general iconographic theme of the picture can be interpreted as a gathering of devotees around the Buddha; he is shown preaching at Vulture Peak, which rises in the background among swirling cloud formations. This famous site in northeastern India, as rendered here, appears to be a variation of literal visual interpretations of the landscape in which the peak is depicted in the form of a bird's head, its perceived shape and hence the derivation of its name.[1] An unusual feature of this painting, however, is the inclusion of two additional figures at the bottom of the composition: on the left, Shōtoku Taishi (574–622), prince-regent during the reign of the Empress Suiko (reigned 592–628), and on the right, the monk Kūkai (774–835, known posthumously as Kōbō Daishi), the celebrated founder of Shingon Buddhism. Similar convention-alized portraits of these well-known historical figures were also represented individually or together with deities for other formats of religious pictures.

Many early Buddhist figure paintings have been traditionally attributed to painters of the hereditary Takuma school of *e-busshi* (artists who take the tonsure and specialize in Buddhist painting), who were active in Kyoto, Nara, and Kamakura in the Late Heian and Kamakura periods. The style of the Burke painting suggests that it was produced in the fourteenth century. If conclusive evidence is discovered in the future to ascribe this painting to the Takuma school, it would be a rare example considering the significant number of recorded names of Takuma artists and the relatively few extant works attributed to them.[2] These artists, and other painters associated with Takuma painters in the Nara area, were noted for incorporating Sung and Yüan painting styles into their oeuvre. Landscape elements, such as the precipitous rocks delineated in ink texture strokes, and the use of modulating lines for the robes of the *rakan*, reflect some of the stylistic elements that Japanese artists absorbed from Chinese ink paintings brought from China to Japan by Zen Buddhist monks as early as the thirteenth century. The connection between Takuma artists and Zen temples is, for instance, further substantiated by the inscriptions of Zen monks that appear on paintings attributed to the former.[3]

The individual portraitlike representation of the aged Indian recluses reflects a tradition of *rakan* figure painting that is associated with the Northern Sung master Li Kung-lin (1040–1106). In following this tradi-tion, the artist of this painting delighted in rendering a

variety of facial expressions for the Buddha's disciples and created lively representations of the various creatures—including a tiger, a goose, two monkeys, and a dragon—that often accompany the *rakan*. A specific identification of each *rakan* when they are depicted in groups, rather than individually, is problematic since the iconography can vary from painting to painting; although Pindola, the first disciple of the Buddha, is often shown holding a small pagoda. The ethereal beauty of Fugen and Monju, the Bodhisattvas of Universal Virtue and Wisdom, respectively, and of the fully enlightened Buddha is rendered in an elegant, refined manner that retains stylistic elements found in Late Heian-period Buddhist paintings; these three figures provide a contrast with the worldly appearance of the *rakan*. Another unusual pictorial feature is the depiction of Shaka holding a begging bowl—an attribute symbolic of his mendicant nature—in lieu of displaying a mudra (symbolic hand gesture).

The inclusion of Shōtoku Taishi and Kōbō Daishi in this painting has been interpreted, in part, as reflecting the beliefs of the monk Eizon (1201-1290, also known as Kōshō Bosatsu), who founded the Shingon-Ritsu sect of Buddhism and established the center of his teachings at Saidaiji near Nara.[4] Eizon combined the esoteric doctrines of Shingon, which emphasized the use of mandalas, mudras, and mantras (magic phrases) to achieve spiritual awareness, with the beliefs of the eighth-century Nara Ritsu sect, which focused on the importance of the *vinaya* (rules and regulations for the clergy; in Japanese, *ritsu*). The *vinaya* reform that Eizon advocated was thought to be a method by which a practitioner could defeat the effects of *mappō* (decline of the Buddhist Law)—which Buddhists believed would plague the world until the appearance of Miroku, the future Buddha—in order to achieve salvation. *Rakan*, who are often identified with Zen Buddhist beliefs as symbolizing the pursuit of individual enlightenment,

Manjusri
Wisdom
Sutra — Sword
Scepter — instrument
of instruction

may have in the context of Shingon-Ritsu doctrine epitomized the ideals of *vinaya* as monks who adhered to monastic discipline. During the Kamakura period, there was a general trend in some religious communities to revive the ancient Nara sects of Buddhism in reaction to the widely popular Pure Land Buddhist faith, which centered on devotion to the Buddha of the Western Paradise, Amida. Incorporated into the beliefs associated with Eizon's Shingon-Ritsu sect was the same attitude shared by other revivalists of the Nara sects that the historical Buddha Shaka, as founder of the Buddhist religion, was a primary symbol of a return to the "ancient way" of Nara Buddhism.[5] During the Kamakura period, a major cult of worship developed in Nara; it focused on the prince-regent Shōtoku Taishi, whose adherents regarded him as a reincarnation of Shaka Buddha. Partly in response to the growing interest in the Taishi cult and in addition to his own emphasis on *vinaya* practice, Eizon related his own injunctions against hunting and fishing (taking life in any form was forbidden by Buddhist doctrine) and his humanitarian concerns for the needy to his faith in Shōtoku, who had propagated the same ideals of religious behavior.[6] The detail of fish swimming upstream, which appears in the lower left corner of the painting, may be a subtle reference to one aspect of Eizon's teachings.

As a result of the expansion of the Taishi cult, numerous portraits of Shōtoku as prince-regent were produced, as seen in this painting. The portrait of Kōbō Daishi (also a conventionalized likeness) probably reflects the idea that he was considered by Kamakura-period devotees of the Shingon faith to be a reincarnation of Prince Shōtoku, a concept used by them to authenticate their allegiance to the Taishi cult.[7] The complex iconography of this painting seems, therefore, to be a pictorial amalgamation of the fundamental teachings of Eizon, which were joined with the faith in Shaka Buddha and the cult of Shōtoku Taishi.

Several paintings of the same theme are extant in Japan, including a painting in the collection of the Tokyo National Museum; other examples are in temple and private collections, one of which includes a portrait of Eizon.[8] Although the exact circumstances of the production of the Burke painting are as yet unknown, there are records indicating that *rakan* paintings were displayed in temples for dedicatory services held for the *rakan*.[9] This painting may have functioned for practitioners of the Shingon-Ritsu sect in a similar manner, or perhaps it was used to commemorate the anniversary of Eizon's passing. GWN

NOTES

Special thanks to Masako Watanabe for supplying some comparative source material.

1. A fourteenth-century painting of a Shaka triad and sixteen *rakan* in the collection of Tōdaiji in Nara (which shares some compositional affinities with the Burke painting) also depicts this mountain peak in the shape of a bird's head. See Donohashi Akiho, "Tōdaiji Shaka Sanzon Jūroku Rakan ni tsuite" (The Todaiji Shaka Triad with Sixteen Rakan), *Bukkyō Geijutsu* 112 (April 1977): 58.
2. Takasaki Fujihiko, *Rakan-zu* (Rakan Paintings), Nihon no Bijutsu no. 234 (Tokyo: Shibundō, 1985), 74.
3. Hirata Yutaka, "Takuma Ha ni okeru Dentō-sei" (The Traditionalism of the Takuma School), *Kokka* 1085 (July 1985): 15.
4. Miyama Susumu, ed., *Kamakura Bukkyō* (Kamakura Buddhism), vol. 4 of *Zusetsu Nihon no Bukkyō* (Illustrated Japanese Buddhism) (Tokyo: Shinchōsha, 1988), 325.
5. Alicia Matsunaga and Daigan Matsunaga, *Foundation of Japanese Buddhism* (Los Angeles and Tokyo: Buddhist Books International, 1976), 2:269.
6. Ibid., 272.
7. Ishida Mosaku, *Shōtoku Taishi Sonzō Shūsei* (Collection of Images of Shōtoku Taishi) (Tokyo: Kodansha, 1976), 1:10.
8. Ibid., vol. 2, p. 267, pl. 1104 and p. 268, pl. 1105; Toyama Bijutsukan, ed., *Bukkyō Kaiga* (Buddhist Painting) (Toyama, 1986), p. 71, pl. 22; The Executive Committee for the Exhibition "Treasures of the Shitennōji Temple and the Worship of Prince Shōtoku," ed., *Shitennōji no Hōmotsu to Shōtoku Taishi Shinkō* (Treasures of the Shitennōji Temple and the Worship of Prince Shōtoku) (Osaka, 1992), p. 150, pls. 204 and 205; p. 152, pls. 207 and 208; p. 153, pl. 209.
9. A set of fifty *rakan* paintings completed in 1386 by the artist Minchō was used for a dedicatory service at Tōfukuji in Kyoto. See Mochizuki Shinkō, ed., *Bukkyō Daijiten* (Dictionary of Buddhism), revised by Tsukamoto Zenryū (Kyoto: Sekai Seiten Kankō Kyokai, 1958), 5:4948-49.

7.

Ten Rakan *Examining a Painting of a White-Robed Kannon*

Edo period, 1792
Katō Nobukiyo (1734–1810)
Hanging scroll; ink, color, and gold on paper
H. 130.3 x W. 57.7 cm (55⁵⁄₁₆ x 22³⁄₄ inches)
SIGNATURE: "Hoke-kyō ichibu yokan o motte kinsho Enjinsai Nobukiyo"
SEALS: "Nobukiyo," "Nobukiyo In," "Kudoku Muhen"
FORMER COLL.: Ryūkōji, Tokyo
PUBLISHED: Gunhild Avitabile, ed., *Die Kunst des Alten Japan: Meisterwerke aus der Mary and Jackson Burke Collection, New York* (Frankfurt: Kulturgesellschaft Frankfurt mbH, 1992), no. 104; Pratapaditya Pal and Julia Meech-Pekarik, *Buddhist Book Illuminations* (New York, Paris, Hong Kong, and New Delhi: Ravi Kumar, 1988), figs. 131-32; Laura Kaufman, "Practice and Piety: Buddhist Art in Use," *Apollo* (February 1985), figs. 13-14.

Katō Nobukiyo was a minor official in the Tokugawa government who lived in Edo and was reputed to be a talented swordsman. In his early fifties, he left his family and took the vows of abstinence and meditation in order to accomplish a remarkable act of lay piety. In 1788, he began a project to copy a group of fifty *rakan* (*lohan* in Chinese; *arhat* in Sanskrit) paintings—each with ten figures—attributed to the artist Minchō (1352-1431), which are in the collection of Tōfukuji, a major Zen temple in Kyoto.[1] Nobukiyo's version also included ten *rakan* per scroll; however, he added one painting of a Shaka triad (no longer extant) to complete the set.[2] The original group of fifty-one scrolls was finished in 1792 and dedicated to Ryūkōji in Edo.[3] A seal reading "Kōfu Ryūkō Zenji Jyūbutsu" (A Treasure of the Edo Zen Temple Ryūkō) is affixed to the left center edge of the painting.

The depiction of a group of five hundred *rakan* was one of several conventional formats derived from Chinese prototypes for representing the advanced disciples of the historical Buddha Śākyamuni (Shaka in Japanese) who, in the context of Zen Buddhism, epitomized the ideals of self-discipline and meditation in the search for enlightenment. The *rakan* in this composition are examining a painting of a White-Robed Kannon, the Bodhisattva of compassion and mercy, who was also incorporated into Zen imagery. When

inspected more closely, this painting reveals an unusual technical feat that is visible in the pictorial elements delineated in Chinese characters. The characters represent a section from the *Lotus Sutra* (*Myōhō Rengekyō* in Japanese; *Saddharma-pundarīka* in Sanskrit), better known in Japan by its abbreviated title *Hokekyō* and preserved there as the most popular and influential text from the enormous body of Buddhist scriptural writings. Although numerous characters are difficult to read since, in some cases, they have been compressed or distorted to conform to descriptive features of the painting, the title for Chapter Four of the *Lotus Sutra* can be found in an area of the trees in the upper left corner. The title is read "Shingehon Dai Yon" ("Belief and Understanding," Chapter Four).[4] In this section of the sutra, the disciples of Shaka Buddha express their happiness with his teachings by reciting a parable about a rich man's prodigal son who returns home after a long absence; the *rakan* consider their joy analogous to that of the son who eventually resumes his position as heir to his father.[5] However, the Burke painting probably represents only part of this chapter, since the *Lotus Sutra*, which comprises twenty-eight chapters, was presumably divided into sections by the artist for representation in his set of fifty paintings.

Even the facial details and some areas that appear to be shaded with color and white pigment are, in fact,

法華經以一部餘卷謹書遠塵齋信清

clusters of thinly drawn Chinese characters. The pictorial technique that Nobukiyo used for these *rakan* paintings (as well as for an Amida Buddha triad produced in 1794, now in the collection of Kongōji in Tokyo) appears to be unique among extant examples of Edo-period Buddhist paintings.[6] However, it does have a precedent found in earlier periods when sutras were transcribed in characters to create the form of a pagoda. Even though this painting exhibits a pious, technical tour-de-force, Nobukiyo's innovative tendency may have been inspired more by a desire to amaze the viewer than by religious devotion.[7]

Documentation of the production of Nobukiyo's paintings is notable. For instance, the project attracted the attention of the monk Daiten Kenjō (1719–1801), who was affiliated with the Zen temple Shōkokuji in Kyoto and served as biographer of the celebrated painter Itō Jakuchū (1716–1800), the eldest of the three "eccentrics" of the Edo period. In 1792, Daiten wrote the *Jiunzan Ryūkōji Gohyaku Rakanzuki* (*Record of Five Hundred Rakan Paintings at Ryūkoji on Mount Jiun*), which includes a description of the paintings.[8] In a nineteenth-century document entitled the *Zōho Edo Nenjū Gyōji* (*Supplementary Record of Annual Events in Edo*), it is noted that this group of *rakan* paintings was displayed three times annually for viewing by the public.[9] And according to the *Koga Bikō* (*Notes on Old Painters*), the scrolls were dispersed from Ryūkōji in 1892.[10] GWN

NOTES

1. Pratapaditya Pal and Julia Meech-Pekarik, *Buddhist Book Illuminations* (New York, Paris, Hong Kong, and New Delhi: Ravi Kumar, 1988), 323. Another painting from the same set is in the Kimiko and John Powers Collection (see *Buddhist Book Illuminations*, p. 314, pl. 100). Forty-seven scrolls from the original set of fifty attributed to Minchō are preserved at Tōfukuji; see *Kaiga* (Paintings), vol. 2, no. 8 of *Jūyō Bunkazai* (Important Cultural Properties) (Tokyo: Mainichi Shimbunsha, 1973), 90-92. The set attributed to Minchō was in turn based on a group of one hundred scrolls, each depicting five *rakan*, that were produced by the twelfth-century Chinese Ning-po artists Chou Chi-ch'ang and Lin T'ing-kuei and were imported to Japan in the thirteenth century. A painting from this set in the collection of Daitokuji in Kyoto is the ultimate source for the Burke picture. See Wen Fong, *Beyond Representation: Chinese Painting and Calligraphy, 8th–14th Century* (New York: The Metropolitan Museum of Art, 1992), 343-347, 361, 375-76.
2. Suzuki Hiroyuki, "Enjinsai Katō Nobukiyo hitsu Amida Sanzon Zō" (Amida Triad by Enjinsai Katō Nobukiyo), *Bijutsu Kenkyū* 343 (February 1989): 40.
3. Ibid.
4. For the complete text of Chapter Four of the *Lotus Sutra* see Takakusu Junjirō and Watanabe Kaigyoku, eds., *Taishō Shinshū Daizōkyō* (The Taishō Edition of the Tripitaka) (1927; reprint, Tokyo: Society for the Publication of The Taishō Edition of the Tripitaka, 1960), 9:16-19.
5. Willa J. Tanabe, *Paintings of the Lotus Sutra* (New York and Tokyo: Weatherhill, 1988), 8.
6. Suzuki, "Enjinsai Katō Nobukiyo hitsu Amida Sanzon Zō," 37-39, 40-42.
7. Ibid., 42.
8. Ibid., 38.
9. Ibid., 44.
10. Ibid., 40.

8.

Monju Bosatsu (Bodhisattva Mañjuśrī) on a Lion

Muromachi period
Shūsei (late fifteenth century)
Hanging scroll; ink on paper
H. 81.9 x W. 33.1 cm (32¼ x 13 inches)
SEAL: "Shūsei" (?)
PUBLISHED: Tokunaga Hiromichi, "Gukyoku Reisai Gasan Kishi-shi Monju Zō" (Mañjuśrī Mounted on a Chinese Lion by Gukyoku Reisai), *Kokka* 933 (1971): 19.

According to tradition, Monju Bosatsu (Bodhisattva Mañjuśrī in Sanskrit), the incarnation of Supreme Wisdom and the seeker of truth, was the most enthusiastic member of the audience at the sermons of Shaka Buddha, always inundating the Buddha with questions. His name appears in Chinese literature as early as the fourth century.[1] Before the rise of his popularity in the T'ang dynasty, however, Chinese Buddhists knew him primarily as the divine antagonist of the wiser and older intellectual, Vimalakīrti (Yuima in Japanese), in a legendary debate on difficult metaphysical questions.[2] Chinese T'ang Buddhists discovered in the sutra *Wen-shu-shihli-fapaotsang-t'oloniching* (*Monju Shiri Hōbōzō Darani-kyō* in Japanese) that Monju's early residence was at Wut'ai-shan, a mountain in Shansi province, north China, the abode of many native gods.[3] Wut'ai-shan then became a famous pilgrimage site, especially for the T'ien-t'ai Buddhists (Tendai in Japanese), and Monju was exalted as their archangel. The standard visual representation of this learned teacher and dialectician usually depicts Monju on his vehicle, the fearless and golden-haired lion. He holds a sutra and/or a sword, with which to cut through the darkness of ignorance. In iconic representations in triad form, Monju is shown at the left side of Shaka with Fugen (Samantabhadra in Sanskrit) riding on an elephant on the right.

Monju's popularity rose sharply among Chinese Ch'an (Zen in Japanese) Buddhists, who felt that his identity as the embodiment of transcendental knowledge came closest to their concept of the Ideal Teacher, who guides the faithful along the difficult path to Supreme Englightenment.[4] In the Ch'an pantheon, Monju is distinguished from the traditional Buddhist icon by his dress. Instead of the usual *dhoti* and scarves worn by other Bodhisattvas, he wears a long-sleeved kimonolike garment.

The cult of Monju and Wut'ai-shan (Godaisan in Japanese) was well known to the Japanese of the Heian period, and some monks wrote memoirs about their visits to this sacred and remote mountain in China.[5] Japanese Zen Buddhists were deeply affected by the scholasticism prevalent among Ch'an devotees of Sung China. Since Monju was regarded as a teacher of Shaka Buddha's doctrines in the latter's absence, he was also viewed as a guide in the meditational practices held daily in Zen temples. It is thus natural that many *kōan* (exchanges of questions and answers between Zen teachers and pupils) were written about this deity. This trend eventually led to the creation of a new iconographic type, in which Monju is represented as a monk-teacher, rather than a Bodhisattva. As his teaching role was emphasized, his sword came to be replaced by a sceptre, an instrument of instruction.[6]

The diversity of Monju iconography and the large number of Monju paintings produced for Zen circles are truly amazing.[7] Because many paintings of this deity include colophons by renowned Zen monks—whose lives are well documented—it is possible to trace with some accuracy the evolution of Monju imagery. The earliest representation followed traditional Buddhist iconography in which the deity was depicted in colors, with the full regalia of a Bodhisattva, a crown, and many jewels. However, he was depicted with a youthful visage to reflect his untainted wisdom. Gradually, this traditional iconic image was replaced by a deity dressed, as in Chinese Ch'an works,

in a kimonolike robe that no longer includes jewelry. Since Monju and Fugen were also regarded in Zen circles as avatars of Kanzan and Jittoku, two of the most popular eccentric figures in the Zen pantheon, Monju was often depicted in ink monochrome with long, untrimmed hair.

Painters of Monju in Japanese Zen circles moved toward simplification, spontaneity, and individualization. This was especially true of Zen monks who painted as an avocation.[8] An ink monochrome painting of 1438 by Gukyoku Reisai (1362–1452)—a chief abbot of Nanzenji, Tōfukuji, and other temples, who was well known for his calligraphy—is the epitome of this new type.[9] The expressive calligraphic lines that define the drapery folds and the outline of the beast imbue the painting with a lively personal quality. In this version, Monju holds both sceptre and sutra in his hands. His bare feet protrude beneath the hem of his robe, while the lion under him growls, looking up at him as if to urge him on.

In the Burke painting, further simplification is observed. Monju wears his long untrimmed hair in a casual manner, his hands and feet are both tucked under his robe, his sceptre is placed in front of him, and the lion is clearly tame. The air of relaxed freedom is due not only to the submissive lion but also to the fact that the sceptre is out of the deity's hand. The loosely falling skirt of the robe and the peaceful countenance of the youthful Monju appear to suggest that the deity is at ease and at peace. This painting is reminiscent of a scene in the parable of *The Ten Ox-herding Songs*, in which a boy in search of the truth (symbolized by an ox) gives up his effort, and all thoughts become void.[10]

The seal impressed at the lower right is difficult to decipher. It was, in fact, reproduced in the *Koga Bikō*, and the book's editor expressed doubt about its reading; according to the accompanying notation,[11] this seal was copied from an ink monochrome painting on paper, depicting Monju on a lion. It is almost certain that the notation refers to the painting in the Burke Collection. The work was attributed to a professional artist by several scholars,[12] because of the absence of strong, assertive individuality. However, the directness

and simplicity of its execution—apparent in the deity's face, hair, and the expressive swirls of brush lines on the lion's tail—convey a freshness of vision that may reflect the spiritual status of a monk who followed in the footsteps of Gukyoku Reisai. The painting thus may be dated, tentatively, to the late fifteenth century.

NOTES

1. For a discussion of this Bodhisattva and the history of its faith, see Alexander C. Soper, *Literary Evidence for Early Buddhist Art in China* (Ascona, Switzerland: Artibus Asiae, 1959), 220–21. For my earlier treatment of this deity and its iconography, see Miyeko Murase, *Japanese Art: Selections from the Mary and Jackson Burke Collection* (New York: The Metropolitan Museum of Art, 1975), no. 29.

2. For the early Chinese representations of this episode, see LeRoy Davidson, *The Lotus Sutra in Chinese Art: A Study in Buddhist Art to the Year 1000* (New Haven: Yale University Press, 1954), 32 ff.

3. This sutra was translated by an Indian, Bodhiruci, into Chinese in 710. See Takakusu Junjirō and Watanabe Kaigyoku, eds., *Taishō Shinshū Daizōkyō* (The Taishō Edition of the Tripitaka) (Tokyo: Society for the Publication of The Taishō Edition of the Tripitaka, 1928), vol. 20, no. 1185 A, p. 791.

4. For this aspect of the Monju cult, see Jan Fontein and Money L. Hickman, *Zen Painting and Calligraphy* (Boston: Museum of Fine Arts, 1970), no. 32.

5. For example, the *Nittō Gubō Junrei-kō Ki*, Priest En'nin's chronicle of his trips to T'ang China, describes his visit to the mountain in 840. See also Bussho Kankōkai, ed., *Dai Nihon Bukkyō Zensho: Yūhō-den Sōsho* (Buddhist Documents of Japan: Records of the Quest for Law) (Tokyo: Bussho Kankōkai, 1959), 1:169–281; also *San Tendai Godaisan Ki* (Record of Visit to Tendai's Godaisan) by Jōnin, who visited there in 1072; see ibid., 3:1–167.

6. For a discussion of Monju's roles in a Zen context, see Shimada Shūjirō, ed., *Zenrin Gasan: Chūsei Suibokuga o yomu* (Painting Colophon from Japanese Zen Milieu) (Tokyo: Mainichi Shimbunsha, 1987), 61 ff.

7. A large number of paintings of this deity are reproduced in Kanazawa Hiroshi, *Japanese Ink Painting: Early Zen Masterpieces, Japanese Arts Library*, trans. Barbara Ford (Tokyo: Kodansha International, 1972).

8. Shimada, *Zenrin Gasan*, 68.

9. Tanaka Ichimatsu, *Suiboku Bijutsu Taikei* (Ink Monochrome Painting) (Tokyo: Kodansha, 1978), p. 5, pl. 109.

10. Fontein and Hickman, *Zen Painting and Calligraphy*, no. 49.

11. Asaoka Okisada, *Koga Bikō* (Notes on Old Painters), revised and enlarged by Ōta Kin as *Zōtei Koga Bikō* (1904; reprint, Kyoto: Shibunkaku, 1983), 3:2057.

12. Tokunaga Hiromichi, "Gukyoku Reisai Gasan Kishishi Monju Zō" (Mañjuśrī Mounted on a Chinese Lion by Gukyoku Reisai) *Kokka* 933 (1971): 20, n. 10.

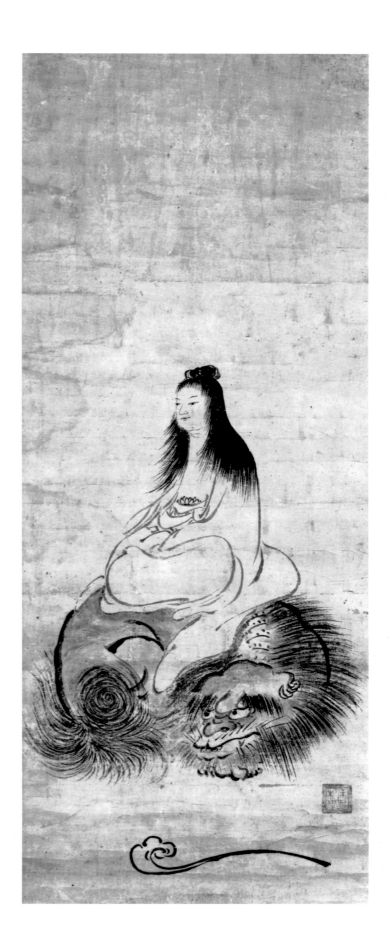

9.

Kensu and Chotō

Muromachi period
Yōgetsu (active late fifteenth-early sixteenth century)
Pair of hanging scrolls; ink on paper
H. 28.5 x W. 22.8 cm (11¼ x 8¹⁵⁄₁₆ inches) each
SEALS: "Yōgetsu" on both scrolls
PUBLISHED: Matsushita Taka'aki, *Muromachi Suibokuga*
(Suiboku Painting of the Muromachi Period) (Tokyo: Muromachi
Suibokuga Kankōkai, 1960), no. 55, p. 61.

The two quasi-historical Zen (Ch'an in Chinese)
figures in this diptych–identified as Kensu Oshō
(Priest Clam or Shrimp) and Chotō Oshō (Priest Boar's
Head)–are shown standing on grassy slopes with their
respective attributes, a shrimp and a boar's head. Both
paintings bear a seal that reads "Yōgetsu" (willow
moon), the name of a monk-artist active from the late
fifteenth to early sixteenth century.[1]

The sources for this genre of Zen pictorial themes
are found in Chinese paintings and hagiological texts
that were introduced to Japan by Buddhist monks
as early as the thirteenth century. Although there are
various writings that refer to Kensu, the earliest docu-
ment to include his biography is the *Ching-te ch'uan-
teng-lu*, compiled in 1004 by the Chinese monk Yung-
an Tao-yüan.[2] This source, known in Japanese as the
Keitoku Dentōroku (*Record of the Transmission of the Lamp*),
comprises thirty brief books that contain the biogra-
phies of Zen masters of approximately fifty-two gener-
ations. Kensu's name appears as Hsien-tzu Ho-shang
(Kensu Oshō in Japanese), Priest Clam, and he is iden-
tified as a disciple of Tung-shan Liang-chieh (Dōzan
Ryōkai in Japanese, 807-869), an historical patriarch
who was one of the founders of the T'sao-tung (Sōtō in
Japanese) sect of Ch'an Buddhism. In Kensu's biogra-
phy the following is cited:

Priest Clam from the capital district [present-day
Sian]: his background is unknown. Accounts con-
cerning him are rather unusual. He did not reside in
any fixed location. After he had received the trans-
mission of the mind from Tung-shan, he lived along
the Min River [in present-day Fukien]. He neither
used Buddhist implements nor observed the pre-
cepts. All day long he would go along the riverbank,

gathering clams and shrimps to fill his belly. In the
evening he slept amid the paper money at White
Horse Shrine on East Mountain. The inhabitants
called him priest Clam. . . . [he] did not gather disci-
ples or expound the Dharma. All he did was feign
madness.[3]

The Chinese text in which accounts of the lives of
both Kensu and Chotō appear, although in different
sections, is the *Fo-tsu t'ung-chi* (*History of the Founders of
Buddhism*; *Bussotōki* in Japanese), compiled by the T'ien-
t'ai (Tendai in Japanese) monk Chih-p'an (ca. 1220-
1275). This book provides a history of the Tendai sect
and also serves an ecumenical function as a chronicle
of the history of Buddhism, so monks like Kensu
who belong to other Buddhist traditions were included.
The same details about Kensu's life found in the *Keitoku
Dentōroku* are repeated in the *Bussotōki*, but here his
name is recorded as Hsia-tzu using the Chinese charac-
ter for "shrimp."[4] In the *Bussotōki*, Chu-t'ou (Chotō
in Japanese), who is believed to have lived during the
eleventh century, is described thus:

A monk from Wu-chou [present-day Chekiang],
Chih-meng, surnamed Hsü, wore embroidered robes
and enjoyed eating boar's head. When he prognos-
ticated people's fortunes there was never a prediction
that did not prove true. . . . He passed away one day,
seated in meditation. . . . His parting words were: "I
am the Dīpaṅkara Buddha [Buddha of the Past]. . . .
People . . . call him Priest Boar's Head."[5]

In the Zen pictorial tradition paintings of Kensu and
Chotō are broadly classified as *dōshaku-jimbutsu ga*, pic-
tures inspired by Buddhist, Confucian, and Taoist fig-
ural themes. But Kensu, Chotō, and some other Zen

eccentrics such as Kanzan, Jittoku, Bukan, and Hotei should be specifically categorized by the Chinese term *san-sheng* (literally, "scattered saints"; *sansei* in Japanese). Chotō's biography does not provide any evidence, however, for his inclusion in groupings of *sansei*, also rendered as "uncommitted saints."[6] Another aspect of some "scattered saints" is their association with Buddhas and Bodhisattvas. The idea that Chotō is an incarnation of the Dīpaṅkara Buddha corresponds to the same concept which, for example, links Kanzan with Monju and Jittoku with Fugen.[7]

In addition to these biographies, references to Chinese paintings of the *sansei* theme and collections of Chinese poems offer the most convincing evidence for the pairing of Kensu and Chotō. The earliest record of a *sansei* painting in which Buddhist subjects appear refers to a handscroll by the twelfth-century Chinese Ch'an painter Fan-lung, a follower of the celebrated master Li Kung-lin (ca. 1040-1106).[8] The Fan-lung painting (presumably no longer extant) was recorded under the title *Fan-lung shih-san-sheng* (*Ten Uncommitted Saints by Fan-lung*) by the late Ming scholar and connoisseur, Li Jih-hua (1565-1635). This citation is found in Li Jih-hua's collected works, entitled *Liu-yen-chai erh-pi*, along with a list of the figures depicted, which include Chotō (mentioned here as the saint of Chin-hua, another name by which he is known) and Kensu.[9] Li Jih-hua also notes that poems accompanied each *sansei* figure.[10]

Other literary sources relevant to the Kensu-Chotō iconography are the *yülu* or analects (*goroku* in Japanese) of Buddhist monks. Some Chinese compilations incorporate sections of verse about *sansei* that would have been inscribed on paintings.[11] A Japanese compilation that imitates this format is a collection of model Sung and Yüan poems selected by the Zen monk Gidō Shūshin (1325-1388) entitled *Jūkan Jōwa Ruijū So'on Renpōshū*.[12] This work is part of a large corpus of literature known as *gozan bungaku* (*gozan* literature), which refers to writings collected or produced by monks associated with temples in Kyoto and Kamakura that were part of the so-called *Gozan* (Five Mountains) monastic ranking system. In the section for *sansei* in the *Jōwa Shū*, one or more poems are assigned to each *sansei*; certain verses selected for Kensu and Chotō are especially pertinent to their pictorializations. The first

poem listed for Kensu, for instance, is rendered as follows:

> With shrimps and clams he fills his vegetable bowl,
> Thus from youth kept a vegetarian diet—but not
> of eggplants and greens.
> Since leaving the cave he's had no rival;
> Boar's Head and Chicken Feet would be his disciples.[13]

Even though the life spans of Kensu and Chotō presumably did not overlap and the biography of the former states that he had no followers, this poem alludes to a legendary master-disciple relationship between the two monks and supplies another potential basis for their pairing in paintings. The second poem cited for Chotō describes him as

> The paragon of eccentricity—
> Anyone will say it is the [Sage of] Chin-hua.
> Try and distinguish true and false from within:
> Boar's head in hand, two teeth exposed.[14]

The imagery of this verse suggests a potential source for the representation of Chotō holding a boar's head, as seen in the Burke example.[15] It has been speculated that Kensu and Chotō were probably depicted as a pair because of the commonality of their respective themes: the Buddhist admonition against eating meat of any kind. This paradoxical subject was compatible with the Zen idea that all phenomena consist of illusions, including the adherence to or defiance of Buddhist precepts.[16] However, the textual evidence for the appearance of Kensu and Chotō together in groupings of *sansei* figures and their apocryphal relationship, which may stem from Chinese verse, should be added to this interpretation.

The problem of Yōgetsu's identity is complicated by the fact that only minimal biographical information about his life is available in Edo-period histories of painting, which posit two separate traditions concerning his background. Related to this question is the matter of artistic development, which is difficult to trace since there exists such stylistic diversity among paintings that bear Yōgetsu seals. Both the *Honchō Gashi* (*History of Japanese Painting*) and the *Koga Bikō* (*Notes on Old Painters*) describe Sō Yōgetsu (monk Yōgetsu) as a native of Satsuma in Kyūshū, who learned the ink painting styles of Shūbun (flourished 1414-1463)

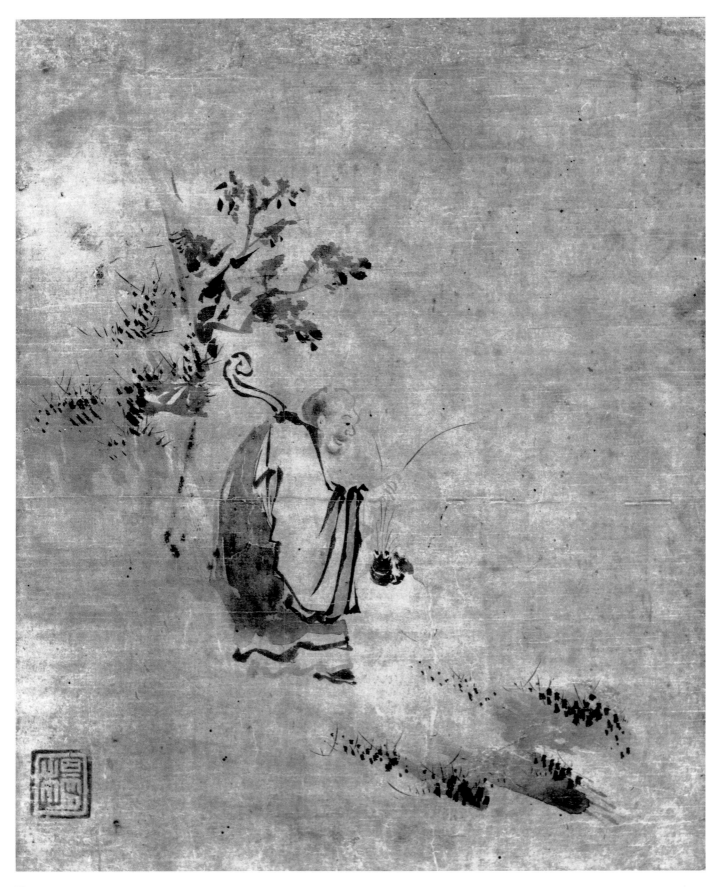

Kensu

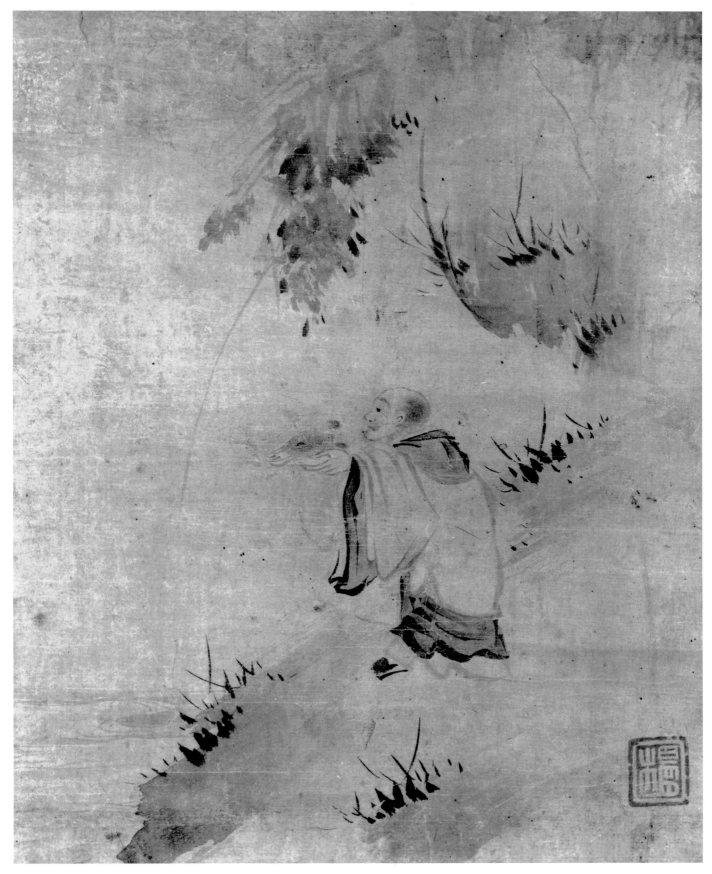

Chotō

and Sesshū (1420-1506), two prominent artists of the Muromachi period.[17] If Yōgetsu can be associated in particular with Sesshū (the theory generally accepted by scholars),[18] his center of activity may have been in Kyoto, possibly in affiliation with Shōkokuji, as were Shūbun and Sesshū. Conversely, according to other Edo-period sources, the *Gakō Benran* (handbook of painters) and *Tansei Jakubokushū* (biographies of Japanese painters), Yōgetsu lived at Kenchōji in Kamakura and worked in the style of Kenkō Shōkei (flourished ca. 1478-1506; also known as Kei Shoki).[19]

In the category of figure painting, Yōgetsu's connection with Sesshū is suggested, for instance, by the latter's painting of the Taoist recluse Huang Ch'u-p'ing of the Chou dynasty, which is inscribed with the name of the Chinese master Liang K'ai (flourished mid thirteenth century), whose original he presumably copied.[20] Sesshū's compositional device of anchoring a figure at one side in an abbreviated landscape setting rendered in swiftly executed ink brushstrokes is a feature consistent with the Burke paintings. And the angular outlines employed for the figure in Sesshū's picture is related in particular to the contour of Kensu's robes.[21] The stylistic techniques exhibited in Yōgetsu's diptych seem, therefore, to reflect a generic notion of a "Liang K'ai style" as conceived and transmitted by Sesshū. In general, the stylistic idiom of the Kensu and Chotō pictures was derived from ink paintings rendered in the manner of those masters classified by the Chinese as *i-p'in* (untrammeled), including Liang K'ai, who employed coarse, abbreviated brushwork for the outlines of figures. As for the other lineage associated with Yōgetsu, there is scant pictorial evidence to support an argument that Yōgetsu (who may have been a professional monk-artist considering his period of activity) was affiliated with Kenkō Shōkei.[22]

The function of *sansei* pictures is related to the burgeoning taste that developed in the Muromachi period for Chinese objects (which included ornamental vessels and utensils as well as paintings) and the corresponding emphasis placed on the appropriate arrangement of imported treasures. One textual source that epitomizes "the transformation of Chinese art" in Japan through a "'policy of decoration'" is the *Kundaikan Sayūchōki*, a catalogue of Chinese paintings that includes a section of diagrams and explanatory notes for the proper methods of decoration of shogunal residences.[23] This work, which is attributed to Nōami (1397-1471), the celebrated cultural advisor to the Ashikaga shoguns, was begun in the late fifteenth century and revised by his grandson Sōami (died 1525) in the early sixteenth century. Earlier documents, however, provide examples of what was already an established interest in the appropriate display of paintings. A text known as the *Sekiso Ōrai*, for instance, traditionally attributed to the courtier-scholar Ichijō Kanera (1402-1481), also includes instructions for the arrangement of Buddhist figure paintings. The writer suggests that for the main image, pictures of *Daruma Crossing the River*, *Shussan Shaka*, and Hotei among others are appropriate; to this can be added, for example, flanking images of Kanzan, Jittoku, Chotō, and Kensu.[24] The specific application is unclear, but in view of the social mingling between courtiers, monks, and the military elite, the prescribed display formula may have been applied for a variety of situations, including tea and poetry gatherings.[25] Such descriptions reflect the Japanese concern for the evocation of a "sublime atmosphere" meant to impress the viewer.[26] Considering this preoccupation with ornamentation, it is possible that the Burke paintings may have been appreciated more for their aesthetic value than as pictures intended for spiritual contemplation. G W N

NOTES

Poems and excerpts from Chinese texts were translated by Edward Walsh.

1. A landscape painting that bears the "Shinsō Yōgetsu" seal and a colophon dated 1485 by the Nanzenji priest Son'an [Kisei] Reigen (1403-1488) is cited as evidence to establish the artist's presumed period of activity; his exact dates are not recorded. This picture is recorded in Asaoka Okisada, *Koga Bikō* (Notes on Old Painters), revised and enlarged by Ota Kin as *Zōtei Koga Bikō* (1904; reprint, Kyoto: Shibunkaku, 1983), 707, and reproduced as "Yōgetsu hitsu Sansuizu" (A Landscape Painting by Yōgetsu), *Kokka*, 164 (January 1904).
2. Yoshiaki Shimizu and Carolyn Wheelwright, eds., *Japanese Ink Paintings from American Collections* (Princeton: The Art Museum, Princeton University, 1986), 82.
3. *Keitoku Dentōroku* (Record of the Transmission of the Lamp), vol. 51 of *Taishō Shinshū Daizōkyō* (The Taishō Edition of the Tripitaka) (Tokyo: Society for the Publication of the Taishō Edition of the Tripitaka, 1928; reprint, 1973), 338.
4. *Bussotōki* (History of the Founders of Buddhism), vol. 49 of *Taishō Shinshū Daizōkyō* (The Taishō Edition of the Tripitaka)

(Tokyo: Society for the Publication of The Taishō Edition of the Tripitaka, 1927), 390. The "tzu" of Hsien-tzu and Hsia-tzu (or "su" of Kensu) can be translated as "child" or "master"; however, this part of the name is usually omitted in the English rendering.

5. Ibid., 403.

6. "... These figures in Chinese Buddhist tales were marked by their eccentric behavior and utterances...[thus they were] free from the constraint of worldly conventions...and became models for aspiring Ch'an monks crossing the threshold into the realm of psychic and spiritual freedom." See Yoshiaki Shimizu, "Six Narrative Paintings by Yin T'o-lo: Their Symbolic Content," *Archives of Asian Art* 33 (1980): 13.

7. Yoshiaki Shimizu, "Problems of Moku'an Rei'en (?1323-1345)," (Ph.D. diss., Princeton University, 1974), 1:180.

8. Ibid., 1:182; 2:120-21. In his discussion of the record of the Fan-lung painting and the term *sansei*, Shimizu suggests that the latter may have origins in a classification system for Taoist saints and sages.

9. Ibid., 1:182, 185. Li Jih-hua, *Liu-yen-chai erh-pi* (Notes from Liu-yen Studio, Second Collection), chüan 2:5b-6a, in *Ssu-k'u ch'üan-shu chen-pen ch'i-chi*, vol. 57 (Taipei: Commercial Press, 1977; photolithic reprint).

10. Li Jih-hua recorded the poem for Chotō that is translated by Shimizu in "Problems of Moku'an Rei'en," 1:186.

11. Ibid., 1:190.

12. Ibid., 1:192-94.

13. Gidō Shūshin, *Jūkan Jōwa Ruijū So'on Renpōshū* (A Collection of Sung and Yüan Ch'an Priests' Poems, 1388) in vol. 88 of *Dai Nihon Bukkyō Zensho* (The Collected Works of Japanese Buddhism) (Tokyo: Suzuki Gakujutsu Zaidan, 1972), 107. The phrase "leaving the cave" is an allusion to Kensu's training under Tung-shan, the first part of whose name consists of the word "tung," meaning "cave." This poem was used as the basis for establishing a relationship between Kensu and Chotō in an Edo-period history of the Zen religion entitled *Zenrin Kujitsu Konmeishū* (Collection of Chinese Zen Monks' Common and Alternate Names). However, the identity of Keisoku, or "Chicken Feet," who is mentioned in the poem and may have been another Zen eccentric, is noted in the Edo text as being unclear (see *Kokuyaku Zenshū Sōsho* [Tokyo: Kokuyaku Zenshū Sōsho Kankōkai, 1927], 2nd compilation, 5:25). Moreover, the entry for the name Keisoku in the *Zengaku Daijiten* cites it in reference to a mountain located in India with no reference to a monk. See *Zengaku Daijiten* (Dictionary of Zen Names and Terms) (Tokyo: Taishukan Shoten, 1978), 1:262.

14. Gidō, *Jōwa Shū*, 107. The poem is unclear as to whom the "two teeth" belong, but it is likely that the imagery refers to the protruding teeth of the boar's head.

15. Similar imagery for Chotō is found in the poem recorded by Li Jih-hua; see n. 10.

16. Shimizu and Wheelwright, *Japanese Ink Paintings*, 82.

17. Kasai Kasa'aki et al., ed., *Yakuchū Honchō Gashi* (Annotated Honchō Gashi) (Kyoto: Dōhōsha, 1985), 243-44; Asaoka, *Koga Bikō*, 706-707. These histories record his affiliation with the Kasagidera, considered to be the temple located in Yama-shiro (present-day Kyoto prefecture). The location may instead have been at Kagoshima in Kyūshū; see Kasai, *Honchō Gashi*, 244, and Tanaka Ichimatsu and Nakamura Tanio, *Suiboku Bijutsu Taikei* (Ink Monochrome Painting) (Tokyo: Kodansha, 1973), 7:186. No textual authority for this information, however, is cited in either reference, and so far no Kagoshima Kasagidera has been found in Japanese dictionaries of Buddhist temples.

18. Tanaka and Nakamura, *Suiboku Bijutsu Taikei*, 7:186.

19. Sakazaki Shizuka, ed., *Gakō Benran*, in *Nihon Garon Taikan* (Collection of Essays on Japanese Painting) (Tokyo: Ars, 1929), 1097; Sakazaki Shizuka, ed., "Tansei Jakubokushū," in *Nihon Gadan Taikan* (Survey of Discussions on Japanese Paintings) (Tokyo: Mejiro Shoin, 1917), 1010.

20. Sesshū's painting is reproduced in Tokyo National Museum, ed., *Nihon no Suibokuga* (Japanese Ink Painting) (Tokyo: Tokyo National Museum, 1987), p. 161, no. 103.

21. Another painting by Yōgetsu that depicts the Taoist hermit T'ai-kung Wang fishing also shares stylistic and compositional affinities with Sesshū's painting and the Kensu and Chotō pictures. The painting of T'ai-kung Wang, which forms part of a triptych with paintings of a bird and flowers, is reproduced in Tanaka and Nakamura, *Suiboku Bijutsu Taikei*, fig. 13; 7:61; no. 98, p. 139.

22. A possible exception may be a pair of Kensu-Chotō paintings by Yōgetsu (which bear the same seal as the Burke paintings) in the Tokyo National Museum. The figures in these pictures are delineated by wet, broad ink strokes executed in a manner similar to a painting of Kanzan and Jittoku by Kōetsu (flourished late fifteenth-early sixteenth century), a follower of Shōkei. The former are reproduced in Jan Fontein and Money L. Hickman, *Zen Painting and Calligraphy* (Boston: Museum of Fine Arts, 1970), 142-43. The Kōetsu painting, in the Sansō Collection, is reproduced in Kawai Masatomo et al., *Dorakka Korekushon* (Drucker Collection): *Suibokuga Meisaku Ten* (Exhibition of Masterpieces of Japanese Ink Painting) (Tokyo: Nihon Keizai Shimbunsha, 1986), no. 38, n.p.

23. Gail Capitol Weigl, "The Reception of Chinese Painting Models in Muromachi Japan," *Monumenta Nipponica* 35 (1980): 260, 270.

24. Nancy Wey, "Mu-ch'i and Zen Painting" (Ph.D diss., University of Chicago, 1974), 121-22. See also Sen Sōshitsu, ed., *Chadō Koten Zenshū* (Complete Works of the Classics of the Tea Ceremony) (Kyoto: Tankōsha, 1958), 2:192.

25. Another *ōraimono* (collections of model correspondence) entitled the *Kissa Ōrai*, which dates from the early Muromachi period, describes the display of Buddhist figure paintings, including *sansei*, for a *chakai* (tea gathering) in a tea pavilion; see Paul Varley and Kumakura Isao, eds., *Tea in Japan: Essays in the History of Chanoyu* (Honolulu: University of Hawaii Press, 1989), 16, and Sen Sōshitsu, *Chadō Koten Zenshū*, 2:196, 199. The display of a Hotei painting for a poetry meeting in a court apartment is mentioned in an entry dated 1424 in the *Kammon Gyoki*, the diary of Go-Sukōin; see Weigl, "The Reception of Chinese Painting Models," 264.

26. Weigl, "The Reception of Chinese Painting Models," 265.

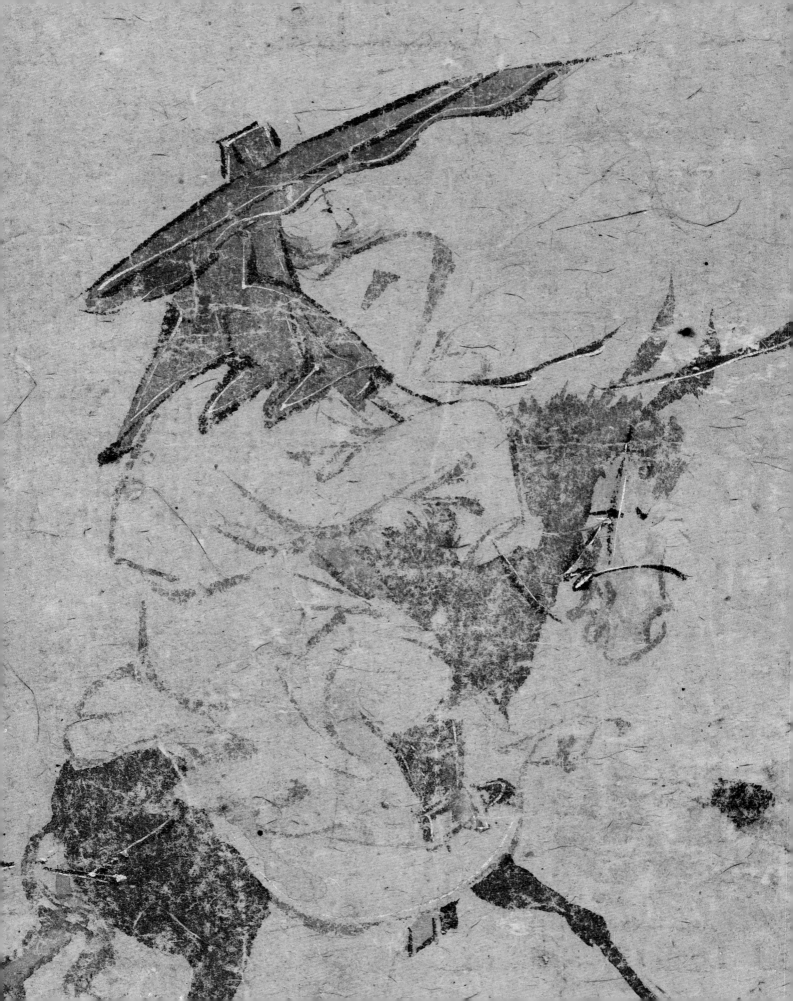

2

Evocations of China

This chapter contains paintings (nos. 11–32) and one example of calligraphy (no. 10) that give evidence of Japanese attempts to absorb Chinese aesthetics and to emulate their ink monochrome brushwork and literati philosophy. The concept and techniques of ink monochrome painting were first made known to Japan in the thirteenth century, as a result of the importation of Zen Buddhism. Eighteenth- and nineteenth-century *bunjinga* (or *nanga*) paintings by scholar-gentlemen represent the last major instance of Japanese artistic "borrowing" from China. Both types of imagery demonstrate the determination with which Japanese artists strove to achieve the aesthetic goals established by their counterparts in China; yet, in both cases, it is also evident that Chinese models, techniques, and artistic concepts were modified to satisfy native sensibilities. By incorporating elements indicative of their own aesthetic preferences into these "Chinese-style" works, the Japanese produced a hybrid art that reflects the extraordinary adaptability they have always exercised with regard to cultural matters.

The sect of Buddhism known in China as Ch'an and Japan as Zen focuses on contemplative meditation, devoid of appeals to Buddhist deities, as a means of attaining enlightenment. This practice originated in India but was formalized in China, and its followers claimed that meditation (*dhyana* in Sanskrit) was the essence of Buddhist truth, transmitted from Śākyamuni to his disciples before his earthly demise and final entry into Nirvana. According to a long-standing tradition, a princely monk from South India by the name of Bodhidharma (Daruma in Japanese) introduced meditation to China, traveling there in the sixth century and sailing up the Yangtze River on a pair of fragile reeds. The Ch'an sect was enthusiastically received in Japan in the wake of an unexpected political development: the thirteenth-century Mongol invasion of China, which forced a number of eminent Ch'an monks to flee to Japan. These emigrés worked with Japanese converts to make Zen the most influential and powerful religious force in the country. The Chinese prelates were educated men of letters in the classic tradition of their own land, and they introduced the Japanese to an appreciation of Chinese literature, calligraphy, and ink monochrome painting. For the second time, elements of Chinese culture stimulated the educated elite of Japan through the vehicle of religion.

The Zen emphasis on self-discipline and the attaining of enlightenment through a sudden flash of inspiration held enormous appeal to members of Japan's warrior class. These samurai, quick-tempered men of action, controlled the country during the Kamakura period. Military rulers provided generous assistance to Zen priests for their evangelical work; they also helped to found temples like Kenchōji (1253) and Engakuji (1282) in the city of Kamakura, the base of their military government, or *bakufu*. The city, today an affluent suburb of Tokyo, enjoyed prestige as a major center for Chinese learning, both religious and secular. Among the arts inspired by the new sect

Bokudō Sōjun (1373–1459)
Detail, *Su Tung-p'o on a Donkey* (no. 11)

45

was ink painting, and early practitioners were for the most part Zen monks; the works produced during the Kamakura and Muromachi periods are generally Zen-related. The primary subjects of these paintings were historical and quasi-historical characters drawn from the Zen pantheon of patriarchs, teachers, and enlightened individuals. In time, however, artists moved on to secular themes such as bamboo, plums, orchids, and birds; these were endowed with scholarly symbolism and had long been staple motifs of the professional and amateur ink-painter's art in China. The range of subject matter eventually broadened to include literary figures and landscapes. In all likelihood monk-painters adopted these subjects as a means of expressing their religious convictions and Zen-inspired views of nature. Some were able to travel to China, where they learned ink-brushwork techniques firsthand from Chinese masters. Most Japanese artists, however, studied by copying valuable, imported Chinese works. The romantic, idealized landscapes of the Southern Sung dynasty, which characteristically featured a strongly asymmetrical composition and an evocative use of empty space, became models for generations of Japanese ink painters.

The political and cultural importance of Kamakura was short-lived. By the mid fourteenth century fighting among contending feudal barons had reduced the once-bustling city to ruins. Yet the Kamakura legacy lived on as local schools of ink painters spread the techniques of Chinese-style brushwork to other areas of eastern Japan. A local baron who gave himself the name of "Go-Hōjō" (Latter-day Hōjō) was particularly active in this process of late fifteenth- to early sixteenth-century dissemination. He gave much-needed encouragement to the local artists around his own city of Odawara, not far from Kamakura. Painters flocked to the region to receive his patronage; their "school," long neglected by art historians and still somewhat undefined, is only now being thoroughly investigated by scholars of the ink painting tradition.

The Ashikaga clan, which took the reins of government around 1336, established its *bakufu* in Kyoto.

Once again the old capital rose to political and artistic prominence. The clan produced several leaders outstanding for their refined artistic tastes, if not for their political achievements. The third shogun Yoshimitsu (1358-1408), in particular, saw to it that Zen and the arts flourished under his reign. Many of the Zen monasteries now regarded as popular tourist attractions were constructed during his tenure as military ruler. Among these, the temple of Shōkokuji was of great significance as the principal center of Zen learning as well as the residence of scholar-monks and ink painters who served as the shogun's "official" artists.

Zen monks also introduced the Japanese to the custom of drinking tea, a practice that had a deep and lasting impact on their life and culture. The tea used in the so-called tea ceremony (*chanoyu*) is a deep green, powdery substance that is whipped—not steeped—with a bamboo whisk. It was at first used for medicinal purposes and as a stimulant by monks during their long hours of Zen meditation. The eighth Ashikaga shogun, Yoshimasa (1435-1490), helped to raise the elegant pastime of sharing tea with a few select friends to a genuine art. At its highest level the tea ceremony involves an appreciation of garden design, architecture, interior design, calligraphy, painting, flower arrangement, and a variety of arts including ceramic and lacquerware, bamboo and metal works, and even food preparation. This experience, truly unique on many levels, traditionally takes place within the sequestered microcosm of a tea room, a space designed specifically for the *chanoyu*. It was during and after Yoshimasa's time that the accoutrements of the tea ceremony, and even ancillary practices like flower arranging, were codified and elevated to the level of fine art.

By the mid sixteenth century the Zen-inspired, subtle art of ink monochrome painting had been transformed by artists of the Kano school. Kano Motonobu (ca. 1476-1559) was largely responsible for the creation of a dramatic, decorative style of ink painting that appealed to the tastes of the secular community. The second-generation leader of the Kano school, Motonobu is believed to have married a woman from the Tosa family, guardians of the

traditional, native *yamato-e* mode of painting. This alliance presumably enabled him to incorporate aspects of *yamato-e* into his ink painting, thus laying the foundation for the brilliantly decorative Kano-school style of the Momoyama period. This style, with its enlarged motifs and use of colors and gold, was well suited for decorating the interiors of large castles and palaces constructed during this "Golden Age" of screen painting.

The birth of this dynamic style was at least partly aided by the unexpected arrival of the Portuguese. Their muskets—weapons previously unknown in Japan—were immediately copied by Japanese craftsmen, which significantly altered the nature of warfare and military architecture throughout the country. The castles that were built as fortifications against these powerful firearms also served as residences, and their large, dark interiors required colorful, exuberant, and thematically appropriate decorations. The type of painting suitable for large castle halls, first devised by Motonobu, was taken to even greater artistic heights by Motonobu's grandson Eitoku (1543–1590). Many different schools of artists participated in the sudden, unprecedented flurry of castle decoration. Besides the artists of the Kano studio, major masters of the era included Hasegawa Tōhaku (1539–1610), Kaihō Yūshō (1533–1615, no. 21), and Unkoku Tōgan (1547–1618). Their creative energies culminated in a reconciliation of two long-standing artistic traditions: the polychrome lyricism of *yamato-e* and the Zen-inspired genre of ink painting.

The resplendent Momoyama style came to an end with the destruction of Osaka Castle in 1615, last stronghold of the supporters of deceased warlord Toyotomi Hideyoshi. The castle fell to the armies of Tokugawa Ieyasu, who shortly thereafter founded the Tokugawa shogunate, based in the once small fishing town of Edo (modern Tokyo). The Tokugawa government was able to maintain a state of relative domestic peace for the next 250 years, a period that was especially notable for the shoguns' strict control of feudal barons, an extraordinary expansion of the national economy, and the resultant rise of an affluent urban middle class. A broad variety of schools of painting

also flourished, particularly during the eighteenth and nineteenth centuries. Patrons of the arts in earlier eras had been members of the aristocracy or military rulers, but with the changing society of eighteenth-century Japan, new sponsors for the arts were as likely to come from the city-based bourgeoisie. Since *bakufu* policy insured that feudal lords were kept virtually insolvent, military men were unable to provide large-scale subsidies for painters or craftsmen, and the patronage role was transferred to the pragmatic, moneyed middle class. Middle-class patronage, in turn, contributed to the development of an age of mass culture, best represented by colorful *ukiyo-e* woodblock prints. Among the different schools of painting that prospered during this time were the Kano, Rimpa, and Maruyama-Shijō, but the *nanga* (literati) and *ukiyo-e* traditions were especially dynamic as unique, antithetical forces in their approach to art. Each was representative of an important aspect in the cultural development of early modern Japan.

Nanga (literally, southern painting), the last artistic movement for which China served as a direct inspiration, owed much of its success to the Tokugawa government's policy of national isolation. Its decision to close Japan off from the outside world, instituted and carried out in the 1630s, was in part the result of shogunal anti-Christian sentiment and a general suspicion of Western motives in Japan. Trade with Portugal, Spain, and England, which had flourished since the late sixteenth century, was halted in an attempt to curtail Christian missionary activity, and Japanese subjects were forbidden to travel abroad. Commercial exchange with foreigners was limited exclusively to the Chinese and the Dutch, who were admitted only to the port of Nagasaki in Kyūshū. It was through this small "window" that eighteenth-century Japanese artists became aware of Western art theories and techniques and revived their admiration for the arts of China. Among the Chinese businessmen who visited Nagasaki were amateur artists, some of whom gave, in rare instances, painting instruction to Japanese enthusiasts. Chinese paintings also occasionally found their way into Japanese hands.

For artists in Japan, however, the most important guides to understanding something about Chinese scholar-painting were Chinese printed books that contained reproductions of ancient masterpieces. One example, the *Hasshu Gafu*, consisted of eight albums of woodcut pictures; another is well known in the West as *The Mustard Seed Garden Manual* (*Chiehtzu-yüan Hua-chuan*, or *Kaishi-en Gaden* in Japanese). These painting manuals came to Japan along with books on Confucianism, most of which were permitted into the country by the *bakufu* as aids to Confucian study. (Confucianism—especially the Chu Hsi branch that emphasized strict codes of moral conduct—was highly regarded by the government as an aid to strengthening the sense of fidelity and loyalty that theoretically formed the base of the feudal system.) A small number of illustrated books on Western sciences, such as medicine and geology, were also allowed into Japan, and these provided a limited exposure to Western techniques of drawing and perspective.

The term *nanga*, or *nanshūga* (southern school painting), is used interchangeably with the term *bunjinga* (literati painting). Neither term is easy to define, since the original Chinese interpretations do not apply to the art of most Japanese *nanga*-school painters of the eighteenth and nineteenth centuries. The concept of *Wenjen-hua* (*bunjinga* in Japanese) evolved in China as part of the native philosophy of life and art. From ancient times, the Chinese believed that the personal views and refined spirit of a truly well-educated individual could be conveyed through poetry, music, calligraphy, and painting. As it was thought that knowledge of the inner workings of the universe was denied to the mere professional artist and revealed only to the gentleman-philosopher-artist, accomplishments of professional painters were regarded as nothing more than efforts to capture the outward appearance of nature. The superior scholar-painter supposedly painted not on commission but from the desire for self-expression and his own enjoyment, or that of his circle of equally learned friends. The term *bunjinga* thus refers not to any one particular style but to an artistic approach that ideally encompasses the background,

social standing, education, and state of mind of the painter.

The high-minded concept of *nanga* derives from a theory developed by Tung Ch'i-ch'ang (1555-1636), a Ming-dynasty critic and painter who divided the artists of China into two groups: Northern and Southern.[1] Tung's classification had no relation to the geographical areas in which the painters functioned; rather, the divisions were made as an analogy to a split in the Zen Buddhist sect. The Northern branch of Zen emphasized a step-by-step approach to salvation, while the Southern branch advocated enlightenment through an intuitive and spontaneous grasp of truth. Since the literati did not paint to earn their livelihood, they were considered free from the taint and dictates of official or popular taste, and could be more spontaneous and individualistic in their art than those painters working under patronage. Hence the inclusion of superior, literati painters in the "Southern" category, while professional and academic artists were relegated to the "Northern" group.

Tung's theories were virtually unknown to the Japanese until the beginning of the eighteenth century. Once they were introduced into artistic circles, they captured the imagination of many educated and serious-minded painters and patrons. Most of Japan's *nanga* artists were not true literati in the Chinese sense; some earned their living from painting, while others served feudal lords. Few were fortunate enough to have the kind of financial independence to allow them to pursue the life of a scholar-gentleman. Scarcity of good Chinese models and a general failure to comprehend the finer points of Tung's philosophy produced an unexpected diversity of styles among Japanese *nanga* painters. Non-Chinese elements borrowed from native artistic schools—Rimpa, Tosa, and *ukiyo-e*—were freely incorporated into their work. Aspects of Chinese Southern Sung- and Ming-dynasty academic and professional painting, the antithesis of scholar-painting according to Tung Ch'i-ch'ang, were also assimilated into Japanese *nanga*.

Beyond the conceptual strictures established by the Chinese, *nanga* appealed to Japanese artists as something new and different. Numerous *nanga* paint-

48

ers took to using Chinese-sounding names, either by dropping parts of their own names or by utilizing different readings of the characters. Ike Taiga and Yosa Buson, for example, dropped the word *no* (field) from their names (see nos. 24–27). Their commitment to Chinese ideals was complete.

NOTE

1. Wai-kam Ho et al., *The Century of Tung Ch'i-ch'ang* (Kansas City, Mo.: Nelson-Atkins Museum of Art, 1992).

10.

Chinese Couplet by Po Chü-i

Muromachi period
Bokusai (d. 1492)
Hanging scroll; ink on paper
H. 118.8 x W. 26.4 cm (46¾ x 10¼ inches)
SEALS: "Shōtō," "Shiran"

Taller, taller, wild grasses grow in the field,
Only to wither at the end of the season.[1]

This calligraphic work quotes the first two lines from a poem by Po Chü-i (772-846), a T'ang Chinese poet revered by the Japanese from early times. The entire poem includes six more lines of five letters each, describing wild grasses that come back to life in spring and grow almost tall enough to engulf the ruins of an old fortress. It also describes the figure of a departing friend among tall grasses, which deepens the sorrow of parting. Another work by the same calligrapher and written in a calligraphic style almost identical to this piece includes two more lines from the same poem.[2]

The calligrapher of this piece began the line with a brush heavily saturated with ink and continued to write without replenishing his brush with ink. He ran out of space for the last word, *ei* (to flourish), which he wrote at the side in a smaller size. The two seals that follow the last word read "Shōtō" and "Shiran," identifying the calligrapher as the Zen monk Bokusai, who was also known by the religious name Botsurin Shōtō (or Motsurin Jōtō). Bokusai was a devoted disciple of the monk Ikkyū (1394-1481), an iconoclastic priest renowned for his eccentricities.

The best known aspect of Bokusai's life concerns his close relationship with his master. Bokusai was first associated with the Tenryūji temple in Kyoto, but later shifted his allegiance to Ikkyū of Daitokuji. He moved to this temple, perhaps in 1452, to live with Ikkyū. Nothing is known about Bokusai prior to this conversion. Afterwards, he seems to have shown complete devotion to this eccentric priest. Bokusai compiled the *Ikkyū Oshō Nempu*,[3] a short biography of Ikkyū, and is generally thought to have painted the sketchlike, penetrating portrait of Ikkyū presently in the Tokyo

National Museum.[4] He also became the first abbot of the Shinju-an, a mortuary temple built for Ikkyū in 1491 at Daitokuji.

In addition to this portrait, a small number of paintings by Bokusai are known today. These paintings of landscapes, plants, and flowers—all of them unpretentious ink monochrome works—have a directness and spontaneity that suggest he painted purely as an avocation.[5] Yet they also reflect the strong influence of the painters who gathered around Ikkyū at Daitokuji, artists such as Saiyo and Bokkei.[6]

Bokusai almost always wrote inscriptions on his paintings in a style strongly reminiscent of Ikkyū's powerful and expressive colophons.[7] Although he imitated such idiosyncracies of Ikkyū's style as the long diagonal strokes and the dry broken brush, Bokusai's own calligraphy is calmer and more carefully ordered. This divergence from the model provided by his master is readily detected when the piece from the Burke Collection is compared to the colophon written on his painting, *Splashed-Ink Landscape* (Shinju-an, Daitokuji), or the example on the portrait of Ikkyū, which was a copy of Ikkyū's own inscription. In both works, Boku-

sai attempted to come quite close to Ikkyū's style. The Burke piece is less dependent on his master's model, especially in the absence of pronounced contrast between thick and thin strokes and dark and light ink tones, which would have created a more dramatic effect. In spite of the seemingly unrestricted freedom of the brush, this piece in actuality reflects a slow and deliberately conducted movement of a fairly dry brush, which creates a pleasing effect through the merging of gray ink and the white of the paper used. The repetitive use of gray, scratchy brushstrokes and the uniformly squarish profile of each character also contribute to the general impression of calm and restraint, suggesting that this piece may be a product of Bokusai's later years, sometime after his initial encounter with the more turbulent, idiosyncratic style of his master.

NOTES

1. The entire poem is in Wang Ju-pi, ed., *Po Chü-i hsüan-chi* (Selected Works of Po Chü-i) (Shanghai: Shanghai kuchi ch'u-pan-she, 1980), 1.

2. Reproduced in Komatsu Shigemi, ed., *Nihon Shoseki Taikan* (Compendium of Japanese Calligraphy) (Tokyo: Kodansha, 1980), vol. 8, no. 69.

3. Reproduced in Zoku Gunsho Ruijū Kanseikai, ed., *Zoku Gunsho Ruijū* (Collection of Miscellaneous Works, Continued) (Tokyo: Zoku Gunsho Ruijū Kanseikai, 1927), 744-66.

4. Donald Keene, "The Portrait of Ikkyū," *Archives of Asian Art*, 20 (1966-1967): 54-65.

5. For these paintings, see Yoshiaki Shimizu and Carolyn Wheelwright, eds., *Japanese Ink Paintings from American Collections: The Muromachi Period* (Princeton: The Art Museum, Princeton University, 1976), no. 14 and fig. 41. The Burke Collection also owns a painting of plums that may be by Bokusai. Miyeko Murase, *Japanese Art: Selections from the Mary and Jackson Burke Collection* (New York: The Metropolitan Museum of Art, 1975), no. 36.

6. For other works by the painters at this temple, see Matsushita Taka'aki and Tamamura Takeji, eds., *Suiboku Bijutsu Taikei* (Ink Monochrome Painting) (Tokyo: Kodansha, 1978), vol. 6, pls. 97-108.

7. For Ikkyū's calligraphy, see Yoshiaki Shimizu and John M. Rosenfield, *Masters of Japanese Calligraphy: 8th-19th Century* (New York: The Asia Society Galleries and Japan House Gallery, 1984), nos. 49-51; and Jan Fontein and Money L. Hickman, *Zen Painting and Calligraphy* (Boston: Museum of Fine Arts, 1970), nos. 52, 53.

11.

Su Tung-p'o on a Donkey

Muromachi period
Bokudō Sōjun (1373-1459)
Hanging scroll; ink and gold on paper
H. 57 x W. 26 cm (22⅞ x 10¼ inches)
SEAL: "Bokudō"

A man on a donkey crosses a path below a tall precipice. The description of the setting is held to a minimum: a few coarse brushstrokes in pale dry ink merely suggest the shape of the rocky cliff and the rough terrain below; darker ink spots that define a few trees and bamboo leaves on the ground give accents to this otherwise pale-colored landscape. Our attention is focused on the figure of the rider and his black-colored donkey. Again, details are minimal: a few outlines define the rider's face and robe and the donkey's head, while darker ink washes shape the beast's body and the man's large hat. In this stark, sketchlike depiction, thin gold-ink lines that trace the outlines of the hat and head wraps, leggings, bridle bit, and several other details give an unexpected sense of luxury.

The scene of a man riding on a donkey, a poor man's conveyance, symbolized the eremitic life of a scholar-poet and became a favorite subject for painting among the ink painters of the Muromachi period. Men depicted in such paintings are variously identified, either as Tu Fu, Su Tung-p'o, or other poets of China. The T'ang-dynasty poet Tu Fu (712-770) was well-regarded in fourteenth-century Japan. His popularity was overshadowed in the fifteenth century by Su Tung-p'o (also known as Su Shih, 1037-1101) of the Sung dynasty,[1] whose poems were introduced to Japan together with Zen teachings and became widely popular among Zen monks there. Yet without specific attributes, it is difficult to distinguish the rider's identity in such depictions.

In this painting, however, the rider's large hat, its windswept ribbons, and the forlorn look of the landscape suggest that the poet is traveling through rain. The painting may thus belong to a special iconographic type in which Su Tung-p'o is represented wearing a rain hat and wooden clogs, as he is depicted in the

Shūbun-attributed painting in the Metropolitan Museum of Art, New York.[2] It illustrates a charming episode that took place while Su was in exile in Tan-hsien on Hainan Island, off south China, between 1097 and 1110. As he took leave of a friend whom he was visiting, rain started, and he borrowed a bamboo hat and wooden clogs from a farmer. The strange sight of a city literatus dressed in a humble farmer's outfit startled women and children and made them laugh.[3]

Although the gold ink outlines on the hat and the donkey's fittings are not quite in keeping with this tale, the rider still may represent the Sung poet, since inclement weather is suggested clearly by the fluttering ribbons of his hat and the desolate landscape setting.

The seal reading "Bokudō" helps to identify the artist of this painting. Bokudō (or Bokudō Sōjun) was a Zen monk belonging to Tenryūji in Kyoto, a center of learning and home to many scholarly monk-poets. This temple is also remembered in the history of Japanese painting since generations of monks working there wrote poetic colophons on a large number of ink paintings during that period. A noted monk of the time, Zuikei Shūhō (1391-1473), mentioned Bokudō's visit in his diary *Gaun Nikkenroku* (*Chronicle of Gaun*) and added that Bokudō excelled in paintings of Fudō (*Acala* in Sanskrit) and other ferocious guardian deities and Bodhisattvas. Bokudō was also able to copy an entire text of the *Han'nya Haramitta Shingyō* (*Prajnāpāramitā-hydaya sutra* in Sanskrit), one of the most important Buddhist scriptures, on his fingernails.[4] Such activities suggest that Bokudō must have painted as an avocation; this explains certain awkward features in this painting, such as the left sleeve of the rider, which is raised to his chin and partly conceals the right side of his cheek.

The use of gold outlines in an otherwise austere ink monochrome painting was a technique particularly

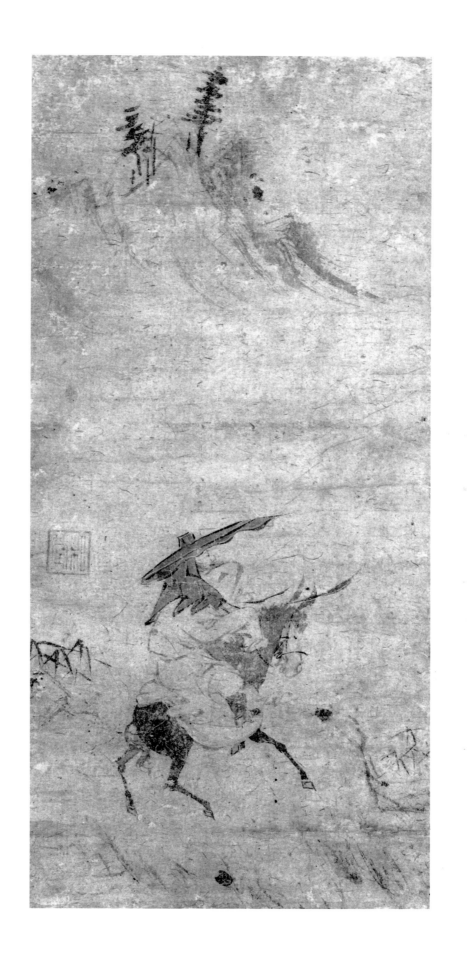

favored by the professional painters of the late four-teenth and fifteenth centuries for paintings of Buddhist icons. These painters include Minchō and Ryōzen of the mid fourteenth century and Reisai of the mid fifteenth century, artists who were closely associated with Tōfukuji in Kyoto, a thriving center of ink mono-chrome painting in the early Muromachi period. Bokudō's paintings of Fudō and other Buddhist deities mentioned in the *Gaun Nikkenroku* may have been highlighted by gold outlines, just as the figure of the poet in this painting. Bokudō may have learned this technique from the paintings in the Tōfukuji collec-tion, since this temple belonged to the Rinzai sect, the religious school with which his own temple, Tenryūji, was affiliated.

NOTES

1. Shimada Shūjirō and Iriya Yoshitaka, eds., *Zenrin Gasan: Chūsei Suibokuga o yomu* (Painting Colophon from Japanese Zen Milieu) (Tokyo: Mainichi Shimbunsha, 1987), 162; Haga Kōshirō, *Chūsei Zenrin no Gakumon oyobi Bungaku ni kansuru Kenkyū*, *Haga Kōshirō Rekishi Ronshū*, III (Studies on Scholarly and Literary Works of Medieval Zen Monks: Historical Studies by Haga Kōshirō, III) (Kyoto: Shibunkaku Shuppan, 1981), 284-85.

2. This painting is reproduced in Shimada Shūjirō, ed., *Zaigai Hihō* (Japanese Painting in Western Collections) (Tokyo: Gakken, 1969), vol. 1, pl. 78; Shimada Shūjirō, ed., *Zaigai Nihon no Shihō* (Japanese Art Treasures Abroad) (Tokyo: Mainichi Shimbunsha, 1979), vol. 3, pl. 26; and Shimada and Iriya, *Zenrin Gasan*, no. 62. Another Shūbun-attributed painting depicting the poet walk-ing through rain while wearing a large hat and wooden clogs is reproduced in Watanabe Hajime, *Higashiyama Suibokuga no Kenkyū: Zōho-ban* (Study of Muromachi Ink Painting: Revised) (Tokyo: Chūōkōron Bijutsu Shuppan, 1985), p. 124, fig. 61. Tani Bunchō (1763-1840), an Edo-period *nanga* painter, made copies of a few similar works in his *Honchō Gasan* (Collection of Japanese Paintings). See "Honchō Gasan Fukkoku" (Illus-trated Biographies of Japanese Painters; Newly Compiled and Reprinted from Various Editions), *Bijutsu Kenkyū* 88 (April 1939), pt. 3, pp. 153 and 189 for paintings by Zean and Yūei (Yūei's painting is very similar to Bokudō's); and *Bijutsu Kenkyū* 89 (May 1939), pt. 4, p. 204, for a painting by Sekkyū.

3. Shimada and Iriya, *Zenrin Gasan*, no. 62.

4. For this information, see entry for the fourteenth day, first month, third year of the Kasei era (1457). See Kondō Heijō, ed., *Zoku Shiseki Shūran* (Collection of Historical Materials, Contin-ued) (Tokyo: Kondō Shuppanbu, 1930), and Asaoka Okisada, *Koga Bikō* (Notes on Old Painters), revised and enlarged by Ōta Kin as *Zōtei Koga Bikō* (1904; reprint, Kyoto: Shibunkaku, 1983), 313-14.

12.

Water Buffalo and Herdboy

Muromachi period, late fifteenth century
Folding fan, mounted on a hanging scroll; ink on gilded paper
H. 18.2 x W. 47.1 cm (7⅛ x 18½ inches)
SEAL: "Masanobu" (?)

Although its worn, vertical creases attest to frequent use, this gilded fan still provides a sumptuous setting for the illustration of a humble herdboy returning home from work. Bulls and water buffalo had a special place in Chinese symbolism, both religious and secular. The water buffalo was treated as an emblem of spring and agriculture, and thus by extension as a water god and a symbol of the earth's fertility.[1] At the same time, this animal may have been considered propitiatory in nature, and for that reason its depiction in painting increased during the politically troubled Southern Sung and Yüan periods.[2] Chinese Taoists also regarded the water buffalo as a symbol of honest bucolic life, and saw in the theme of the buffalo and its herdboy a basic element of nature and its rhythms.[3] Various types of paintings developed that illustrated the nature of the beast's relationship to its master, and thirty-eight paintings of this motif are reported in the *Hsüanho*

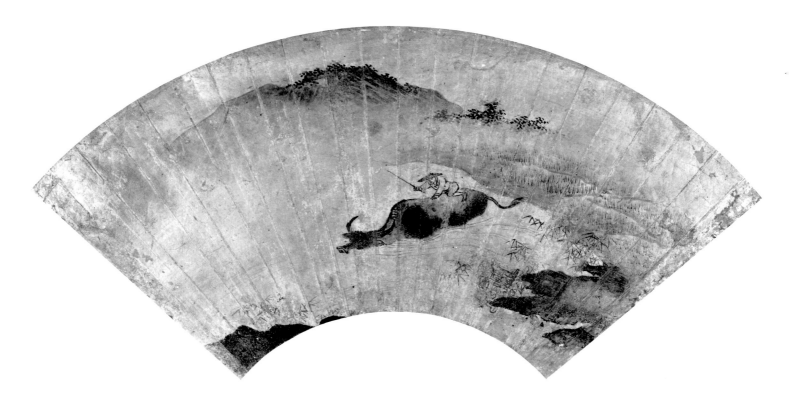

huap'u, the catalogue of Emperor Hui-tsung's art collection (reigned 1100–1125).⁴ In Ch'an (Zen) Buddhism, the relationship of this beast to its master and the act of herding took on a religious significance: progressive

degrees of enlightenment in the search for the Buddha's nature were described in the parables of *The Ten Ox-herding Songs.*⁵

Paintings of bulls were popular in Japan, especially during the Kamakura period, when the finer specimens that drew carriages of courtiers and noblemen were singled out for "portraits."⁶ After the introduction of Zen Buddhism, water buffalo found a special place in the teaching of this dogma as the subject of *The Ten Ox-herding Songs.* Many Chinese paintings depicting either oxen or water buffalo are recorded in the catalogues of shogunal collections of Chinese art objects, the *Butsu-nichi-an Kōmotsu Mokuroku* and *Kundaikan Sayūchōki.*⁷ Although no pictures of oxen by Hsia Kuei (late twelfth century) are mentioned in either catalogue, a small, round, fan-shaped painting of this theme with the name "Hsia Kuei," once part of the Kuroda Collection and then the Nakamura Collection,⁸ must have been imported to Japan at least before the end of the fifteenth

century. Japanese paintings that were modeled after this painting exist, including one by Sekijō, a late fifteenth-century artist,[9] and the Burke fan, which may be dated about the same time.

In the Burke fan, the buffalo and the herdboy are depicted from a closer viewpoint than in the Chinese model, and the second buffalo in the Chinese work is eliminated. Otherwise, the painting is nearly identical, including such details as the axe-cut strokes applied on the hills in the background, the configuration of the shorelines and rice paddies, and the posture of the herdboy with a hat and a switch.

With the help of his switch, the herdboy is urging the buffalo to wade through the shallow waters; behind them are rice paddies where they have been working. Short stubbles of rice plants growing in the field suggest that the time is early summer. A small patch of land with a growth of bamboo at the lower left serves as a foreground. Gentle hills with a thick growth of trees close off the distant view, providing the entire area with a look of well-protected farm land. This painting most likely belongs to the secular theme of ox-herding, unconnected with the Zen allegory of *The Ten Ox-herding Songs*. This is apparent in the clear indication of the season of the year, and the suggestion that the beast and its master have performed their task in the rice field. The golden shimmer from the gilded background of the fan also enhances the bucolic and poetic impression, supporting this interpretation.

A large seal in the shape of a cauldron with a tall neck and a bulbous body is impressed at the lower right, but its letters are not clear enough to decipher. The seal may belong to a group of similarly shaped seals that are considered to have been used by Kano Masanobu (1434–1530). Masanobu, the first nonpractitioner of Zen to be appointed as the Ashikaga shoguns' official painter, laid the foundation of the Kano school, which was to have an astonishing longevity for more than three hundred years. While the life of this important artist is slowly emerging through diligent research by scholars who examine documentary material,[10] his oeuvre still remains unclear, and only a small number of extant paintings have been accepted as his genuine works. Many extant paintings bear similar "Masanobu" seals, but the seals are varied as well as the painting

styles, and are not helpful in determining the authenticity of the attributions.

Kano Masanobu is said to have been from either Kazusa (modern Chiba prefecture), or Izu (modern Shizuoka prefecture),[11] both in eastern Japan. However, nothing is known about the circumstances in which he was trained as a painter and "discovered" by the important monks who acted as liaisons to the prominent temples of the *Gozan* (literally, Five Mountains) system of Kyoto, which gave him commissions. His first such commission materialized in 1463. Nearly twenty years later, he is believed to have succeeded Oguri Sōtan (1413–1481) and become the shogun's official painter, the most coveted and most powerful position for a painter. Once he was appointed to that august position, his major projects for shogunal commissions are recorded in detail in various official documents.[12] One such document refers to his borrowing a triptych of Chinese paintings from the shogun's collection. The central piece consisted of *Monju and Yuima* by Li Kung-lin (late eleventh century), and on the sides were paintings of oxen by Li Ti (late twelfth century). He needed the Chinese paintings to use as models for a shogunal commission, which he completed in February 1486.[13]

It is a well-known fact that painters who worked for shoguns were often ordered to use Chinese paintings in the shogunal collection as models.[14] The Burke fan painting, which closely resembles Hsia Kuei's work, may have been copied directly from the Chinese work, unlike other similar works by Sekijō and others, which seem to be one step removed from the Chinese original. Although it is not established that the Hsia Kuei painting in question was in a shogunal collection, the possibility remains that it was in a long-standing and important collection.

Folding fans were often exported to China and Korea, along with folding screens, many of which were gilded.[15] Fans were also made as gifts to be presented annually by the painters themselves to the Imperial court and the shoguns who employed them. In his 1529 diary, the *Sanetaka-kō Ki*, Lord Sanjōnishi Sanetaka referred to fans presented by the court artists as "Edo-koro fans" (fans by the painters of the Painting Bureau), while those presented by the Kano artists were termed "Kano fans."[16] Since Masanobu was the leading Kano

artist of the time, those fans of 1529 most likely were presented by himself.

The possibility that the Burke fan is a work of Masanobu still remains, since the painting seems to be a direct copy from the Hsia Kuei painting. Moreover, it is thickly covered with gold leaf, which indicates that it may have been made as one of the annual gifts to the court or shogun. If the seal on this fan can be deciphered as "Masanobu," and the painting attributed to him, then it should be dated sometime after 1491, when he adopted this name as his new sobriquet.

Folding fans, indispensable during summertime, were usually discarded at the end of a season. Those that were treasured for their painted decorations or for other reasons were often pasted on albums and folding screens, increasing the chance for their preservation. The present fan may have survived under similar circumstances, and was later remounted on a hanging scroll.[17]

NOTES

1. Edward H. Schafer, *The Golden Peaches of Samarkand* (Berkeley and Los Angeles: University of California Press, 1963), 73.

2. Wai-kam Ho et al., *Eight Dynasties of Chinese Painting: The Collections of the Nelson Gallery-Atkins Museum, Kansas City and the Cleveland Museum of Art* (Cleveland: The Cleveland Museum of Art, 1980), no. 41.

3. Wai-kam Ho, *Eight Dynasties*, no. 76.

4. Reprint in *Hsüanho huap'u* (Peking: Jenmin meishu ch'u-pan-she, 1964).

5. Jan Fontein and Money L. Hickman, *Zen Painting and Calligraphy* (Boston: Museum of Fine Arts, 1970), no. 49.

6. For these works, see *Court and Samurai in an Age of Transition: Medieval Paintings and Blades from the Gotoh Museum, Tokyo* (New York: Japan Society, 1990), no. 5, and Komatsu Shigemi, ed., *Nihon Emaki Taisei* (Compendium of Japanese Emaki) (Tokyo: Chūōkōronsha, 1978), vol. 14.

7. *Butsunichian Kōmotsu Mokuroku* is in Kamakura-shi Shi Hensan Iinkai, ed., *Kamakura-shi Shi Shiryō Hen II* (Tokyo: Kamakura-shi Shi Hensan Iinkai, 1956); *Kundaikan Sayūchōki* is reprinted in *Bijutsu Kenkyū* 121 (January 1942): 27-36 and *Bijutsu Kenkyū*, 122 (February 1942): 67-77.

8. I owe this information to Saehyang Chung's paper, "Fan Painting of Boy on Waterbuffalo" (Columbia University, 1976); see "Kakei-hitsu Hōgyū-zu" (Ox-herding Painting by Hsia Kuei), *Kokka* 165 (February 1904): 182.

9. This painting was destroyed in the Tokyo earthquake of 1923; see Watanabe Hajime, *Higashiyama Suibokuga no Kenkyū: Zōho-ban* (Study of Muromachi Ink Painting: Revised) (Tokyo: Chūōkōron Bijutsu Shuppan, 1985), p. 120, fig. 31. Another, indirect copy is reproduced on p. 131, fig. 64 (Kuki Collection).

10. For the life of Masanobu, see Watanabe, *Higashiyama*, 165-226; for documentary material, 192-216; and for seals, 215-16. For Masanobu's life, see also Ueno Kenji, "Kantō Kanryō Uesugi Shi to sono Shūhen: Kano Ha no Shutsuji ni furete" (The Uesugi Clan: Governor of the Kantō Region and Their Milieu, Especially in Connection with the Emergence of the Kano School), in the *Ohta Dōkan Kinen Bijutsu Ten: Muromachi Bijutsu to Sengoku Gadan* (The Ohta Dōkan Memorial Art Exhibition: Art of the Muromachi and Sengoku Periods) (Tokyo: Tokyo Metropolitan Teien Art Museum, 1986), 114-24; also Yamaoka Taizō in *Nihon Bijutsu Kaiga Zenshū* (History of Japanese Painting) (Tokyo: Shūeisha, 1978), vol. 7; and Kawai Masatomo, "From Oguri Sōtan to Kano Masanobu," in the *International Symposium of the Conservation and Restoration of Cultural Property: Periods of Transition in East Asian Art* (Tokyo: Tokyo National Research Institute of Cultural Properties, 1988), 167-80.

11. Ueno, "Kantō Kanryō," 116.

12. Watanabe, *Higashiyama*, 192-216.

13. Ibid., 193.

14. For other instances of using Chinese models, see Yoshiaki Shimizu and Carolyn Wheelwright, eds., *Japanese Ink Paintings from American Collections: The Muromachi Period* (Princeton: The Art Museum, Princeton University, 1976), 162; Minamoto Toyomune, ed., *Tōhaku Gasetsu* (Painting Theory of Hasegawa Tōhaku) (Kyoto: Wakō Shuppansha, no date), 17; an entry for the twenty-fourth day, eleventh month, seventeenth year of the Bummei era (1485) in the *Inryōken Nichiroku* (Chronicle Kept at Inryōken of Shōkokuji Temple), ed. Tamamura Takeji and Katsuno Takanobu (Kyoto: Shiseki Kankōkai, 1953); and Gail Capitol Weigl, "The Reception of Chinese Painting Models in Muromachi Japan," *Monumenta Nipponica* 35, no. 3 (Autumn 1980): 257-72.

15. Akazawa Eiji, "Jūgoseiki no Kachō-zu Byōbu: Ushinawareta Sakuhin o motomete" (Folding Screens of the Birds and Flowers from the Fifteenth Century: In Search of the Lost Works) in *Nihon Byōbu-e Shūsei* (Collection of Japanese Folding Screens) (Tokyo: Kodansha, 1978), 6:128.

16. Takahashi Ryūzō, ed., *Sanetaka-kō Ki* (Diary of Lord Sanjōnishi Sanetaka) (Tokyo: Zoku Gunsho Ruijū Kanseikai Taiyōsha, 1958), entries for the twelfth day, eighth month, second year of the Kyōroku era (1529), and the first day of the fifth month of the fifth year of the same era (1532), which refers only to the "Kano" fans.

17. For the painted fans from different periods, see Egami Yasushi, *Semmenga: Kodai Hen* (Painted Fans: Ancient Period), Nihon no Bijutsu no. 319 (Tokyo: Shibundō, 1992); Miyajima Shin'ichi, *Chūsei Hen* (Medieval Period), no. 320 (1993); and Kobayashi Tadashi, *Kinsei Hen* (Recent Period), no. 321 (1993).

13.

Sparrows among Millet and Asters

Muromachi period
Geiai (ca. 1489)
Hanging scroll; ink on paper
H. 83.1 x W. 46.2 cm (32¾ x 18 inches)
SEAL: "Geiai"

Five lively sparrows frolic around millet and aster flowers. The millet is heavy with grain; the stems seem hardly able to withstand the weight of small birds. The animated caper of the sparrows seems to have stirred the nearby asters. A feeling of open space under the crisp, sunny autumnal sky permeates this painting. In sharp contrast to the two paintings of the bird-and-flower genre included here—by Uto Gyoshi and Shikibu Terutada (nos. 16 and 17)—this work by Geiai in monochrome ink relies largely on soft, "boneless" techniques. Lines are limited to small details such as birds' feathers, the veins of leaves, the outlines of floral petals, and the weeds that give accent to the ground, and small ink dots delineate individual grains. The sharp lines in moist, yet dark ink give pleasing accents to the soft washes of pearl-gray ink. Gentle swaying blades of millet against the neutral background heighten the sense of a large open space beyond the picture frame. Sketchy yet naturalistic renderings of the birds capture the spirit of their movements. There is an unmistakable feeling of airiness and lightness, a sense of sophistication that is absent from the works of Uto Gyoshi and Shikibu Terutada, both representatives of the school of painters active in eastern Japan.

Several similar ink paintings of birds frolicking among a variety of plants, which also bear "Geiai" seals, are known to exist. One of these, in the Metropolitan Museum of Art in New York City, is almost identical to this work in composition.[1] A few other similar paintings are in Japanese and American collections, including one in the Freer Gallery of Art in Washington, D.C.[2] These paintings not only have similar dimensions, suggesting that they might once have been pasted on folding screens, but also are executed in a similar style. They depict vigorous movement in the plants and birds; long arching blades of grass or tree branches bend in opposite directions. The soft, pearl-gray ink washes give an air of graceful refinement.

To this group of ink paintings should be added another work in polychrome in the collection of the Nezu Museum in Tokyo, which is almost identical in composition and the choice of plants, but depicts quail, rather than sparrows.[3] Another painting, which is included in this exhibition (no. 14), executed in colors on silk, should also be added to this group of paintings that depict millet and birds. All these paintings may eventually be traced to a Ming Chinese model, which was most likely in color.

These ink monochrome paintings of plants and birds are impressed with "Geiai" seals, but none bear the artist's signature. Furthermore, the seals found on these paintings show slight differences, which suggests there might be at least two different "Geiai" seals. However, what this difference implies must be clarified with further research in the future. Some of the paintings bear an additional seal reading "Tonshu."[4] The extant paintings that bear the "Geiai" seals represent a wide variety of subjects—landscapes, figures, and bird-and-flower genres. These works are executed on hanging scrolls or handscrolls and large screens. The overwhelming majority are in the bird-and-flower genre, done in either polychrome or ink monochrome Chinese Sung or Ming academy style. These are best represented by a work in the Museum of Fine Arts, Boston, and a recently discovered pair of screens in the Nezu Museum, Tokyo.[5] The other paintings of this genre are executed in a soft ink monochrome style that is exemplified by the painting shown here.

No documentary material on the artist who used the "Geiai" seal exists, except for an indirect piece of evidence, an underdrawing of a vivacious bird among flowers, executed in ink and gold, which was found on

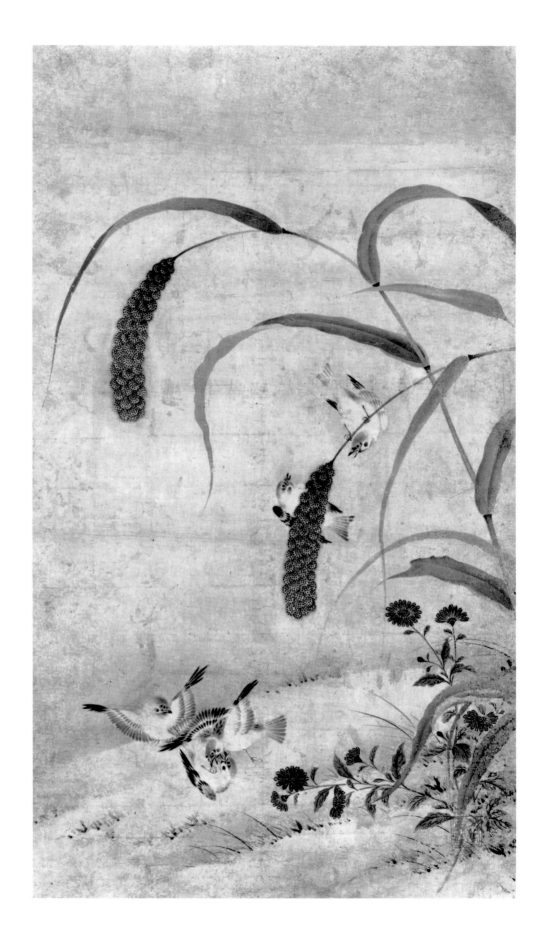

a document that dates to 1489.[6] Edo-period records, including Kano Eino's *Honchō Gashi* (*The History of Japanese Painting*) of 1678, traditionally identified Geiai-sealed paintings as works by Oguri Sōritsu (d. 1556).[7] Unfortunately, little is known about Sōritsu or the family that used the name Oguri. The school's founder, Oguri Sōtan (ca. 1413-1481), served after Shūbun as the shogun's official painter at Shōkokuji, the most prestigious position for painters at that time. The difficulty in supporting a connection between Geiai and Sōritsu is that no extant painting is accepted as genuine work by Sōtan or Sōritsu. Several paintings by Sōtan's son Sōkei are known, notably his sliding panels at Daitokuji's subtemple, Yōtoku-in, completed in 1490 after his father passed away with the work incomplete.[8] Unfortunately, there is not sufficient evidence to separate the work of Sōkei from his father's work. Even attempts to identify Sōritsu's relationship to the other Oguri artists—was he a pupil or son of Sōtan?—have produced no definitive answers. And Geiai's relationship to the Oguri family has been even more difficult to document.[9]

What emerges from this rather inconclusive situation is that the paintings traditionally attributed to Sōtan and Sōritsu often resemble some of Geiai's works, such as the ones in the Boston and Nezu museums that are polychrome bird-and-flower paintings in Chinese Ming academy style. On the other hand, Geiai's diptych of landscape paintings (which might have become separated from a set of four depicting two scenes from the *Eight Views of Hsiao and Hsiang Rivers* on each scroll)[10] combine the clear outlining of the academy technique with a painterly style based on soft "boneless" ink washes, the technique closely associated with the leading ink painter of the early sixteenth century, Sōami (also known as Shinsō, d. 1525). An intriguing question comes to mind: was the name Geiai derived from the name of Sōami's father, Geiami (also known as Shingei, 1431-1485)?

Whoever Geiai really was, the extant paintings bearing his seal exhibit a wide range of brush technique, reflecting a trend dominant among the late fifteenth-century artists who were active in the Kyoto area.

NOTES

1. Shimada Shūjirō, ed., *Zaigai Hihō* (Japanese Paintings in Western Collections) (Tokyo: Gakken, 1969), no. 98. This subject apparently was very popular. A similar work that is attributed to a late sixteenth-century artist, Kano Motohide (or Genshū), also depicts, in color, sparrows among millet and asters. See Sugahara Hisao, *Japanese Ink Painting and Calligraphy from the Collection of the Tokiwayama Bunko, Kamakura, Japan* (New York: The Brooklyn Museum, 1967), no. 39. The subject seems to have become a standard repertory for Kano-school artists, such as Sanraku, who embellished it by adding other pictorial elements and painting them on screens. See Miyeko Murase, *Byōbu: Japanese Screens from New York Collections* (New York: The Asia Society, 1971), no. 14.

2. Shimada Shūjirō, ed., *Zaigai Nihon no Shihō* (Japanese Art Treasures Abroad) (Tokyo: Mainichi Shimbunsha, 1979), vol. 3, no. 77; also, similar paintings can be found in Matsushita Taka'aki and Tamamura Takeji, eds., *Suiboku Bijutsu Taikei* (Ink Monochrome Painting) (Tokyo: Kodansha, 1978), vol. 6, nos. 91 and 92.

3. This painting bears a seal that is generally deciphered as "Motohide" or "Genshū." See *Kobayashi Collection Ten: Muromachi Suiboku-ga o Chūshin to shite* (Kobayashi Collection: Gift of Mr. Kobayashi Ataru) (Tokyo: Nezu Museum, 1981), no. 66.

4. This unusual seal, which means to "bow to pay one's respect," is found only on a few paintings of Geiai's, but whenever found, it is always impressed upside down. What this implies needs further study.

5. Matsushita Taka'aki, *Muromachi Suibokuga* (Suiboku Painting of the Muromachi Period) (Toyko: Muromachi Suibokuga Kankōkai, 1960), pl. 104; and Kawai Masatomo, *Muromachi Jidai Suibokuga no Keifu* (Ink Monochrome Painting of the Muromachi period) (Tokyo: Nezu Museum, 1992), no. 27.

6. Matsushita and Tamamura, *Suiboku Bijutsu*, fig. 25; and Tamamushi Satoko, "Muromachi Jidai no Kingindei-e to Nōami hitsu *Shū Hyakku no Renga*" (Gold and Silver Painting in the Muromachi Period and the *Shū Hyakku no Renga* by Nōami), *Kokka* 1146 (1991), fig. 16.

7. One of the first among the modern art historians to work on this problem is Narazaki Muneshige; see his "Geiai-hitsu Kachōzu ni tsuite" (On the Pictures of Flowers and Birds by Geiai) *Kokka* 704 (November 1950): 383-86.

8. Kawai Masatomo, "Oguri Sōtan kara Kano Masanobu e" (From Oguri Sōtan to Kano Masanobu), *International Symposium of the Conservation and Restoration of Cultural Property: Periods of Transition in East Asian Art* (Tokyo: Tokyo National Research Institute of Cultural Properties, 1988), 167-80; also see Yoshiaki Shimizu and Carolyn Wheelwright, eds., *Japanese Ink Paintings from American Collections: The Muromachi Period* (Princeton: The Art Museum, Princeton University, 1976), 116, no. 3.

9. Geiai's other seal, "Tonshu," which is always impressed upside down, leads us to speculate whether he was in fact connected with the Oguri family and served shoguns. The use of this unusual seal in such an unusual manner might have been the mark of his position, but this must remain mere speculation at this point.

10. Matsushita, *Muromachi*, no. 102.

14.

Quail, Sparrows, and Millet

Muromachi period, early sixteenth century
Hanging scroll; ink and color on silk
H. 82.2 x W. 34.7 cm (32³/₈ x 13⁵/₈ inches)

In this hanging scroll painting a group of meticulously detailed quail and two sparrows feed on grain from ripening ears of millet. The bending stalks emerging from the right-hand border of the silk give a diagonal orientation to the composition, and a single quail in flight hovers above the millet in the upper left. Although the birds are carefully rendered, with fine brushstrokes, light wash, and touches of white pigment, ground-cover plants are more cursorily painted in soft, washy strokes with little detail. The overall effect of the image is decorative, with the ears of millet, executed as tiny, almost pointillistic dots of white and pink color, glowing faintly against the sepia tones of the old silk. The stalks of millet in particular are given an almost ornamental appearance; they form a crisscross pattern that contrasts with the more naturalistic depiction of the quail below. Stems and stalks are rather heavily outlined in ink and filled in with a rich application of brilliant mineral green.

It is difficult to assign any single artist, or even a school of painters, to this refined and elegant image. The theme itself was clearly derived from Chinese academic or professionally painted bird-and-flower works, and as a number of such paintings were treasured in temple and shogunal collections of Muromachi-period Japan, it is conceivable that this hanging scroll was copied from or inspired by a Chinese example. The stiffness of line in the millet stalks and the somewhat awkwardly drawn three-quarter view of the flying quail suggest the hand of a copyist. However, no work of Chinese origin that might have served as a direct model is presently known to exist, and it is also likely that the unknown artist simply copied pictorial motifs from more than one image and combined them with elements of his own to create a pastiche. The decorative treatment of the millet ears is more two-dimensional than the naturalistic approach found in most Chinese court and professional paintings of

the subject. In addition, the arrangement of the green millet stalks is somewhat reminiscent of the repeated arcs of autumn grasses in *yamato-e* paintings, most specifically the sixteenth-century "Pampas Grass" screens in the Cleveland Museum of Art.[1]

A number of late Muromachi- to early Momoyama-period artists produced images of quail or millet, or both, in a precise, detailed style adapted from Chinese courtly academic works of the Sung, Yüan, and early Ming dynasties. Perhaps one of the best-known examples is the small painting of a quail among hibiscus flowers by Tōshun (active first half of the sixteenth century),[2] in ink and color on paper (private collection). The Burke hanging scroll, however, exhibits several features—specifically the use of heavily applied opaque color, generally precise and careful brushwork, and a decorative appeal—which suggest that it may have been inspired by a work of China's P'i-ling school of painting, also known as the Ch'ang-chou school.[3] This group of professional artists, located in the region of P'i-ling, present-day Ch'ang-chou prefecture (Kiangsu province), in the lower Yangtze River valley, specialized in bird-and-flower and bird-and-insect paintings, often executed in rich polychrome. The school flourished from the later Sung through the Ming dynasty, and during that time paintings by P'i-ling artists were exported to Japan from the nearby port city of Ning-p'o (east of Hangchow), along with Buddhist images and commercially produced pictures from Ning-p'o's own artists.[4] Although Chinese critics, scholars, and connoisseurs of the arts evinced little interest in P'i-ling-school paintings, they were enthusiastically received in Japan where they were preserved, among other places, in Zen Buddhist temples. Names of P'i-ling artists and their works appear in the *Kundaikan Sayūchōki*, a catalogue of Chinese paintings in the collection of the Ashikaga shoguns, compiled by the ink-painting master Sōami (?-1525),[5] and some similarities

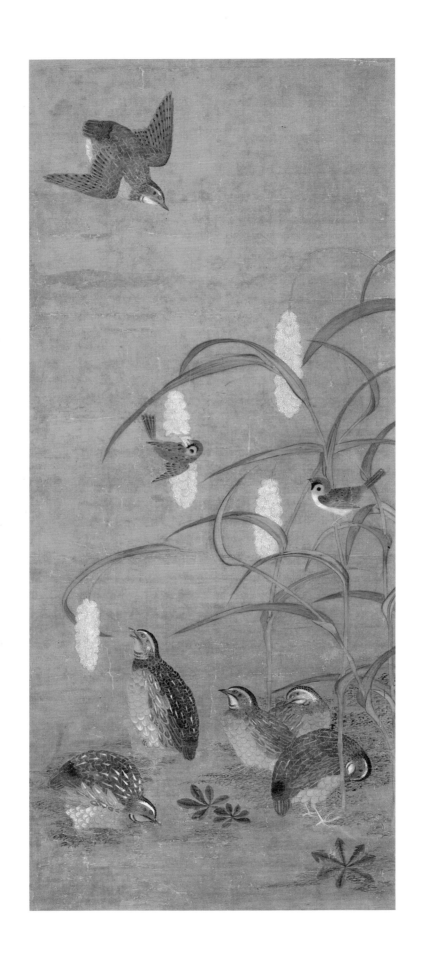

may be found between the Burke hanging scroll and examples of P'i-ling painting still extant in Japan. One early P'i-ling-school work, a hanging scroll of bamboo and insects from the Southern Sung dynasty (now in the Tokyo National Museum), is believed to have been in Japan since at least the fifteenth century.[6] It features stalks of bamboo that emerge from the right-hand border of the picture plane and send out branches to form decorative arcs against the blank silk background. A fourteenth-century work, a pair of hanging scrolls in the Tokyo National Museum entitled *Lotus Pond and Waterfowl*, also displays repeated arcs of foliage that create a sense of surface pattern rather than recession into depth or an impression of movement[7]—a characteristic taken even further by the artist of the Burke image.

Among Japanese bird-and-flower paintings of the sixteenth century, one hanging scroll of quail and millet, in ink and color on paper, is quite close in composition to the Burke painting. This work, in the Nezu Museum, Tokyo, is generally attributed to Kano Motohide (or Genshū) (1551–1601),[8] the second son of Kano Shōei (see no. 19) and younger brother of the great Eitoku. It is impressed with a "Genshū" seal that differs somewhat from other "Genshū" seals found on paintings by this artist. In spite of the similarity in the placement of pictorial elements, it is less static in appearance than the Burke *Quail, Sparrows, and Millet*; its leaves are naturalistically rendered, and the body of the flying quail is more accurately delineated. Comparison therefore suggests that the Burke hanging scroll was not a product of the same studio, and the Burke painting also bears little resemblance to bird-and-flower compositions by other ink-painting artists active in the late Muromachi and Momoyama periods. While it is clearly the work of an individual trained in a Chinese-derived mode of ink and polychrome painting, for which decorative images of the P'i-ling school may have served as inspiration, attribution to any single group of artists must await further investigation.[9] sw

NOTES

1. A frequently reproduced work, traditionally attributed to Tosa Mitsuyoshi (1539–1613), it was most recently published in Michael R. Cunningham et al., *The Triumph of Japanese Style: Sixteenth-Century Art in Japan* (Cleveland: The Cleveland Museum of Art in cooperation with Indiana University Press, 1991), no. 10.

2. This is one of eleven album-leaf-sized paintings mounted on a pair of six-fold screens, with inscriptions added above each. For a discussion and translation of the poetic inscriptions, see Watanabe Akiyoshi, Kanazawa Hiroshi, and Paul Varley, *Of Water and Ink: Muromachi-Period Paintings from Japan, 1392–1568* (Detroit: Founders Society, Detroit Institute of Arts, 1986), no. 50.

3. For a detailed history of the P'i-ling school, see Saehyang P. Chung, "An Introduction to the Changzhou School of Painting," *Oriental Art* 31, no. 2 (Summer 1985): 146–60 (Part I), and *Oriental Art* 31, no. 3 (Autumn 1985): 293–308 (Part II). See also Shimada Shūjirō, "Ro Keifu no Sō-Chū-Zu: Jōsho Sō-Chū-Ga ni tsuite" (Lu Ching-fu's Plant and Insect Paintings: Comments on Plant and Insect Paintings of the Changchou School), *Bijutsu Kenkyū* 150 (1948), and Kitano Masao, "Hiryo Gaha Kenkyū no Josetsu" (An Introduction to the P'i-ling School of Painting), *Yamato Bunka* 36 (March 1961): 12–21.

4. James Cahill, *Parting at the Shore: Chinese Painting of the Early and Middle Ming Dynasty, 1368–1580* (New York and Tokyo: Weatherhill, 1978), 107; see also 136–37.

5. Chung, "An Introduction to the Changzhou School," 146–47.

6. Ibid., 155; reproduced in fig. 8. See also Tokyo National Museum, ed., *Sō-Gen no Kaiga* (Sung- and Yüan-Dynasty Painting), (Kyoto: Tokyo National Museum, 1962), pl. 18.

7. See Wen C. Fong, *Beyond Representation: Chinese Painting and Calligraphy, 8th–14th Century* (New York: The Metropolitan Museum of Art, 1992), 386; reproduced in fig. 163.

8. Briefly discussed in *Kobayashi-Collection Ten* (Exhibition of the Kobayashi Collection) (Tokyo: Nezu Museum, 1981), no. 66; see also vol. 14 of *Nihon no Ishō* (Japanese Design in Art) (Kyoto: Kyoto Shoin, 1986), pl. 14.

9. This painting was added to the collection shortly before catalogue preparation began; consequently, research into its origins has been limited. The author wishes to thank Barbara Brennan Ford, Associate Curator of Japanese Art, and Maxwell K. Hearn, Curator of Chinese Art, both of The Metropolitan Museum of Art, New York, for their insights into this particular work.

15.

Bird Resting on a Tree

Muromachi period, before 1535
Painting by Unkei Eii (first half of sixteenth century)
Calligraphy by Daiko Shōkaku (d. 1535)
Hanging scroll; ink on paper
H. 23.7 x W. 27.6 cm (9¼ x 10¾ inches)
SEALS: "Eii," "Daiko," "Shōkaku"
PUBLISHED: Shimada Shūjirō, ed., *Zaigai Nihon no Shihō*
(Japanese Art Treasures Abroad) (Tokyo: Mainichi Shimbunsha,
1979), vol. 3, pl. 54; Tanaka Ichimatsu and Nakamura Tanio, *Suiboku
Bijutsu Taikei* (Ink Monochrome Painting) (Tokyo: Kodansha, 1977),
vol. 7, fig. 11; Fukushima Tsunenori, "Unkei Eii: Tenbun-nenkan
ni okeru Suō no Sesshū-ha" (Unkei Eii: Regarding the Sesshū-school
in Suō during the Tenbun Era, 1532-1555) *Bijutsu Shi* 133 (1993), fig. 22.

A small bird (a tit) seems to have just alighted on the branch of a tree that is bare except for a few long hanging vines. The bird twists its neck and looks down as though in search of, or enticing, a companion beyond the frame of the picture. The painting is utterly simple and unassuming, consisting of just a few strokes, some of which are broken because there was insufficient ink on the brush. A marvelous sense of balance between filled and unfilled space is created by a long tree branch that cuts the pictorial space into two triangles. One triangle is filled with writing, the other is almost empty except for the artist's seal, "Eii," the lightly washed area, and a few vertical brush strokes that are too ill-defined to identify easily. The rhythmic flow of ink lines defining the tree branches and vines is recaptured by the calligraphy of the colophon, which carries it on in smooth yet strongly punctuated writing. The perfect relation between the painting and calligraphy misleads us into thinking that they were executed by a single artist. But the painting was done by Unkei Eii, whose seal is at the upper left. The calligraphy is by a person who placed two seals, "Daiko" and "Shōkaku," next to the poem, which was composed by yet another person—Son'an, a Zen monk. In translation the poem reads:

> Woods are thick and good for the birds
> to come back in the evening to nest together,
> Coupled birds are still above the sky,
> their wings carry them high in the sky,

But that is not the place to spend the night.

(by) Son'an[1]

Son'an (also known as Kisei) Reigen (1402-1488), the founder of the temple of Chōshō-in in Kyoto, was a well-known and highly respected poet whose works were often quoted by later Zen monks. This poem, composed in 1444, is included in his anthology *Son'an Kō*.[2] Daiko Shōkaku, who inscribed the poem, was the 204th abbot of Tōfukuji in Kyoto and died in 1535. The date of this monk's death provides the terminus date for the painting, as well as one of the very few chronological points known in Unkei's life.

This piece reveals the artist's expressive power with brush and ink, rare among the bird-and-flower paintings included here, or among the many works of other artists of the same period. It suggests that the artist might have been a Zen monk who painted only as an avocation. Even during the Edo period, the identity and life of Unkei Eii eluded scholars. In Japan's first book on the history of Japanese painting, the *Tansei Jakubo-kushū*, its author, Kano Ikkei (1599-1662), mentions that as many as four artists used the name Unkei;[3] facts about the life and works of "Unkei" are therefore rather confused. Recently one scholar has undertaken a serious investigation into this murky situation by focusing on paintings that bear seals reading "Eii."[4] This group of paintings, which includes the Burke piece, exhibits several features that lead us to a proper understanding of the artist.

64

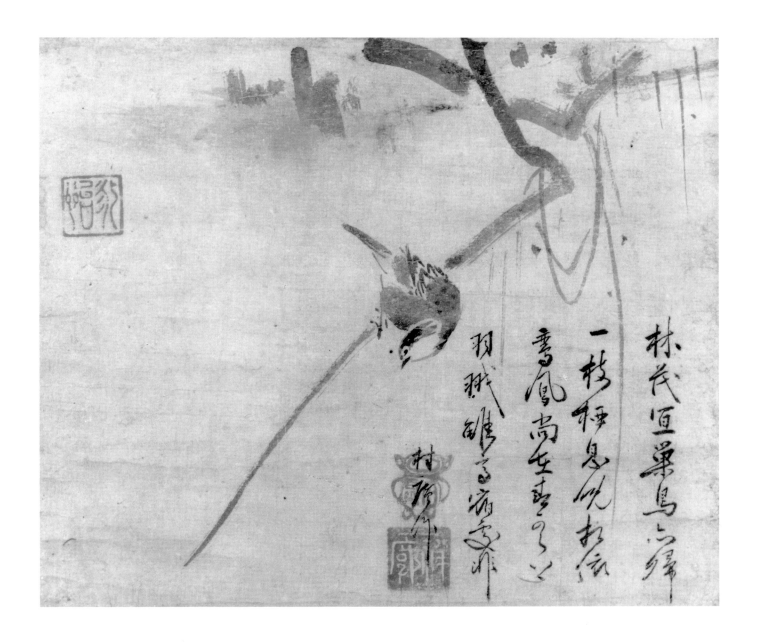

Nearly thirty paintings, most of which bear "Eii" seals, cover a wide range of subject matter: Buddist icons in ink monochrome, ink paintings of Zen personalities such as Daruma, landscapes both in *haboku* (splashed-ink) and linear styles, and polychrome bird-and-flower paintings in the Chinese academic manner. Unkei's oeuvre also includes a portrait of Lord Naitō Okimori (only a later copy remains today); an *ema* (votive tablet) painted with a horse, which was dedicated to the Sumiyoshi Shrine in Shimonoseki in Yamaguchi prefecture at the southern tip of Honshū Island; and the polychrome paintings of a dragon and *apsaras* (or *apsarasas*) (flying Buddhist attendant) executed on the ceiling of the Golden Hall of the Fudō-in (1540), which is now in Hiroshima but was originally built farther west in the Yamaguchi area. This information reveals two important facts about this artist. First, contrary to some previous conclusions, he probably did not live at Mount Kōya.[5] Second, he was active farther west, mainly around Yamaguchi, where Sesshū had settled sometime before 1464. Unkei may not have been old enough to have received instruction directly from this great master, as Sesshū died in 1506. We do know, however, that in 1505 Unkei received Sesshū's copies of Chinese paintings from one of Sesshū's pupils.

Unkei's oeuvre resembles that of Sesshū in its wide range of subject and technique. His works varied from portrait painting in the traditional mode to highly abbreviated ink works (such as the Burke painting). He painted landscapes in well-constructed compositions with light colors, and also engaged in *haboku* and Zen figure painting. Such a range of subjects and styles suggests that Unkei was not an amateur artist, but rather a professional, most likely trained at some Zen temple. It also suggests that he was taught by one of Sesshū's pupils, if not by the great master himself. Unkei's possible connection with Sesshū is further suggested by the fact that Daiko Shōkaku, whose inscription is on the Burke painting, was a religious pupil of Jonan Etetsu (1446-1507), the 183d abbot of Tōfukuji, Kyoto, appointed in 1499. Etetsu lived near Hiroshima in his later years and wrote inscriptions on some of Sesshū's paintings. The expressive use of the dry brush, as exemplified by the Burke painting, reveals that Unkei learned this aspect of Sesshū's work well, as this technique is especially prominent in the latter's early paintings bearing the seal "Sessō."[6]

It is well known that the powerful Lord Ōuchi of Yamaguchi gave Sesshū much needed financial and moral support when he moved there. After the demise of the Ōuchi family in 1551, Lord Mōri (whose descendants still own Sesshū's famous *Long Scroll*) continued the Ōuchis' cultural policies. The notion that Mōri was interested in Sesshū's art is bolstered by the fact that he helped to restore Sesshū's studio, the *Unkoku-an*. Unkei seems to have been also blessed with Mōri's patronage, as a number of his paintings can be traced to former Mōri ownership. And the previously mentioned Lord Naitō Okimori, whose portrait Unkei painted, was one of the high-ranking subjects of Lord Ōuchi. Since Unkei was most likely a young student in 1505, when he was given Sesshū's copies of Chinese paintings, and was presumably in his prime in 1540 when he painted the ceiling at the Fudō-in, the span of his career may be placed comfortably within the first half of the sixteenth century.

NOTES

1. I am grateful to Dr. Cornelius Chang for assisting me in translating this poem.
2. Tamamura Takeji, ed., *Gozan Bungaku Zenshū* (Collected Works of Literature by Monks of the Gozan System) (Tokyo: Tokyo Daigaku Shuppankai, 1968), 2:215.
3. *Tansei Jakubokushū* is reproduced in Sakazaki Shizuka, ed., *Nihon Gadan Taikan* (Survey of Discussions on Japanese Paintings) (Tokyo: Mejiro Shoin, 1917), 923-50.
4. Fukushima Tsunenori, "Unkei Eii— Tenbun-nenkan ni okeru Suō no Sesshū-ha" (Unkei Eii: Regarding the Sesshū-school in Suō during the Tenbun Era, 1532-1555), *Bijutsu Shi* 133 (1993): 72-92.
5. John Rosenfield, ed., *Japanese Paintings from the Sanso Collection* (Seattle: Seattle Art Museum, 1980), no. 11.
6. For the examples of such works by Sesshū, see Nakamura Tanio, *Nihon Bijutsu Kaiga Zenshū* (History of Japanese Painting) (Tokyo: Shūeisha, 1976), vol. 14, pls. 72, 73.

16.

Jakō Neko *(Musk Cat)*

Muromachi period
Uto Gyoshi (active second half of the sixteenth century)
Hanging scroll; ink and color on paper
H. 76.1 x W. 46.5 cm (30 x 18¼ inches)
SEAL: "Uto Gyoshi no In"

The doglike animal shown here, with its long snout, black and white fur, and bushy tail, is known in Japanese as *Jakō Neko* (musk cat) and in China is considered an auspicious animal endowed with both sexes. Perfume extracted from the gland of the musk cat was popular among the European aristocracy. As if attracted by the animal's scent, the great tit in the painting seems agitated and chirps busily at it. Clear and strong brush strokes in dark ink define the slender willow branches, the leaves and flowers of the camellia, and the foreground, which consists of small clusters of bamboo and grass and rocky ground. The physical features of the musk cat and its fur are meticulously rendered in extremely fine brush lines. The same exacting care was taken in describing details and applying heavy colors of green and pink on the camellia. The artist's seal, which reads "Uto Gyoshi no In" (Seal of Uto Gyoshi), appears at the lower right-hand corner.

The name "Uto Gyoshi" sounds more like an official rank than a personal name. In fact, this is also a Chinese term for an associate censor in chief (*yu-tu-yü-shih*) at the Censorate set up by the first emperor of the Ming dynasty in 1382.[1] However, there is no record that this rank or office ever existed in Japan, nor is it known why and how this artist chose to use this unusual-sounding name as his artistic name. For that matter, the very identity of this artist is shrouded in mystery. As was true with another artist represented in this collection, Shikibu Terutada (nos. 17 and 18), Uto Gyoshi's real name has been confused with that of certain other artists, including Shikibu's. What follows is a discussion summarizing Gen Sakamoto's recent study,[2] which deals with the confusion around Uto Gyoshi's identity and provides a hypothetical interpretation of his life.

Uto Gyoshi's name does not appear in the earliest book on Japanese artists, the *Tansei Jakubokushū* by Kano Ikkei (1599-1662). But later, in 1672, the anonymous author of the *Bengyokushū*[3] initiated the practice of including Uto Gyoshi's seal under the artist named Kano Gyokuraku, yet another painter whose identity seems uncertain.

Kano Gyokuraku had been included in the earlier book by Ikkei, and he is repeatedly mentioned in all later Edo-period books on painters as a nephew (or a niece, as the original word makes no distinction) and a student of the august leader of the Kano clan, Motonobu (ca. 1476-1559). According to Ikkei's account, Gyokuraku served Hōjō Ujimasa (1538-1590), the fourth ruler of the so-called Go-Hōjō (Latter-day Hōjō) clan in Odawara near Kamakura. The clan is given this designation to distinguish it from the earlier, legitimate Hōjō family, whose members served as regents to the Minamoto shogunate during the Kamakura period in the thirteenth century. Uto Gyoshi was thus possibly

a member of the school known as the Odawara Kano school, which is distinct from the metropolitan Kano school active in Kyoto. In the sixteenth century, Odawara was the seat of Go-Hōjō power and the epicenter of cultural activity for eastern Japan, the Kantō region.[4] Some Kano family documents claim that the main branch of the family came from nearby Izu province, and the branch that produced Motonobu came from further east in Chiba province, both of which were under Hōjō control.[5]

Edo history books on painting followed the tradition of the *Bengyokushū* until Kano Einō (1634-1700), in his *Honchō Gashi* of 1678, caused further confusion: he quoted Kano Tan'yū (1602-1674), the most powerful leader of the Edo-period Kano school, who identified Gyokuraku as having used the sobriquet Maejima Sōyū.[6] Thus, three names—Uto Gyoshi, Kano Gyokuraku, and Maejima Sōyū—came to be identified as one and the same artist. Einō further noted that Gyokuraku paintings *without seals* were easily mistaken for Motonobu's works.[7] Some modern scholars claim that Motonobu's painting style was transmitted faithfully to the Odawara area, and that Gyokuraku's art reflected that style closely.[8] Unfortunately, these statements on Gyokuraku's art were made when not a single painting with his seal or signature had been discovered, except for one bearing a doubtful signature.[9] Stylistic analysis of paintings that bear the seal of Maejima Sōyū reveals that his works differ considerably from those with the Uto Gyoshi seal, and these two artists should therefore be treated as separate entities.

On the other hand, it is quite possible that Gyokuraku used one or the other of these two names, Uto Gyoshi or Maejima Sōyū, but this cannot be determined today without further evidence. It is perhaps best, at this point, to consider all three artists as separate individuals and to establish stylistic frameworks for each of them.

A great majority of paintings bearing Uto Gyoshi seals belong to the bird-and-flower genre in ink monochrome, executed in bold, clearly defined brushstrokes, sometimes combined with a soft, painterly ink wash. Pictorial elements in these works are arranged in a strongly asymmetrical manner, and they reflect the unmistakable influence of the Shōkei (Kei Shoki) school of painting, which dominated the Odawara area where

artists such as Shikibu Terutada were active. Technical features of Uto Gyoshi's works, such as colors meticulously applied to fill in carefully defined floral petals and foliage, recall idiosyncrasies that distinguish the art of Shōkei and of Shikibu.

In addition to the Burke painting of the musk cat, there are two other examples on the same subject: a diptych of hanging scrolls in the Tokugawa Museum in Nagoya,[10] and a single hanging scroll belonging to the Museum of Fine Arts, Boston.[11] Among the predominantly monochromatic paintings of the bird-and-flower genre by Uto Gyoshi, these works are unique in that they are polychrome, and their painting technique is much more finely detailed and meticulous than in his ink monochrome works. The scrolls in the diptych, impressed with Uto Gyoshi's seals but attributed to Gyokuraku, depict a family of musk cats (two parents and three kittens) in an elaborate composition that includes detailed background settings. Yet the pose of one animal and the foreground rock with a growth of small bamboo are repeated in a manner similar to the Burke scroll in one panel of the diptych. The Boston scroll, which sets a single animal against a background of hibiscus and birds, is similar in dimensions to the Tokugawa Museum's pair but bears no seal. These three paintings were remounted from sliding panels, thus allowing for the possibility that the seals on the Tokugawa diptych may have been impressed surreptitiously at a later date.[12] That these three paintings display fastidiousness and a delicate decorative quality may be due to the fact that they were made as decorative sliding panels. While attribution of these paintings of musk cats to Gyokuraku needs further study, their connection to a Kano artist is not altogether implausible, since the subject was very popular among the early Kano masters.[13]

The *Jakō Neko*, although not native to Japan, nevertheless came to be known among the Japanese as early as the Kamakura period through imported Chinese paintings by such Southern Sung masters as Mao I. His paintings of this animal are mentioned in the early catalogues of Chinese imports, such as the *Butsunichi-an Kōmotsu Mokuroku*, the *Kundaikan Sayūchōki*, and the *Inryōken Nichiroku*.[14] Kano artists painted cats and dogs on screens and hanging scrolls that may not all have featured the *Jakō Neko*. They were also chosen as decorative subjects to adorn rooms used for poetry and tea

parties within the palaces and castles of warlords. Such use of paintings depicting musk cats is reflected in the highly decorative quality of these works.

The same decorative quality may have prompted Einō to assert that Gyokuraku's works can be mistaken for those of Motonobu. As was true with the works of Shikibu Terutada, polychrome paintings by Uto Gyoshi combine the reflective style of Motonobu with the influence of Shōkei in such details as the clearly outlined foliage and flowers, which are filled in carefully with heavy pigments. Although Uto Gyoshi's true identity is still uncertain, it appears that he belonged to a group of Kantō artists who combined the techniques of Motonobu and of Shōkei, as did members of the so-called Odawara Kano school.[15]

NOTES

1. Charles O. Hucker, *The Censorial System of Ming China* (Stanford: Stanford University Press, 1966).
2. Gen Sakamoto, "Painting of Jakō Neko and Problems Concerning the 'Uto Gyoshi' Seal" (Unpublished term paper, Columbia University, New York, Spring semester, 1992).
3. For *Tansei Jakubokushū*, see Sakazaki Shizuka, ed., *Nihon Gadan Taikan* (Survey of Discussions on Japanese Paintings) (Tokyo: Mejiro Shoin, 1917), 923-50; *Bengyokushū* is not published.
4. For the Go-Hōjō family and its cultural activities, see *Go-Hōjō Shi to Tōgoku Bunka* (Go Hōjō Family and Eastern Culture) (Yokohama: Kanagawa Kenritsu Hakubutsukan, 1989).
5. Ueno Kenji, "Kantō Kanryō Uesugi Shi to sono Shūhen: Kano Ha no Shutsuji ni furete" (The Uesugi Clan: Governor of the Kantō Region and Their Milieu, Especially in Connection with the Emergence of the Kano School) in the *Ohta Dōkan Kinen Bijutsu Ten: Muromachi Bijutsu to Sengoku Gadan* (The Ohta Dōkan Memorial Art Exhibition: Art of the Muromachi and Sengoku Periods) (Tokyo: Tokyo Metropolitan Teien Art Museum, 1986), 114-24.
6. For *Honchō Gashi*, see reprint (Tokyo: Kokusho Kankōkai, 1974), 108; see also Nakamura Tanio "Sōyū to Gyokuraku: Shinshutsu no Rikkazu o Chūshin to shite" (Sōyū and Gyokuraku: On Recently Discovered Painting of Flower Arrangement), *Yamato Bunka* 48 (February 1968): 38-46.
7. Kano Einō, *Honchō Gashi*, 93.
8. Yamashita Yūji, "Shikibu Terutada no Kenkyū: Kantō Suibokuga ni kansuru Ichi Kōsatsu" (A Study of Shikibu Terutada—An Observation about *Suiboku* Painting in the Kantō District), *Kokka* 1084 (1985): 26.
9. Nakamura Tanio, *Sesson to Kantō Suibokuga* (Sesson and Ink Painting of the Kantō Region) Nihon no Bijutsu no. 63 (Tokyo: Shibundō, 1971), fig. 139.
10. Tanaka Ichimatsu et al., eds., *Tokugawa Bijutsukan* (Tokugawa Museum) (Tokyo: Tokugawa Bijutsukan, 1962), no. 13; Nakamura, "Sesson to," pl. 22 and fig. 138.
11. Tokyo National Museum and Kyoto National Museum, eds., *Boston Bijutsukan Shozō Nihon Kaiga Meihin Ten* (Exhibition of Japanese Paintings from the Collection of Museum of Fine Arts, Boston) (Tokyo: Tokyo National Museum and Kyoto National Museum, 1983), pl. 41.
12. Sakamoto, "Painting of Jakō Neko," 19ff.
13. Sakamoto, "Painting of Jakō Neko."
14. *Butsunichi-an Kōmotsu Mokuroku* is in Kamakura-shi Shi Hensan Iinkai, ed., *Kamakura-shi Shi: Shiryō Hen II* (Tokyo: Kamakura-shi Shi Hensan Iinkai, 1956), 201-12; for different versions of the *Kundaikan Sayūchōki*, see *Bijutsu Kenkyū* 20 (August 1933): 375-88; 121 (January 1942): 27-36; and 122 (February 1942): 67-77; and see entry for the eighth year of the Eikyō era (1436), fifth month, thirtieth day, in *Inryōken Nichiroku*, ed. Tamamura Takeji and Katsuno Takanobu (Kyoto: Shiseki Kankōkai, 1953), vol. 1.
15. *Ohta Dōkan Kinen Bijutsu Ten: Muromachi Bijutsu to Sengoku Gadan* (The Ohta Dōkan Memorial Art Exhibition: Art of the Muromachi and Sengoku Periods) (Tokyo: Tokyo Metropolitan Teien Art Museum, 1986), 57.

17.

Birds and Flowers of Summer and Autumn

Muromachi period
Shikibu Terutada (active mid sixteenth century)
Diptych of hanging scrolls; ink and color on paper
H. 95.6 x W. 44.8 cm (37½ x 17½ inches) each
SEAL: "Shikibu" on both scrolls
FORMER COLL.: Murayama Ryūhei, Kobe
PUBLISHED: *Ohta Dōkan Kinen Bijutsu Ten: Muromachi Bijutsu to Sengoku Gadan* (The Ohta Dōkan Memorial Art Exhibition: Art of the Muromachi and Sengoku Periods) (Tokyo: Tokyo Metropolitan Teien Art Museum, 1986), pl. 44; Yamashita Yūji, "Shikibu Terutada no Kenkyū: Kantō Suibokuga ni kansuru Ichi Kōsatsu" (A Study of Shikibu Terutada—An Observation about *Suiboku* Painting in the Kantō District), *Kokka* 1084 (1985), fig. 11; "Ryūkyō hitsu Kachō-zu Kai" (Birds and Flowers by Ryūkyō), *Kokka* 461 (April 1929): 95, 100-105.

Like many other masters of the Muromachi period, the painter of this colored diptych and the ink monochrome fan (no. 18) has long been incorrectly identified or confused with other artists. Differing opinions regarding how to decipher the artist's seals have prevented agreement on the painter's name. Until quite recently, this artist was often called Shikibu Ryūkyō. Today, however, the trend is to call him Shikibu Terutada.[1] The confusion over something as basic as his identity is even more surprising given that he was a painter who often impressed two seals on even very small objects (such as the fan-shaped work included here), and whose fairly large oeuvre includes four pairs of folding screens as well as hanging scrolls and fans in both polychrome and monochrome ink. Some of these works are in American collections and have been widely published.[2] The following summary of his life and possible identity owes a great deal to a recent study by Yamashita Yūji, who surveyed the documentary materials that attempted to identify this artist and who tried to establish an artistic profile through the study of extant paintings attributed to him.

At present, only two paintings are known that provide clues to the proper time frame for Shikibu's life. The first is a set of eight hanging scrolls depicting eight views of Mount Fuji, one of which bears a colo-

phon written by the monk Joan Ryūsū, who died in 1536.[3] The other is *Li Po Viewing a Waterfall*, which is in the Nezu Museum, Tokyo. This bears a colophon by the monk Keikin Genkō, who is believed to have died in the southern part of the Kantō area in 1575.[4] Scanty evidence dates Shikibu's life span from the second quarter to the latter part of the sixteenth century.

The confusion surrounding this artist's identity existed as early as the late seventeenth century, about a century after the presumed date of his death. Kano Ikkei (1599-1662), a Kano painter and author of the first history of Japanese painting, the *Tansei Jakubokushū*,[5] deciphered one of Shikibu's seals as "Ryūkyō" and identified this name as another artistic name used by Kenkō Shōkei (also known as Kei Shoki, active 1478-1506), an artist who worked at Kenchōji in Kamakura. Over a century and a half later, Hiyama Tansai (1774-1842), in his *Kōchō Meiga Shūi* (*Selected Masterpieces of Japanese Painting*) of 1819, determined that the name "Ryūkyō" belonged to yet another painter of Kamakura, Chūan Shinkō, who is believed to have been Shōkei's painting teacher. It was only in 1905, in the revised edition of the *Koga Bikō* (*Notes on Old Painters*),[6] that "Ryūkyō" was finally recognized as an independent artist, and his two seals, such as those impressed on the Burke fan painting, were deciphered as "Terutada" (upper, rectangular relief seal) and "Shikibu" (lower, square intaglio seal). The lower seal had often been read as "Ryūkyō" in the past. Still, this newer reading has not been accepted unanimously, and disputes over this and the larger question of Shikibu's artistic identity persist to this day. Yamashita's study is an attempt to correct the past misunderstandings of this artist's artistic lineage and to set his art in proper perspective.

Despite confusion over the seals, from very early on there has been general agreement that Shikibu's art pointed the way to Kamakura, the area where two

artists, Chūan Shinkō and Shōkei, were known to have been active (these artists, too, were once thought to be one and the same person). Examination of about thirty extant paintings that bear Shikibu's seals also suggests that, indeed, he was closely connected with this area of Japan. There are paintings among his oeuvre that display the unmistakable influence of Shōkei, especially in their structural solidity, unity of composition, and clear definition of details. Yet Shikibu's paintings reveal stylistic traits that set him apart from the rather insular style of other Kamakura-based artists, and this difference can be understood properly only when viewed in its relationship to the contemporary metropolitan style.[7]

Some modern scholars also see strong stylistic connections between the work by this artist and another enigmatic artist who used a seal reading "Uto Gyoshi" (no. 16). Uto Gyoshi is believed to have been one of Kano Motonobu's pupils from Odawara, near Kamakura, where this Kano master's painting style had a loyal following. Motonobu's pupils in Odawara are sometimes referred to as the "Odawara Kano school," to distinguish them from his pupils in Kyoto. Odawara, now a slumbering provincial town east of better-known Hakone, enjoyed a brief period of cultural effervescence during the sixteenth century, when it served as the seat of the military government ruled by the family that adopted the name of Hōjō. This family is often called Go-Hōjō (the Latter-day Hōjō) to differentiate it from an earlier family of the same name (see no. 16).[8] Under a new administration, which started in 1495, a large group of merchants, craftsmen, and artists poured into Odawara and helped it to become a bustling castle town. A succession of Go-Hōjō rulers, who came to reign over a large part of the Kantō region in eastern Japan, showed a strong interest in cultural matters. Zen monks were invited from Daitokuji in Kyoto, and with them came the masters of various arts, such as *chanoyu*, *renga*, *waka*, Noh, and others. The Go-Hōjōs were also aggressive collectors of both Japanese and Chinese art, and this no doubt attracted painters like Sesson Shūkei, who most likely went there to study the Chinese paintings in their collection. Other painters from the Kyoto area migrated to Odawara as well. Its glory was brief, lasting only until 1590; then the city and the Hōjō rule collapsed under Toyotomi Hideyoshi's attack on the castle. The artistic collections of the Hōjōs were dispersed.

Shikibu seems to have found his way to this city and Hōjō patronage, since his paintings of Daruma[9] had been in the possession of Sōunji in Hakone, near Odawara, the site of the Hōjō family temple. However, Shikibu's activities may have gone beyond the confines of eastern Japan and warrior patronage. One of the paintings of Mount Fuji bears a colophon written by a monk who was from Kyoto.[10] Shikibu's mature paintings are considered to be the fruits of his successful assimilation of the art of Motonobu and Shōkei. This is best exemplified by a pair of screens, *Monkeys on Rocks and Trees*, in the Kyoto National Museum.[11] These screens reveal a strong dependence on Motonobu's soft, watery style, as well as the unmistakable residue of the Shōkei style—a successful combination that resulted in the formation of his own highly idiosyncratic mode.[12]

The Burke Collection is fortunate to own two sets of Shikibu's paintings from two different periods in his career. The diptych *Birds and Flowers of Summer and Autumn* is among the earliest known works to reflect his strong dependence on Shōkei's art. The fan painting (no. 18) is from his later, mature period.

The right-hand scroll of the diptych depicts plants of summer: red and white hibiscus and a brownish lily whose stalks are gathered in the lower right corner. The ground line is set low, helping to create a sense of open space beyond. Yet the tallest flower stalk effectively competes with and negates the sense of distance as it towers over the light blue, rhythmically repeated concave profiles of the distant hills, which culminate in towering thin peaks. On the other hand, the other tall plants help create a feeling of a small, enclosed field of vision. The two jays soaring high above the plants heighten the sense of unlimited verticality in the composition.

The two birds seem to be responding to the call of their companion in the left scroll, which depicts hibiscus and late summer flowers—chrysanthemums and miscanthus grasses. Below, in the middle, is a handsome but stiff-looking bull-headed shrike perched on a solid, shell-like rock; it seems to be giving a command to the three other birds. The feeling of density and impenetrability is even stronger in this composition, as the pictorial elements are packed in the lower left area while the plants extend long blades that tower over the

distant peaks. The preoccupation with and profusion of details, especially evident in the left scroll, are distinct features of Shikibu's art and became even more pronounced in his later large-scale compositions, works such as the screens of *Monkeys on Rocks and Trees* in the Kyoto National Museum and *Landscape* in San Francisco.

This diptych reveals Shikibu's close dependence on Shōkei's art. Shōkei, a Zen monk from Kenchōji in Kamakura, is known to have studied in Kyoto under Geiami (1431–1485, also called Shingei), who gave Shōkei one of his paintings in 1480 as proof of the completion of his study. This painting, *Li Po Viewing a Waterfall* (now in the Nezu Museum in Tokyo), contains a number of stylistic features that formed the basis of Shōkei's landscape painting.[13] These include the absence of distance, structural solidity, and profusion of details. These features were then transmitted by Shōkei to his followers, artists such as Shikibu, Keison, and many others. As in Shōkei's paintings, the rocks in Shikibu's diptych are outlined in dark, clearly articulated brushwork, and the surface has the feeling of brittle, shell-like hardness as the parallel strokes are regularly interrupted by short strokes that meet them at right angles. The density of brushwork and the pronounced concavity of the distant hills also reveal the stylistic features shared by many of Shōkei's followers in the Kamakura area.

Shōkei's paintings in the bird-and-flower genre, like the one in the Kyoto National Museum, may have served as a model for this Shikibu diptych.[14] The authoritative look of the stiff-posed bird with an open beak in Shikibu's left-hand scroll is clearly derived from Shōkei's painting. Some technical features, such as the outlining of leaves and flowers with strong ink lines filled in by solid colors, reflect the manner of the Chinese Sung academy style in works of this genre. This convention must have been adopted by Shōkei while he was in Kyoto, where he is known to have copied Chinese paintings through the help of his teacher Geiami, the keeper of the Ashikaga shogun's art collection. The strong ink line also became popular among Shōkei's followers.[15]

Unlike the majority of Shikibu's paintings, this diptych bears only one seal on each panel. Both seals read "Shikibu," but they are almost lost in the densely packed corners of the composition. It must be noted that Shikibu's earliest datable paintings of Mount Fuji—and a few others including some fans, *Li Po Viewing a Waterfall*, and this diptych—constitute a small minority of the works that bear only this seal. Large-scale paintings, the screens, and small paintings in a more mature style are impressed with two seals, those of "Shikibu" and "Terutada." It is still premature to regard this difference as indicative of a chronological evolution, but it is quite possible that Shikibu used the "Terutada" seal with the "Shikibu" seal only in his mature years.

NOTES

1. For the past attempts to decipher his seals see Yamashita Yūji, "Shikibu Terutada no Kenkyū: Kantō Suibokuga ni kansuru Ichi Kōsatsu" (A Study of Shikibu Terutada: An Observation about *Suiboku* Painting in the Kantō District), *Kokka* 1084 (1985): 11–31.
2. For his works in U.S. collections see John Rosenfield, ed., *Japanese Paintings from the Sanso Collection* (Seattle: Seattle Art Museum, 1979), pl. 20; and Shimada Shūjirō, ed., *Zaigai Hihō* (Japanese Paintings in Western Collections) (Tokyo: Gakken, 1969), pls. 99–100, for the pair of landscape screens in the de Young Museum.
3. Yamashita, "Shikibu," figs. 16–21.
4. Kawai Masatomo, *Muromachi Jidai Suibokuga no Keifu* (Ink Monochrome Painting of the Muromachi Period) (Tokyo: Nezu Museum, 1992), no. 57; also Yamashita, "Shikibu," fig. 13.
5. This essay is reproduced in Sakazaki Shizuka, ed., *Nihon Gadan Taikan* (Survey of Discussions on Japanese Paintings) (Tokyo: Mejiro Shoin, 1917), 923–50.
6. Asaoka Okisada, *Koga Bikō* (Notes on Old Painters), revised and enlarged by Ōta Kin as *Zōtei Koga Bikō* (1904; reprint, Tokyo: Yoshikawa Kōbunkan, 1912), 795–99.
7. Yamashita, "Shikibu," 23.
8. A good summary of the Go-Hōjō rule and its art patronage can be found in an exhibition catalogue, *Go-Hōjō Shi to Tōgoku Bunka* (Go-Hōjō Family and Eastern Culture) (Yokohama: Kanagawa Kenritsu Hakubutsukan, 1989).
9. Yamashita, "Shikibu," fig. 22.
10. The other painting of *Li Po Viewing a Waterfall* bears a colophon that was written by a monk who was also from Kyoto but who died in the Kamakura area, suggesting a possibility that Shikibu might have befriended him there, rather than in Kyoto.
11. Michael Cunningham et al., *The Triumph of Japanese Style: Sixteenth-Century Art in Japan* (Cleveland: The Cleveland Museum of Art, in cooperation with Indiana University Press, 1991), no. 14.
12. Yamashita, "Shikibu," 26.
13. Tanaka Ichimatsu and Yonezawa Yoshiho, *Suiboku Bijutsu Taikei* (Ink Monochrome Painting) (Tokyo: Kodansha, 1978), pl. 28.
14. *Ohta Dōkan Kinen Bijutsu Ten: Muromachi Bijutsu to Sengoku Gadan* (The Ohta Dōkan Memorial Art Exhibition: Art of the Muromachi and Sengoku Periods) (Tokyo: Tokyo Metropolitan Teien Art Museum, 1986), pl. 10.
15. Yamashita, "Shikibu," 21.

18.

Fan Painting of a Landscape

Muromachi period
Shikibu Terutada (active mid sixteenth century) *Mature work*
Painting on a fan-shaped paper, mounted as a hanging scroll;
ink and gold pigment on paper
H. 20.7 x W. 53 cm (8⅛ x 20⅞ inches)
SEALS: "Terutada," "Shikibu"
FORMER COLL.: Inoue Collection

A gold-colored mist envelops a fishing village nestled among trees, and tall hills loom over a cluster of houses like gigantic summer clouds. A lone fishing boat is moored on the shore and the small flag of a wine shop is almost lost among the thick growth of vegetation on land. Not a single human figure is depicted, a hint of the hushed calm at the end of day. If the gold-colored clouds are indeed meant to suggest evening mist, rather than an early morning's vaporous air, it is most likely that this fan painting was one of a set of eight paintings that together depicted *Eight Views of the Hsiao and Hsiang Rivers* in south China (see no. 21). The existence of another fan painting (formerly in the Kusaba Collection), which is close to this fan in dimensions and style, seems to bolster this hypothesis.[1] The Burke Collection fan may depict the theme of *Fishing Village in Evening Glow*, while the other may be *Returning Sail off Distant Shore*.

Among the Chinese themes for landscape painting that were adopted by the Japanese, no other subject can match in popularity the *Eight Views of the Hsiao and Hsiang Rivers*. The set depicted, in eight scenes, the general area north of Changsha, south China, where the two rivers meet, eventually to empty into Tung-t'ing Lake. The eight themes are:

Mountain Market, Clear with Rising Mist
Returning Sail off Distant Shore
Fishing Village in Evening Glow
Evening Bell from Mist-shrouded Temple
Night Rain on Hsiao and Hsiang
Wild Geese Descending to a Sandbar
Autumn Moon over Lake Tung-t'ing
River and Sky in Evening Snow [2]

Many ink painters of the Muromachi period painted this theme, in large and small formats, almost always preferring the use of the painterly wash over the linear brush technique. In Shikibu's fan, which, judging from the absence of creases, was never made into a real fan, dry, coarse brushstrokes in dark ink merely suggest thick vegetation without defining its details. The dark ink tones unite and enliven the pale ink wash that covers the hillocks in the foreground and middle ground, and the rising mountains in the distance. While rough brushstrokes that delineate the vegetation may recall the manner of Yü-chien, a Southern Sung artist, the composition of this fan painting and the one in the former Kusaba Collection, the rendering of gentle ink tones for the round mountains in the distance, and the general layout of the pictorial elements vividly recall a section of large sliding panels that decorate a room in the Kyoto temple of Daisen-in.[3] These screens of 1513 by Sōami (also known as Shinsō, d. 1525), a leading ink painter and curator of the shogunal collection of Chinese art objects, clearly reflect his intimate knowledge of handscrolls by another Southern Sung artist, Mu-ch'i, especially the *Fishing Village in Evening Glow* (now in the Nezu Museum).[4] While there is no proof that Shikibu was in Kyoto, or had first-hand knowledge of either Sōami's or Mu-ch'i's painting, he may have learned about Mu-ch'i's celebrated work through Shōkei, who studied painting in Kyoto for three years, from 1478 to 1480, with Shingei (or Geiami, 1431-1485), who is thought to have been Sōami's father.

In this fan painting, the evocative, atmospheric quality of the landscape is heightened by the pale wash of ink that merges delicately with lightly brushed gold ink. Also, the gold-colored mist and red ink of the two large seals for "Shikibu" and "Terutada" give the painting an especially decorative quality.

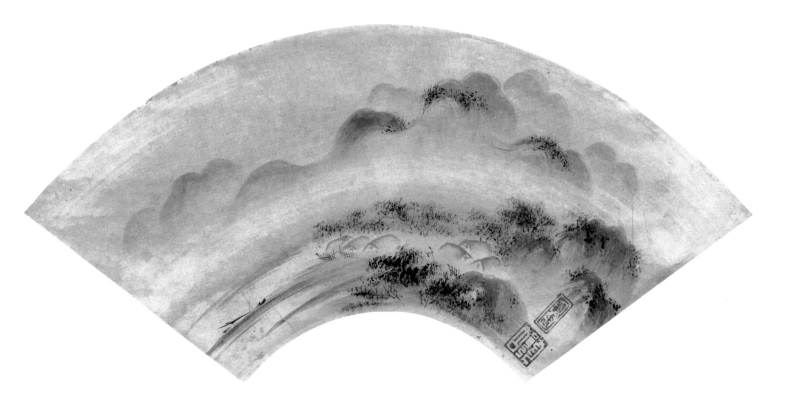

Inscriptions written by the past owners on the lid of the boxes containing the two Burke paintings by Shikibu betray the past confusion about this artist's identity. They both state that the boxes contain "paintings by Kei Shoki."

NOTES

1. Matsushita Taka'aki, *Muromachi Suibokuga* (Suiboku Painting of the Muromachi Period) (Tokyo: Muromachi Suibokuga Kankōkai, 1960), vol. 1, pl. 96.

2. Translation of the themes is by Alfreda Murck. See her "Eight Views of Hsiao and Hsiang Rivers by Wang Hung," in Wen C. Fong et al., *Images of the Mind: Selections from the Edward L. Elliott Family and John B. Elliott Collections of Chinese Calligraphy and Painting at the Art Museum, Princeton University* (Princeton: The Art Museum, Princeton University, 1984), 213.

3. Watanabe Akiyoshi, *Shōshō Hakkei Zu* (Eight Views of the Hsiao and Hsiang Rivers), Nihon no Bijutsu no. 124 (Tokyo: Shibundō, 1976), fig. 7.

4. An attribution to Mu-ch'i is not accepted by most modern scholars, but the Japanese in the past firmly believed it. Also, for works by Mu-ch'i and Yü-chien, see Watanabe, "Shōshō," figs. 3, 4, 27, and 28 for Mu-ch'i, and figs. 30 and 31 for Yü-chien.

19.

Pheasants and Azaleas
Golden Pheasants and Loquat

Late Muromachi-Early Momoyama period, second half of the
sixteenth century
Kano Shōei (1519-1592)
Pair of hanging scrolls; ink and color on paper
H. 101 x W. 49 cm (39¾ x 19⁵⁄₁₆ inches) each
SEAL: "Naonobu"
PUBLISHED: Tsuneo Takeda, *Kano Eitoku*, trans. H. Mack Horton
and Catherine Kaputa (Tokyo, New York, and San Francisco:
Kodansha International and Shibundō, 1977), pls. 43-44.

This pair of hanging scrolls, which depicts pheasants
and flowers in a landscape setting, bears the cauldron-
shaped "Naonobu"[1] seal of Shōei, third-generation
head of the Kano school of painters. Although some-
what overshadowed by the achievements of his father
Motonobu (ca. 1476-1559) and his son Eitoku (1543-1590),
Shōei was highly regarded during his own lifetime as a
master of the Kano style of ink brushwork. He was
commissioned to create works of art for prestigious
temples and Shinto shrines, occasionally in concert
with his celebrated son, and is also known to have pro-
duced at least two paintings for the Imperial court.[2]
Among his best-known works are the ink-mono-
chrome *fusuma* on various themes that he created for
the Jukō-in, a subtemple of Daitokuji, in 1566; however,
many of his extant paintings on folding screens, hang-
ing scrolls, and fans feature bird-and-flower composi-
tions, at which he apparently excelled. A collection of
artists' biographies written in 1649 claimed that Shōei
was most skilled in painting bird-and-flower images in
color,[3] and later Edo-period guidebooks to the old
capital city, like the *Miyako Rinsen Meisho Zue* of 1799,
made reference to bird-and-flower *fusuma* that he pro-
duced for the Zuihōin, another Daitokuji subtemple.[4]
Some of his bird-and-flower scenes were rendered in
ink alone, others in the brilliant colors against gilded
paper beloved of the Momoyama period.

Bird-and-flower painting, which flourished in
Imperial circles of China's Northern and Southern
Sung dynasties, was perpetuated by court and profes-
sional artists of the Ming dynasty; having been brought

to Japan, it formed an important component of the
Kano-school repertoire. During the turbulent six-
teenth century, birds symbolic of power and martial
prowess, like the hawk; longevity, like the crane; or
imperial elegance, like the pheasant, were combined, in
paintings, with similarly auspicious plant motifs.
Enlarged, defined with strong ink brushstrokes, given
brilliance by the application of thick, vibrant colors,
and set against the opulent background of gold leaf on
folding or sliding screens, these images took on a
heroic, dynamic quality. While lacking the literary-
poetic associations of earlier *yamato-e* depictions
of flowers, plants, or birds in landscapes, their gran-
deur was appreciated by the wealthy members of
Momoyama-period warrior society, as well as the more
affluent Buddhist temples of the era. They were also
impressive, if less monumental, as subjects of hanging
scrolls such as the Burke pair. Like many larger-scale
Kano-school works, these paintings emphasize fore-
ground elements and convey the impression of limited
spatial recession through the use of horizontally
layered pictorial elements—water, rocks, or lightly
outlined distant mountains.

The right scroll features a pair of pheasants at the
foot of an evergreen tree bent and twisted into a
reversed S-shape typical of a number of paintings by
Shōei.[5] The prominent h-shaped root is characteristic
of Kano-school ink painting; ink wash and short
brushstrokes executed with a relatively dry brush
model the trunk. On the left, a large rock, given form
by strong outlines and "ax-cut" strokes derived from

Kano

Begin
Momoyama

rovides a coun-
of water,
to a vague mist,
nteract any
ndelions and
season, while
tive of summer.
e feathers on the
ated with fine,
gment. The
lso touched

ight scroll is
f exotic golden
ove which the
S-curve of a loquat tree echoes, in reverse, the compo-
sition of the right-hand image. Both the loquat and the
bamboo give the impression of being bent by the wind,
as do the withered reeds below the rock. The agitation
of the water, with its waves and foam, contrasts with
the placid ripples of the right scroll. Again, two seasons
are apparently represent~~ed: the bent and withering~~
grasses imply autumn, w
berried spearflowers are
their counterparts in the
beautifully detailed. The
bird's breast recalls the c
brushstrokes are just dis
tail, and crest, as well as
mate. In both paintings,
with the Kano-school fo
strokes, "ax-cut" strokes
and wet ink dots, appliec
vegetation.

This pair of hanging s
other bird-and-flower ii
compositional elements
in works by his father an
Shōei's paintings, paralle
of bird-and-flower scree
Agency for Cultural Aff;
with touches of light col
beneath pine trees on th
pheasants on the left.[6] Al
angular mode of brushw
in the placement of the t

the golden pheasants, seated together to form an
X-shaped motif—and in the simple, limited treatment
of spatial depth. Another pair of folding screens at the
temple of Saikokuji in Hiroshima prefecture, generally
attributed to an artist of Shōei's studio rather than
the master himself, features a pair of pheasants similar
to those in the Burke *Pheasants and Azaleas*. Also
reminiscent of the Burke scrolls in its formal style is a
single six-fold screen entitled *Rooster and Pines*, in the
Museum of Fine Arts, Boston; painted in ink and color,
it bears an inscription by Kano Tan'yū (1602-1674)
attributing the painting to Shōei.[7]

Shōei clearly adopted the compositions in both
hanging scrolls from patterns established for the Kano
studio during Motonobu's tenure as leading master of
the school. Ink sketches of designs for screen paintings,
produced by Motonobu in a handscroll format,[8] exhibit
arrangements of birds, flowers, and trees that almost
exactly match those found in the Burke paintings.
A pair of privately owned bird-and-flower folding
screens attributed to Motonobu[9] and painted, like
Shōei's peacock and pheasant screens, in ink with light
touches of color, may also have served as an inspiration;
the pair of pheasants in the left screen, seated on a
craggy, curved boulder, are undoubted prototypes for
the birds in *Golden Pheasants and Loquat*. These same
paired pheasants also appear in the wall paintings that
Motonobu created for the Daisen-in subtemple of
Daitokuji in 1513.

While Shōei's hanging scrolls are difficult to date,
owing to the rarity of contemporary written references
to his work and firmly dated paintings, recent scholar-
ship has noted similarities of execution between the
male bird in *Pheasants and Azaleas* and the pheasant that
appears in a large hanging scroll of the Nirvana, or
Death of the Buddha, painted by Shōei for Daitokuji
in 1563.[10] The handling of floral motifs in the Burke
paintings is comparable to that of the Boston screen,
although treatment of some pictorial elements in the
Burke scrolls, in particular the use of rounded strokes
of color, rather than line, to indicate volume and tex-
ture of plumage in the right scroll, is somewhat softer
and less linear. It seems evident that the Boston screen
was executed before Shōei's work began to reflect
elements of his son Eitoku's more vigorous style,[11] and
features shared by this screen, the Burke paintings,

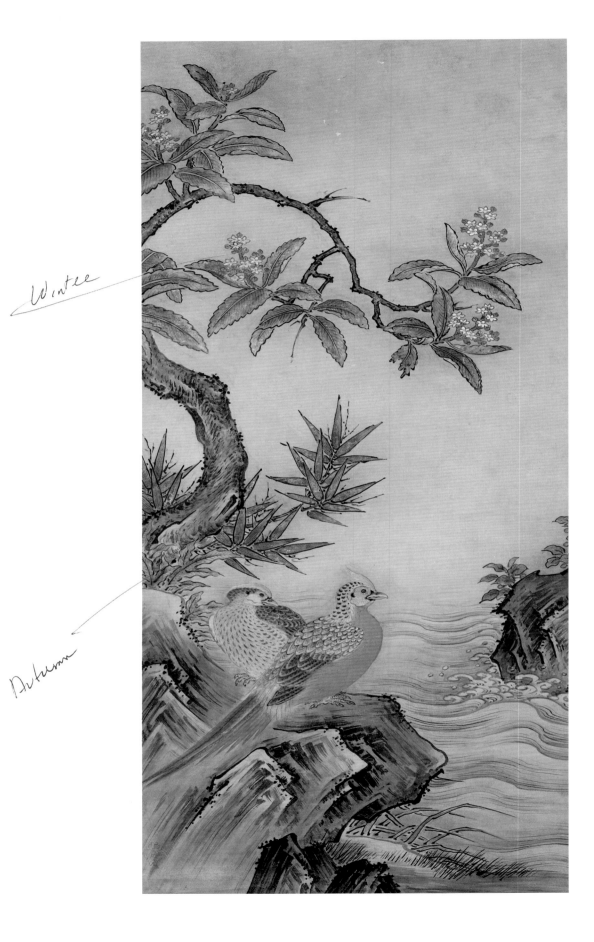

Winter

Autumn

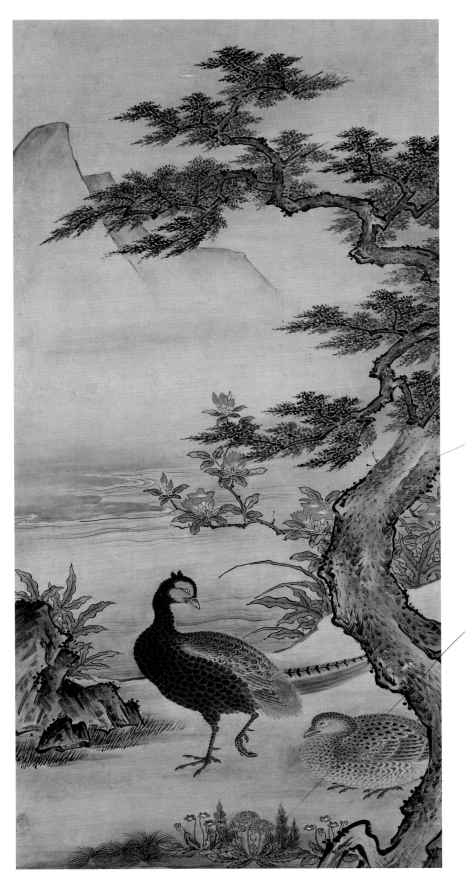

Summer

Winter
Spring

and the Daitokuji Nirvana suggest that all were painted within a few years of each other. It is possible, then, that the Burke hanging scrolls were executed during the early 1560s, before Shōei embarked on his 1566 collaboration with Eitoku to decorate the interior of the Jukō-in. sw

NOTES

1. "Naonobu" is one of the names by which Shōei was known before his probable elevation to the honorary Buddhist rank of Hōgen. See Carolyn Kelley Wheelwright, *Kano Shōei* (Ph. D. diss., Princeton University, 1981), 8-9.
2. One of these, a fan, was painted for the court in 1566; the other, a portrait of courtier Yoshida Kanesuke, was executed in 1572. These objects, neither of which is extant, are among the few works by Shōei to which a precise date can be assigned. See Wheelwright, *Kano Shōei*, 4.
3. Ibid., 364-65.
4. Ibid., 19-20 and 364-65.
5. This angular S-shape appears in Shōei's *fusuma* of monkeys, bamboo, and tigers in the Jukō-in of Daitokuji in Kyoto; his ink monochrome folding screens, *Flowers and Birds of the Four Seasons* (private collection); and a pair of folding screens of the *Twenty-four Paragons of Filial Piety* (private collection, Japan), among other paintings. These are reproduced together in Tsuneo Takeda, *Kano Eitoku*, trans. H. Mack Horton and Catherine Kaputa, *The Japan Arts Library* (Tokyo, New York, and San Francisco: Kodansha International and Shibundō, 1977), pls. 34, 36, and 38.
6. These screens also bear the "Naonobu" seal. See Michael R. Cunningham et al., *The Triumph of Japanese Style: Sixteenth-Century Art in Japan* (Cleveland: The Cleveland Museum of Art, in cooperation with Indiana University Press, 1991), 50-51.
7. It has been noted that in this screen the artist relied fairly heavily on Motonobu's style of brushwork; it is therefore unlikely to be an example of Shōei's late work. See discussion in Miyeko Murase, *Masterpieces of Japanese Screen Painting: The American Collections* (New York: George Braziller, 1990), 41; reproduced on 42-43.
8. Reproduced in several publications, most recently in *Muromachi-jidai no Byōbu-e (Muromachi Period Screen Painting)* (Tokyo: Tokyo National Museum, 1989), pl. 97.
9. Discussed in ibid., 245; reproduced, pl. 71.
10. Wheelwright, *Kano Shōei*, 72.
11. Ibid., 374.

20.

Melons

Muromachi period, sixteenth century
Yamada Dōan
Hanging scroll; ink on paper
H. 33.7 x W. 46.3 cm (13¼ x 18⅛ inches)
SEAL: "Yamada-shi Dōan"

This image of melons rendered in ink against a neutral background bears the seal of the painter Yamada Dōan. The exact identity of Dōan, however, is obscured by varying biographical accounts of three generations of artists with this name, which are found in Edo-period histories of painting.[1] Moreover, the diversity of pictorial subject matter—which also includes landscapes and figures—and styles represented by paintings with

Dōan's seals further complicates the question of attributing these works to one artist.[2]

Paintings with the seal reading "Yamada-shi Dōan," which is affixed to this picture of melons, are sometimes associated with the oeuvre of the first-generation Dōan, lord of Yamada castle in Yamato province (present-day Nara prefecture), who belonged to a collateral branch of the Tsutsui family and may have died in 1573.[3] Dōan was a samurai who lived during the so-called Sengoku era (late fifteenth to sixteenth centuries) when civil wars were prevalent in various provinces of Japan.[4] His particular skill at painting images of fruits is referred to in the *Fūsō Meikō Gafu* (*Record of Japanese Artists and Paintings*), an early eighteenth-century history of painting.[5]

Although the Edo-period histories do not detail other aspects of Dōan's life, it is possible that as a

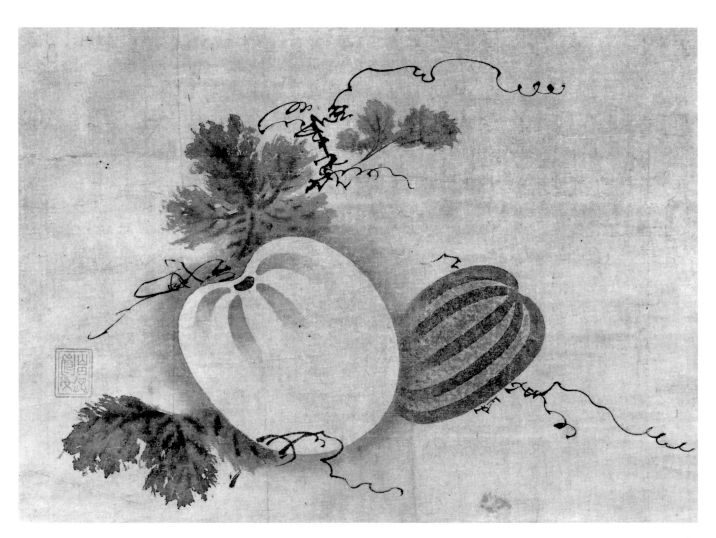

literate member of the military elite he was attracted to the culture available in Zen circles, where he could have learned the technique of ink painting. Indeed, the name Dōan is considered to be one adopted after he took Buddhist vows,[6] possibly as a lay practitioner. The seventeenth-century *Honchō Gashi* (*History of Japanese Painting*) mentions that Dōan studied Sung painting and was a follower of Shūbun and Sesshū, who were affiliated with the Zen temple Shōkokuji.[7] In a general context, Dōan's painting of melons reflects an interest in naturalism, the source being paintings of the Sung dynasty that served as models for Japanese monk artists. The category of fruits and vegetables as pictorial genre is, for instance, cited in the *Hsüanho huap'u*, the catalogue of the Northern Sung Emperor Hui-tsung's art collection (reigned 1100-1125).[8] And in Japan during the Muromachi period, paintings of this theme were often associated with the Southern Sung master Mu-ch'i (flourished mid thirteenth century).

Pictures of fruits and vegetables were displayed in Zen temples for various events. Their production is related to the practice of offering actual fruits and vegetables (symbolic of a monk's diet, which excluded meat) to a religious icon or the image of a Buddhist founder.[9] Considering the relatively small size of Dōan's painting, however, it may have been used as ornamentation in a room designed for a tea gathering. A painting of melons traditionally attributed to Mu-ch'i, for example, has long been treasured as a seasonal *saga* (literally, "tea painting") appropriate for display in the summer.[10]

The abbreviated brush manner used to demarcate leaves and the contrasting tonalities—of areas in reserve and ink wash without contour lines—that define the ridges of the melons are stylistic features consistent with other examples of ink paintings by Zen monks.

Although a detailed rendering in ink and color of a squirrel eating a melon is attributed to Dōan,[11] stylistically this melon painting is more closely related to another work of the same theme by the late fifteenth century monk-painter Yōgetsu (see no. 9). Dōan's work reflects the same generic mode that was employed by the latter, who may also have been a follower of Shūbun and Sesshū.[12]

GWN

NOTES

1. Yoshiaki Shimizu and Carolyn Wheelwright, eds., *Japanese Ink Paintings from American Collections: The Muromachi Period* (Princeton: The Art Museum, Princeton University, 1976), 90. An outline of the conflicting and unclear biographical information found in different textual sources related to the three generations of artists with this name is provided in the discussion of a Hotei painting by Dōan (see pp. 90-92).
2. Ibid., 90.
3. Tanaka Ichimatsu and Nakamura Tanio, eds., *Suiboku Bijutsu Taikei* (Ink Monochrome Painting) (Tokyo: Kōdansha, 1973), 7:192.
4. Tokyo National Museum, ed., *Nihon no Suibokuga* (Japanese Ink Painting) (Tokyo: Tokyo National Museum, 1987), 164.
5. Dōan's expertise in painting fruits is also mentioned in the *Gakō Ryakuden,* another Edo-period history of painting (quoted in the *Koga Bikō;* see no. 17, n. 6). See Shimizu and Wheelwright, *Japanese Ink Paintings,* 91.
6. Kasai Masa'aki et al., eds., *Yakuchū Honchō Gashi* (Kyoto: Dōhōsha, 1985), 244.
7. Ibid., 90.
8. Yoshioka Yukio, ed., *Nihon no Ishō* (Design in Japanese Art) (Kyoto: Kyoto Shoin, 1986), 14:163.
9. Tanaka and Nakamura, *Suiboku Bijutsu Taikei,* 7:186.
10. Nakamura Tanio, *Shiki no Saga* (Tea Ceremony Paintings for the Four Seasons) (Tokyo: Kyūryūdō, 1990), 114-15.
11. *Ohta Dōkan Kinen Bijutsu Ten: Muromachi Bijutsu to Sengoku Gadan* (The Ohta Dōkan Memorial Art Exhibition: Art of the Muromachi and Sengoku Periods) (Tokyo: Tokyo Metropolitan Teien Art Museum, 1986), pl. 68, p. 96.
12. Yōgetsu's ink painting of melons is reproduced in Tanaka and Nakamura, *Suiboku Bijutsu Taikei,* 7:138, pl. 96.

21.

River and Sky in Evening Snow, from the Eight Views of the Hsiao and Hsiang Rivers

Momoyama period
Painting by Kaihō Yūshō (1533–1615)
Calligraphy by Seishō Shōtai (1548–1607)
Hanging scroll; ink and gold ink on paper
H. 71.5 x W. 37.8 cm (28¼ x 14¾ inches)
SEALS: "Yūshō", "Seishō" (?)
PUBLISHED: Ōta Hirotarō, Yamane Yūzō, and Yonezawa Yoshiho, eds., *Shōgakkan Gallery: Shinpen Meihō Nihon no Bijutsu* (New Collection of Masterpieces of Japanese Arts) (Tokyo: Shōgakkan, 1991), vol. 21, pl. 23; Kawai Masatomo, "Yūshō hitsu Shōshō Hakkei Zu" (Shōshō Hakkei—Scenery of Hsiao Hsiang—by Kaihō Yūshō), *Bijutsu Shi* 63 (December 1966), fig. 4.

Ten thousand li of water
 are like ten thousand li of heart;
Snow flowers flutter in the wind
 over the forest below,
The bridge eases the hoofs
 of the horse across the path,
Yet there is no turning around
 at the parting gate in the distance.

[Quoted from] *the old Yü-chien poem, inscribed by the old man Shōtai*[1]

This poem describes the scene known as *River and Sky in Evening Snow*, one of the *Eight Views of the Hsiao and Hsiang Rivers*. Five lines of writing in dark ink seem to float in the vast, vaporous void, defining the painting's middle ground and separating the far from the near. A distant hill and the snow-laden trees clinging to the mass of the mountain are barely visible in a frozen haze behind the written lines. A large boulder, which supports the snow-covered trees, has a startling sense of reality as the only solid and weighty form within the frosty atmosphere. A faint gold wash gives a hint of light in this otherwise still, dim world of winter cold.

Among the many Chinese landscape painting motifs that enjoyed great and lasting popularity among Japanese ink painters, the *Eight Views of the Hsiao and Hsiang Rivers* (*Shōshō Hakkei* in Japanese) stands apart from all others, especially in terms of the influence it exerted on Japanese monochrome ink landscape paintings. The theme of the eight views[2] refers to scenery spread over a wide area of the provinces of Hunan and Chianghsi in south China, where the Hsiao River flows into the Hsiang, eventually to empty into Lake Tung-t'ing after absorbing other rivulets and canals along the way. Criss-crossed by these tributaries, the marshy region is extremely humid and subject to sudden shifts in weather. With its low-lying hills often shrouded in clouds, and the largest lake of China, this area was the source of a rich tradition in literature, including ancient myths, popular lore, and historical tales. Many literati of ancient times were also inspired by the area. By the late Northern Sung dynasty, some had attempted to depict various scenes from this moist region with its constantly shifting weather and light.

Tradition has it that the Northern Sung painter Sung Ti (eleventh century) was the first to paint these scenes in a group of eight. Although this tradition is debatable, it was around this time that the group of eight paintings was accepted as an iconographic type, since each painting expressed some fundamental element of Chinese landscape painting in a succinct manner. The group provided painters with a formula to represent not only the mountains and rivers but also the scenery's appearance at different times of the day, in different seasons of the year, and in changing weather and shifting light.

Although Sung Ti apparently painted the eight scenes several times over, not a single work has survived. The general appearance of his paintings of this subject, however, can be surmised from the poems they inspired.[3] Such literary evidence suggests that Sung Ti's paintings, most likely executed in a handscroll format, did not necessarily depict the actual views but rather portrayed scenery that was suggestive of the mood and the impressions of the place.

Sung Ti's eight views seem to have inspired many other Chinese artists, and their works were sometimes the source of poems. All these poems came to be known by titles suggested by the scenes they evoked:

Mountain Market, Clear with Rising Mist
Returning Sail off Distant Shore
Fishing Village in Evening Glow
Evening Bell from Mist-shrouded Temple
Night Rain on Hsiao and Hsiang
Wild Geese Descending to a Sandbar
Autumn Moon over Lake Tung-t'ing
River and Sky in Evening Snow [4]

While the subject of the eight views lost favor among the Chinese after the end of the Southern Sung dynasty, it came to enjoy a lasting popularity in Japan, where it struck a chord in Japanese sensitivity. The eight views were introduced to Japan, perhaps as early as 1299, by Ishan Ining (d. 1317 in Japan), a Chinese emigré monk. A weak attempt to use this theme was made by an early fourteenth-century Japanese ink painter named Shikan (or Shitan), whose *Descending Geese* bears a colophon by the emigré monk. Chinese representations of this subject were also imported, and some of them became the most revered, treasured, and frequently copied works in Japan. Among the works were those by the thirteenth-century artists Yü-chien and Mu-ch'i of the Southern Sung dynasty: both were originally handscrolls.[5] The one considered to be Mu-ch'i's was in the collection of the third Ashikaga shogun Yoshimitsu (1358-1408), and it was still in the possession of the Ashikaga family at the time of the eighth shogun Yoshimasa (1435-1490). The latter also owned the Yü-chien scroll but had it cut into eight sections. The Mu-ch'i scroll was also cut into eight sections, four of which have survived. Only three sections of the Yü-chien scroll are extant.[6] Each scene in

Yü-chien's representation includes a poem, which, accompanied by the title, enables one to identify each section.[7] These three scenes are *Mountain Market*, *Returning Sail*, and *Wild Geese*.

Both paintings by Mu-ch'i and Yü-chien are executed in the washy, nonlinear, soft technique best suited for the depiction of the moist and humid atmosphere that softens the harsh outlines of landscape. This technique is known as *haboku* (broken, or splashed-ink). Clear outlines are replaced by a soft, painterly wash, then given accents by darker, drier ink, which is applied while the wash has not quite dried. The most famous example of Japanese painting that uses this technique is Sesshū's *Haboku Sansui* (*Landscape in Haboku Technique*) in the Tokyo National Museum, which is dated by inscription to 1495.[8] In the autobiographic inscription in this painting, Sesshū (1420-1506) refers to Yü-chien's work as his model.

Fragments from Mu-ch'i and Yü-chien scrolls became the favorite items to be displayed in tea ceremonies given by the wealthy and powerful, and they are frequently recorded in the chronicles of the tea ceremony almost to the last years of the sixteenth century.[9] These paintings thus provided models for later generations of Japanese artists who painted this theme on hanging scrolls, handscrolls, and sliding and folding screens—ideal formats to represent a series of landscapes across large surfaces. Yü-chien's poems were occasionally copied in these paintings, enabling us to reconstruct the lost sections of his original.

Though never a contiguous composition, *River and Sky in Evening Snow* by Yūshō was originally pasted on an eight-fold screen together with seven other paintings. The paintings were recently detached from the screen, remounted on hanging scrolls, and dispersed among different collections.[10]

There seems to be no established rule as to the sequence in which the eight scenes might be depicted. But two facts suggest that the Burke scroll was the last in the group of eight, and thus pasted on the extreme left panel of the screen. First, the Burke scroll is the only one that identifies the source of the poem; second, it depicts a snowy scene, which in Japanese paintings of the four seasons is traditionally represented as the last scene.

Each of the eight paintings bears the artist's seal, "Yūshō," and has a poem; some poems are preceded by

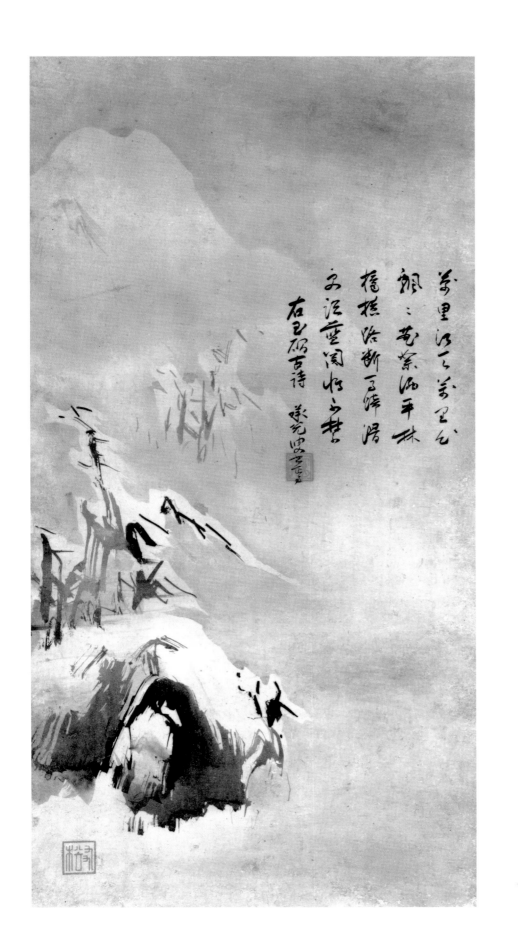

a title. The poems were inscribed by seven monks (one monk wrote two poems) who were the renowned monk-poets of their day. They lived and worked in the five most important Zen temples in Japan. These influential temples, known as *Gozan* (literally, Five Mountains) were part of a hierarchical organization. The monk who inscribed the Burke scroll,[11] Seishō Shōtai (1548–1607), was appointed the 92d abbot of Shōkokuji in 1584 and was a confidant of Toyotomi Hideyoshi and Tokugawa Ieyasu. He also enjoyed a close literary friendship among courtier-poets. Kawai Masatomo's research informs us that among the seven monks, two passed away in 1603, thus establishing the terminus date for these paintings. The names of some of these colophon writers are known in connection with other painting projects by Kaihō Yūshō, the creator of these paintings.

It is quite possible that Yūshō, who enjoyed friendships with the elite of Kyoto society, came across the surviving sections of the Yü-chien scroll. Like Yü-chien, Yūshō used an extremely abbreviated brush technique in which the only recognizable linear elements are architectural features. The rest of the scene is rendered in coarse, seemingly random *haboku*. Even a similarity in composition can be observed between Yūshō's depictions and the remaining sections of the Yü-chien work.

Much of our knowledge about Yūshō's life is based on a colophon written in 1724 by his grandson Yūchiku (1654–1728) above a commemorative portrait of Yūshō and his wife which, in turn, bears the seal of Yūshō's son Yūsetsu (1598–1677) (see no. 22).[12] For reasons still unclear, until 1573, when he was forty years old, Yūshō lived at Tōfukuji, a Zen temple in Kyoto. In that year Lord Asai, the master of Yūshō's samurai father, was killed in a battle fought against Oda Nobunaga, and all the other members of Yūshō's family are said to have perished with him. Yūshō is believed to have returned to a secular life to try to continue the family line.

Details of Yūshō's life as a young monk-painter are not known. According to Kano Einō (1634–1700), an artist and historian of painting, Yūshō studied the Kano-school style before developing his own distinctive approach to brushwork and composition.[13] This claim may be more than just boasting on the part of a Kano artist. In a recent study,[14] a pair of screens (collection of the Freer Gallery of Art, Washington, D.C.) bearing the seals of the great Kano master Eitoku was convincingly reattributed to Yūshō on stylistic grounds. Einō's additional claim that, late in life, Yūshō changed his painting style from the Kano mode to his own, thereby becoming a better-known painter, seems to point to the crux of the matter.

Most extant works by Yūshō date to his late period, when he was in his late sixties and seventies. During these last fifteen years of his life, he developed and perfected his most distinctive personal style, which is characterized by a unique handling of ink and brush. Yūshō steadfastly moved away from the linear brushwork that was the hallmark of Kano-school painting and came to rely more heavily on the use of ink washes. He became a master of the ink-wash technique; he used washes to delineate form, planes, and volume, and this is clearly exemplified by the Burke scroll. In a steady move away from the representational mode and toward an even greater abstraction that relied on the power of ink wash, Yūshō achieved the goal set forth in the ink monochrome painting dictum, "less is more." In that sense, he also achieved the spiritual goal to which Zen monks aspired.

This painting is a testimonial to the congenial relationship that existed between Yūshō and the elite group of Kyoto's Zen community. The great number of Yūshō's paintings bearing the colophons of Zen monks indicates that his association with these monks deepened in the last years of his life. At the same time, an increasing number of screens from Yūshō's later years are found to belong to a format similar to the original of these eight views, known as the *oshi'e-bari byōbu* (folding screen with pasted paintings).[15] Kawai's careful stylistic comparison of the eight views with Yūshō's other paintings demonstrates that the eight views were executed shortly before 1603, their terminus date. Two pairs of six-fold screens, one (dated 1602) in the Tokyo National Museum and the other (1602–1603) in the MOA Museum in Atami, also were executed in Yü-chien's splashed-ink technique and bear a close resemblance to these eight scrolls. This date is compatible with the letter from Konoe Nobutada (1565–1614) that accompanied the original screen of the eight views before it was dismantled. This brief note suggests that Nobutada helped negotiate a payment for Yūshō's paintings.

Circumstantial evidence helps to date this letter some-time after 1599,[16] which gives us a date of about 1602 for the eight pictures.

NOTES

1. I am grateful to Dr. Cornelius Chang, who helped me in translating this poem.

2. For the theme of the eight views, see Alfreda Murck, "Eight Views of Hsiao and Hsiang Rivers by Wang Hung," in Wen C. Fong et al., *Images of the Mind: Selections from the Edward L. Elliott Family and John B. Elliott Collections of Chinese Calligraphy and Painting at the Art Museum, Princeton University* (Princeton: The Art Museum, Princeton University, 1984), 213, 235; Watanabe Akiyoshi, *Shōshō Hakkei Zu*, Nihon no Bijutsu no. 124 (Tokyo: Shibundō, 1976); Richard Stanley Baker, "Gakuō's Eight Views of Hsiao and Hsiang," *Oriental Art* 20, no. 3 (Autumn 1974): 284-303; Suzuki Kei, "Gyokkan Jakufun Shiron" (Hypothetical Theories on Yü-chien So-fen), *Bijutsu Kenkyū* 236 (September 1964): 79-108; Shimada Shūjirō, "Sōteki to Shōshō Hakkei" (Sung Ti and Eight Views of Hsiao and Hsiang Rivers), *Nanga Kanshō* 10, no. 4 (April 1941): 6-13.

3. Murck, "Eight Views."

4. The translation of the titles is by Murck.

5. The attribution of one of the scrolls to Mu-ch'i is not accepted by most modern scholars, but Japanese scholars in the past firmly supported it. Suzuki Kei argues that the calligraphic style of the poems inscribed in the extant sections of the Yü-chien scroll corresponds closely to that of the signed work by this artist. See his "Gyokkan." Also, for Mu-ch'i and Yü-chien scrolls, see Watanabe, "Shōshō," figs. 3, 4, 27, and 28 for Mu-ch'i, and figs. 30 and 31 for Yü-chien.

6. For the past owners of these scrolls, see *Shōshō Hakkei Gashū* (Tokyo: Nezu Museum, 1962).

7. It is possible that Yü-chien himself composed and inscribed these poems. In fact, a record of a tea ceremony given in 1564 notes that all eight Yü-chien scrolls included his own colophons, implying that he also composed the poems. For this tea ceremony record, see *Shōshō Hakkei*. A similar statement about Yü-chien's own poems is found in the *Tōhaku Gasetsu*, a collection of short essays by the great Momoyama-period painter, Hasegawa Tōhaku (1539-1610). See Minamoto Toyomune, *Tōhaku Gasetsu* (Kyoto: Wakō Shuppansha, n. d.), 7.

8. For this famous painting by Sesshū, see Tanaka Ichimatsu and Yonezawa Yoshiho, *Suiboku Bijutsu Taikei* (Ink Monochrome Painting) (Tokyo: Kodansha, 1977), vol. 7, pl. 1.

9. *Shōshō Hakkei*; records of tea ceremonies hosted by such important tea masters as the three generations of Matsuya lacquerers, popularly known as the *Matsuya Kaiki* (Records of Matsuya's Parties), cover the period from 1533 to 1650. They include frequent references to the *Eight Views* scrolls by Mu-ch'i and Yü-chien, which were displayed at their *chakai*. Sen no Sōshitsu, ed., *Chadō Koten Zenshū* (Complete Works of the Classics of the Tea Ceremony) (Kyoto: Tankōsha, 1962), vol. 9.

10. Kawai Masatomo, "Yūshō hitsu Shōshō Hakkei Zu" (Shōshō Hakkei— Scenery of Hsiao Hsiang— by Kaihō Yūshō), *Bijutsu Shi* 63 (December 1966): 96. For photos of the other seven scrolls, see pp. 96-97.

11. For the names and biographies of the six other monks, see Kawai, "Yūshō hitsu," 100.

12. This portrait is still in the possession of Yūshō's descendant Kaihō Hiroshi of Kyoto. Shimizu Yoshiaki, ed., *Japan: the Shaping of Daimyo Culture, 1185-1868* (Washington, D.C.: National Gallery of Art, 1988), no. 41.

13. Kano Einō, *Honchō Gashi* (History of Japanese Painting) (1678; reprint, Tokyo: Kokusho Kankōkai, 1974), 97-98.

14. Takeda Tsuneo, "Freer Bijutsukan no Kuninobu In Kinki Shoga Zu Byōbu" (Screens of Four Accomplishments with the Seal of Kuninobu, in the Freer Gallery of Art), in Shimada Shūjirō, ed., *Zaigai Nihon no Shihō* (Japanese Art Treasures Abroad) (Tokyo: Mainichi Shimbunsha, 1979), 4:98-106.

15. Kawai, "Yūshō hitsu," 102-103.

16. Ibid., 103.

22.

Chou Tun-i Contemplating a Lotus Bloom

Edo period
Kaihō Yūsetsu (1598-1677)
Hanging scroll, ink on silk
H. 32.4 x W. 49.8 cm (12¾ x 19½ inches)
SIGNATURE: "Kaihō Yūsetsu-sai"
SEALS: "Kaihō," "Dōki"

Among all kinds of lovable plants, on land or in the water, the Ch'in dynasty poet T'ao Yüan-ming adored the chrysanthemum. After the T'ang dynasty, most people turned to the peony. I myself love the lotus because it grows out of the shiny mud and yet is not defiled, and because it lives in the pure and rippling water without appearing like a too fascinating and seductive lady. It has a system of tubes inside and is straight outside. Without branches or spreading vines its scent comes from afar. And how pure that fragrance! It is stately and unsullied. It is better to look at it from a distance than from too near—like a lady's petticoat. I consider the chrysanthemum to be a hermit among plants and the peony a flower signifying riches and power. But the lotus is a flower with a noble character.[1]

Chou Tun-i (also known as Chou Lien-chi, 1017-1073), a noted Confucianist scholar of Sung China, made this pronouncement in his famous essay *Ailien-shuo* (*The Love of the Lotus*), attempting to settle the ancient dispute over the relative merits of chrysanthemums and peonies. His declaration concerning the virtues of the lotus was clearly influenced by the Buddhist tradition, which regards this plant as the purest and the most important of the flora in its iconography, comparable in status to the lily in Christian iconography.

In this painting, the aging gentleman-scholar Chou leans on his slender vessel, paying rapt attention to the lotus emerging above the murky pond as the boat slices into a grove of the blooming flowers. Steadying his head between slim arms, the engrossed sage takes in the sensual flowers: his eyes are riveted on the plants, his nostrils spread to take in their scent. As though unwilling to disturb the gentleman's concentration, the young boatman turns his back. The gentleman's schol-

arly cap and collars, the edges of his sleeves, and his sash are the only details to be rendered in dark ink, applied with sharp brushstrokes. Other elements of the picture are represented with soft gray washes. Even the lotus blossoms, the object of the sage's absorption, are rendered in unobtrusive brushstrokes in silvery gray ink. Their leaves are depicted with amorphous smudges of ink wash. The faintest tint of ink wash applied on a silk ground gives off the shimmering light over a pond that is completely calm under Chou's intense concentration.

Although this subject never enjoyed the great popularity accorded other Chinese literary subjects that were adopted by Japanese painters, it is nevertheless widely known in the history of Japanese painting through a masterly rendition by Kano Masanobu (1434-1530), the founder of the Kano school.[2] While Masanobu's representation is in light color, Yūsetsu's painting is executed entirely in ink and captures the essence of the legend in a succinct manner.

Ink monochrome work is rare among this artist's oeuvre; rarer still is a signed work. In this painting, his signature "Kaihō Yūsetsu-sai" appears at the top right, accompanied by two large seals, "Kaihō" and "Dōki."

Son of the great master Kaihō Yūshō (see no. 21), Yūsetsu is remembered primarily for a portrait of his parents that bears his seal.[3] He was summarily dismissed by Kano Einō in his *Honchō Gashi* of 1678: as an afterthought, Einō tacked onto the end of his entry on Yūshō his own opinion that Yūsetsu brought down the family name.[4]

However, new information about his career has emerged from studies of the work of painters who operated *e-ya* (picture shops). Such shops produced and

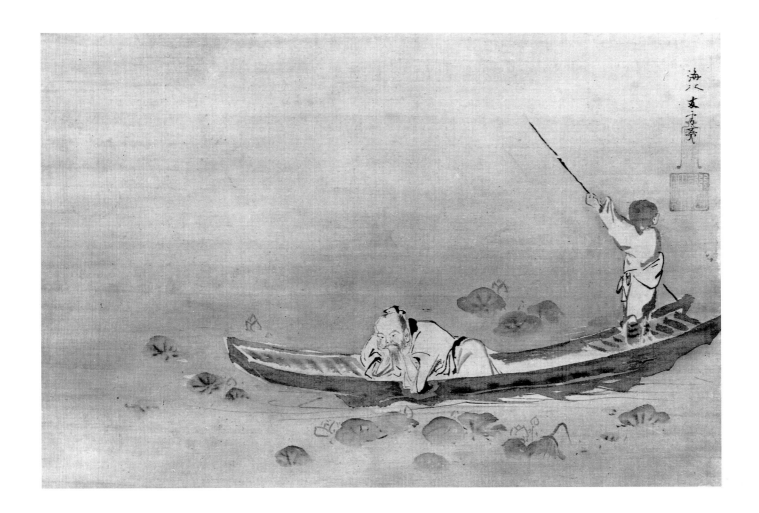

sold ready-made pictures.[5] Yūsetsu, who lost his father when he was seventeen, apparently operated such an *e-ya*. He seems to have considered his position too degrading for the name of his respectable warrior family, so he avoided the use of the Kaihō name and called himself either "*E-ya* Chūzaemon" or "Kotani Chūzaemon." After the year 1628, he is mentioned under these names in courtier Nishinotōin Tokiyoshi's diary, the *Tokiyoshi-kyō Ki*.[6] He was probably introduced to court through his father's contact with such noblemen as Prince Tomohito, who is known for his Katsura Palace in the suburb of Kyoto. Through the concerned intervention of Lady Kasuga (1579-1643), who had been reared by Yūshō and his wife and served as the wet nurse of the third Tokugawa shogun Iemitsu, Yūsetsu obtained several commissions from Iemitsu. The exact date of this turn in Yūsetsu's fortune is not known. It

must have been sometime before 1638, since in that year he was mentioned again in the *Tokiyoshi-kyō Ki*, this time as Kaihō Yūsetsu.[7] Also through Lady Kasuga, Yūsetsu had contact with Kano artists and collaborated with such important members of this august family as Tan'yū, whom he helped decorate the walls of the Imperial Palace in 1655 and 1662, and Kano Yasunobu in 1674.[8] Yūsetsu's paintings, which only faintly echo his father's powerful forms of ink play, present a pleasant mixture of Kano and Tosa features. Apparently, his background as an *e-ya* artist greatly enriched his repertory, and he produced a much wider and richer variety of paintings than his father.

Among Yūsetsu's best known works is a set of twenty scrolls illustrating the *Tsurezure-gusa* (*The Essays in Idleness*) by a fourteenth-century essayist, Yoshida Kaneyasu (widely known as Yoshida Kenkō, 1283-1350).[9]

He is also known to have painted *Genji* pictures on screens and albums.[10] He was equally adept at the academic polychrome style depicting flowers, and ink monochrome work, as is exemplified by the painting shown here.

Although some information on Yūsetsu's life and career has emerged recently, there are still too few known works bearing his signature or seal to construct a chronological study of his work. Even among the signed works, the handscroll of the *Eight Views of Hsiao and Hsiang* in the collection of the Tokiwayama Bunko is rare, in that it includes his age, seventy-three, with his signature, which places it in 1670.[11] Compared to this very late work, the signature on the Burke painting displays a greater vigor in his calligraphy, suggesting a much earlier date for it. Still, it is not possible to determine how much earlier than 1670 this picture should be dated.

NOTES

1. Carson Chang, *The Development of Neo Confucian Thought* (New York: Bookman Associates, 1957), 139-40.
2. Masanobu's painting is reproduced in many publications, for example, Doi Tsugiyoshi, *Suiboku Bijutsu Taikei* (Ink Monochrome Painting) (Tokyo: Kodansha, 1978), vol. 8, pl. 1.
3. The real creator of this painting, which is still in the Kaihō family's possession, is debated. See Yoshiaki Shimizu, ed., *Japan, the Shaping of Daimyo Culture, 1185-1868* (Washington, D.C.: National Gallery of Art, 1988), no. 41.
4. Kano Einō, *Honchō Gashi* (History of Japanese Painting) (1678; reprint, Tokyo: Kokusho Kankōkai, 1974), 98.
5. Yamane Yūzō, "E-ya" (E-ya, Painter's Shop), *Bijutsu Shi* 48 (March 1963): 107-17.
6. Yamane, "E-ya," 110-12.
7. Ibid., 112.
8. Fujioka Michio, *Kyoto Gosho* (Kyoto Imperial Palace) (Tokyo: Chūōkōron Bijutsu Shuppan, 1967), 203, 213, 221, 222.
9. Miya Tsugio, "Kaihō Yūsetsu hitsu Tsurezure-gusa Emaki" (Illustrated Scrolls of Tsurezure-gusa by Yūsetsu Kaihō), *Kobijutsu* 40 (March 1973): 109-11.
10. Yamane, "E-ya," 113.
11. Sugahara Tsūsai, *Hibai Yokō* (Catalogue of Tokiwayama Bunko Collection) (Kamakura: Tokiwayama Bunko, 1967), no. 47.

23.

Parakeets among Flowers

Edo period
Sō Shiseki (1715-1786)
Hanging scroll; ink and color on silk
H. 34.8 x W. 57.8 cm (13¾ x 22¾ inches)
SIGNATURE: "Shiseki"
SEALS: "Sō Shiseki In," "Kunkaku"
PUBLISHED: Miyeko Murase, *Urban Beauties and Rural Charms: Japanese Art from the Mary and Jackson Burke Collection* (Orlando, Fla.: Loch Haven Art Center, 1980), no. 29.

Not much is known about the early life and training of the painter of this colorful depiction of parakeets perched on a hydrangea tree—except that he was from Edo and his family name was Kusumoto.[1] Sometime before 1759 he was in Nagasaki and studied painting with Kumashiro Yūhi (1713-1772), a pupil of the Chinese painter Shen Ch'üan (also called Nan-p'in, active 1725-1780), who had stayed in this port city from 1731 to 1733. Unsatisfied, Kusumoto switched to study with Sung Tzu-yen, who died in Nagasaki in 1760 but had just arrived there from China in 1758. Kusumoto's devotion to his Chinese teacher was apparently so deep that he changed his name to Sō Shiseki (Sung Purple Stone), an obvious reference to the Japanese pronunciation of the teacher's name, Sō Shigan (Sung Purple Cliff).[2]

In sharp contrast to the obscurity of his youth, the life of this painter after his return to Edo with a new Chinese-sounding name is well known. He settled in the Nihonbashi section of the city, the center of the downtown area, and became a next-door neighbor of

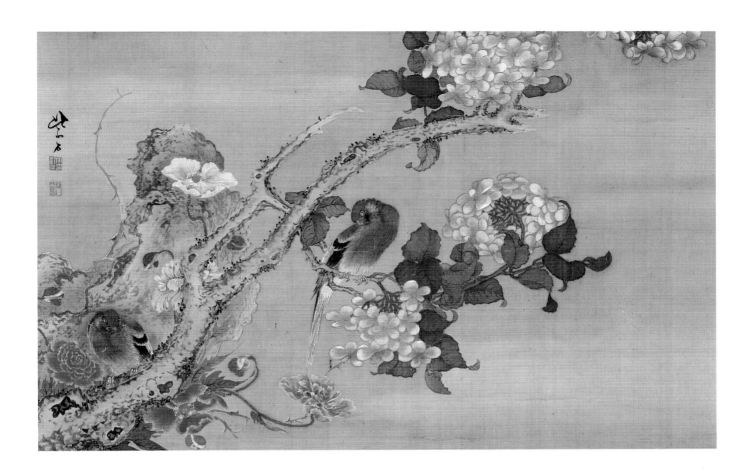

the famous surgeon Sugita Gempaku (1733–1817), who was the leading proponent of Western medicine.

It is quite possible that Sō Shiseki had some training in the Nan-p'in style (a blend of Chinese and Western realism) even before his journey to Nagasaki, since this style was admired and practiced in Edo by such artists as Kurokawa Kigyoku (1732–1756) and Tatebe Ryōtai (1719–1774), who had been exposed to it earlier. Edo was a fertile ground for such new types of painting, as the city's artists had a severely limited artistic choice—between Kano and *ukiyo-e* painting. Neither style proved satisfactory to the many artists who were just awakening to the outside world. Sō Shiseki's return home is dated to sometime before March 1759, as he signed a diptych of carps (Tokuhonji, Tokyo) with this new name.[3] His busy activities as an artist, teacher, and illustrator began in full swing. Among his pupils was Shiba Kōkan (1738–1818), who earlier had studied with Kano and *ukiyo-e* artists but went on to become the most famous Western-style painter after he switched allegiance to Sō Shiseki. There was also Sakai Hōitsu

93

(1761–1828), who first studied Kano and *ukiyo-e* styles but later became the leading force in the Rimpa movement. Accompanied by his son Shizan, Sō Shiseki is recorded as having made frequent visits to the Lord Sakai's mansion.[4] The anonymous author of Hōitsu's biography, the *Tōkaku-in Go-ichidai Ki*, appraises Hōitsu's painting training by saying that he "excelled in the Ming Chinese style as it was practiced by Sō Shiseki."[5] In 1763, he illustrated the catalogue of the first fair of various products to be held in Japan, the *Butsurui Hinshitsu*, which was organized by Hiraga Gen'nai (1728–1779), a botanist and playwright and a man of extraordinarily versatile talent and interest. His publishing activities included the *Sō Shiseki Gafu* (*Paintings of Sō Shiseki*) in three volumes (1765), which reproduced in woodcuts the works by Nan-p'in and other Chinese artists working in Nagasaki, as well as his own painting. In 1770 and 1779, he also published painting manuals.

The majority of paintings by Sō Shiseki belong to the bird-and-flower genre, in which major pictorial elements are meticulously detailed in brilliant polychrome, very much in the manner of the work shown here. The composition of these paintings reflects the deeply rooted convention established by the Southern Sung Chinese painters centuries ago, in which the asymmetrical placement of pictorial elements plays the prominent role. Equally consistent among his paintings is the minutely detailed description of flowers and birds, which is contrasted against a background that is completely neutral aside from the lightly brushed-in wash.[6] Very little variation of this formula is observed among his works throughout his entire painting career. For that matter, this formula persisted among the works of the followers of Nan-p'in in Edo, the so-called Nagasaki school.[7]

The style of calligraphy in his signature also was little varied, which makes it doubly difficult to establish a chronological framework for his oeuvre. Slight modifications in his signature may be detected, however, in the late works from 1770 and later, during which time he sometimes signed his name in a looser *gyōsho* style. The Burke painting, impressed with the seals "Sō Shiseki In" and "Kunkaku," is signed in the *gyōsho* style, and it may be dated to this late period in his life.

NOTES

1. For the life and art of Sō Shiseki, see Yamakawa Takeshi et al., *Sō Shiseki to sono Jidai: Chūgoku Torai no Shaseijutsu Gahō* (Sō Shiseki and His Period: Realism Imported from China) (Tokyo: Itabashi Ward Museum of Art, 1986); Yamakawa Takeshi and Nakajima Ryōichi, eds., *Sō Shiseki Gashū* (Paintings of Sō Shiseki) (Tokyo: Nigensha, 1986); and Tsuruta Takeyoshi, *Sō Shiseki to Nan-p'in Ha* (Sō Shiseki and Shen Nan-p'in School), Nihon no Bijutsu no. 326 (Tokyo: Shibundō, 1993).

2. For Sō Shigan, see Tsuruta Takeyoshi, "Sō Shigan ni tsuite: Raihaku Gajin no Kenkyū" (Painting with a Bird on a Pomegranate Branch and a Bird on a Plum Branch by Sung Tzu-yen), *Kokka* 1028 (1979): 35–39.

3. Yamakawa and Nakajima, *Sō Shiseki Gashū*, pl. 1.

4. Ibid., 130.

5. Ibid., 131.

6. Takeda Kōichi, "Sō Shiseki no Kōzu" (Sō Shiseki's Compositions), in Yamakawa et al., *Sō Shiseki to sono Jidai*, 94–97.

7. For this school's works, see Koshinaka Tetsuya, Tokuyama Mitsuru, and Kimura Shigekazu, eds., *Nagasaki Ha no Kachō-ga: Chin Nanpin to sono Shūhen* (Bird-and-Flower Painting of the Nagasaki School: Shen Nan-p'in and His Followers) (Kyoto: Fuji Art Shuppan, 1981), 2 vols.

24.

Two Birds on Willow and Peach Trees

Edo period, 1774
Yosa Buson (1716–1783)
Hanging scroll; ink and color on silk
H. 128.9 x W. 70.5 cm (50¾ x 27¾ inches)
SIGNATURE: "Sha Shunsei"
SEALS: "Sha Chōkō," "Sha Shunsei"
PUBLISHED: Shimada Shūjirō, ed., *Zaigai Nihon no Shihō*
(Japanese Art Treasures Abroad) (Tokyo: Mainichi Shimbunsha,
1980), vol. 6, no. 27.

Buson is traditionally regarded as one of the two great-est painters of the *nanga* school, the other being his contemporary Ike Taiga (nos. 25-27). He was also one of the most important poets of the Edo period.[1] Buson's literary accomplishments were not in Chinese poetry, the primary interest of *nanga* artists, but in *haikai* (or haiku), a distinctly Japanese verse form of seventeen syllables. Buson's early life is still not clear, but it is generally agreed that he was born in Osaka into the Taniguchi family, who were modest farmers. Around 1735, when Buson was about twenty, he moved to Edo. There, his initial encounter with art was not in paint-ing, but in *haikai*, which he first studied briefly with Uchida Senzan (d. 1758), then from 1737 with Hayano Hajin (1677-1742). He quickly established a reputation as a poet; his poems were published regularly in antholo-gies from 1738 on. In his early career as a poet, Buson admired Matsuo Bashō (1644-1694), the greatest haiku poet. In his later years he came to be regarded as the poet who restored the *haikai* genre to the excellence it had known under Bashō. In 1744, he adopted "Buson" as his *haikai* name, with which he is also best known as a painter. Buson himself signed this name only on his *haiga*, the illustration accompanying the haiku, while using many other names on paintings unrelated to this form of poetry.

Buson apparently learned to paint while working as a young poet in Edo, and he illustrated one of his own poems in a book published in 1738. Nothing is known, however, about his early training or about his painting teacher. All of his early paintings show human figures and reflect some knowledge of Kano or Tosa styles,[2] but nothing of *nanga*. Hattori Nankaku (1683- 1759), a

Confucian scholar and *nanga* pioneer, is sometimes believed to have introduced Buson to the *nanga* ideals, but Buson's knowledge of *nanga* was probably acquired much later in his life.

The death in 1742 of Hajin seems to have prompted Buson to leave Edo on a long journey to the north, retracing the route that Bashō made famous by his travel diary, the *Oku no Hosomichi* (*The Narrow Road to the Deep North*). Buson's wandering lasted almost ten years before he settled in Kyoto in 1751. From about this time, he seems to have spent more time on painting, and his temporary move to Yosa, in Tango, to the northwest of Kyoto, seems to have been made so that he could devote more time to painting. The surname Yosano (or Yosa), by which Buson is generally known, was taken from this small village, which is believed to have been the birthplace of Buson's mother. While in Tango, he painted many screens, no doubt on consign-ment, in a variety of styles: *yamato-e*, *nanga*, and the styles of Sesson and the Unkoku school. At the same time, Buson's paintings increasingly began to reflect his gradual shift toward *nanga*. Sakaki Hyakusen (1697-1752), a versatile artist who included haiku writing among his many accomplishments, is often considered to be Buson's mentor in the eventual turn to *nanga*. Buson's dated paintings increased in number after his return from Tango to Kyoto in 1757, where he kept a permanent home until death. Some of his paintings, like the one included here, are obviously inspired by Chinese models, either Chinese paintings or Chinese manuals. For example, he is said to have devoted his time after his return to Kyoto to the study of bird-and-flower paintings by Shen Ch'üan (Nan-p'in, active

1725-1780), who lived at Nagasaki from 1731 to 1733 and specialized in this genre of painting.

Throughout his life he maintained close contacts with other *haikai* poets, and he never divorced himself from that art form altogether. Curiously, contemporary accounts of his activities, either by Buson himself or by his fellow artists, do not refer to him as a painter.

In this painting, which depicts a scene on a warm spring day, two exotic-looking birds call to each other, one from the tall branch of a willow tree that has sprouted thick masses of green leaves, the other, its mate, on a lower perch of a peach tree full of pink blossoms. It is a work from the last ten years of the artist's life, yet it is a testimonial to Buson's debt to Chinese models such as the works by Shen Nan-p'in, or the works by followers known under the rubric of the Nagasaki school. Just as this group of artists incorporated some Western concepts of perspective, Buson's painting here also displays a ground line set very low. Such details of nature as the birds' features and floral petals are also delineated with extreme care. Yet the spatial relationship of trees to rocks is too ambiguous to create a sense of real space, and the structure of rocks is flattened out, so that any feeling of mass and volume is eliminated. What remain true to Chinese or Chinese-derived works are the subject of the painting—exotic birds—and the short brushstrokes in wet ink or varying tonalities that cover rocks and tree trunks. These features are shared by many of Nan-p'in's followers, such as Kumashiro Yūhi (1713-1772).[3]

The short inscription at the right states that the painting was made in summer, in the third year of the An'ei era (1774), at the Yahantei Studio, and it is followed by his signature, "Sha Shunsei," and two seals, "Sha Chōkō" and "Sha Shunsei." The character "Sha" in his seals and signature is another reading of the Chinese character for "Sa" of his newly adopted surname "Yosa."[4]

NOTES

1. For a detailed discussion of his life, see Calvin French, *The Poet-Painters: Buson and His Followers* (Ann Arbor, Michigan: The University of Michigan Art Museum, 1974).
2. For these works, see Hayakawa Monta and Yamamoto Kenkichi, *Buson Gafu* (Paintings by Yosa Buson) (Tokyo: Mainichi Shimbunsha, 1984).
3. Koshinaka Tetsuya, Tokuyama Mitsuru, and Kimura Shigekazu, eds., *Nagasaki Ha no Kachō-ga: Chin Nanpin to sono Shūhen* (Bird and Flower Painting of the Nagasaki School: Shen Nan-p'in and His Followers) (Kyoto: Fuji Art Shuppan, 1981), 2 vols.
4. The Metropolitan Museum of Art in New York owns a painting that seems to have been modeled after this work. It is signed "Heian Sha Shunsei" and bears two seals, "Sha Chōkō" and "Sha Shunsei." See Shimada Shūjirō, ed., *Zaigai Hihō* (Japanese Paintings in Western Collections) (Tokyo: Gakken, 1969), vol. 2, no. 86. This painting was incorrectly identified as belonging to the Burke Collection in Hayakawa and Yamamoto, *Buson Gafu*, no. 15.

25.

Wintery Landscape after Kuo Chung-shu

Edo period
Ike Taiga (1723-1776)
Hanging scroll; ink and light color on paper
H. 98.8 x W. 31.8 cm (38¾ x 12½ inches)
Signature: "Hō Kaku Chūjo hitsu Ike Mumei"
Seals: "Mumei," "Hekigo Suichiku Sanbō," "Itsuka Issan Tōka Issui"
Published: Miyeko Murase, *Urban Beauties and Rural Charms: Japanese Art from the Mary and Jackson Burke Collection* (Orlando, Fla.: Loch Haven Art Center, 1980), no. 24.

The artistic brilliance of Ike Taiga lay in his ability to free himself, both spiritually and artistically, from the narrow confines of *nanga*, whose tenets had been more rigorously maintained among previous literati painters of Japan. These pioneers of *nanga* were not *bunjin* (literati) by the strict Chinese definition because they were employed by feudal lords in various capacities. They were, however, *bunjin* in the sense that they were highly educated scholar-artists. Taiga and Buson (no. 24), two of the most prominent *nanga* artists of Japan, failed to fit even that adjusted Japanese meaning of *bunjin*. Although both were well educated, each lacked formal education in Chinese classics, a background considered necessary for gentlemen-scholars of their time. Moreover, they worked as professional artists, supporting themselves solely through painting.

Taiga was extremely prolific and endowed with unusual versatility. His dedication to painting was complete. A catalogue of his work assembled more than eight hundred individual pieces,[1] and many more, not included at that time, have since come to the attention of scholars and collectors. Much of his work relies on Chinese subject matter and style, which he learned from Chinese painting manuals. Taiga's talent was restless. He was perpetually in quest of new styles and new approaches to painting, while his broad artistic range and curiosity about other schools of painting knew no bounds. Some of his works exhibit familiarity with Western perspective; others demonstrate his interest in indigenous themes and styles of art. Those paintings that make use of divergent sources often achieve a unique fusion of various artistic traditions.

Apocryphal legends abound concerning Taiga's early life and training, probably because fame reached him very early in life.[2] The standard account places his birth in Kyoto. He eventually dropped the "no" ("field") from his family name, Ikeno, to make it sound Chinese. Taiga is believed to have started his formal training in calligraphy at the age of seven under the tutelage of the priest Seikō-in Issei (1672-1740). But he was apparently able to handle brush and ink comfortably even before that time; one extant specimen of his calligraphy is believed to have been executed when he was only two years old.

Unfortunately, little information is available concerning Taiga's early training in painting. What is known is that by age fourteen or fifteen, he was able to support his widowed mother by selling paintings from his own fan shop. His earliest extant painting, *The Willows at Wei-Ch'eng*, was painted when he was twenty-two years old. Its subject and style indicate that he was then already working in the *nanga* manner, and it seems that he acquired the *nanga* concept and technique from the *Hasshu Gafu*, a collection of eight albums of Chinese woodcut pictures reprinted in Japan in 1671. Taiga soon made the acquaintance of other *nanga* artists, who no doubt contributed to his knowledge. He attracted the attention of Yanagisawa Kien (1704-1758), one of the pioneers of *nanga*, and Kien encouraged Taiga, sometimes writing colophons on the young man's compositions.

Taiga engaged in artistic activities throughout his life. Many poets and scholars gravitated toward him. During his lifetime he became friendly with almost all

98

the *nanga* artists of his day. Among many artists who were inspired or influenced by him was his wife Gyokuran (no. 28), whom he is believed to have married around 1751, and who was also a *nanga* painter.

In this severely attenuated format, the foreground has been arranged in almost a straight line with a tall pine tree and the large, mysteriously alive hillock in the middle ground. Opaque blue-gray wash applied on the sky, water, and the surface of the mountains and hills creates the effect of an icy, frozen atmosphere on a wintery day. Almost forgotten, yet nonetheless clearly delineated, is a cluster of smaller houses in the distance at the right. Also quite unobtrusive is a fragile-looking boat, near the bottom of the composition, carrying a bowman and single passenger. The soft, tawny tint

applied in small dots and short strokes on the vegetation, the boat, and the human figures is equally inconspicuous. The gray palette of the painting is highlighted by coal-black ink lines that delineate bare twigs of trees and rounded contours of hills and mountains. The brightest spots in this otherwise blue-gray landscape are provided by the luminous red of the artist's three seals.

Taiga's inscription at the top right reads "Hō Kaku Chūjo hitsu Ike Mumei" (After the Brush of Kuo Chung-shu, Ike Mumei). The inscription is written in dark ink, but with a rather dry brush that was guided carefully and deliberately. Kuo Chung-shu (Kaku Chūjo in Japanese pronunciation), a tenth-century Chinese painter who excelled in precise architectural

drawings and landscapes, was known for his eccentric behavior. It is most unlikely that Taiga had the opportunity to see and study the original works of this Chinese artist. Rather, he must have become acquainted with Kuo's name and work through some painting manuals such as *The Mustard Seed Garden Manual* (*Chiehtzu-yüan Huach'uan; Kaishi-en Gaden* in Japanese), which was introduced in Japan shortly after its first publication in China in 1679 (it was then reprinted in Japan in 1748). Kuo's name appears in this manual in connection with a landscape painting by Kuan T'ung of the Five Dynasties period. The painting features a strangely alive and leaning mountain similar to the one in the middle ground in Taiga's painting. The explanation accompanying Kuan's painting states that his mountains were "often touched with snow" and that Kuo Chung-shu followed his style.[3]

A small boat carrying the scholarly looking passenger, who might be on his way to visit a friend in one of the houses in the distance, is described by wavy, sharp, hard, and needle-thin lines. This suggests they might have been drawn not by a paint brush but by fingernails. Taiga is believed to have learned the technique of finger painting from Yanagisawa Kien, his early mentor. In this technique, made famous by a Ch'ing Chinese painter, Kao Ch'i-p'ei (1660-1734), painters use fingernails, fingertips, and the palms of the hands instead of brushes.[4] (Forever experimenting, Taiga also tried a "paper brush" technique, in which a twisted and hardened paper was used as a paint brush.) Taiga became quite adept and famous for the dexterity with which he executed the finger-painting technique. He frequently demonstrated it in front of friends and patrons when he was between about twenty-five and thirty-five years old. One of the last and largest works he executed in this technique is a set of eight sliding panels at Mampukuji, Kyoto.

A few words of explanation are necessary about Taiga's seals, of which he is believed to have had as many as 115, perhaps more. Some survive to the present.[5] Three seals are impressed on this small painting. The one at the top, "Mumei" (or Mumyō, Arina) is the name he used most frequently after adopting it in 1749 at the suggestion of Gion Nankai (1677-1751). An oft-quoted story tells us that when Taiga met Nankai, a much older *nanga* pioneer, Taiga was still using his personal name Tsutomu. Asked about his artistic name, Taiga replied that he had "no name" (*mumei*), upon which Nankai cited a passage from a Taoist text that included the word *mumei*. He also presented Taiga with woodblock pictures of the *Eight Mountains of Han-shan County* by the Ming artist Ch'en, who used the sobriquet "Mumei" (Wu-ming in Chinese). Taiga also gave a humorous twist to this name, pronouncing it "Arina" (Have Name).

While "Mumei" was used as a signature and seal throughout his life, a small rectangular seal directly below it had a much shorter life span. This seal reads "Hekigo Suichiku Sanbō" (Mountain Studio of Blue Paulownia and Green Bamboo), and it seems to have been confined to a relatively short period from his late twenties and thirties. After that it ceases to appear.[6] The third seal, at the lower left, reads "Itsuka Issan Tōka Issui" (Five Days to Paint Mountain and Ten Days to Paint Water).

This work may be dated to Taiga's early career, his late twenties and early thirties, or from about 1755. This view is based on the fact that the painting was modeled after woodcut manuals (like many other works from this period) and that Taiga used fingernails for a portion of the painting. Also, the calligraphy of his inscription has a noticeable slant in the horizontal bars, with carefully placed emphasis at their beginnings. This is the case with many signatures from this period.

NOTES

1. Tanaka Ichimatsu et al., eds., *Ike Taiga Sakuhin Shū* (The Works of Ike-no Taiga) (Tokyo: Chūōkōron Bijutsu Shuppan, 1960), 2 vols.
2. For the biography of this artist, see Melinda Takeuchi, *Taiga's True Views: The Language of Landscape Painting in Eighteenth-Century Japan* (Stanford: Stanford University Press, 1992).
3. Mai-mai Sze, *The Tao of Painting: A Study of the Ritual Disposition of Chinese Painting*, Bollingen Series no. 49 (New York: Pantheon Books, 1956), 1:23.
4. For Kao Ch'i-p'ei's work, see Klaas Ruitenbeek and Joan Stanley-Baker, *Discarding the Brush: Gao Qipei (1660-1734) and the Art of Chinese Finger Painting* (Amsterdam: Rijksmuseum Amsterdam, 1992).
5. Suzuki Susumu, ed., *Ike Taiga*, Nihon no Bijutsu no. 114 (Tokyo: Shibundō, 1975), 105-106.
6. Tanaka, *Ike Taiga*, no. 27, is an example of a painting from his early forties that bears this seal.

26.

Gion Festival Float under Moon

Edo period
Ike Taiga (1723-1776)
Hanging scroll; ink and light color on paper
H. 30.5 x W. 35.1 cm (12 x 13½ inches)
SEAL: "Ike Mumei In"
FORMER COLL.: Okamoto Kōhei, Kanagawa
PUBLISHED: Miyeko Murase, *Urban Beauties and Rural Charms: Japanese Art from the Mary and Jackson Burke Collection* (Orlando, Fla.: Loch Haven Art Center, 1980), no. 25; Tanaka Ichimatsu et al., eds., *Ike Taiga Sakuhin Shū* (The Works of Ike-no Taiga) (Tokyo: Chūōkōron Bijutsu Shuppan, 1957-59), fig. 155.

An enormous waxing moon hangs in midair, a counterbalance to the tall stake atop the festival float, which is strung with lanterns dotted with the almost imperceptible tints of the lightest pink. Placed low at the bottom of the composition are horizontal rows of houses, some of which also have hanging lanterns in the celebration of this most important and popular summer event of Kyoto, the Gion Festival of mid July. The painting is acutely evocative of the mood of the festival and filled with nostalgia for the evening of excitement.

The Gion Festival, which is inseparably associated today with the Gion Shrine of Kyoto, actually predates the founding of the shrine around 934. The festival originally was observed as a prayer for relief from the epidemics in 863. Much later it came to be dedicated to this shrine.

The simple composition and the impromptu execution in soft ink epitomize the artist's mastery of the brush techniques. This painting and the painting of *Cycad* (no. 27) are marked by spontaneity and keen observation of nature, enriched by Taiga's technical dexterity in translating what he saw onto paper in a vivid and direct manner.

In subject and technique, this painting of the Gion Festival is a far cry from the lofty ideals of the Chinese literati painting, but it explains at least partly the enormous popularity that Taiga's works enjoyed during the artist's lifetime as well as in our own time.

27.

Cycad

Edo period
Ike Taiga (1723-1776)
Hanging scroll; ink on paper
H. 28 x W. 32.1 cm (11 x 12½ inches)
SEAL: "Ike Mumei In"
FORMER COLL.: Okamoto Kōhei, Kanagawa
PUBLISHED: Miyeko Murase, *Urban Beauties and Rural Charms: Japanese Art from the Mary and Jackson Burke Collection* (Orlando, Fla.: Loch Haven Art Center, 1980), no. 27; Tanaka Ichimatsu et al., eds., *Ike Taiga Sakuhin Shū* (The Works of Ike-no Taiga) (Tokyo: Chūōkōron Bijutsu Shuppan, 1957-59), fig. 159.

This sketchlike depiction of the cycad plant, with curling lines for its leaves and parallel bands for the bulbous stems, is alive with traces of masterful brushwork.

This painting, as well as that of the Gion Festival (no. 26), were among the group of paintings and calligraphy pasted on a pair of screens that once belonged to the Okamoto Collection. The assemblage included paintings of different subjects in small album-sized formats (like these two paintings shown here) and some fan-shaped formats. A number of them are today in the Burke Collection. Both paintings are impressed with the seal "Ike Mumei In" (Seal of Ike Mumei) but no signature. Both works have been dated to Taiga's early thirties.[1]

NOTE

1. Tanaka Ichimatsu et al., eds., *Ike Taiga Sakuhin Shū* (The Works of Ike-no Taiga) (Tokyo: Chūōkōron Bijutsu Shuppan, 1960), nos. 155 and 159.

28.

Peony and Bamboo by a Rock

Edo period
Tokuyama Gyokuran (1728?-1784)
Hanging scroll; ink and light color on paper
H. 92.8 x W. 41.7 cm (36½ x 16½ inches)
SIGNATURE: "Gyokuran"
SEAL: "Gyokuran"
PUBLISHED: Pat Fister, *Japanese Women Artists: 1600-1900*
(Lawrence, Kans.: The Spencer Museum of Art, University of
Kansas, 1988), no. 31; Miyeko Murase, *Urban Beauties and Rural
Charms: Japanese Art from the Mary and Jackson Burke Collection*
(Orlando, Fla.: Loch Haven Art Center, 1980), no. 28.

Gyokuran, wife of the prominent painter Ike Taiga
(nos. 25-27), was a daughter of the second generation of
owners of a tea shop called Matsuya, which operated
south of the Gion Shrine in Kyoto. Gyokuran's mother,
Yuri (1694-1764), and Yuri's adoptive mother, Kaji,
made reputations for themselves as *waka* poets and had
their poems published in anthologies: *Sayuriba* (*Leaves
of Small Yuri*) and *Kaji no Ha* (*Kaji's Leaves*, 1707), respec-
tively.[1] Gyokuran, nee Machi, was thus exposed to the
world of literature early in her life through her mother,
who also befriended Yanagisawa Kien (1704-1758), a
pioneer *nanga* artist and Taiga's early mentor. Kien may
have started Machi on painting, and he gave her part
of his artistic name "Gyoku" to make up her sobriquet
"Gyokuran." The date of her marriage to Taiga is
debated, but it is believed to have taken place around
1751. In their famous conjugal devotion and their
absorption in painting, they are often compared to
Chao Meng-fu (1254-1322) and his wife, Kuan Tao-
sheng (d. 1319), of Yüan China, who were both promi-
nent painters. However, contemporary records,
including the 1768 edition of the *Heian Jimbutsu Shi*—
the "Who's Who" of Kyoto—lists Gyokuran as
Tokuyama and not Ike or Ikeno.[2]

Although Gyokuran seems to have painted even
before her marriage to Taiga, her husband's influence
on her works is undeniable. However, in her work
Taiga's idiosyncrasies are muted and softened. Her use
of the angled brush, as is apparent in this painting in
the broad strokes delineating bamboo leaves and the
rock below them, immediately reminds us of Taiga's

favorite technique. Although lacking the dazzling
brilliance of her husband, she holds her own in her
tranquil depiction of nature, which is imbued with
purity and freshness of vision. Pale blue washes, applied
boldly behind the plants and on the rock below, en-
hance the rich coloristic effects created by the varying
tonality of black ink.

It is difficult to trace the evolution of her art, since
only a single work with a dated inscription is known, a
painting of a plum on which her mother Yuri wrote a
poem sometime before her death in 1764.[3] Gyokuran's
signature on this painting is written in a vigorous,
youthful calligraphic style. The painting is almost
identical to Taiga's work of the same subject,[4] which is
thought to have been completed when Taiga was about
thirty years old and Gyokuran about twenty-five. Some
of Gyokuran's works reflect Taiga's youthful style, oth-
ers his late works. Although comparison of her works
with her husband's dated works seems to be an un-
satisfactory method by which to give a chronological
framework to her oeuvre, at present it is the only viable
one.[5] We may tentatively conclude, then, that the style
of her signature on the peony painting shown here
represents the period when she was about forty years
old. The "gyoku" of her name in this style of calligraphy
is written with a distinct loop in the middle, making
the letter look round and spacious. Later on, this letter
seems to have lost the loop altogether and acquired a
narrower, leaner profile.

NOTES

1. For this book and Gyokuran's life, see Pat Fister, *Japanese Women Artists: 1600-1900* (Lawrence, Kans.: Spencer Museum of Art, University of Kansas, 1988), no. 30.
2. It has been noted that Gyokuran's address is listed in this book as different from that of Taiga and that she was interred together with her mother and grandmother, rather than with her husband; see Hoshino Rei, "Ike Gyokuran hitsu Bokubai Zu: Sansui Zu" (Landscape by Ikeno Gyokuran and Plum Tree by Ikeno Gyokuran), *Kokka* 998 (1977): 36.
3. Ibid.
4. Tanaka Ichimatsu et al., eds., *Ike Taiga Sakuhin Shū* (The Works of Ike-no Taiga) (Tokyo: Chūōkōron Bijutsu Shuppan, 1960), no. 93.
5. Suzuki Susumu, "Taiga to Gyokuran" (Works of Taiga and Gyokuran), *Kobijutsu* 44 (April 1974): 37-50.

29.

Golden Pheasants among Rhododendrons

Edo period
Yamamoto Baiitsu (1783-1856)
Hanging scroll; ink and color on silk
H. 108 x W. 41.8 cm (42½ x 16½ inches)
Signature: "Baiitsū Ryō utsusu"
Seal: "Ryō In"
Published: Miyeko Murase, *Urban Beauties and Rural Charms: Japanese Art from the Mary and Jackson Burke Collection* (Orlando, Fla.: Loch Haven Art Center, 1980), no. 40.

Baiitsu, who is best known for his elegant polychrome paintings in the bird-and-flower genre, was born to a carver's family in Nagoya, a city halfway between Edo and Kyoto. The painting teacher of young Baiitsu is believed to have been Chō Gesshō (1770-1832), a minor artist of the Shijō school. Yamamoto Rantei, a now almost forgotten Kano-school artist, might also have given Baiitsu instructions in this art, as well as the use of his surname.[1] While Baiitsu was still in his teens, he met Nakabayashi Chikutō (1778-1853), a fellow Nagoyan painter, and in 1802 they left Nagoya together for Kyoto to pursue further painting instruction. Always in search of new ideas, new models for painting, and new friends, Baiitsu traveled throughout the Kyoto-Osaka area. Such a life of constant travels was in keeping with the ideals set forth by the literati of China. And Baiitsu was also involved in other literati pursuits such as composing poems (both in the Chinese style and *waka*) and playing the flute. In about 1815, the sphere of his travel widened to include Edo, where he met many more literati. His life fluctuated among these cities until about 1854, when he finally returned to Nagoya for the remainder of his life.

Although his close friends were *nanga* artists and his lifestyle remained true to literati ideals, Baiitsu's paintings in the bird-and-flower genre retained traces of his early training in the Shijō school. A delicate realism in the portrayal of nature is especially apparent in this group of paintings. At the same time, like many other Japanese works in this genre, the source for these paintings may be traced ultimately to paintings by late Ming artists such as Chou Chih-mien of Souchou (active, 1580-1610), an artist who was widely admired in Japan as a specialist in the bird-and-flower genre.

Like the work included here, Baiitsu's paintings are pleasant and easy to appreciate. His palette is restrained, his ink brushwork is unobtrusive, and his pictorial forms are easily recognizable. He employed soft, "boneless" washes of color to define leaves and bird feathers, which contrast with the sharp lines used for twigs and grasses, and the dry, scratchy contour lines of rocks. Light washes of colors added to graded ink give a lyrical feeling to a small segment of nature captured under warm spring light.

The style of his signature also remained fairly constant through his career, with only the slightest modifications. The paintings that are impressed with the small oblong seal "Ryō In" (Seal of Ryō), like the one seen here, are often dated by inscription to the 1830s.[2]

NOTES

1. For a detailed study of Baiitsu's life, see Patricia Graham, *Yamamoto Baiitsu: His Life, Literati Pursuits and Related Paintings* (Ph.D. diss., University of Kansas, 1983), 21-79.
2. Ibid., seal no. 47.

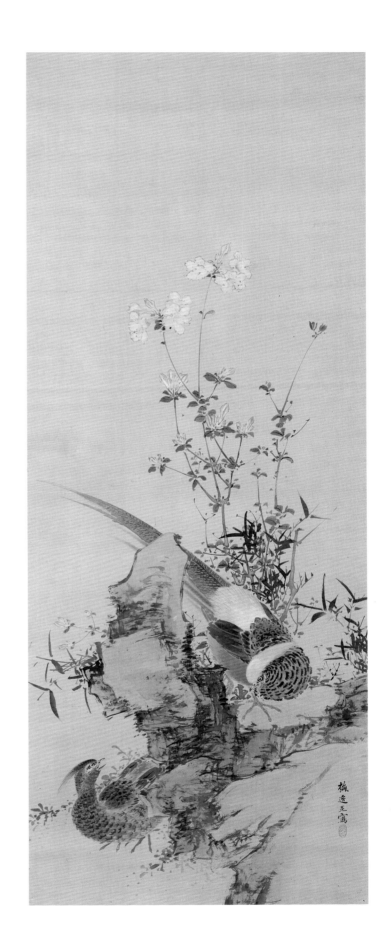

30.

Landscapes of Four Seasons

Edo period, 1848
Yamamoto Baiitsu (1783–1856)
Four hanging scrolls; ink and light color on silk
H. ca. 102.6 x W. 35.2 cm (40¼ x 13¾ inches) each
SIGNATURES: *Spring*: "Boshin Mōshun utsusu Baiitsu Ryō"
Summer: "Baiitsu tsukuru"
Autumn: "Baiitsu egaku"
Winter: "Baiitsu Gyokuzen-shitsu ni oite tsukuru"
SEALS: "Yamamoto Ryō" on all four scrolls
"Meikyō" on Winter scroll
PUBLISHED: Miyeko Murase, *Urban Beauties and Rural Charms: Japanese Art from the Mary and Jackson Burke Collection* (Orlando, Fla.: Lock Haven Art Center, 1980), no. 41; Suzuki Susumu, "Yamamoto Baiitsu hitsu Shiki Sansui Zu" (Landscape of Four Seasons by Yamamoto Baiitsu), *Kobijutsu* 40 (March 1973): 75–82.

Each of the four hanging scrolls depicting the four seasons of the year is signed and sealed. The first one, *Spring*, gives the date as "Boshin Mōshun" (the year of dog-monkey, the first month of spring), which translates to January 1848. The last scroll, *Winter*, identifies the place where Baiitsu painted the set as the Studio of Jade Contemplation ("Gyokuzen-shitsu"). His signature, "Baiitsu," written on each scroll, shows a slight variation in writing style from that of the earlier period: with darker ink and wider strokes used for the left-side component of the first character, "bai" (meaning plum), and with generally less emphatic brush lines than in earlier writings.

Each scene depicts the solitary figure of a scholar, except for *Summer*, where two gentlemen and a servant are shown. In each case the scholar, or scholars, enjoy the height of the season. They are engaged in quiet contemplation or music-making, such as in the *Summer* and *Autumn* scrolls. The solitary figure of a flute player under the full autumn moon (or for that matter, all the figures shown in these scrolls) may have been intended as Baiitsu's self-portraits, or at least as manifestations of his yearning for the life of a hermit.

The scrolls are an exercise in brush techniques. Dark, wet, and unusually short strokes are employed to convey the feel of lush vegetation in the warm spring and summer seasons. Dark inks are combined with

Detail, *Winter* scroll

Detail, *Spring* scroll

Detail, *Summer* scroll

pale, soft washes. Together these fade into the shimmering natural color of the unpainted silk, effectively suggesting a warm spring haze enveloping distant hills, and vaporous mist rising from the gushing waterfall of summer. The *Autumn* scroll conveys a greater sense of open space, as the trees have shed their leaves. Strong lines describing reeds give accents to the otherwise muted, dry tones of the painting. Dry, broken strokes in light ink cover the distant hills. The barren, snow-covered, and flat-topped peaks in *Winter* are somewhat reminiscent of landscape paintings by Baiitsu's fellow Nagoyan, Chikutō. Traces of dry brush, barely visible,

cover the entire land, where a scholar intently contemplates the frozen space.

Baiitsu also tried to give the composition variation within a unified theme: a relatively high point of view was taken from the long vista in the *Spring* and *Autumn* scrolls, while a closer viewpoint was adopted for the more intimate and introspective scrutiny of the scenery in the *Summer* and *Winter* scrolls.

This set of four scrolls represents Baiitsu, at age sixty, reaching his most accomplished state, both in brush technique and in the expression of the life and longings of a *nanga* artist.

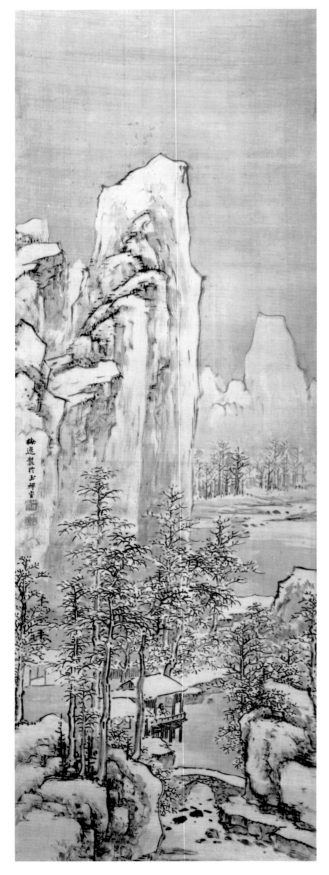

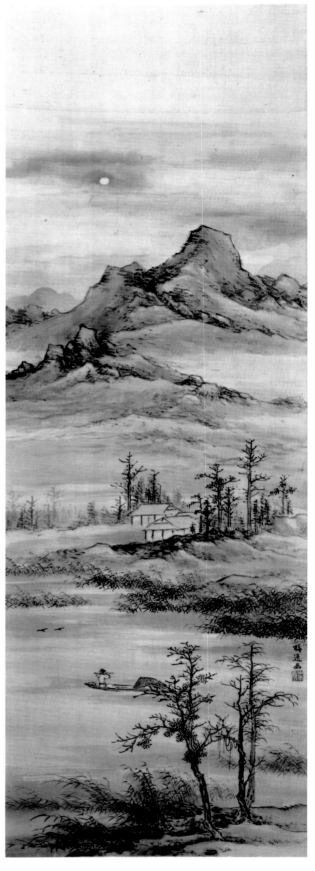

Winter *Autumn*

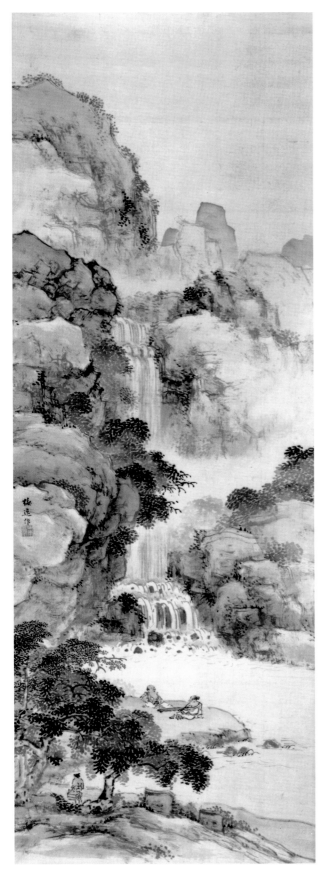

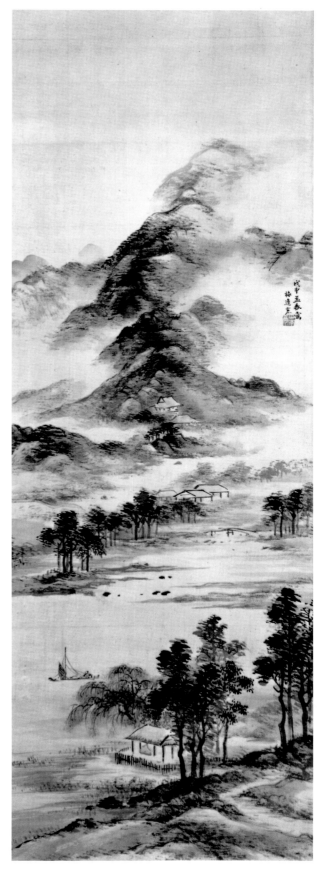

Summer Spring

31.

Landscape with a Waterfall

Edo period
Kameda Bōsai (1752-1826)
Hanging scroll; ink and light color on silk
H. 107.2 x W. 48.6 cm (42¼ x 19 inches)
SIGNATURE: "Bōsai Rōjin Kō Suisha"
SEALS: "Chōkō no Ki," "Kaitō Rōnin," "Kikubu Shōsho"
PUBLISHED: Stephen Addiss, *The World of Kameda Bōsai: The Calligraphy, Poetry, Painting and Artistic Circle of a Japanese Literatus* (New Orleans: New Orleans Museum of Art and University Press of Kansas, 1984), no. 22.

Kameda Bōsai, the artist of this landscape painting, appears to have been a paragon of a literatus. Born in Edo to a middle-class merchant of tortoise-shell products, Bōsai chose a scholarly path for his own life. For about ten years, from the age of thirteen, Bōsai studied under Inoue Kinga (1732-1784), a Confucian scholar teaching at a private academy in his neighborhood.[1] Specimens of Kinga's calligraphy and impromptu paintings provide evidence that he not only formulated the foundation of Bōsai's art in calligraphy and painting, but also continued to influence Bōsai throughout his career.

By the age of twenty-two, in 1774, Bōsai opened his own private school of Confucian studies. Among the notable products of Bōsai's academy was Takizawa Bakin (1767-1848), one of the most popular novelists of the nineteenth century. The teacher's life did not last long, however, as an authoritarian shogunal policy was soon instituted and Confucian teachings were confined to the Neo-Confucian doctrine promulgated by Chu Hsi (1130-1200) of Sung China. Bōsai's teachings were deemed heresy and he was forced to close his academy in 1797.

His life as an impoverished but free scholar began at that time. He not only wrote commentaries on important Confucian texts, but also published essays on such esoterica as the food production and eating habits of ancient Chinese. He traveled extensively and found friends among scholars and artists. To earn a living, he produced calligraphic works and he also wrote colophons on paintings by famous artists such as Ike Taiga (nos. 25-27); Sakai Hōitsu (1761-1828), the leading Rimpa artist; and Hōitsu's pupil Suzuki Kiitsu (1796-1858).[2] Hōitsu's respect and friendship for Bōsai was such that on the occasion of publishing the famous book of woodcut reproductions, *One Hundred Paintings by Kōrin (Kōrin Hyaku Zu)*, in 1815 to commemorate the one-hundredth anniversary of Ogata Kōrin's death, he asked Bōsai to write the preface.[3] Perhaps inspired by this experience, Bōsai designed a woodblock printed book of his own landscapes, *Kyōchūzan (Mountain in My Heart)*, the following year.[4]

Bōsai was primarily a scholar and calligrapher, with painting playing a relatively minor role in his artistic endeavor. He is believed to have started producing paintings only from about age fifty.[5] Limited mostly to imaginary landscapes, with few calligraphic lines for technique and small variation in compositional schemes, his paintings are the epitome of avocational works by a true *bunjin* (literatus). In addition, he frequently included in his signature the word "suiga," or "suisha," meaning that he painted while in a state of intoxication.

The landscape painting shown here is a rare exception in Bōsai's oeuvre. Although he signed it "Bōsai Rōjin Kō Suisha" (Drunkenly Painted by the Old Man Bōsai Kō), the painting is more solidly constructed than many other works that are also signed "inebriated." Extensive use of ink washes and carefully applied pale tints of blue and buff colors also make us wonder about the true state of his "drunkenness." This work is a monumental version of two other landscape paintings that are dated to 1807 (Gitter Collection, New Orleans).[6] Human figures are eliminated from the

Burke painting altogether, their presence merely suggested by solid-looking houses. The foreground is firmly established by trees with a thick growth of foliage, which are painted in dark ink, and the row of houses nearby. Mottled effects of dark ink applied on the tall, craggy hills in the middle ground are reminiscent of the *tarashikomi* (poured-in ink) technique, a hallmark of Rimpa works. This suggests that Bōsai may have been inspired by his association and collaboration with Rimpa artists Hōitsu and Kiitsu. Finally, the distant view of a group of small trees in light gray and the farthest mountain in pale blue close off this powerful composition.

Bōsai's signature is written in an expressive, uninhibited cursive script, which is nevertheless in perfect control. Three seals are found, and they read from the top down: "Chōkō no Ki" (Record of Chōkō), which is believed to have been used in his late period from 1817 to 1824; "Kaitō Rōnin" (Masterless Man from Eastern Sea), used on paintings dated between 1807 to 1817; and at the bottom a large one that reads "Kikubu Shōsho" (Malt Section, Reverence for Books), a possible reference to his fondness for sake, which was used on the works dated between 1808 and 1823.[7] These seals, the painting style, and the calligraphy style of signature help to date this work to the artist's late period, around 1817.

NOTES

1. For the life of Bōsai, see Sugimura Eiji, *Kameda Bōsai no Sekai* (The World of Kameda Bōsai) (Tokyo: Miki Shobō, 1985), and Stephen Addiss, *The World of Kameda Bōsai: The Calligraphy, Poetry, Painting and Artistic Circle of a Japanese Literatus* (New Orleans: New Orleans Museum of Art and University Press of Kansas, 1984).

2. The colophon on the Taiga painting is reproduced in Addiss, *World of Kameda Bōsai*, no. 9, and Miyeko Murase, *Japanese Art: Selections from the Mary and Jackson Burke Collection* (New York: The Metropolitan Museum of Art, 1975), 246; the colophon on Hōitsu's painting (Hosomi Collection) is in Yamane Yūzō, ed., *Rimpa Kaiga Zenshū: Hōitsu Ha* (Paintings of Rimpa: Hōitsu School) (Tokyo: Nihon Keizai Shimbunsha, 1978), vol. 5, no. 62. His colophon on Kiitsu's painting is in Addiss, *World of Kameda Bōsai*, no. 48.

3. The entire text of this preface is translated in Addiss, *World of Kameda Bōsai*, 116.

4. Ibid., nos. 28a–28h.

5. Ibid., 27.

6. Ibid., nos. 14 and 15.

7. Ibid., 123–24.

32.

Woodcutters and Fishermen

Edo period
Matsumura Goshun (1752–1811)
Pair of six-fold screens; ink and light color on paper
H. 170.8 x W. 347.6 cm (67¼ x 136½ inches) each
SIGNATURES: "Goshun utsusu" on the right screen, "Goshun" on
the left screen
SEALS: "Goshun" and "Hakubō" on both screens
PUBLISHED: Takeda Tsuneo, ed., *Byōbu-e Taikan* (Collection of
Painted Folding Screens) (Tokyo: Kodansha, 1981), pls. 83 and 171;
Miyeko Murase, *Byōbu: Japanese Screens from New York Collections*
(New York: Asia Society, 1971), no. 13; Shimada Shūjirō, ed., *Zaigai
Hihō* (Japanese Paintings in Western Collections) (Tokyo: Gakken,
1969), vol. 1, pl. 89. (This pair of screens was published here erro-
neously as the property of the De Young Museum.)

Set against gentle rolling hills and a quiet enclosed
lagoon are the idealized lives of workingmen: wood-
cutters among the pines and fishermen gathered on a
small fishing boat. Though the settings lack any clear
indication of season, their gentle hazy atmosphere,
particularly in the palest blues of the willow leaves,
suggests the sunny warmth of spring. The colors
are mellow shades of the palest blues, ochers, and
tawny bisques. Even the dark black ink is limited to
a few dots and details, giving accents to otherwise
gray tones.

The workingmen are old, besides one youthful
man in each group. Their clothes, except their shoes,
indicate that they are Chinese. The woodcutters, their
backs heavily laden with kindling, come from the
woods into the clearings. The fishermen have gathered
on their boat to enjoy a tea break, some with their
mouths open, and a bemused animation on their
wrinkled faces. One may have just told a good story,
which seems to have caught the attention even of the
two cormorants on a nearby tree. This is an urbanite's
imaginary depiction of the tranquil lives of workmen.
The artist most likely intended this painting to be the
representation of an idealized, idyllic life in the coun-
try, especially since the Chinese, from ancient times,
regarded a fisherman's life as a symbol of the loftiness
and purity of a scholarly mind. Such are the ideals
of aesthetics put forth by Chinese scholar painters, and
Goshun, as a practitioner of *nanga*, must have felt the

same yearnings to be one with nature. Yet as a true
urbanite, he may never have intended to represent the
reality of the workingman's life. In much the same way,
he depicted men as Chinese although the settings are
devoid of any indication of a particular locale.

Goshun was born to the Matsumura family, whose
members, according to the family's genealogy, served
as officials at the government mint for four successive
generations before Goshun himself.[1] Goshun's father,
Kyōtei, had his residence on Shijō Street (Fourth Street)
in the bustling midtown center of Kyoto. It was here
that Goshun was most likely born and raised. In his
later years, he arranged for almost all of his pupils to
live near him; thus the name of his successful painting
school, Shijō school. Goshun was a genuine urbanite,
and this upbringing had a distinct impact on the
character of his art. The gold mint at which Goshun's
ancestors had been employed was established by the
Edo *bakufu* to purchase and inspect gold bullion,
as well as to mint and authenticate coins. Because this
organization was at the base of the monetary economy,
stringent employment requirements were enforced.
Officials were selected from responsible families, and
Goshun, born into this distinguished family, became a
mint foreman as a young man. Precisely when Goshun
resigned from this much-honored position to start a
life as a painter has been a point of contention among
scholars. The family genealogy states that the mint
office in Kyoto was incorporated into the head office in

115

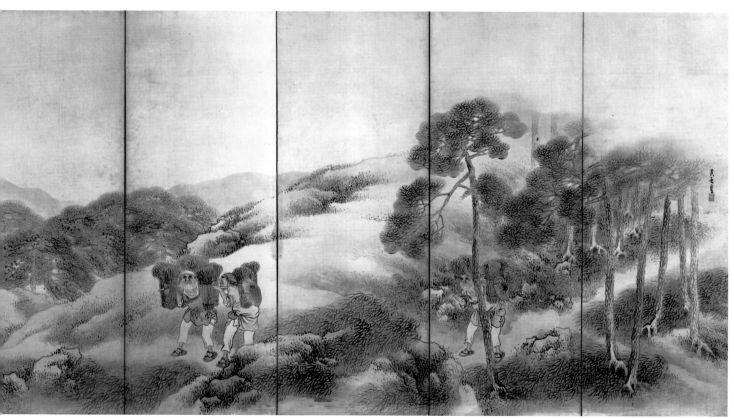

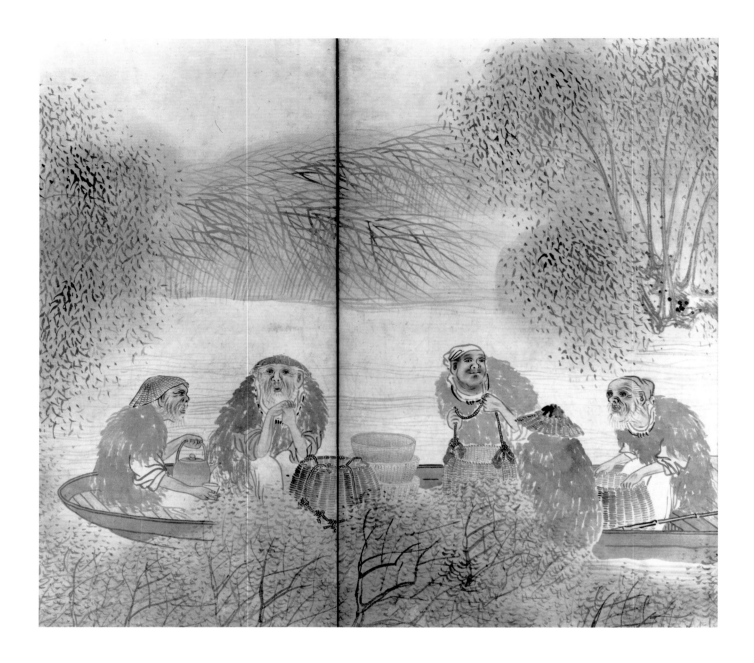

Edo in 1791, and the employees of the Kyoto office were initially forced to take a vacation and a few months later were given severance pay. But this change in the government policy probably did not affect Goshun, since he had been active as a professional painter long before this.

Still, it is uncertain when Goshun began the life of an artist. He first studied painting as an avocation, a cultural accomplishment expected of a young man from a wealthy upper-class family. His first painting teacher was Ōnishi Suigetsu, though he soon became a pupil of Yosa Buson (no. 24), a much more influential artist. Goshun studied both painting and haiku under Buson. This association must have started sometime in Goshun's early twenties, since a painting that closely follows this master's style is dated to 1774.[2] By 1775, Goshun had attained sufficient respect as an artist to be listed as the twelfth-ranked painter in the *Heian Jimbutsu Shi*, Kyoto's "Who's Who" listing of the day.[3] He seems to have absorbed Buson's artistic sensibilities quickly and thoroughly. Paintings from this early period are usually derived from known works by Buson

and can easily be mistaken for the master's own works. This is true for both his painting and calligraphy styles.[4] Professionally and personally, Goshun maintained a close association with, and a deep attachment to, Buson until his master's death in 1783.

After the losses, in quick succession, of his wife and father in 1781, Goshun moved out of his hometown to live in Ikeda (in modern Osaka), where he took tonsure and the new name of Goshun, for which he is best known. (Formerly, he had gone by the lesser known sobriquet of Gekkei.) He remained in Ikeda until 1789. This brief period, however, was a productive one artistically, and is known now as his Ikeda period. After Buson's death, Goshun's Ikeda-period paintings began to display a gradual shift away from his master's influences. This may have been prompted by his meeting with Maruyama Ōkyo (1733-1795). In 1787, Goshun joined a group of six painters, headed by Ōkyo, to paint sliding door panels at Daijōji in modern Hyōgo prefecture, northwest of Kyoto. The contract describing this project refers to Goshun as "Buson's star pupil,"[5] indicating that nearly four years after Buson's death he was still known as his old master's most outstanding pupil. At the same time, this project indicates that he had become closely associated with Ōkyo sometime earlier—although his paintings at this temple are still strongly reminiscent of Buson's art.

The general scholarly consensus is that Goshun shifted his artistic alliance to the sort of realism advocated by the Maruyama school after living temporarily with Ōkyo at the Kiun-in temple. He sought refuge there after the great fire that devastated Kyoto on New Year's Day in 1788. No definite proof for the theory exists, but Goshun's work shows a noticeable stylistic shift toward the Maruyama school's aesthetics around that year. In 1795, on a second trip to the same temple where Ōkyo's pupils again worked together, Goshun's paintings of farmers at work reflects a clear shift to Ōkyo's style. Yet his farmers are still Chinese workers, dressed much the same way as the woodcutters in the Burke screen. This may reflect his long years of involvement with *nanga* aesthetics, rather than the lack of empathy toward country life.[6] Goshun learned Ōkyo's technical devices well, features such as the naturalistic details of landscape, perspective, and plasticity. But these gains are also counterbalanced by the loss of shimmering luminosity and elegant lyricism distinguishing his earlier, Buson-derived works.

The present pair of screens closely adheres to Buson's art in such details as the painterly use of pale color tones, the soft watery ink lines gently defining natural elements and creating a translucent luminosity, and a lingering sense of lyricism. The signature on the right-hand screen, reading "Goshun utsusu" ("painted by Goshun") is written in rich, dark ink, in the soft *gyōsho* (running) style, as are the signatures of most of his Buson-influenced works. Two seals that accompany the signature read "Goshun" and "Hakubō." The same two seals are impressed on the left-hand screen, below the signature "Goshun." This signature, however, is written in clearly articulated standard script (*kaisho*), which appears on Ōkyo-influenced works. The general consensus is that Goshun first used the *gyōsho*-style script for his signature, then combined this with *kaisho*-style writing (as shown here at the left) until finally switching to the exclusive use of *kaisho*-style writing. This last change is believed to have taken place around 1789. The style of the left-side, *kaisho*-type signature is still tentative here, lacking the leftward slant that became increasingly pronounced in later works. The present screens therefore may be dated to around 1785 and 1786.

NOTES

1. Okada Ribei, "Matsumura-ke Ryakkei to Gekkei (Goshun) Den," *Nihon Bijutsu Kōgei*, 266 (November 1960): 2-8. Also, for Goshun's biography, see Inazuka Takeshi, "Goshun ni tsuite" (On Goshun), *Kokka* 348 (May 1919): 417-21 (Part I); *Kokka* 349 (June 1919): 451-56 (Part II); and "Goshun Tetsubun" (Anecdotes on Goshun), by the same author, *Kokka* 358 (March 1920): 392-96 (Part I).
2. Mochizuki Shinjō, *Goshun,* in *Tōyō Bijutsu Bunko* (Library of Oriental Art) (Tokyo: Atlier, 1940), pl. 2.
3. *Heian Jimbutsu Shi* is reproduced in "An'ei Yonen-ban Heian Jimbutsu Shi" (Heian Jimbutsu Shi: Address Book of Artists and Scholars in Kyoto, published in the fourth year of An'ei [1775]), *Bijutsu Kenkyū* 54 (June 1936): 263.
4. Suntory Museum, *Itsuō Bijutsukan Meihin Ten: Buson to Goshun* (Exhibition of Masterpieces from the Itsuō Art Museum: Buson and Goshun) (Tokyo: Suntory Museum, 1981).
5. Yamakawa Takeshi, *Nihon Bijutsu Kaiga Zenshū* (History of Japanese Painting) (Tokyo: Shūeisha, 1977), 22:116.
6. Ozaki Yoshiyuki, "Nishi Honganji no Goshun hitsu Kōsaku Zu ni tsuite" (Farming Scenes Painted by Goshun at Nishi-Honganji Temple), *Kobijutsu* 85 (1988): 62.

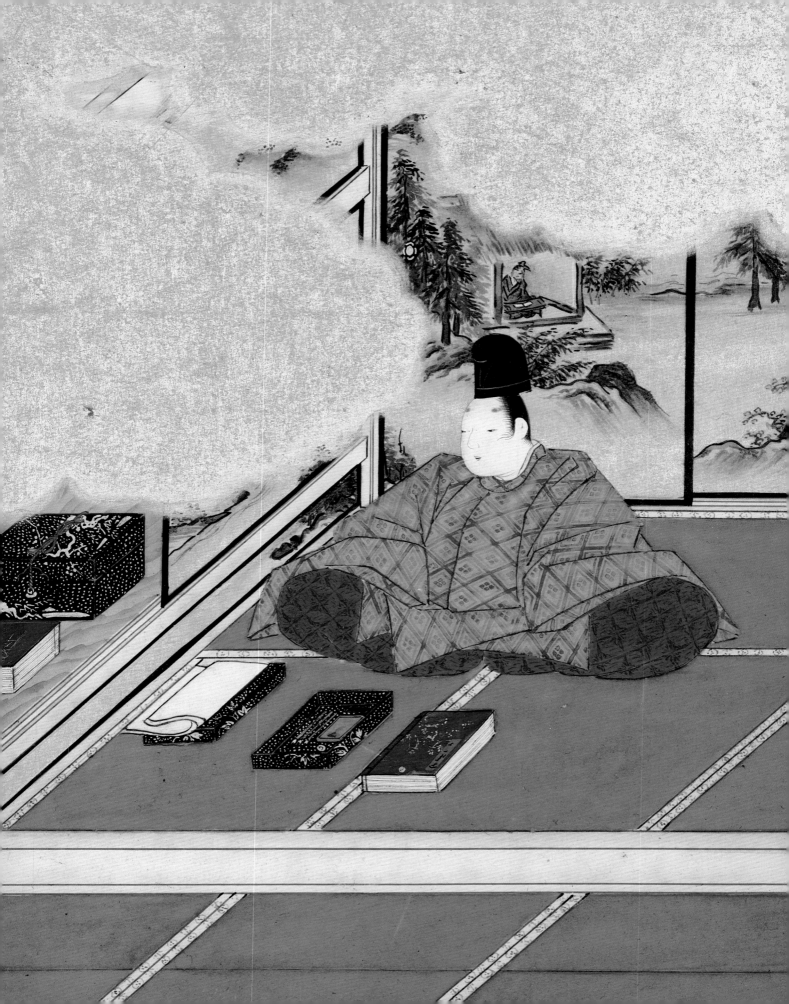

3
Native Sensibilities

In the year 894, an epoch-making decision was made to put an end to the periodic sending of court-appointed emissaries to T'ang-dynasty China, a practice the Japanese court had maintained since the early seventh century. The resolution to terminate the diplomatic relationship with the powerful mainland civilization had a prodigious impact on every aspect of Japanese art and life. The period of isolation from China, which lasted for several hundred years, allowed the Japanese to assess what they had learned from mainland Asia in past centuries and put an end to their wholesale, indiscriminate emulation of Chinese culture. The cessation of diplomatic relations was also indicative of a new and growing sense of self-confidence, and an awareness of their own national identity.

The year 894 is therefore commonly designated as the beginning of the Late Heian period, also known as the Fujiwara period. This was an era during which native trends in the arts reached their height, as the Japanese succeeded in assimilating and adapting elements of continental culture to suit their own needs and distinctive sensibilities. The term *Fujiwara* derives from the name of a powerful aristocratic family, which emerged as one of the great political powers early in the tenth century. The influential Fujiwara nobles and their small, aristocratic coterie devoted much of their lives to pleasure and beauty, controlling not only the affairs of state but also the course of courtly aesthetics. An aura of courtly

sophistication and sensitivity, regarded by some recent historians as effeminate and lacking in vigor, permeated all of the visual and literary arts, the lifestyle of the nobility, and even the practices of religion. The legendary Fujiwara commitment to the arts and to a life of somewhat frivolous pleasure is best understood from the standpoint of the *Genji Monogatari*, or *Tale of Genji*, the masterpiece of Heian-period romantic literature, written in the early eleventh century.[1] This novel, composed by a court lady known as Murasaki Shikibu, is said to have been based on the life of Fujiwara no Michinaga (966-1027), patriarch of the Fujiwara clan and perhaps the greatest cultured spendthrift in the history of Japan.

The most significant cultural development of the Late Heian period was the evolution of *kana* script in the early ninth century. This native system of writing consists of a fairly small number of highly abbreviated Chinese characters, each representing a different syllable. This simple, practical "alphabet" enabled the Japanese to record their everyday speech with ease and liberated them from their dependence on written Chinese. *Kana* writing was inadequate as a vehicle for serious business correspondence and documentation, and Chinese was retained as the language of government papers, law, and records of an official nature. However, the new syllabary provided members of the courtly class with a freedom of expression never before experienced. *Kana* played a major role in artistic developments of the period—for example, in the area of calligraphy and painting—but it was in the literary arena that it naturally

Detail, the "Sakaki" Chapter
of the *Genji Monogatari* (no. 38)

had the most profound effect: Japanese poets and novelists were now able to produce a vernacular literature. Without the new writing system, native verse (*waka*), elegant calligraphic works, and, above all, great prose narratives like the *Genji Monogatari* could not have been created.

The birth of secular painting, loosely termed *yamato-e*, is closely related to the development of *kana* script and indigenous modes of literature. *Yamato* is the name that was commonly applied to the region of southwestern Honshū that served as the political and cultural center of ancient Japan, an area encompassing the cities of Kyoto, Nara, and Osaka. The word *yamato* thus represents "Japan," and *yamato-e* literally means "Japanese painting." However, the Japanese of the Late Heian period often used this word to distinguish the new, native approach to painting from *kara-e* (literally, T'ang painting), or Chinese-style pictures. In addition, it is clear that a conscious effort was gradually made to define the two types of painting in terms of both style and subject matter. According to contemporary records, a screen in the Imperial palace, painted in the ninth century, displayed a famous scene from the *Shan-hai-ching* (a Chinese book of geography) on one side and a depiction of the Uji River, a favored scenic spot southeast of Kyoto, on the other. This screen clearly reflects an attempt to decorate the palace interior with images that contrasted native scenery with scenes of foreign lands. *Yamato-e* was used to depict native scenes or illustrate native literature; *kara-e* was used for scenery and tales of China. The word *yamato-e*, applicable to landscape, narrative, and figure paintings, therefore refers to both a style distinctly different from *kara-e* and a subject matter that is purely Japanese in nature.

It is difficult to assess how the Heian-period Japanese determined major stylistic differences between *yamato-e* and *kara-e*. Few examples of *yamato-e* have survived from the years prior to the mid twelfth century; the existence of such works is known primarily from literary and documentary references, which lack any explicit references to stylistic features. What these documents do indicate is that the inhabitants of Kyoto were deeply moved by the subtle seasonal changes that colored the hills and mountains surrounding them and regulated the pattern of their day-to-day life. Indeed, two types of *yamato-e* landscape that appear in literary references—*meisho-e*, pictures of famous scenic spots, and *tsukinami-e*, images of activities taking place during the twelve months or four seasons—reflect this sensitivity to the beauties of the country's heartland. Since both types of imagery included human activity, they also fit the category of genre paintings with an emphasis on background scenery. *Meisho-e* and *tsukinami-e* laid the foundations for a distinctly Japanese style of landscape painting that was to survive centuries of change in the periods succeeding the Heian era (see nos. 50-51).

A strong predilection for paintings depicting human affairs undeniably distinguishes the Japanese artist from the Chinese. The Chinese did, certainly, excel in figure painting, but their examples are often didactic in nature, while Japanese artists delighted in pure narrative illustration both secular and sacred in theme. It is not known exactly when native literature was first illustrated, but a painting depicting the tragic life of a young girl is known to have been presented to an empress dowager in 907, and the art of narrative handscroll illustration had reached its peak by the early twelfth century. Using the extended horizontal space permitted by the handscroll format, Japanese artists depicted events from native tales and legends with an ingenuity and a fresh, creative vision not found anywhere else in the world. The narrative picture scroll, known as *emaki*, or *emaki-mono*, was not the only painting format used for illustration: the broad surfaces of sliding and folding screens were also used as vehicles for pictorial storytelling. These larger images were better-suited for public viewings by large numbers of people than the small *emaki*, and they became the favored format for narrative illustration during the Momoyama and Edo periods. Rendered in brilliant colors against a gilded background, screen paintings of scenes from classical novels like the *Genji Monogatari* or episodes from plays of the Noh theatre (no. 52) served the same function as the wall paintings and frescoes of biblical or historical tales in European churches and palaces.

Lady Yodo (1567-1615)
Two poems from the *Genji Monogatari*
(Selection 4, no. 33)

Until recently a general scholarly consensus held that *yamato-e* survived Japan's turbulent medieval period through the efforts of Tosa Mitsunobu (active ca. 1469–1523), a court-appointed artist, and his followers. These painters functioned during the Muromachi period, an era of intense Sinification that witnessed the rise to prominence of Zen Buddhism and ink monochrome painting. They were believed to have continued to specialize in narrative illustration on a miniature scale, producing *yamato-e* images on *emaki*, album leaves, and folding fans (nos. 36–37). Although they traced the origins of their role as court artists to the Kamakura period, Tosa artists had little access to the prosperity enjoyed by such Momoyama screen painters as the Kano school. Their art, delicate and detailed in nature, was thought to have been primarily restricted to small painting formats that required close scrutiny, and not applied to large-scale room decoration.

The traditional assessment of the Tosa school is now being challenged and revised.[2] The new evaluation of their work views the school as one that made significant contributions to the art of screen painting. Tosa masters successfully preserved and transmitted Heian traditions through the less than congenial atmosphere of the Muromachi period, passing them on to Momoyama-period screen painters. Their images, which exhibit a strong sensitivity to seasonal change, a commitment to literary themes of the classical past, and an elegant, if somewhat subdued, use of luminous color, served as inspiration to the painters of numerous other schools.

Even in the light of newly identified Tosa achievements, it cannot be denied that the true champion of *yamato-e* in the Edo period was the Rimpa school, a loosely knit group of artists whose creations in many ways epitomized the traditional, native Heian aesthetics. The name "Rimpa" is something of a misnomer, as it means "School (*ha* or *pa*) of Ogata Kōrin." Kōrin (1658–1716) was not the founder of the group but a later "rejuvenator" of the artistic ideals cultivated by the school's actual progenitors, Hon'ami Kōetsu (1558–1637) and Sōtatsu (died ca. 1642). (Sōtatsu's name is often combined with that of his painting studio, Tawaraya.) These two masters established the aesthetic standards for Rimpa painting, calligraphy, paper decoration, ceramics, and lacquerware. Kōetsu's *kana* calligraphy harks back to the delicate script of Heian times, and Sōtatsu's paintings drew many of their motifs from scenes in earlier *yamato-e* works. Between them, they revitalized and enlivened old classical ideals, and their remarkable vision resulted in compositions of astonishingly bold decorativeness, enhanced by strong colors, which often overshadow or nearly conceal the literary content of the images. The works of Kōetsu and Sōtatsu signal the triumph of native traditions in the arts; their ideals, drawn for the most part from courtly culture, found committed followers in later Rimpa painters. With the shift of political and economic power to the new city of Edo, Rimpa circles in the old capital city soon dwindled, and the most brilliant of the school's disciples in the eighteenth century were Edo artists, led by Sakai Hōitsu (1761–1828) and his pupils (nos. 39, 41), who added new dimensions to Rimpa imagery.

The art that perhaps best represents the energetic culture of the Edo period is *ukiyo-e*, literally "pictures of the floating world." The word *ukiyo* has ancient origins. It originally carried strong Buddhist overtones, implying that life (*yo*) on this earth is wearisome (*uki*), ephemeral, and transitory, unlike the eternal bliss promised to the enlightened by the Buddha. This rather pessimistic interpretation was altered during the Edo period: the first part of the word, *uki*, was written with a different Chinese character, meaning "to float," and, in an apparent about-face, the term became an injunction to enjoy life while it lasts by plunging into its midst and floating upon its current. *Ukiyo-e* artists unabashedly sought the support of Edo's burgeoning middle class, whose primary concern seemed to be the enjoyment of momentary, worldly pleasures. Money, sex, and the theatre were the major preoccupations of *ukiyo-e* painters and woodblock-print designers as well as their patrons.

Unlikely as it may seem, the ancient roots of *ukiyo-e* lay in *meisho-e* and *tsukinami-e*, the genre paintings of the Heian period, with their emphasis on scenic views and the various activities of the seasons. However, *ukiyo-e* artists gradually shifted

their attention from outdoor activities to indoor scenes that provided a closer look at famous women of the pleasure quarters or popular actors of the Kabuki theatre (nos. 45–48). Women were depicted in striking, fashionable costumes, while actors were posed in dramatic stances. *Ukiyo-e* paintings were followed by inexpensive woodblock prints, making these images available to all but the poor.

Merchants of the Edo period, theoretically situated on the lowest rung of the social ladder, were generous with their newly won wealth and supported developments in *ukiyo-e* with an unabashed joie de vivre. For them, the pleasures of the theatre and brothels were available solely on the basis of one's financial status, as opposed to one's place in the social hierarchy. These transitory joys promised an escape from reality and an easy road to earthly happiness. Yet the bourgeois clientele to whose taste *ukiyo-e*

was tailored was far from illiterate, and many of the artists catering to its demands were also familiar with aspects of ancient culture. Even in this most prosaic of art forms, inspiration was apparently provided by classical as well as contemporary literature (nos. 44, 46). The native traditions of Japan endured, sometimes in the most unlikely of guises.

NOTES

1. Murasaki Shikibu, *The Tale of Genji*, trans. Edward G. Seidensticker, 2 vols. (New York: Alfred A. Knopf, 1976).
2. See *Muromachi Jidai no Byōbu-e: Kokka Sōkan Hyaku-nen Kinen* (Screen Paintings of the Muromachi Period: In Commemoration of the 100th Anniversary of the Kokka Publication) (Tokyo: Tokyo National Museum, 1989), and Michael R. Cunningham et al., *The Triumph of Japanese Style: Sixteenth-Century Art in Japan* (Cleveland: The Cleveland Museum of Art, in cooperation with Indiana University Press, 1991).

Mokagami, *an Album of 298 Calligraphic Specimens*

Nara to Edo period
H. 40 x W. 34.4 cm (15¾ x 13½ inches)

1. *A poem from the* Shūishū (*Collection of Gleanings*) (251st piece)
Edo period
Kojima Sōshin (1580–ca. 1655)
Ink on paper, decorated with floral designs in gold and color
H. 31 x W. 24.8 cm (12¼ x 9¾ inches)

2. *A personal correspondence* (254th piece)
Kamakura period
Hōjō Masako (1157–1225)
Ink on paper
H. 20.8 x W. 11.6 cm (8¼ x 4½ inches)

3. *Two episodes from the* Ise Monogatari (*Tales of Ise*) (258th piece)
Momoyama period
Keifuku-in Gyokuei (1525–after 1602)
Ink on dyed paper
H. 22.6 x W. 9.7 cm (8¾ x 3¾ inches)

4. *Two poems from the* Genji Monogatari (*Tale of Genji*) (259th piece)
Momoyama period
Lady Yodo (1567–1615)
Ink on *shikishi* decorated with design of marine life in gold and silver
H. 20.5 x W. 18 cm (8⅛ x 7 inches)

The generic name for such an accordion-shaped album of calligraphy specimens is *tekagami*, *te* meaning "hand" (as in "handwriting") and *kagami* meaning "mirror," which succinctly expresses the long-held Chinese belief that one's calligraphy mirrors one's character, education, and upbringing. Such *tekagami* are sometimes called *kohitsu tekagami*. *Kohitsu* literally means "old (hence superior) brush."[1] In other words, an album such as this is a collection of specimens of superior old calligraphy, created out of veneration for past accomplishments in this art.

Pages from books or small sections of handscrolls were pasted into these accordion-folded albums of stiff paper. This format seems to have come into use in the late Muromachi period and, later, to have become increasingly popular in the Momoyama period, when ownership of *tekagami* signified education and sophistication. *Tekagami* were often displayed during the tea ceremony; still later, in the Edo period, such albums formed part of a well-born young woman's dowry. The rising popularity of *tekagami* led to willful fragmenting of complete manuscripts.

The contents and format of *tekagami* became more or less standardized by the late sixteenth century. A standard album consisted predominantly of fragments from poetic anthologies and sections of Japanese—and occasionally Korean—Buddhist sutras. Specimens of documents, tales, and correspondence may be included, though in much smaller numbers. By the mid seventeenth century the arrangement of these fragments seems to have become regularized: writings by members of the royal family, noblemen, and high court officials were pasted on the obverse of the accordian folds; specimens by famous calligraphers, eminent priests, and warriors on the reverse; examples by women at the very end of the reverse side.

Most treasured old specimens from the Heian and earlier periods, particularly fragments from larger manuscripts, lacked calligraphers' signatures. To identify the calligraphers, connoisseurship of a sort developed. The first connoisseurs were knowledgeable courtiers and priests, but soon professional experts appeared. The first such professional is thought to have been Hirasawa Yashirō (1587–1662), who operated a studio called Fuya and used the name Kohitsu Ryōsa and the seal "Kinzan" (Lute Mountain). Besides attributing unsigned works to known personalities, calligraphy experts also appraised specimens and decided their sequence within a given album.

By the mid seventeenth century demand for *tekagami* had risen so high that a printed reproduction of an original album, including Ryōsa's preface, was pub-

lished in 1651 under the title *Keian Tekagami* (*Album of the Keian Era*, 1648-1651). It was intended as a guidebook for collectors. In many albums, such as the one shown here, the specimens may be accompanied by small pieces of paper, each bearing the name of the calligrapher to whom the writing was attributed, the seal of the professional connoisseur who made the attribution, and the first words. Most attributions made by Ryōsa and his descendants and pupils are no longer consid-

ered authoritative, but they retain a historical interest and importance.

The album shown here with its silk brocade cover bears the label *Mokagami* (Mirror of Seaweed). Inside the cover are two narrow strips of inscribed paper, attributing this label to Karasumaru Mitsuhiro (1579-1638), a scholarly courtier known for his idiosyncratic calligraphic style and a profound knowledge of the classics. This attribution was first made by a member

(1) Kojima Sōshin

(2) Hōjō Masako (Nii no Ama)

(3) Keifuku-in Gyokuei

of the Kohitsu school (who included an impression of his "Kinzan" seal) and was seconded by another, who used a different "Kinzan" seal.

Among the 298 specimens included in this book are those attributed to the most prominent figures in Japanese history: Emperor Shōmu (reigned 724–748) and his consort Kōmyō, Prince Shōtoku (574–622), Sugawara no Michizane (845–903), and Priest Saigyō (1118–1190). Attributions to these pivotal figures in Japan's history or literature are difficult to prove; more plausible are the attributions to men and women from later

periods. Four examples are illustrated here, chosen for the beauty of calligraphy or the paper used. One is an example of personal correspondence, and three others are quotations from classical literature. Each piece is accompanied by a label, written on a small piece of paper, that includes the attribution to a calligrapher, the first words, and either one of two "Kinzan" seals. Generations of connoisseurs used these seals, even in the twentieth century, and it is difficult to distinguish the individual connoisseurs from seals alone.[2]

1. "During the Engi era (901-923), written on a folding screen, by Ki no Tsurayuki (884-946):

> I thought only pines are evergreens,
> But the spring water that flows constantly
> also shines in green."

The paper, which is decorated with small clusters of flowers delicately painted in gold and color, provides a perfect setting for elegant calligraphy in which letters run together in an almost uninterrupted flow. It is attributed by Kinzan to Shindokuken Sōshin, another name for Kojima Sōshin, whose handscrolls of poems are in a number of American collections.[3]

Born in Kyoto, Sōshin was a student of Hon'ami Kōetsu (1558-1637), founder of the Rimpa school, and was connected with Kōetsu's small community of artists and craftsmen who lived at Takagamine, north of the city. Later, he instructed Ogata Sōken (1621-1687)[4] (no. 35) in the art of calligraphy. Relatively little is known of his life, but it is possible that he was also inspired by the writing styles of Heian-period calligraphers.

Sōshin's elegant calligraphy reflects Kōetsu's style in its deliberate contrast between thick and thin lines, and in its juxtaposition of strongly brushed Chinese *kanji* characters with thin, *kana* letters that are executed with nervous, sharp strokes.

2. Many compilers of *tekagami* seem to have felt obliged to include tattered pieces of personal correspondence, many of which are attributed to Hōjō (Taira) Masako (1157-1225), known as *Nii no Ama* (Nun of the Junior Second Rank). The wife of Minamoto no Yoritomo, first shogun of Japan, Masako took her religious vows after her husband's death in 1199, but at the same time exercised firm control over the military government. Following a common practice of the time, the back of the paper on which the letter was written was re-used for other purposes.[5] Because of the severe damage the paper has suffered, only disconnected letters can be deciphered.

3. Concluding part of Episode 112,
 Ise Monogatari (Tales of Ise)
"Captured by the gale,
The smoke from the salt-fires
Of the fisherfolk at Suma
Had drifted off
In an unforseen direction."

Episode 113
"A poem composed by a man who had been left to live alone:

> How deficient in feeling
> Is the heart
> That can forget
> In the short span
> Of a human life."

Beginning part of Episode 114
"Once the Ninna Emperor commanded—on an outing to the Serikawa River—"[6]

Fragments similar to this one from the *Ise Monogatari*, a tenth-century book of short stories centered around poems, can be found among many other *tekagami*.[7] Sections from Episodes 112 to the beginning part of 114 from this book were copied in a firm hand on paper partly dyed in blue.

The label by Kinzan, attached to this piece, attributes the calligraphy to Keifuku-in Gyokuei, daughter of the Kyoto courtier and regent Konoe Tane'ie (1503-1566). While this attribution cannot be supported by documentary evidence, there are persuasive stylistic similarities between this piece and other specimens of calligraphy by this high-born lady, who became a nun and lived in Nara.[8] Attributed also to her are a large number of works related to the *Tale of Genji* (*Genji Monogatari*) (see nos. 36-37), such as the charming handscrolls in ink (1554), now in the Spencer Collection, New York Public Library.[9] She also wrote a number of commentaries on the *Genji*, reflecting her deep interest in this literary masterpiece of the Heian period: for example, in 1589, at the age of sixty-four, she wrote the *Kaoku Gyokuei Waka* (Yōmei Bunko Library, Kyoto), a complete collection of poems from the *Tale of Genji*. She continued to work even later, writing such commentaries on *Genji* as the *Kaokushō* (1594) and the *Gyokueishū* (1602).[10]

4. "Because of one chance meeting by the wayside
The flower now opens in the evening dew."

"And how does it look to you"
 (Genji)

"The face seemed quiet to shine in the evening dew,
But I was dazzled by the evening light."
 (Yūgao)[11]

This short quotation from the *Genji Monogatari* is written on dark blue paper decorated with designs of marine life in silver and gold. Calligraphy that contrasts bold letters in dark ink against delicate scripts in light ink is attributed by Kinzan to Lady Yodo (1567-1615), a younger sister of Oda Nobunaga who was Toyotomi Hideyoshi's concubine. She enjoyed power and influence as the mother of Hideyoshi's successor Hideyori, but she, her son, and the army that remained loyal to her deceased husband perished by suicide at the fall of the Osaka Castle under siege by Tokugawa Ieyasu's army in 1615.

This piece seems to have been separated from a book of *shikishi* (decorated poem cards); a piece similar in size, style and decoration, which quotes a poem from the *Shin Kokinshū*, is included in another *tekagami*.[12]

NOTES

1. For a general introduction to *tekagami*, see Kinoshita Masao, ed., *Tekagami*, Nihon no Bijutsu no. 84 (Tokyo: Shibundō, 1973); also, for my earlier research, see *Court and Samurai in an Age of Transition: Medieval Paintings and Blades from the Gotoh Museum, Tokyo* (New York: Japan Society, 1990), no. 19.

2. For the listing of *kohitsu* connoisseurs, see Kinoshita, *Tekagami*, 108-109.

3. For other examples of his calligraphy, see Shen Fu, Glenn Lowry, and Ann Yonemura, *From Concept to Context: Approaches to Asian and Islamic Calligraphy* (Washington, D.C.: Freer Gallery of Art, 1986), no. 30; Miyeko Murase, *Tales of Japan: Scrolls and Prints from the New York Public Library* (New York and Oxford: Oxford University Press, 1986), no. 17; Yoshiaki Shimizu and John M. Rosenfield, *Masters of Japanese Calligraphy: 8th-19th Century* (New York: The Asia Society Galleries and Japan House Gallery, 1984), no. 109; and John M. Rosenfield, Fumiko E. Cranston, and Edwin A. Cranston, *The Courtly Tradition in Japanese Art and Literature: Selections from the Hofer and Hyde Collections* (Cambridge: Fogg Art Museum, Harvard University, 1973), no. 61.

4. For a discussion of Sōken's background and his art, see Yamane Yūzō, "Ogata Kōrin and the Art of the Genroku Era," trans. Rei Sasaguchi, *Acta Asiatica* 15 (December 1968): 71-74.

5. Zaitsu Eiji, ed., *Tegami* (Personal Correspondences), Nihon no Bijutsu no. 82 (Tokyo: Shibundō, 1973).

6. Helen Craig McCullough, *Tales of Ise: Lyrical Episodes from Tenth-Century Japan* (Stanford: Stanford University Press, 1968), 144-45.

7. Kohitsu Tekagami Taisei Henshū Iinkai, ed., *Kohitsu Tekagami Taisei* (Collection of *Kohitsu Tekagami*) (Tokyo: Kadokawa Shoten, 1983), vol. 5, no. 177.

8. Ibid.

9. Murase, *Tales of Japan*, no. 20.

10. *Kohitsu Tekagami*, vol. 5, no. 177.

11. Murasaki Shikibu, *The Tale of Genji*, trans. Edward G. Seidensticker, 2 vols. (New York: Alfred A. Knopf, 1976), 1: 69-70.

12. *Kohitsu Tekagami*, vol. 7, no. 136.

styles used
Waka Chinese poetry

34.

Henjō and Jichin from the Mokuhitsu Jidai Fudō Uta-awase-e (*Stylus Drawing of the Competition among Poets of Different Eras*)

Nambokuchō period
Hanging scroll; ink on paper
H. 31.2 x W. 52.8 cm (12¼ x 20¾ inches)
FORMER COLL.: Mōri Collection
PUBLISHED: Mori Tōru, *Uta-awase-e no Kenkyū: Kasen-e,*
rev. ed. (Study of Poetry Competition: Painting of Poets)
(Tokyo: Kadokawa Shoten, 1978), pl. 32.

Waka

Refined aristocrats of the Heian period expressed and exchanged thoughts and emotions, both private and public, through *waka*, short verses of thirty-one syllables. The ability to compose *waka* extempore was an essential element of aristocratic deportment; ambitious courtiers, both men and women, also found it an indispensable prerequisite to recognition and promotion in the capital.

Courtly pastimes of the Heian period included a variety of contests or competitions in almost every aspect of artistic endeavor, including painting. Poetry competitions, *uta-awase*, were also a vital component of patrician life. These took place at parties where courtiers gathered to enjoy each other's company and compare their versifying skills. Although it is not known exactly when the first *uta-awase* took place, the custom can be traced back to the 880s and the games played among women of the court.[1] (Aristocratic women were the first to adopt *waka* as a major mode of literary expression, while their male counterparts still clung to traditional Chinese style of poetry.) In a classic poetry match, contestants were divided into two groups, called "left" and "right."

Long-held tradition has it that the renowned scholar, critic, and poet Fujiwara no Kintō (966-1041) and the poet-critic Prince Rokujō Tomohira (964-1009) differed in their choice of the greatest poet of *waka*.[2] Kintō nominated Ki no Tsurayuki (884-946) for the first place, whereas Tomohira preferred Kakinomoto no Hitomaro (late seventh century). To buttress his opinion, Kintō selected thirty-six poets of the Nara and

Heian periods and requested other *waka* connoisseurs to evaluate and rank them. The majority gave highest honors to Hitomaro. It then became popular to make up lists of great poets, usually numbering thirty-six and with Hitomaro in premier position. When Kintō selected the thirty-six masters, soon to be known as *kasen* (immortal poets), he also chose representative verses of each, 150 poems altogether.[3]

It is difficult to determine exactly when the first group portrait of *kasen* was made, but several timely developments appear to have contributed to the formation of a pictorial iconography for the "immortal poets." The *kasen* theme as a subject for painting may have been inspired by an earlier tradition of paying homage to the painted image of Hitomaro. According to long-standing tradition, ceremonies in which Hitomaro's portrait was venerated as an icon were initiated in 1118. On this first occasion a newly made imaginary portrait of the genius of poetry was displayed, with flowers and offerings placed before it.[4] The poet was portrayed as aged and informally clad, with a sheaf of writing paper in his left hand and a brush in his right. The ceremony, which endured for centuries, was obviously inspired by the Chinese custom of paying homage to images of Confucian sages.

The 1118 portrait of Hitomaro is traditionally believed to have been based on an image that appeared in the dream of a certain Awata Sanuki-no-kami Kanefusa, an aficionado of *waka*.[5] Kanefusa, who aspired to poetic greatness, had prayed to the spirit of Hitomaro for divine assistance. One evening a pensive old gentleman

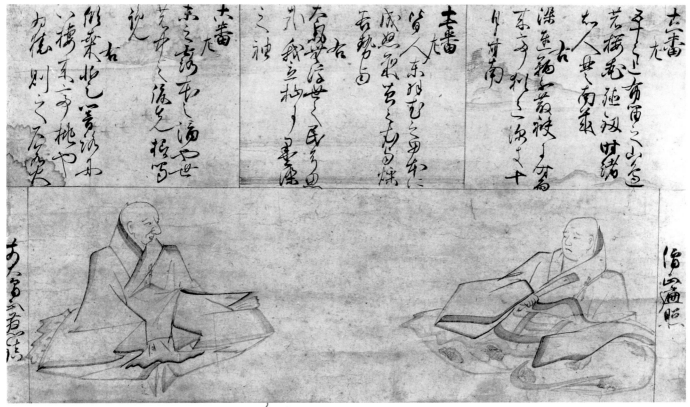

Imaginary Competition.
Poets - Heian Period
Chinese Characters Scattered

in informal attire appeared to him in a dream and identified himself as Hitomaro. He held a bundle of writing paper in his left hand and a writing brush in his right. In the morning, Kanefusa called for an artist to render the dream figure into painting, intending to use it as an icon for worship. Thereafter Kanefusa's poetry showed great improvement, and the miraculous portrait was willed to the emperor Shirakawa (reigned 1072–1086). Many copies of this painting were made, and they became indispensable in ceremonies dedicated to the "holy man" of *waka* poetry.

The Kamakura period witnessed the peak in production of *kasen-e* (pictures of immortal poets). Several historical tendencies contributed to the rise in popularity of this genre of painting: the fierce determination of the politically enfeebled Kyoto court to assert aristocratic cultural traditions, a keen new awareness of his-

tory and interest in historical personages, and the growing popularity of portrait paintings known as *nise-e*. Although *kasen-e* are imaginary likenesses of men and women who lived long before the paintings were made, the desire to create individualized "portraits" of the immortal poets reflects the spirit of the Kamakura era.

The richness and diversity of Kamakura-period *kasen-e* is truly impressive; there was a growing trend to produce variations on the *kasen-e* theme that deviated from the Kintō model in the choice of poets and sample verses. The *kasen-e* tradition endured throughout the Muromachi and later periods, continuing to generate even richer variations and innovations on the poet-portrait theme, while retaining the vigor of its ancient roots.[6] For all of their deceptively simple content, *kasen-e* express the quintessential Japanese reverence for the power of word and image. At the

same time they unite the three "high" arts of literature, calligraphy, and painting.

The basic premise of Kintō's selection of thirty-six immortal poets was a *jidai fudō*, or listing of poets of different eras. A later selection, known as the *Jidai Fudō Uta-awase* (*Competition among Poets of Different Eras*), differs from Kintō's in presenting one hundred poets as paired, competing rivals. This assemblage of bards "from past and present," each represented by three poems, is generally accepted as the creation of the retired emperor Gotoba (reigned 1185-1198).[7] The *Jidai Fudō Uta-awase*, believed to have been completed between 1232 and 1235, sets up an imaginary competition among the one hundred poets, who were evenly divided into "left" and "right" teams. The "left" team was made up of poets represented in the three earliest Imperial anthologies: the *Kokinshū* (*Collection of Ancient and Modern Poems*, ca. 920), the *Gosenshū* (*Later Collection*, 951), and the *Shūishū* (*Collection of Gleanings*, ca. 1005-1011). The "right" team was drawn from more "recent" authors represented in the five later anthologies: the *Go Shūishū* (*Later Collection of Gleanings*, 1086), the *Kinyōshū* (*Collection of Golden Leaves*, ca. 1124-1127), the *Senzaishū* (*Collection of a Thousand Years*, ca. 1188), the *Shikashū* (*Collection of Verbal Flowers*, 1151), and the *Shin Kokinshū* (*New Collection of Ancient and Modern Poems*, ca. 1206).

Tradition has it that Gotoba commissioned a Kyoto artist to depict the hundred poets in a painting of the *Jidai Fudō Uta-awase-e*. The story cannot be verified, but the many extant paintings of Gotoba's one hundred poets, dating mostly from the mid Kamakura through the Muromachi period, attest to the enormous popularity of Gotoba's concept. Unfortunately all known paintings of the *Jidai Fudō Uta-awase-e* have been fragmented, except for several copies and "new" works produced during the Edo period.[8]

Some of the established characteristics of the *Jidai Fudō Uta-awase-e* can be determined from the extant fragments. Paintings of this large group of poets (for which the most satisfactory format is the handscroll) show the poets in competing pairs and identify the "round" of the competition and each poet's team. Competitors of the "left" team are shown at the viewer's right, those of the "right" team at the viewer's left. With the notable exception of Hitomaro, the poets

in these paintings differ completely in appearance and pose from their counterparts in traditional *kasen-e*. This may indicate a deliberate attempt to create an entirely new tradition for these images of the "Contest of the Different Eras."

The present hanging scroll depicts two Buddhist monks, Henjō, at our right (816-890), and Jichin (posthumous name for Jien, 1155-1225), competing as poets. It was separated from a handscroll that originally represented one hundred poets, each meeting for three rounds of the match. Altogether, they produced three hundred poems. In this fragment, the two poets meet for rounds 16 through 18, and their resulting six poems are paired and written within the areas marked off above. Each squared-off area is decorated with underdrawings of landscapes or flowers that give an impression of a *shikishi* (decorated poem card). The names of the poets are written in narrow rectangular spaces reserved behind them. Their poems are written in a rather unusual manner that combines *kana* and *man'yō-gana* (the first Japanese system of writing using Chinese characters to represent Japanese sounds). This mode of writing is believed to have come into vogue in the late Kamakura period.[9]

The two poets are dressed in priestly habits, which are drawn with a flat wooden stylus called a *mokuhitsu* (wooden brush). This brush creates thread-thin, parallel lines revealing the white of the paper in between the lines and producing an effect known as *hihaku* (flying white). This technique was introduced from China and known to the Japanese as early as the mid eighth century. Later, it seems to have become closely associated with the Shingon sect of Esoteric Buddhism (*Mikkyō*).[10] Attempts at individualization of the poets' facial characteristics are apparent: Henjō is represented as a youngish monk, while Jichin is an older man with an unusually prominent nose. He seems to be on a winning streak, as his younger rival looks at him in consternation.

The handscroll from which this fragment was separated once belonged to the Mōri Collection, and it bore a listing of all the one hundred contestants at the beginning.[11] However, the box that contained this handscroll bears an inscription dated to 1725, indicating that even at that time the scroll was incomplete, as the box is large enough for only one handscroll. The scroll

included only poets 1 to 48, and the 43d and 45th poets were also missing.[12] The original handscroll, therefore, must have belonged to a set of two scrolls. Another fragment from this scroll is now in the collection of the Asian Art Museum, San Francisco,[13] but the calligraphy in that fragment differs from the calligraphy in other sections from the same scroll, including the Burke piece. This suggests that more than one calligrapher was involved in this daunting undertaking, the copying of three hundred poems.

The six poems of this fragment read as follows:

16th Round Left (*Henjō*):
> Cherry trees on Mt. Furu ("Old") at Iso no Kami
> are as old as the mountain,
> No one knows who had planted them there.[14]

16th Round Right (*Jichin*):
> Leaves turned colors,
> yet linger still in the valley,
> Autumn showers deepen their colors even further,
> as it is the tenth month of the year.[15]

17th Round Left:
> Everyone now is garbed again
> in robes with hues of springtime blossoms,
> Oh moss-colored sleeves of mine,
> won't you at least become dry.[16]

17th Round Right:
> Vainglorious I may be,
> But I try to protect
> the people of this wearisome world,
> who might come under my priestly sleeves.[17]

18th Round Left:
> Dewdrops from the tips of leaves
> or droplets at the tree's root,
> No matter,
> Sooner or later they will all vanish.[18]

18th Round Right:
> Let me hope that I will linger awhile
> in this lightless path,
> To brighten it with
> the sparks from Buddha's law.[19]

NOTES

1. Minegishi Yoshiaki, *Uta-awase no Kenkyū* (Study of Poetry Competition) (Tokyo: Sanseidō, 1958), 13.
2. For literary records on this dispute, see Hasegawa Nobuyoshi, "Sanjūrokkasen no Seiritsu" (Selection of the Thirty-six Immortal Poets), in *Shinshū Nihon Emakimono Zenshū* (New Collection of Japanese *Emaki*), ed. Tanaka Ichimatsu (Tokyo: Kadokawa Shoten, 1979), 19: 40-44.
3. The first four poets on Kintō's list (Hitomaro, Tsurayuki, Mitsune, and Ise) and the last two (Kanemori and Nakatsukasa) were represented by ten poems each; whereas the rest were represented by three each.
4. "Kakinomoto Eigu Ki" (Record of Offerings Made to Kakinomoto's Portrait), ed. Fujiwara no Atsumitsu (1061-1144), in *Shinkō Gunsho Ruijū* (Revised Edition of Old Literary Materials), ed. Kawamata Kōichi (Tokyo: Naigai Shoseki Kankōkai, 1929), 13: 53.
5. For the record of this dream, see the *Jikkinshō*, a 1252 collection of old tales, ed. Izumi Motohiro (Tokyo: Kasama Shoin, 1982), 118-19.
6. For some of the later variations, see Miyeko Murase, *Tales of Japan: Scrolls and Prints from the New York Public Library* (New York and Oxford: Oxford University Press, 1986), nos. 12-16.
7. Mori Tōru, *Uta-awase-e no Kenkyū: Kasen-e* (Study of Poetry Competition Painting: Painting of Poets) (Tokyo: Kadokawa Shoten, 1978), 153 ff.
8. For reproductions of these later examples, see Mori, *Uta-awase-e*, figs. 33-35.
9. Mori, *Uta-awase-e*, p. 167, no. 3.
10. The Shōsōin Office, *Shōsōin no Kaiga* (Paintings in Shōsōin) (Tokyo: Nihon Keizai Shimbunsha, 1968), 153; also, for the examples of calligraphy in this style, see Ariga Yoshitaka, ed., *Heian Kaiga* (Paintings of the Heian period), Nihon no Bijutsu no. 205 (Tokyo: Shibundō, 1983), figs. 29-31.
11. Mori, *Uta-awase-e*, fig. 22.
12. Ibid., p. 166, no. 1.
13. Yoshiaki Shimizu and John M. Rosenfield, *Masters of Japanese Calligraphy: 8th-19th Century* (New York: The Asia Society Galleries and Japan House Gallery, 1984), no. 38.
14. Poem no. 49 in *Gosenshū*.
15. Poem no. 6107 from Jien's anthology, *Shugyokushū* (Assembled Jewels).
16. Poem no. 847 from *Kokinshū*. Laurel R. Rodd, *Kokinshū: A Collection of Poems Ancient and Modern* (Princeton: Princeton University Press, 1984).
17. Poem no. 1134 from *Senzaishū*.
18. Poem no. 757 from the *Shin Kokinshū*.
19. Poem no. 1931 from the *Shin Kokinshū*.

35.

Two Poems from the Shin Kokinshū

Edo period
Ogata Sōken (1621-1687)
Pair of hanging scrolls; ink and gold pigment on paper
H. 21 x W. 19.5 cm (8¼ x 7¾ inches) each
PUBLISHED: Carolyn Wheelwright, ed., *Word in Flower:*
The Visualization of Classical Literature in Seventeenth-Century Japan
(New Haven: Yale University Art Gallery, 1989), no. 42.

The old capital city of Kyoto in the late sixteenth and seventeenth centuries was the site of what many scholars have labeled a virtual renaissance in the courtly arts. In an era that witnessed the close of a lengthy period of internecine warfare and the establishment of a new urban center, Edo (modern Tokyo), as the center of government for the Tokugawa shogunate, Kyoto experienced a remarkable flowering of creative activity among its educated social elite. The art of calligraphy in particular flourished under the influence of such major masters as Hon'ami Kōetsu (1558-1637), Konoe Nobutada (1565-1614), and Shōkadō Shōjō (c. 1584-1639)—who were known as the *Kan'ei no Sanpitsu,* or Three Great Brushes of the Kan'ei era (1624-1644)—and the courtier-scholar Karasumaru Mitsuhiro (1579-1638).

A co-founder of the group of artists that later became known as the Rimpa school, Kōetsu exerted a profound influence on the aesthetic values of several generations of his followers. Among these, Ogata Sōken, the calligrapher of this pair of exquisite *shikishi* (poem cards), can perhaps be described as a third-generation Rimpa artist. The *Honchō Kōkin Meikō Kohitsu Shoryū (Styles of Classical Brushes of Past and Present in Japan)*, written in 1694, cites Sōken as one of seventeen calligraphers who worked in a manner inspired by Kōetsu,[1] and Sōken's father, Ogata Sōhaku, was Kōetsu's nephew. Sōken's teacher, Kojima Sōshin (1580-c. 1656), was a Kōetsu disciple who may have worked for a time at Takagamine (northwest of Kyoto), the community of artists, craftsmen, *chanoyu* (tea ceremony) adepts, and adherents of the Nichiren sect of Buddhism, established by Kōetsu around 1615.[2]

Sōken's brushwork contains elements of both Kōetsu's and Sōshin's calligraphic styles, and the choice of poems inscribed on this pair of *shikishi* likewise reflects the literary concerns and interest in Heian- and Kamakura-period culture expressed by his Rimpa-school predecessors and other members of Kyoto's educated circles. The cultivated "upper classes" of seventeenth-century Kyoto were fairly broad in scope in that they encompassed not only the Imperial court and descendants of the hereditary aristocracy but also wealthy merchants, tea masters, and samurai representatives of the Edo military regime. Master craftsmen like Kōetsu, a sword-polisher and connoisseur by profession, were also permitted entry into this world; Sōken, as a prosperous designer of textiles and owner of the fashionable Kariganeya fabric shop, was in frequent contact with members of courtly society as well as other educated merchants active in the capital's artistic-literary milieu.[3]

Although Sōken is perhaps best known as the father of Kōrin (1658-1716) and Kenzan (1663-1743), two of the most outstanding artists of the Rimpa school, he was an accomplished calligrapher in his own right, with an elegant, delicately balanced, sometimes rather mannered style. The Burke *shikishi* bear two verses from the *Shin Kokinshū (New Collection of Poems from Ancient and Modern Times)*, the Imperial poetry anthology commissioned by Emperor Gotoba (reigned 1183-1198) and compiled by Fujiwara no Teika (1162-1241) and other distinguished poets of the early Kamakura period. The verse inscribed on the *Spring shikishi* was composed by Ki no Tsurayuki (ca. 872-945), one of the leading Heian-period masters of the 31-syllable *waka* poem.

Autumn

Spring

It reads as follows:

With blossom scent
The fragrance of these garments
Takes on a new depth
In every gust of wind that blows
Beneath the shadow of the trees.[4]

The name "Tsurayuki" is written with a bold brush in the center of the composition, following the first two lines of the verse.

The *Autumn* poem by Fujiwara no Ietaka (1158–1237) reads:

Travel poem
submitted with a 100-poem sequence
Lord Fujiwara Ietaka

Although no promise
Kept me here, the night has passed—
Kiyomi Strand
Where now the waves are left behind
By the brightening sky of dawn.[5]

The *Autumn shikishi* features a more compressed arrangement of calligraphy; characters are written closer together and lines seem somewhat crowded in the limited space.

On both works the calligraphy starts with a flourish, with each line beginning at a different vertical indentation, in a manner known as *chirashi gaki* (scattered writings). For the *Spring* poem by Tsurayuki, the first word, the Chinese character for *hana* (flower), is written with a bold hand and a brush richly laden with ink. Sōken allows the brush tip to remain exposed, which creates the slight, tapering point at the entrance and closure of each stroke. The following character (*no*) exhibits the same idiosyncracies, with the tail end of the final brushstroke trailing off to form a linkage with the following word. Subsequent characters in both Chinese and native *kana* syllabic writing become much more fragile in appearance, with wavering, spidery strokes that fluctuate in thickness. At times Sōken's vertical movements of the brush take on a shaky or unsteady quality. One wonders whether this was the result of age, or even a deliberate affectation to copy elements from late works by Kōetsu, who suffered from a palsy of the hands in the final years of his life. (Study of Sōken's calligraphy has been limited to date,

and it is extremely difficult to date his work.) Another notable aspect of the writing on both *shikishi* is the tendency of the brush to flick upwards slightly at the close of both Chinese and *kana* characters—in part a natural movement of the hand to retrace the stroke, but also, in the case of Sōken's work, a conscious mannerism with the movement (and resulting "hooks" where the brush lifts up from the paper) emphasized for visual effect. This nervously flickering quality of line contributes to the brittle yet gossamer delicacy of Sōken's calligraphy.

Sōken's hand owes its fluid elegance to the style of brushwork established by Kōetsu and emulated, to an extent, by his own mentor Sōshin. It is therefore by connection indebted to the Shōren-in school of calligraphy, in whose tradition Kōetsu received training. This school had roots in the Kamakura period and combined the grace and flowing asymmetry of Heian-period *kana* with the more sharply articulated brushstrokes of Chinese character writing. The contrast, in Sōken's calligraphy, between prominent, darkly inked and strongly written Chinese characters and fine, flowing lines of native *kana* is also typical of both Kōetsu's and Sōshin's writing, and has been cited by scholars as a feature drawn from mannerisms of Chinese calligraphers of the Southern Sung dynasty, in particular the writing of Chang Chi-chih (1186–1266), whose work was known in Japan.[6]

Although Sōken's writing is clearly in the "Kōetsu style," it is, in general, less rhythmic and smooth than calligraphy firmly attributed to the first-generation Rimpa master. Its self-conscious delicacy, which at times borders on preciousness, is more closely derived from the work of Sōshin (see no. 33), whose extant handscrolls of verses from a number of imperially commissioned poetry anthologies exhibit calligraphy of a similar mannered refinement, with a frequently exposed brush tip.

The underpaintings of Sōken's *shikishi* are executed in fine lines of gold pigment and light gold wash. The *Spring* painting depicts a cherry tree in bloom on the gently sloping banks of an undulating stream, the *Autumn* painting a river flowing over rocks and around patches of autumn foliage. Unlike the sumptuous, relatively abstract or pastichelike underdecorations that Rimpa artist Sōtatsu (d. ca. 1643) produced for many of

Kōetsu's calligraphic works, these are literal interpretations of nature. It is possible that Sōken executed the underpaintings himself; the stylized, repetitive swirling water patterns in the *Autumn* sheet are similar to those used in textile designs of the period. Comparisons may also be made with details found in poetry handscrolls by Sōshin. Many of these are ornamented with small-scale images of flowers and rocks, painted in gold or in colors pooled together to create the marbled effect known as *tarashikomi*.[7] However, one example, a handscroll of verses from the tenth-century *Gosenshū* poetry anthology in the Arthur M. Sackler Museum (The Harvard University Art Museums), Cambridge, Massachusetts, contains a section decorated with a design of fans floating on stylized waves, beneath a band of mist in pale gold.[8] The tiny paintings on the open fans, some of which depict trees, flowers, and flowing water, are much like the Burke *shikishi* underpaintings. Yet another portion of this scroll displays the repeated motif of chrysanthemums floating upon swirling currents of water (see no. 61), reminiscent of the underpainting on the Burke *Spring shikishi*. It is not known who made the pictorial images on Sōshin's handscrolls, although several possibilities have been noted. One scholar believes the designs to be the work of the Sumiyoshi school, an offshoot of the traditional Tosa studio.[9] It has also recently been suggested that the underpaintings of both Sōken's and Sōshin's works were inspired by images from the enamelled ceramic wares of Nonomura Ninsei (flourished first half of the seventeenth century), and that Sōshin may have collaborated with Ninsei on a number of artistic projects.[10]

Certainly, the tradition of inscribing poems over small paintings of motifs from nature, executed in gold or silver pigment, was one that dated back to the Heian period, when it was practiced in courtly circles. In Sōken's time it was in common use among calligraphers; even Kōetsu sometimes eschewed the underpaintings of bold, flat motifs favored by Sōtatsu's studio for the more naturalistic, fine-lined depictions of plants or landscapes that appear on a number of his *shikishi*.[11] It is evident that Sōken was influenced by both the classical past and his contemporaries in his choice of images to form the backdrop for his work as well as in the development of his distinctive calligraphic style.

sw

NOTES

1. Kuboki Shōichi, *Kojima Sōshin Waka-kan* (Kojima Sōshin's Calligraphy of Waka Poetry), vol. 27 of *Nihon Meiseki Sōkan*, ed. Komatsu Shigemi (Tokyo: Nigensha, 1979), 57.

2. In one letter written to Sōken, Sōshin mentions an upcoming visit to Takagamine. However, it is not certain whether he maintained a residence there, or exactly when he studied with Kōetsu. See Kuboki, *Kojima Sōshin Waka-kan*, 58.

3. Sōken's background and activity within these circles are briefly discussed in Yamane Yūzō, "Ogata Kōrin and the Art of the Genroku Era," trans. Rei Sasaguchi, *Acta Asiatica* 15 (December 1968): 71-74.

4. *Shin Kokinshū*, no. 111, trans. Edwin A. Cranston, in *Word in Flower: The Visualization of Classical Literature in Seventeenth-Century Japan*, ed. Carolyn Wheelwright (New Haven: Yale University Art Gallery, 1989), 115.

5. Ibid.; *Shin Kokinshū*, no. 969.

6. See Yoshiaki Shimizu and John M. Rosenfield, *Masters of Japanese Calligraphy: 8th-19th Century* (New York: The Asia Society Galleries and Japan House Gallery, 1984), 120, and Komatsu Shigemi, *Kan'ei Sanpitsu* (The Three Great Brushes of the Kan'ei Era), vol. 10 of *Nihon no Sho* (Tokyo: Chūōkōronsha, 1981), 106-107. Chang Chih-chih, some of whose calligraphy has been preserved in temples in Japan, was known for a writing style that "epitomizes the definition of *Sung-k'ai*—a fluency created by numerous ductile ligatures." His extant calligraphy, mostly in the standard (noncursive) script, reveals a tendency to contrast strong brushstrokes with finer, more delicate ones, often within the same character. See Shen C. Y. Fu with Marilyn W. Fu, Mary G. Neill, and Mary Jane Clark, *Traces of the Brush: Studies in Chinese Calligraphy* (New Haven and London: Yale University Press, 1977), 138, no. 11a.

7. One instance of this type of underpainting occurs in a handscroll of poems from the late twelfth-century *Senzaishū* poetry anthology, in the Spencer Collection of The New York Public Library; reproduced in Miyeko Murase, *Tales of Japan: Scrolls and Prints from The New York Public Library* (New York and Oxford: Oxford University Press, 1986), no. 17. A similar passage also appears in a handscroll in the Arthur M. Sackler Museum (The Harvard University Art Museums), described below.

8. Reproduced in John M. Rosenfield, Fumiko E. Cranston, and Edwin A. Cranston, *The Courtly Tradition in Japanese Art and Literature: Selections from the Hofer and Hyde Collections* (Cambridge: Fogg Art Museum, Harvard University, 1973), no. 61, pp. 190-91; also Shimizu and Rosenfield, *Masters of Japanese Calligraphy*, 262-63, no. 109.

9. Kuboki, *Kojima Sōshin Waka-kan*, 60.

10. This suggestion was made by Matthew McKelway, currently a Ph. D. candidate in Japanese art at Columbia University, New York. His observations were drawn on the basis of stylistic comparison, and the likelihood that Sōshin and Ninsei were active in the same circles.

11. Examples recently published and discussed include a *shikishi* in the Kimiko and John Powers Collection, New York, with an underpainting of willows and water, and another in the Denver Art Museum, with a motif of pine tree branches. See Shimizu and Rosenfield, *Masters of Japanese Calligraphy*, nos. 90-91. For other instances of Kōetsu calligraphy executed over paintings of landscape elements in gold or silver, see *Shiika to Sho: Nihon no Kokoro to Bi* (Tokyo: Tokyo National Museum, 1991), 148-50.

Episode from the "Kochō" ("Butterflies") Chapter of the Genji Monogatari (Tale of Genji)

Momoyama period, late sixteenth century
Fan painting mounted as a hanging scroll; ink, colors, and gold
on paper
H. 25.2 x W. 54.6 cm (10 x 21½ inches)

One of the most frequently illustrated works of literature in the history of Japan, the *Genji Monogatari* (*Tale of Genji*) served as a rich source of imagery for all schools of artist and all forms of painting: handscrolls, hanging scrolls, screens, albums, and fans. This story of the aesthetically idealized Prince Genji[1]—a paradigm of male virtue—and the elegant refinement of Heian aristocratic life, with its overtones of the bittersweet awareness of the inexorable passage of time, inspired artists almost from the time that it was written by the eleventh-century court lady Murasaki Shikibu. The earliest *Genji* pictures, perhaps produced shortly after the fifty-four-chapter novel was completed, are no longer extant, but the lineage of *Genji* illustration may be traced through the numerous works that survive from the twelfth century through the Edo period.[2] A diary kept by the twelfth-century courtier Minomoto no Morotoki contains the earliest known reference to *Genji* paintings in an entry for the year 1119;[3] the oldest extant illustrations, which consist of richly colored *tsukuri-e* (built-up pictures), are presently divided among the Goto Museum, the Tokugawa Reimeikai, and other Japanese collections. These scenes remain among the most beautiful and subtly evocative visualizations of episodes from the narrative.

Transmission of *Genji* imagery was simplified in the late Muromachi period with the standardization of pictorial elements to be included in scenes from each chapter; *Genji* synopses and painting manuals, available as early as the fifteenth century, provided descriptions of the manner in which important episodes should be depicted,[4] based on models approved by *Genji* connoisseurs. Such instructional books enabled artists to produce illustrations for the tale without having to read the entire lengthy text. Other painters may have simply relied upon earlier painted works. By the sixteenth century, when this small fan painting was executed, *Genji* pictures had become chiefly the province of amateur painters in courtly circles, who produced simple and charmingly naive illustrations, often in the *hakubyō* (literally, white drawing) ink-line mode,[5] and of the Tosa school, which catered to aristocratic circles. Tosa masters were professional artists who specialized in a conservative interpretation of classical *yamato-e* and functioned as leaders of the Imperial Painting Bureau. Numerous *Genji* scenes were painted by members of this atelier, most of them in the small *shikishi* (poem card) format well suited to their finely detailed, delicate painting technique. These works are generally characterized by static, rather schematized compositions, heavily applied pigments in brilliant colors, and pictorial devices inherited from Heian-period *yamato-e*, such as *fukinuki-yatai* (architectural structures drawn without any roof to permit visual access to interiors) and doll-like figures with *hikime-kagihana* features (dashes for the eyes, a hook for the nose).

Attribution of the Burke Foundation fan to a Tosa artist is logical, although it cannot be confirmed with any certainty. The red cauldron shape of the illegible seal in the lower right-hand corner is reminiscent of seals used by members of the Kano school, and Kano artists did occasionally produce *Genji* paintings.[6] However, the style of the painting is consistent with that of Tosa-school illustrations, and the small format is an effective vehicle for the miniaturist approach favored by such Momoyama-period Tosa masters as Mitsuyoshi (1539–1613) and Mitsunori (1583–1638).

Genji fan paintings in vibrant polychrome with a gold background and gold-colored cloud motifs were produced at least as early as the late Muromachi period.

Ground Plain tifted ees
sumptuous use of gold & color
Clouds prevent recession in space
Used as a fan — (Many teported to cheer)

Among the earliest are a set of sixty fans dating to some time between the late fifteenth and early sixteenth centuries; these are mounted on screens and are now in the collection of Jōdoji temple in Hiroshima prefecture. Other *Genji* fans from the late Muromachi period include another group of sixty (also mounted on screens) in the Eisei Bunko in Tokyo, as well as a privately owned set, contained in an album.[7] The fans in the Eisei Bunko Collection also bear a cauldron-shaped seal, whose characters may be read as "Kanga."[8]

The scene painted on the Burke Collection fan is of an episode from "Kochō," the twenty-fourth chapter of the *Genji Monogatari*. In the narrative, spring festivities are organized for the gardens of the Rokujō Palace, Genji's residence. Dragon and phoenix boats, "brilliantly decorated in the Chinese fashion,"[9] are launched in the lake, bearing ladies dressed in their most elegant garb, while musicians perform for the enjoyment of the spectators. On the following day, a sutra reading is commissioned by the empress Akikonomu. Guests attire themselves in formal dress and Murasaki, Genji's favorite consort, costumes several of her prettiest page girls as birds and butterflies and sends them to dance before Akikonomu's quarter of the palace.

The birds brought cherry blossoms in silver vases, the butterflies *yamabuki* in gold vases. In wonderfully rich and full bloom, they completed a perfect picture. . . . Akikonomu had declined Murasaki's offer of awnings and had instead put out seats for the orchestra in one of the galleries adjoining her main hall. The little girls came to the stairs with their flowers. Incense bearers received them and set them out before the holy images.[10]

The fan painting combines these events of two days into a single scene, a device commonly used for both album-leaf "Kochō" illustrations and larger-scale

versions on screens. (One example of the latter is the late sixteenth–early seventeenth-century "Kochō" screen in the Burke Foundation Collection, attributed to Tosa Mitsuyoshi.)[11] The central area of the arc-shaped format is taken up by the figures of five dancing children dressed in costumes with colorful wings, long trains of red brocade embroidered with gold, and bejeweled, ribboned chaplets. On the right, an expanse of veranda and a stairway introduce a strong geometric element into the composition. Outdoor curtains have been erected on either side of the little dancers, and the wall and roof of a covered corridor emerge from the mist in the lower left corner of the fan. Several courtiers are assembled on the veranda to view the performance. In the upper left corner, the prow of a pleasure boat, ornamented with wings and a dragon head, comes into view against a lapis-colored lake. Billowing, stylized cloud forms, a pictorial convention typical of narrative illustration, partially obscure figures, trees, and architectural structures. Outlines are fine and uninflected, in the manner of Tosa-school painting. Much of the original pigment has darkened and some has flaked from the surface; the entire fan shows the effects of use as well as the passage of time. That it actually filled the function of a folding fan and was not simply a decorative fan-shaped painting is made evident by the worn, vertical creases where the wooden spokes were once pasted. The reverse side of the fan may have borne another scene from the *Genji*, or perhaps a simple, decorative motif unrelated to the tale.

The painting itself is less refined and delicate in execution than works attributed to Mitsuyoshi or Chō-jirō (flourished late sixteenth–early seventeenth century), another Tosa artist active during the Momoyama period. Comparison with a *shikishi* by Mitsuyoshi in the Burke Collection,[12] depicting a scene from the "Fujibakama" ("Purple Trousers") chapter of the tale, reveals less finesse in the treatment of the figures and handling of the composition. However, the liveliness of the "Kochō" image and the delightful depiction of the dancing children endow this small work with a charm to which the application of gold adds a touch of courtly splendor. s w

NOTES

1. The name "Genji" derives from the appellation (also read "Minamoto") given to imperial sons destined for commoner status rather than the position of potential contenders to the throne.

2. Aspects of *Genji* illustration and details to be included in the various scenes from each chapter were subjects of dispute among connoisseurs of the tale as early as the thirteenth century. However, a relatively standardized imagery was familiar to many artists by the late Muromachi period. For discussion of the history of *Genji* painting and documentation concerning *Genji* iconography see Miyeko Murase, *Iconography of "The Tale of Genji: Genji Monogatari Ekotoba"* (New York and Tokyo: Weatherhill, 1983), and Akiyama Terukazu, *Genji Monogatari Emaki: Gengi-e* (The Tale of Genji Handscrolls: Genji Illustrations), Nihon no Bijutsu no. 119 (Tokyo: Shibundō, 1976). For representative images see Akiyama Ken and Taguchi Eiichi, eds., *Gōka "Genji-e" no Sekai: "Genji Monogatari"* (A World of Splendor in Genji Illustrations: *The Tale of Genji*) (Tokyo: Gakken, 1988).

3. Minamoto no Morotoki, *Chōshūki*, Zōho shiryō taisei, no. 16 (Kyoto: Rinsen Shoten, 1965), 183.

4. One such instructional text is a fifteenth-century copy presently in the collection of Osaka Women's College. This work, known as the *Genji Monogatari Ekobota*, is translated in its entirety in Murase, *Iconography of "The Tale of Genji."* Another *Genji* manual from the middle of the Edo period is in the Imperial Household Collection; see Shimizu Yoshiko, *"Genji Monogatari Kaiga no Ichi Hōhō"* (Techniques of *Tale of Genji* Illustration), *Kokugō Kokubun* (Japanese Language and Literature), no. 309 (1960): 1-14. For another discussion of these manuals and what their impact on painters may have been, see Julia Meech-Pekarik, "The Artist's View of Ukifune," *Ukifune: Love in The Tale of Genji*, ed. Andrew Pekarik (New York: Columbia University Press, 1982), 189-95.

5. See Shimbo Toru, *Hakubyō Emaki* (Ink-Drawing Illustrated Handscrolls), Nihon no Bijutsu no. 48 (Tokyo: Shibundō, 1970).

6. One of the best-known sixteenth-century examples of a Kano-school *Genji* painting is undoubtedly the pair of screens attributed to Kano Eitoku (1543-1590). This work, which depicts scenes from several chapters of the narrative, is in the Imperial Household Collection.

7. For brief discussion of these three examples of early *Genji* fan paintings, see *Genji Monogatari no Kaiga* (Illustrations of *The Tale of Genji*) (Sakai: Sakai City Museum, 1986), 17-19; also color plate 4.

8. Ibid., 18.

9. Murasaki Shikibu, *The Tale of Genji*, trans. Edward G. Seidensticker (New York: Alfred A. Knopf, 1982), 418.

10. Murasaki Shikibu, *The Tale of Genji*, 422-23.

11. Recently published in *Nihon no Bijutsu Meihin Ten: New York Burke Collection* (A Selection of Art from the Mary and Jackson Burke Collection) (Tokyo: Tokyo National Museum, The Tokyo Shimbun, and The Chunichi Shimbun, 1985), no. 30.

12. Ibid., no. 37.

Episode from the "Miotsukushi" ("Channel Buoys") Chapter of the Genji Monogatari (Tale of Genji)

Momoyama period, late sixteenth century
Fan painting mounted as a hanging scroll; ink, color,
and gold on paper
H. 18 x W. 55.7 cm (7⅛ x 22 inches)

This work is comparable in date to the Burke fan painting of a scene from the "Kochō" chapter of the *Genji Monogatari* (no. 36), and it is also similar in that it bears an illegible, red cauldron-shaped seal and is executed in thickly applied colors and gold leaf, in the miniaturist style traditionally associated with artists of the Tosa school. In this episode from "Miotsukushi," the fourteenth chapter of the tale, Prince Genji undertakes a pilgrimage to the Sumiyoshi Shrine in present-day Osaka prefecture to give thanks for the cessation of his exile to Suma. Accompanied by a splendid entourage of courtiers, guards, and page boys, he travels to the famous sacred precinct, renowned for its protection of *waka* poets and dedicated to three deities descended from Susanoō no Mikoto (brother of the sun goddess), and the deified Empress Jingu. Unbeknownst to Genji, the Akashi lady, a young girl with whom the prince became involved in Suma, has also come to the shrine on pilgrimage. She has arrived by boat and is intimidated by the sight of the large and resplendent crowd about the man she had known only in the humble surroundings of her father's country dwelling. In spite of the fact that she has just borne Genji a daughter, destined to become an empress, she feels inadequate and unimportant in the presence of such grandeur.

> To have chosen this day of all days, to be among the distant onlookers—her own inferiority could not have been emphasized more painfully. She was, in spite of it, tied to him by some bond or other, and here were these underlings, completely pleased with themselves, reflecting his glory. . . . For the lady it was a torment to see all the splendor and not to see Genji himself. . . . [she] felt as if she were gazing at

a realm beyond the clouds. Her own child seemed so utterly insignificant.[1]

Most *Genji* illustrations representing the "Miotsukushi" chapter focus on Genji's pilgrimage to Sumiyoshi. One of the earliest extant renditions of this event, part of a fourteenth-century handscroll in the Harry G. C. Packard Collection in the Metropolitan Museum of Art, New York, simply depicts the prince's shrine-bound procession—with a carriage, courtiers on foot and on horseback, and elegantly clad page boys, also on horseback against a blank background.[2] By the time this fan painting was made, however, the imagery for this scene had been standardized to contain several figures from Genji's entourage, at least one carriage, an architectural reference to the Sumiyoshi Shrine—a *torii* gate or the shrine's signature high-arched bridge, or both—and sometimes the boat carrying the forlorn Akashi lady. In this painting part of the crimson *torii* (Shinto shrine gate) is just visible in the upper right corner of the fan; the topmost crossbar is not inside the picture plane. Pine trees line the beach edged with a dusting of white pigment. Five carriages, one of which is almost totally obscured by gold clouds, can be seen in the lower half of the image. Courtiers assemble around the carriages while four priests carrying food to be offered to the *kami* (native deities) of the shrine—cooked rice, or perhaps round cakes of pounded rice paste, on lacquer stands—pass under the *torii* gate.

Figures are delineated with a Tosa-school delicacy, and pigments are richly applied, although once-bright colors have now taken on a gently muted quality. Many of the fine details in the painting are still quite distinct. One carriage, for example, is clearly ornamented with a *kikusui* (chrysanthemums and flowing water) design,

and another with the *Tatsutagawa* (Tatsuta River) motif of maple leaves floating on a current, so evocative of classical poetry.[3] The drawing is slightly more meticulous and refined than that of the Burke "Kochō" fan, and the composition is better oriented to the curved shape of the painting format. Even the gold clouds have more crisply and evenly scalloped edges.

The scene contains most of the basic components cited by *Genji* painting manuals as images necessary for representations of this "Miotsukushi" episode. Some pictorial elements are absent, most notably the boat of the Akashi lady. The sixteenth-century *Genji Monogatari Ekoboba* painting manual also refers to the presence of Genji's son Yūgiri, on horseback, uniformed dancers, and stableboys,[4] but all of these features are rarely included in small *shikishi* (poem card) or fan pictures. Some small-scale renditions of the scene depict an abbreviated procession of Genji's attendants through the *torii* gate of the shrine; a fine example of this type is the album-leaf version by Tosa Mitsunori (1583-1638) in the Tokugawa Museum of Art in Nagoya.[5]

An interesting comparison can be made between the Burke Foundation fan and another fan painting of this "Miotsukushi" scene, an early Edo-period work of the Tosa school in the collection of Ninnaji temple.[6] This image also depicts a pine-lined beach and courtiers gathered around Genji's carriage, and the Akashi lady's boat is likewise omitted. However, the Sumiyoshi Shrine is symbolized by its famous arched bridge (the crimson *torii* is dwarfed beneath it), and the placement of the figures indicates a closer connection to the most important aspect of this episode: the near-encounter of the prince and his former lover. In the Ninnaji version, Koremitsu, Genji's attendant and confidant, approaches the carriage with a writing box in his hand. Having heard of the Akashi lady's attempted landing at the beach and her subsequent decision to proceed to Naniwa, Genji writes her a message, in poetic form, to express his regret at the situation.

Although the Ninnaji painting conveys a stronger impression of the emotional content of the scene, the Burke fan, slightly earlier in date, is more sensitively painted, with a keener eye for courtly detail. Accordingly, it may be dated to the late Momoyama period, when Tosa masters like Mitsunori (1583-1638) and Chōjirō (flourished late sixteenth-early seventeenth century) were active. s w

NOTES

1. Murasaki Shikibu, *The Tale of Genji*, trans. Edward G. Seidensticker (New York: Alfred A. Knopf, 1982), 282.

2. Reproduced in Akiyama Terukazu, *Genji-e* (Genji Pictures), Nihon no Bijutsu no. 119 (Tokyo: Shibundō, 1976), pls. 64–65; also discussed in Yoshiaki Shimizu and Susan Nelson, *Genji: The World of a Prince* (Bloomington: Indiana University Art Museum, 1982), 22-25.

3. This theme, associated with the autumn season, was the subject of poetry and painting from at least the time of the *Kokinshū*, the imperial poetry anthology compiled in 905. See Helen Craig McCullough, *Kokin Wakashū* (Stanford: Stanford University Press, 1985), 72 (Autumn 2, nos. 293 and 294).

4. Miyeko Murase, *Iconography of "The Tale of Genji, Genji Monogatari Ektoba"* (New York and Tokyo: Weatherhill, 1983), 109.

5. Akiyama Ken and Taguchi Eiichi, eds., *Gōka "Genji-e" no Sekai: "Genji Monogatari"* (A World of Splendor in Genji Illustrations: The Tale of Genji) (Tokyo: Gakken, 1988), 78, pl. 59.

6. Ibid., 79, pl. 60.

38.

Two Episodes from the "Sakaki" ("Sacred Tree") Chapter of the Genji Monogatari (Tale of Genji)

Edo period, ca. 1650
Two segments from a handscroll, mounted on wood; ink, color, and gold on paper
H. 136 x W. 32.5 cm (53⁹/₁₆ x 12¹³/₁₆ inches)
H. 137.1 x W. 32.5 cm (54 x 12¹³/₁₆ inches)
PUBLISHED: Galerie Janette Ostier, *Les jardins d'or du Prince Genji: Peintures japonaises du XVIIᵉ siècle* (The Golden Gardens of Prince Genji: Japanese Painting of the Seventeenth Century) (Paris: Galerie Janette Ostier, 1980); Miyeko Murase, *Iconography of "The Tale of Genji: Genji Monogatari Ekobota"* (New York and Tokyo: Weatherhill, 1983), 101-102.

These glowing scenes, painted in rich polychrome against a background of brilliant gold, represent a mere fraction of what was perhaps the most comprehensive series of illustrations of the *Genji Monogatari* known to have been made.[1] In its original condition the number of handscrolls in the set to which these paintings belonged may have exceeded a hundred, containing the entire text of the classic Heian-period narrative with numerous illustrations for each chapter. Examination of other extant fragments and complete scrolls from the set, now scattered among various collections, indicates that various calligraphers were involved in production of the text portions, written primarily in *hiragana* (native Japanese syllabic characters) on paper ornamented with gold underpaintings. Likewise, while the paintings all conform to certain stylistic standards and are clearly the work of a single atelier, slight variations from chapter to chapter, or even scroll to scroll, suggest that at least several artists had a hand in executing the meticulously detailed, exquisitely rendered scenes.

Both of the Burke scroll segments illustrate episodes from "Sakaki" ("The Sacred Tree"), the tenth chapter of the *Genji Monogatari*. The first depicts an elegant palace viewed from without, at a slightly raised angle to enable the viewer to see the interior; the roof is eliminated in the *fukinuki-yatai* (blown-away roof) mode typical of *yamato-e* paintings. Inside is a resplendent gathering of Buddhist priests and courtiers, some of whom are separated from the principal group by semitransparent

bamboo blinds. Courtiers are also seated outside on the veranda. An elaborately decorated sutra box and several rolled-up scrolls on a brocade-draped table stand in the center of the central chamber. A gilded altar, spread with a cloth of gold-and-crimson brocade, appears at the top of the composition, where it is partially obscured by gold clouds. It is winter and the pine trees in the garden are lightly dusted with snow.

The palace is the Sanjō residence of the family of Fujitsubo, favorite consort of Genji's recently deceased emperor-father, and Genji's own secret love. Fujitsubo herself has organized a reading of the Lotus Sutra following memorial services for the emperor, and Genji is in attendance with his fellow princes, half-brothers by his father's various women.

> All of the details were perfection. . . . No one was surprised, for she [Fujitsubo] was a lady who on far less important occasions thought no detail too trivial for her attention. The wreaths and flowers, the cloths for the gracefully carved lecterns—they could not have been outdone in paradise itself. . . . The princes made offerings and Genji seemed far handsomer than any of his brothers.[2]

The atmosphere is melancholy, but the painstaking detail with which the painting is executed gives a sense of the solemn splendor of the ritual. Elegant ladies in the multilayered robes of contrasting hues worn by aristocratic women of the Heian period are visible through the gauzy barrier of fine bamboo blinds; even the clerical garb of the visiting priests is sumptuous in appearance.

The second scene depicts a later incident in the chapter. One evening, "when boredom is very great,"[3] Genji's close friend Tō no Chūjō comes to call, bringing with him several collections of Chinese poetry. Genji compiles his own selection and invites several "connoisseurs of Chinese poetry at court and in the university"[4] to participate in a verse-guessing contest. In the illustration, Genji and his guests are seated in a spacious and handsomely appointed interior, rifling through an assortment of bound volumes. In keeping with their reading matter, the *fusuma* (sliding screens) and walls of the room are painted with Chinese-style landscapes and figures in ink with touches of light color. These paintings within paintings contrast with the outdoor scene to the right of the mansion; there, a lush summer garden surrounds a small stream or pond whose surface is broken by jutting, rectangular rocks and spray from a tiny waterfall. The softly undulating bank of the stream, rounded hill slopes, and jewel-like colors reflect the influence of the classic *yamato-e* style of narrative painting, and the foliage on the ground and trees, delineated with a miniaturist's care, is close in mode of execution to details in album-leaf *Genji* paintings by such Edo-period Tosa artists as Mitsunori (1583-1638) and Chōjirō (active early seventeenth century). Indeed, the entire set of scrolls to which these fragments belong have traditionally been attributed to Tosa Mitsuoki (1617-1691),[5] a master who produced numerous jewel-like miniature *Genji* illustrations, most in the album-leaf format.[6] However, many of the plants and flowers are sharply outlined in ink, and angular, strongly articulated brushwork visible on garden rocks—along with the clearly Chinese-inspired paintings in the interior scenes—implies the hand of an artist trained in the Kano school. The rectangular rocks in the garden stream are slightly reminiscent of the tall, narrow boulders in *fusuma* paintings of peonies by Kano Sanraku (1561-1635) in the temple of Daikakuji in Kyoto.

In its original state, the "Sakaki" chapter comprised six scrolls with some thirty-one paintings as well as lengthy sections of text.[7] Other illustrations from this chapter (now dispersed among various collections) also exhibit stylistic elements derived from the hybrid ink-painting style of the Kano school. Scene 20, in which Genji pays an evening visit to the emperor, also includes a garden scene with angular, sharply defined rocks and embankments. However, other illustrations feature soft, rounded rocks and riverbanks that derive from the artistic vocabulary of Tosa-school artists. In all of the painted scenes the manner in which the figures are delineated is essentially conservative, in keeping with the traditional standards of narrative handscroll illustration. Pear-shaped white faces of aristocratic ladies and gentlemen are expressionless and virtually interchangeable, although not always rendered in the archaic *hikime-kagihana* (literally, dashes for the eyes, a hook for the nose) mode. The outlines of the figures and details of their dress are fine and delicate and devoid of any real modulation, in contrast to the brushwork used for outdoor landscape elements and the miniature paintings on interior walls and screens.

It is the *gachūga* (paintings-within-paintings), miniature images on the *fusuma*, *byōbu* (folding screens), and walls of palace interiors that provide the best evidence for the eclectic training of the artists involved in production of these *Genji* scrolls. The *fusuma* paintings in the scene of the poetry-guessing contest bear some stylistic similarities to works by such early seventeenth-century Kano artists as Sanraku, head of the Kyoto branch of the school, and Kōi (ca. 1569-1636).[8] Shapes of mountains and rocks in particular are reminiscent of those found in Sanraku's screen and *fusuma* paintings. Although Kano artists were best known for works that combined Chinese themes and ink-painting techniques with the flat, decorative surface and brilliant colors of *yamato-e*, it was not uncommon for them to produce *Genji* illustrations: the pair of six-fold *Genji* screens (in the Imperial Household Collection) attributed to the great Momoyama-period master, Eitoku (1543-1590), and a screen by Sanraku illustrating an episode from the "Aoi" ("Heartvine") chapter (in the Tokyo National Museum) are cases in point. If the scrolls to which the Burke Collection scenes belonged were executed by Kano painters, they may well have come from the "Kyo Kano" studio in the old capital city, as opposed to the new atelier established in Edo under the patronage of the Tokugawa shogunate. Two factors would appear to argue for a Kyoto origin: Nishiike Suemichi, one of the calligraphers whose signature appears in extant scrolls from the "Suetsumuhana" chapter (presently in the collection of the New York

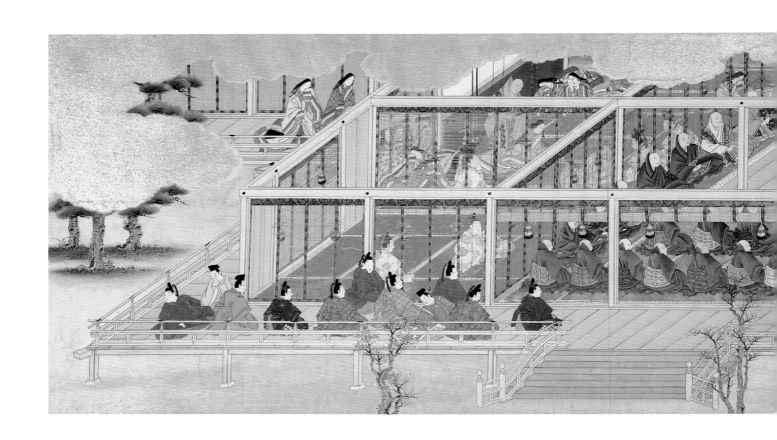

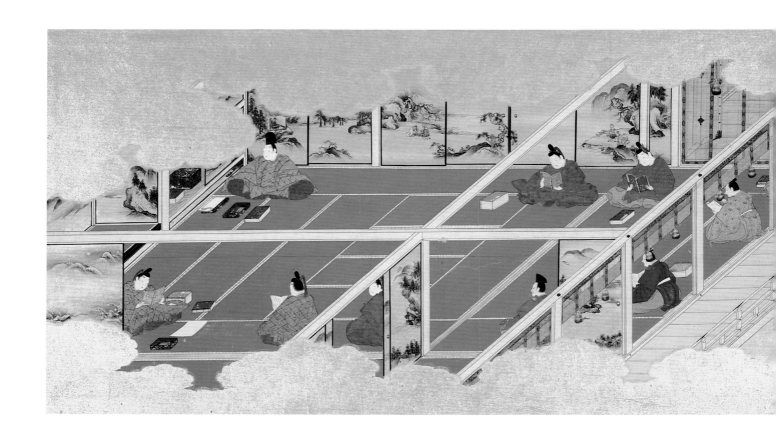

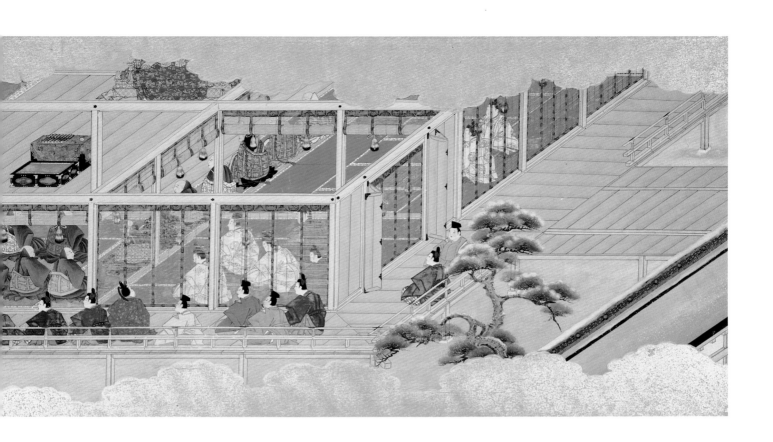

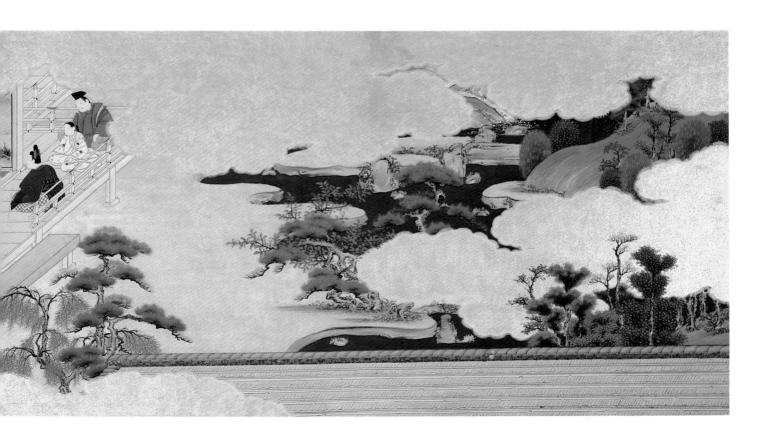

Public Library), belonged to a family with ties to the Kamo Shrine in Kyoto, while another, Yottsuji Suetaka, held the court-appointed title of *Chūjō* (middle captain).[9] It is conceivable that the scrolls were commissioned by a member of the old aristocracy or the increasingly cultured and well-educated merchant class. That the original set contained the entire text of the lengthy novel, rather than the brief selections of prose and poetry commonly used to represent each chapter, indicates a more than superficial interest in classical literature on the part of the patron.

Three complete scrolls from this set—one from the "Hahakigi" ("The Broom Tree") chapter and two from "Suetsumuhana" ("The Safflower")—belong to the Spencer Collection of the New York Public Library; another "Suetsumuhana" scroll is owned by the Ishiyamadera temple in Kyoto. Six scrolls of the "Aoi" chapter are in private hands in Japan. Like the two scenes in the Burke Collection, the illustrations from these intact scrolls feature delicacy of execution, meticulous attention to detail, and generous use of gold and vibrant color, while the paintings-within-paintings give further evidence of the artist's familiarity with the major schools of painting active in the early 1600s. In addition to Kano-esque bird-and-flower images and ink landscapes, some of the miniature screens and sliding panels exhibit compositions similar to works by Rimpa and Tosa artists. The scrolls are also unusual in that they do not follow the formulae that had been established for *Genji* pictures by the late Muromachi period, for they contain scenes not found in any other illustrated versions of the tale. It is likely that the artists did not make use of *Genji* painting manuals like the sixteenth-century *Genji Monogatari Ekotoba*; they may have simply relied on the text of the novel itself for inspiration. The exquisite illustrations are certainly among the most remarkable narrative paintings of the Edo period, and are striking evidence of the seventeenth-century revitalization of a classical tradition. The highly detailed quality of the images is well suited to the nature of the tale, which dwells at great length upon such aesthetic aspects of everyday life as the choice of colors in a lady's multilayered dress, the furnishings of a private chapel, or the psychological implications inherent in an individual's calligraphy and the scent and hue of the paper on which it is inscribed.

The paintings can be dated to the mid seventeenth century on stylistic grounds. In addition, the signature of Suetaka, found on the scroll at Ishiyamadera, includes the *Chūjō* title bestowed upon him in 1647,[10] suggesting that the *Genji* handscrolls were produced between that time and the date of his death, in 1668.

sw

NOTES

1. See the discussion of all of the extant scrolls and fragments from this set of *emaki-mono* (handscroll painting) in Miyeko Murase, *Iconography of "The Tale of Genji: Genji Monogatari Ekotoba"* (New York and Tokyo: Weatherhill, 1983), 330, and Miyeko Murase, *Tales of Japan: Scrolls and Prints from The New York Public Library* (New York and Oxford: Oxford University Press, 1986), 104-108.
2. Murasaki Shikibu, *The Tale of Genji*, trans. Edward G. Seidensticker (New York: Alfred A. Knopf, 1976), 204-205.
3. Murasaki Shikibu, *The Tale of Genji*, 209.
4. Ibid.
5. *Genji Monogatari no Kaiga* (Illustrations of *The Tale of Genji*) (Sakai: Sakai City Museum, 1986), 14.
6. The Burke Collection owns a set of two small *Genji* albums by Mitsuoki, each containing twenty-seven illustrations (not arranged chronologically) in brilliant colors and gold on paper; these are published (but not fully reproduced) in *Nihon no Bijutsu Meihin Ten: New York Burke Collection* (A Selection of Art from The Mary and Jackson Burke Collection) (Tokyo: Tokyo National Museum, The Tokyo Shimbun, and The Chunichi Shimbun, 1985), cat. no. 40. Another, similar, set is in the Shin'enkan Collection in Los Angeles. Mitsuoki also produced *Genji* screens, a pair of which are in the Avery Brundage Collection in the Asian Art Museum of San Francisco. See Shirahata Yoshi, "Tosa Mitsuoki no Monogatari-e byōbu" (Narrative Imagery on Screens by Tosa Mitsuoki), *Kobijutsu*, no. 33 (March 1971).
7. Reproduced in full in Galerie Janette Ostier, *Les jardins d'or du Prince Genji: Peintures japonaises du XVIIᵉ siècle* (The Golden Gardens of Prince Genji: Japanese Painting of the Seventeenth Century) (Paris: Galerie Janette Ostier, 1980).
8. A pair of six-fold landscape screens by Kano Kōi in the Tokyo National Museum and another in a private collection exhibit some general similarities in style and coloration to the tiny *fusuma* paintings in the *Genji* scene. See *Kano Ha to Fūzokuga: Edo no Kaiga I* (The Kano School and Genre Painting: Edo Painting I), vol. 17 of *Nihon Bijutsu Zenshū* (Survey of Japanese Arts) (Tokyo: Kodansha, 1992), pls. 19-20, and *Kano Ha no Kyoshō Tachi* (Great Masters of the Kano School) (Shizuoka: Shizuoka Prefectural Museum, 1989), pl. 33.
9. See the discussion of three scrolls from this same set of *emaki-mono*, now in the collection of The New York Public Library, in Miyeko Murase, *Tales of Japan: Scrolls and Prints from The New York Public Library* (New York and Oxford: Oxford University Press, 1986), 104-107.
10. Murase, *Iconography of "The Tale of Genji,"* 330, and Murase, *Tales of Japan*, 107.

39.

Mu-Tamagawa—*Scenes of Six Tamagawa (Jewel Rivers)*

Edo period
Sakai Ōho (1808–1841)
Six handscrolls; ink, color, and gold on silk

Scroll I "Noda no Tamagawa"
H. 9 x W. 118 cm (3⁹/₁₆ x 46½ inches)

Scroll II "Tetsukuri no Tamagawa"
H. 9 x W. 119.2 cm (3⁹/₁₆ x 46¹³/₁₆ inches)

Scroll III "Noji no Tamagawa"
H. 8.9 x W. 118 cm (3½ x 46½ inches)

Scroll IV "Ide no Tamagawa"
H. 9 x W. 124 cm (3⁹/₁₆ x 48¹³/₁₆ inches)

Scroll V "Kinuta no Tamagawa"
H. 9.2 x W. 118.8 cm (3⅝ x 46⅞ inches)

Scroll VI "Kōya no Tamagawa"
H. 8.9 x W. 119.1 cm (3½ x 46¹⁵/₁₆ inches)

SIGNATURE: "Ōho hitsu" on each scroll
SEAL: "Hansei" on each scroll

These six handscrolls are so tiny that, when rolled up, they fit comfortably into the palm of the hand. The paintings shimmer with vibrant color. Their pristine condition may be a result of the fact that they have seldom been opened for viewing in the little more than a century and a half since they were made. Each scroll bears a small piece of paper on its cover, decorated with gold and silver particles, on which its title is inscribed. The six titles read: *Noda no Tamagawa*; *Tetsukuri no Tamagawa*; *Noji no Tamagawa*; *Ide no Tamagawa*; *Kinuta no Tamagawa*; and *Kōya no Tamagawa*. The labels were most likely executed by the individual who wrote the two inscriptions on the lid of the two-tiered box in which the paintings are kept. On the outside of the lid, five characters identify the set of paintings as "Six Scrolls of Mu-Tamagawa"; on the underside, the artist's name is given as Ōho and the calligrapher gives his own name of Seisei Kigyoku. A son of Nakano Kimei (1834–1891), a pupil of Suzuki Kiitsu (1796–1858), Kigyoku belonged to the last generation of artists to follow the Rimpa-school tradition preserved by the artist of these scrolls, Sakai Ōho. Ōho himself signed "Ōho hitsu" (brushed by Ōho) at the end of each scroll, which was also impressed with his "Hansei" seal.

About one third of each composition is given over to a horizontal expanse of landscape that slowly introduces the main element of the composition and then fades out slowly in an almost cinematic fashion. Ōho seems to have found it singularly challenging to work with a format allowing so little room for vertical expansion while offering a broad area of horizontal space. The tradition of creating such miniature handscrolls was established, long before his time, by the *ko-e* (little pictures) mentioned in the literature of the Muromachi period, of which actual examples are still extant.[1] Ōho did paint another group of scrolls, this time of the "Eight Views of Ōmi," which are even smaller (8.1 cm in height)[2] than the works in the Burke Foundation.

In the *Mu-Tamagawa* paintings, hills and shorelines of rivers are rendered in soft gray ink, and a light shade of robin's-egg blue leads the eye to the middle section of each scroll where breathtaking views of the river in mid-current unfold in fresh and vivid hues of darker aquamarine. Scroll I depicts a river named "Tamagawa" (jewel river) like the five others in this group; it is located at a site called Noda (near Sendai), in the province of Mutsu (modern Miyagi prefecture). An aristocratic

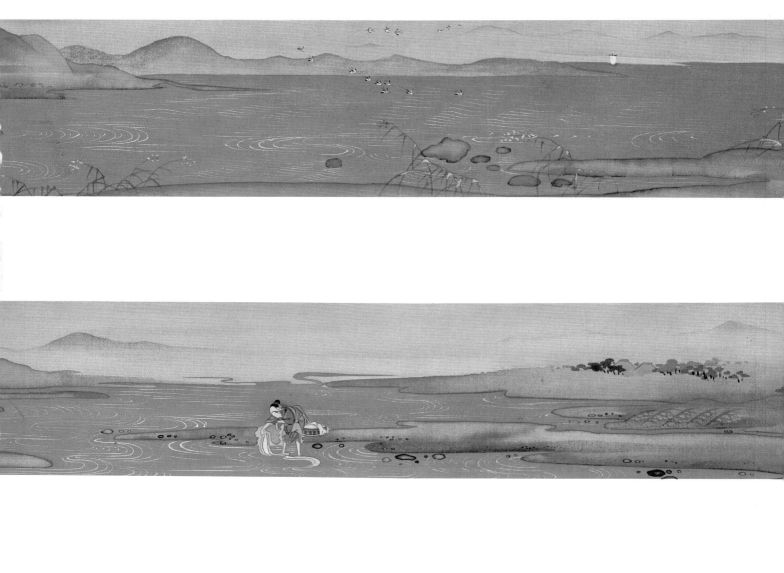
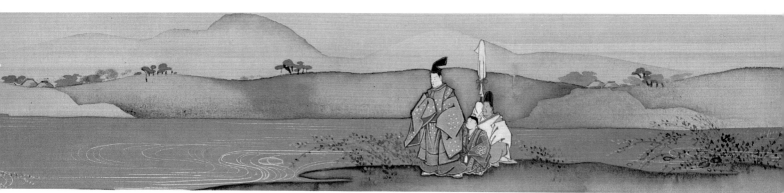

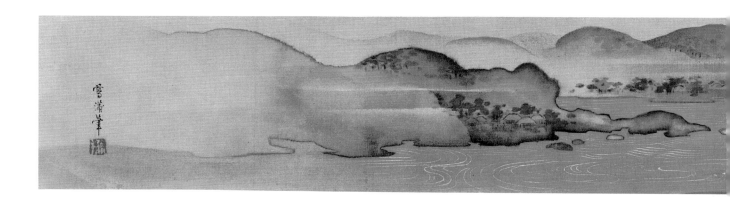

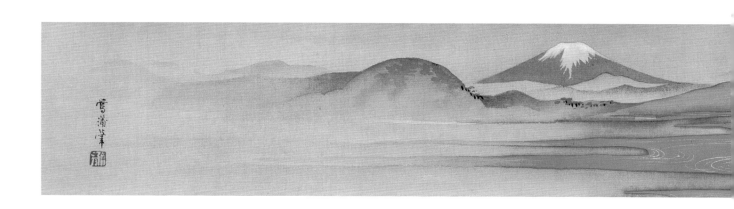

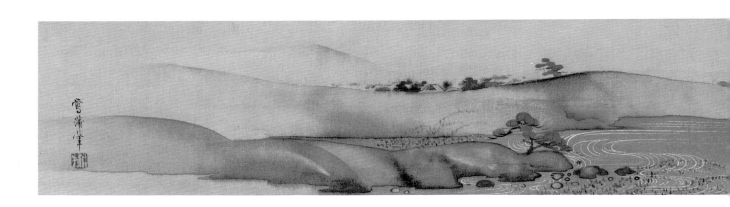

lady, elegantly dressed, is shown traveling with a male attendant. Their attention is diverted by a flight of beach plovers, and the lady turns her head toward the birds, partially shielding her face with a raised sleeve in a gesture reminiscent of a dance pose. A single boat with a white sail appears on the horizon, and a small cluster of houses tucked away at the foot of the hills across the water suggests the great distance this couple has yet to cover. Ripples on the water are rendered by finely drawn lines of gold ink that glisten upon the blue water. The composition is simple and the palette is limited, yet the picture is at once poetic and evocative of the mood of the travelers and the loneliness of this isolated place in the far north.

The second Tamagawa is Tetsukuri (or Tatsukuri) in the Musashino area, west of modern Tokyo. In this scene, from Scroll II, two women beat cloths in a mortar while white, ribbonlike strips of fabric are hung up to dry near the farmhouses behind them. The river banks are protected by a weir. Beyond a short stretch of sandbar, the single bent figure of a woman can be seen, rinsing her cloth in the shoals of the stream. Across the broad expanse of water towers the majestic Mount Fuji, its snow-covered peak looming high above a range of lesser hills.

Scroll III portrays the Tamagawa at Noji, in Ōmi in the neighboring province of Kyoto. At this river, also known as *Hagi* (bush clover) *no Tamagawa*, a courtier and his two attendants stand on the bank contemplating a grove of bush clover resplendent with autumn color.

The Tamagawa frequently cited by ancient poets is located at Ide, south of Kyoto. In this fourth scroll, a courtier, accompanied by two attendants, crosses the water on horseback. He may be the same gentleman who appeared on the banks of Noji no Tamagawa in the third scroll. Here the season is spring: small, yellow *yamabuki* flowers are in bloom and the distant hills are adorned with blossoming cherry trees.

The fifth scene, at the Tamagawa of Kinuta in present-day Osaka, is the most poetic of the six. A light gray ink wash creates the shadows cast by the miscanthus plants that ring the foot of low-lying hills, preparing the viewer for an evening scene. The heads of miscanthus in the foreground are tinged with a gold color; hills, trees, and houses in the distance are sub-

merged in a shadowy gray. Two women are hard at work fulling cloth, their night repast close at hand. Spots of gold wash applied to the teapot, cups, and fulling block indicate the radiance of the full moon, hanging high above the calm river and distant hills. A school of geese ascends in the direction of the shining orb; one can imagine their cries echoing the clatter of the fulling blocks below and breaking the peaceful stillness of the evening.

The sixth and final handscroll represents the Tamagawa located deep in the folds of the sacred mountains at Kōya. Dark tones of ink dominate, mixed with a deep green that enhances the shadowy depth of the mountain range. The current of this river appears rough, broken by many stones and rocks, and no flowering plants are visible. The figure taking in this wild and barren scene is, appropriately, an aging Buddhist monk accompanied by a young proselyte. The atmosphere is somber, befitting the holy character of the site, home to the headquarters of the Shingon sect of Buddhism.

As the descriptions of each scroll indicate, there is no attempt in any of the scenes to depict the four seasons of the year in a systematic manner. Nor is there an apparent means by which one may organize the six rivers into any particular sequence. Therefore, an arbitrary system is adopted here, with the northernmost river, Noda no Tamagawa, placed first and the southernmost, at Kōya south of Kyoto, placed last. The iconographic tradition for depicting the six Tamagawas is equally ambiguous, and it is difficult to determine when and how each of these rivers was singled out as a subject for poetry or painting. The name of each river, *Tama* (jewel) *gawa* (river), may originally have been used to refer to any beautiful river, as the word *tama* was often employed by itself as an adjective to describe any splendid or elegant object.

A poem about a Tamagawa does appear in Japan's earliest poetic anthology, the eighth-century *Man'yō-shū*. This verse, from the section entitled "Azuma uta" ("Eastern poems"), refers to the bleaching of cloth, an occupation later selected for inclusion in images of Tetsukuri no Tamagawa. The name "Tamagawa" was eventually included in a large compendium of place-names used as *uta-makura* (literally, pillow-words), phrases that served to inspire poets; consequently,

Eccentric - Set of 6 - 4 f long 3½" high
Rimpa School
Atmosphere - Pigment on wet surface
Blue - Green ink
Soft by Yamato-e School
6 Jewel Rivers - Rare Theme

Jap pick up diff views from Chinese
Tamagawa - Jewel River
Toptgo - Short of water - River diverted to create
aqueduct
Sets of Scenes - Chinese - These Jap in style

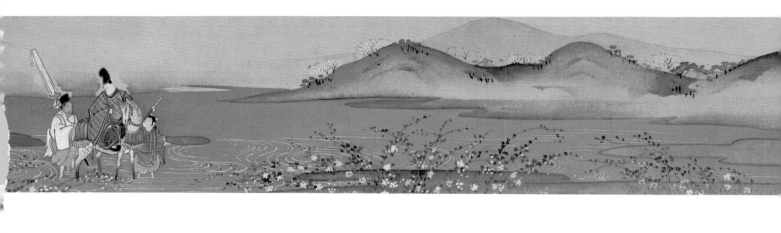

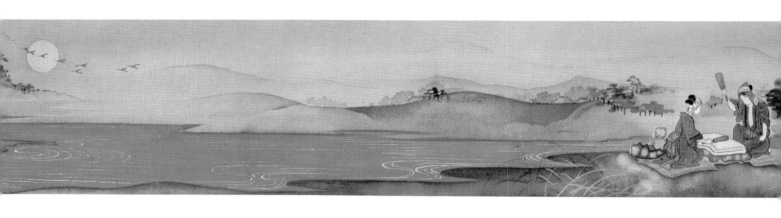

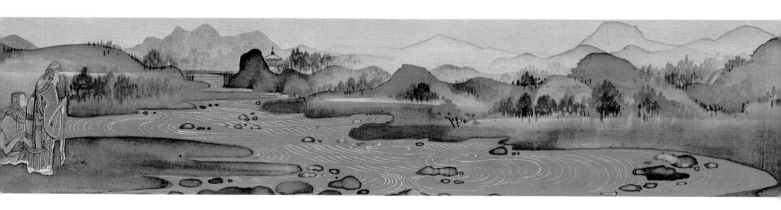

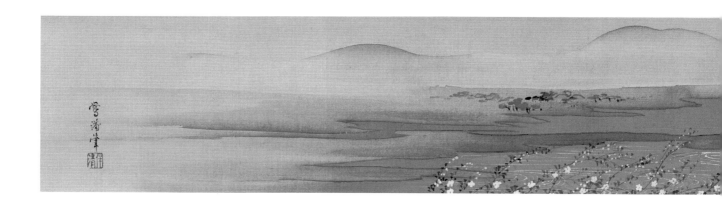

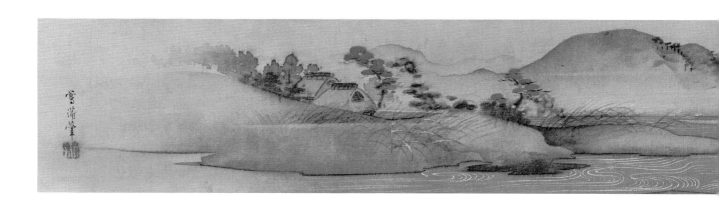

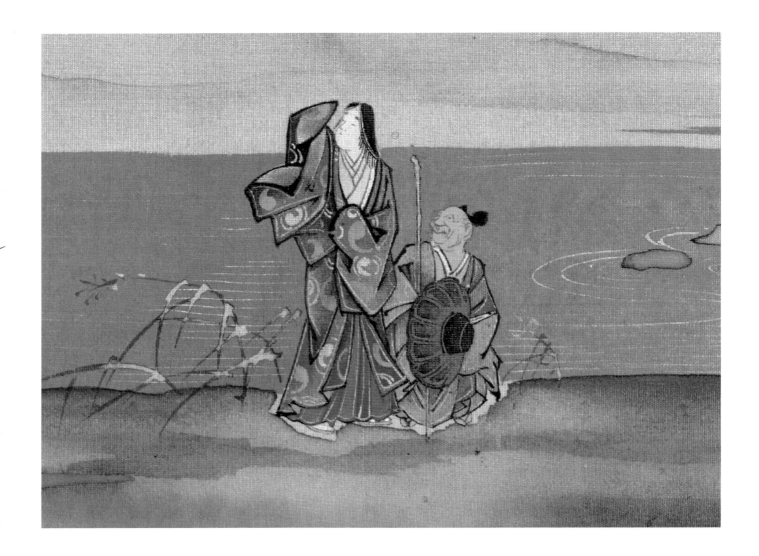

many verses were composed about rivers called Tama-gawa.[3] However, the majority of these poems mention "beautiful rivers" without reference to specific sites. A small number of exceptions to this rule describe specific objects, activities, or other attributes that later became associated with six different rivers.[4] These attributes and their rivers may be listed as follows:

1. Noda no Tamagawa	beach plovers, new green leaves
2. Tetsukuri no Tamagawa	bleaching and drying of cloth
3. Noji no Tamagawa	bush clover, moon
4. Ide no Tamagawa	*yamabuki* flowers, *unohama* flowers, horseback-riding, frogs
5. Kinuta no Tamagawa	fulling of cloth, pines
6. Kōya no Tamagawa	travelers

While many *meisho* (famous scenic places) served as subjects for works of art, only one poem about a Tamagawa is known from the records of Heian-period paintings compiled by Ienaga Saburō in his *Jōdai Yamato-e Nempyō*.[5] When the vast palace complex of the Saishō Shitennō-in was built for retired Emperor Gotoba in 1207, an encyclopedic attempt was made to represent a large number of *meisho* in sliding-panel *fusuma* paintings. These screens, depicting forty-six *meisho* from all sectors of the country, were lost long ago, but a diary kept by courtier-poet Fujiwara no Teika preserves a day-to-day account of the progress of the painting project and provides us with information about the artists, the specific places chosen as subjects, and the general layout of the scenes. The appearance of the lost paintings can be reconstructed to a certain degree from the 460 poems by ten poets (one poem per

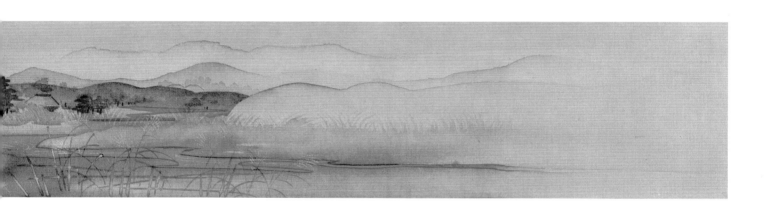

meisho for each) that were written to accompany the paintings.[6] Not a single one of these paintings or poems refers to a "Tamagawa," which suggests that the river was not a staple subject of *meisho-e* (pictures of famous places) during the Heian and Kamakura periods. Records on *meisho-e* from subsequent eras are scanty,[7] and there may be references that have not yet come to light; however, it is possible that six Tamagawas were singled out as *meisho* only shortly before the production of sets of six Tamagawa prints by the woodblock-print master Suzuki Harunobu (1725-1770). These prints can be dated to the brief period, between 1765 and the year of his death, when Harunobu perfected the technique of making *nishiki-e* (literally, brocade picture), multicolored prints by using multiple blocks for a single image. The prints bear the title *Mu-Tamagawa* and depict six rivers; each scene includes a quotation from a Heian-period poem. Such prints may have provided a prototype for other Edo-period *ukiyo-e* artists, whose works utilize the same poems and contain some of the same site-identifying motifs.

1. Noda no Tamagawa:
 When evening approaches,
 Plovers cry in the briny air
 Over Tamagawa's stream,
 at Noda of Michinoku.

 Nōin Hōshi[8]

2. Tetsukuri no Tamagawa:
 The cloth that is hung over the fence for bleaching
 Catches the morning dew
 At the village of Tamagawa.

 Fujiwara no Teika[9]

3. Noji no Tamagawa:
 I shall come back again tomorrow
 to the Tamagawa of Noji,
 Moon shines over the bush clovers
 and rests upon the river's colored waves.

 Minamoto no Toshiyori[10]

4. Ide no Tamagawa:
 As I stop my horse to give him water,
 yamabuki flowers drop their dews
 Into the stream of Tamagawa at Ide.

 Fujiwara no Shunzei[11]

5. Kinuta no Tamagawa:
 Autumn wind over pines sounds forlorn,
 Adding to the loneliness
 Is the sound of fulling of cloth at Tamagawa.

 Minamoto no Toshiyori[12]

6. Kōya no Tamagawa:
 Forgetting the warning not to do so,
 Traveler to Kōya's Tamagawa
 Dips his hand in its water.

 Kōbō Daishi[13]

The earliest-known occasion when six Tamagawa rivers were grouped together and given the designation "Mu-Tamagawa" took place around the year 1700. At that time, a number of essays by *haikai* poets were published that included the name "Mu-Tamagawa" in their titles.[14] Almost contemporaneous with Harunobu's prints was the creation of a musical composition for the *koto* (a thirteen-stringed instrument) entitled *Mu-Tamagawa*. This composition by Mitsuhashi Kengyō (d. 1760) apparently inspired a series of variations in the form of song and dance pieces, used until the mid nineteenth century as musical themes by such schools of music as the Tomimoto, Jōruri, Nagauta, and Kiyomoto.

In addition to the essays and musical compositions bearing the title *Mu-Tamagawa* was an intriguing series of *haikai* poems published with commentaries by the editor Kei Kiitsu (1695-1762).[15] The first of these poems made its appearance in 1750, and publication was continued by Kiitsu's son until 1776, fourteen years after Kiitsu's death. In this case, however, the word *Mu* was written with the character for *Musashi* instead of the character (*mu*) for "six." It thus refers to Tetsukuri no Tamagawa, the Tamagawa of Musashi province. In his preface to the first volume, the editor boldly proclaims that the book is expected to follow the example of the Tamagawa of Musashi in that it will send out a thousand small tributaries to wet the lips of ten thousand citizens of the city of Edo.[16]

None of the above-mentioned essays, books, or musical compositions involves paintings. Pictorial representation of the *Mu-Tamagawa* theme was virtually confined to *ukiyo-e* prints by such notable artists as Harunobu, Utamaro, Shunman, and Hiroshige. It may be that Harunobu, who made use of the theme several

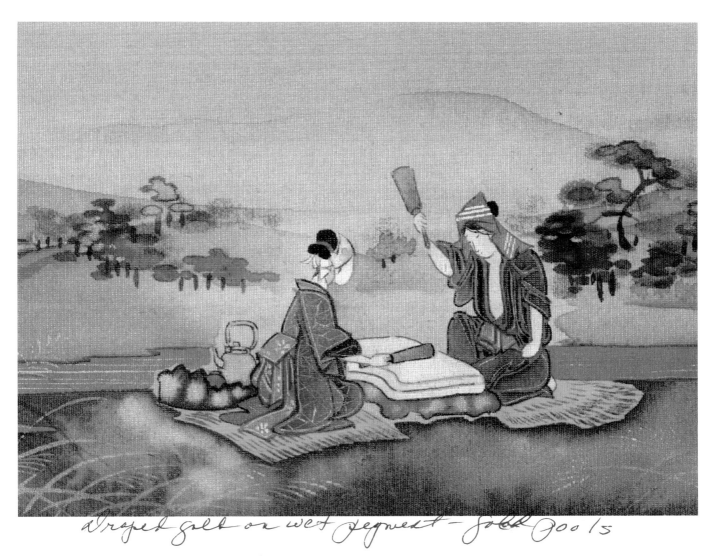

Draped gold on west segment — gold pools

times, was influenced by the *haikai* poets who provided him with artistic inspiration for other types of subject matter. Printmakers may also have been inspired by the song and dance performances on the *Mu-Tamagawa* theme.

Information on the no-longer-extant wall decorations of Edo Castle may provide another missing link. Edo Castle, now used as the residence of the Imperial family in Tokyo, was the seat of the Tokugawa administration and the residence complex for the shogunal family. First constructed in 1456, it was selected as the Tokugawa power base by Ieyasu (1542–1616) in 1600. The castle-palace underwent an endless succession of construction and reconstruction throughout the Edo period, while the city of Edo, a small fishing village before Ieyasu's day, expanded by leaps and bounds. Edo's mushrooming population suffered from a chronic water shortage, particularly disastrous with regard to the fires that frequently ravaged the city and the castle. Many large-scale efforts to rebuild the castle were undertaken, sometimes commencing only days after a fire was extinguished. Nothing of the splendor of the Edo-period interior decoration remains today, but the layout of sliding-panel paintings can be discerned from the enormous number of small sketches made in preparation for the reconstruction work. These drawings were produced for the rebuilding of the Nishi-no-maru (residence of the retired shoguns and heirs-apparent), carried out in 1839, and the 1845 reconstruction of the Hon-maru, the living quarters for the reigning shoguns. The drawings, now mounted onto 264 handscrolls, are preserved in the Tokyo National Museum along with volumes of an official record known as the *Kōyō Nikki* (*Chronicles of Official*

Projects).[17] This chronicle was kept by Kano Osanobu (1796-1846), the leader of the Kano school to whom responsibility for both reconstruction projects had been given.

Osanobu received his orders from the shogun but he, in turn, admonished his fellow artists to study and copy extant screen paintings in the Hon-maru for both projects.[18] These sliding panels, executed by the most revered of Kano-school masters, Kano Tan'yū (1602-1674), had been created for a much earlier reconstruction of 1659, and were still in place in the Hon-maru. Sadly, they were lost in a fire in 1844, and it is thus difficult to determine that Tan'yū's *fusuma* were used as models for each and every screen painting created for Osanobu's restorations. However, it seems safe to assume that most of the new screens were based closely on mid seventeenth-century works.[19]

In both the Nishi-no-maru and the Hon-maru, the *kyūsoku-no-ma* (rooms for relaxation and rest) were decorated with numerous *meisho* scenes. Understandably, these included places from the eastern and northern provinces, many of which were "new" famous sites rather than staple subjects from the *meisho-e* repertory of the Heian and Kamakura periods. Scenes of the various Tamagawa were among these pictures, and it is possible that their inclusion marked their debut in the genre of *meisho* painting. Most significantly, these scenes are identifiable even without inscriptions: their principal pictorial elements are identical to those that appear in the Tamagawa woodcuts and Ōho's *Mu-Tamagawa* paintings. Also enlightening is the fact that most of the scenes were placed in the bottom areas on small screens, while Tetsukuri no Tamagawa occupied the entire length of a full screen.[20] This arrangement recalls the preface in Kei Kiitsu's book, which claimed that the Tamagawa of Musashi province was a source for one thousand tributaries that wet the lips of ten thousand Edo residents.

What prompted Tan'yū, in 1659, and Kiitsu, 100 years later, to accord such a prominent position to Tetsukuri no Tamagawa? The answer to this question may be found in the records of city construction projects commissioned by the Edo *bakufu* (shogunal government). In 1652, in order to alleviate the chronic and severe shortage of water needed for everyday purposes as well as fire-fighting, the *bakufu* launched an ambitious engineering project to construct an aqueduct that would bring water to the city from the Tamagawa of Musashi. This aqueduct, known as the Tamagawa Jōsui, is still partially preserved in the western section of modern Tokyo. It originally extended for 85 kilometers through the open field of Musashino, first as an open canal and then, inside the city proper, as a series of pipes made of wood and bamboo. Its completion in 1654 was loudly celebrated, as it provided much-needed water to both the citizens of the city and the residents of Edo Castle.[21]

Although further study is needed, it may be suggested that the theme of the six Tamagawa rivers was devised to commemorate the government's successful undertaking. The grouping together of six rivers was clearly inspired by the ancient practice of assembling objects, themes, or persons into groups of six, such as the *Rokudō* (Six Realms of the Transmigration of the Soul) or the *Rokkasen* (Six Immortal Poets). It is, however, interesting to note that the *Mu-Tamagawa* theme does not appear to have become a part of the standard painter's repertory even after it was depicted on the walls of Edo Castle.

Ōho, one of the last Rimpa artists of the Edo period, died quite young leaving only a small body of work. Many of his paintings were based on, or inspired by, the works of Sakai Hōitsu (1761-1828), Ōho's adoptive father and teacher. The second son of a monk in the Buddhist temple of Honganji at Tsukiji, in Edo, Ōho was adopted at age twelve by Hōitsu's mistress. He later became the rightful heir to Hōitsu's artistic tradition and was allowed the use of Hōitsu's sobriquets, *Senshin* and *Uka-an*. His paintings reflect the powerful influence of his teacher, but also the influence of Suzuki Kiitsu, Ōho's older colleague and Hōitsu's star pupil. Hōitsu was a noted *haikai* poet with a number of poetry anthologies to his credit, and Kiitsu followed suit. It is thus possible that Ōho was inspired to make use of the Tamagawa theme by its popularity among *haikai* poets. Other factors may have encouraged Ōho to turn to this subject. It is well known, for instance, that Hōitsu, early in his career, experimented with various genres of painting, including *ukiyo-e*. Ōho's use of a subject frequently adopted by printmakers may be a result of his teacher's early involvement with the *ukiyo-e* school. The important role that the six

Tamagawa played in the repertory of the performing arts in his day may also have had an impact on his selection of this theme. As noted in the description of Ōho's Noda no Tamagawa scroll, above, the postures of the figures in the tiny painting are strongly reminiscent of the poses used in dance performances.

The *Mu-Tamagawa* theme might well have vanished into oblivion as a subject for painting after Tan'yū utilized it in 1659. Fortunately, it was revived in 1839, when Osanobu copied Tan'yū's wall paintings, and Ōho's handscrolls may be dated to around the same time. Although no connections have been established between Ōho and the Kano school, it may be that he was first introduced to the visual imagery of the six rivers by artists of the Kano school.

NOTES

1. One such example of *ko-e* is the *Genji Monogatari Emaki* (Tale of Genji Scrolls) in the Spencer Collection, The New York Public Library. See Miyeko Murase, *Tales of Japan: Scrolls and Prints from the New York Public Library* (London and New York: Oxford University Press, 1986), no. 20; Umezu Jirō, "Suzuriwari Emaki sonota: Ko-e no Mondai" (On the Suzuriwari Zōshi Picture Scroll), *Kokka* 828 (March 1961): 103-104; and Okudaira Hideo, *Otogi Zōshi Emaki* (Illustrated Narrative Scrolls) (Tokyo: Kadokawa Shoten, 1982), 22-23.

2. Kobayashi Tadashi, *Rimpa* (Rimpa Paintings without Flowers and Human Figures) (Kyoto: Shikōsha, 1991), no. 59.

3. Katagiri Yōichi, ed., *Heian Waka Utamakura Chimei Sakuin* (Index of Place Names used as Utamakura in Heian-period Waka) (Kyoto: Daigakudō Shoten, 1972), 418-19.

4. Takahashi Yoshio, "Utamakura Mu-Tamagawa no Seiritsu" (Formation of Mu-Tamagawa into Utamakura), *Gakuen* 9 (September 1974): 2-21.

5. Ienaga Saburō, *Jōdai Yamato-e Nempyō* (Chronology of Ancient Yamato-e), rev. ed. (Tokyo: Bokusui Shobō, 1966) lists a poem no. 899 (listed again as no. 935) by Mibu no Tadami, which was composed in 958. The poem has a preface stating that it was

6. "composed about a painting on a *byōbu*, which depicted a man leaning over a fence, trying to entice a girl at a place called Ide, where *yamabuki* flowers were in bloom."

6. These poems can be found in Kawamoto Kōichi, ed., *Shinkō Gunsho Ruijū* (Revised Edition of Old Literary Materials) (Tokyo: Naigai Shoseki, 1928), 178:398-410. Also see Imagawa Fumio, *Kundoku Meigetsu Ki* (Annotated Text of the Meigetsu Ki) (Tokyo: Kawaide Shobō Shinsha, 1977), 2:297.

7. Inoue Ken'ichirō, "Chūsei no Shiki Keibutsu: Waka Shiryō ni yoru Shiron" (Depiction of Four Seasons in Medieval Period: Study of *Waka* as Historical Documents), in *Nihon Byōbu-e Shūsei* (Compendium of Japanese Screen Paintings) (Tokyo: Kodansha, 1977), 9:150-55.

8. This poem by Priest Nōin (b. 988) is included in the *Shin Kokinshū* (New Collection of Ancient and Modern Times) of 1205, poem no. 643.

9. From the anthology of Fujiwara no Teika (1162-1241), *Fubokushū*.

10. This poem by Minamoto no Toshiyori (1055?-1129?) is poem no. 280 in the *Senzaishū* (Collection of a Thousand Years) of ca. 1188.

11. Fujiwara no Toshinari (1114-1204) is also called Shunzei. This poem, no. 159, is in the *Shin Kokinshū*.

12. This poem, no. 339, by Toshiyori, is in the *Senzaishū*.

13. Also known as Kūkai (774-835). This poem, no. 1788, is included in the *Fūgashū* (Collection of Elegance) of 1344-1346.

14. Takahashi, "Utamakura Mu-Tamagawa," 9.

15. Modern Edition, Yamazawa Hideo, ed., *Haikai Mu-Tamagawa*, 4 vols. (Tokyo: Iwanami Shoten, 1984).

16. Yamazawa, *Haikai*, 1-21.

17. Excerpts from this chronicle are found in the Tokyo National Museum, ed., *Edo-jō Shōheki-ga no Shita-e* (Preliminary Drawings for the Screen Paintings at Edo Castle), 2 vols. (Tokyo: Daiichi Hōki, 1989), Text vol., pp. 167-461.

18. Tokyo National Museum, *Edo-jō*, Text vol., pp. 22-23.

19. Ibid.

20. For the Hon-maru wall paintings of this theme, see Tokyo National Museum, *Edo-jō*, Pl. vol., p. 58, and for the ones at Nishi-no-maru, the same volume, p. 129, which are reproduced in a larger, color plate in *Tokubetsu Tenkan Edo-jō Shōheki-ga no Shita-e* (Special Exhibition: Preliminary Paintings for Edo Castle) (Tokyo: Tokyo National Museum, 1988), 18.

21. For a summary of this project, see Hamurochō Kyōiku Iinkai, ed., *Kōza Tamagawa Jōsui* (Lectures on Tamagawa Acqueduct), vol. 6 of *Hamurochō Shi Shiryōshū* (Historical Materials on Hamurochō) (Tokyo: Hamurochō Kyōiku Iinkai, 1980).

X **40.**

Breaking a Plum Branch on a Snowy Night; Bamboo in Snow

Edo period *early 19th C*
Attributed to Okada Tametaka (1823–1864)
Pair of fan paintings mounted on panels;
ink, color, and gold on paper
H. 18.8 x W. 48.7 cm (7¾ x 19¼ inches)

These two small fan paintings sparkle with gold and brilliant hues of crimson and blue. In one, a solitary courtier bends a branch of a blossoming plum tree as he stands in the snow beneath a full moon. In the other, a cluster of bamboo heavy with snow glows against a snow-covered ground and azure sky. Both images are revealed through openings in golden clouds, which appear almost to have parted to allow the viewer a momentary glimpse into an earlier time. The two paintings were originally pasted together, front to back, to form a single folding fan; the side on which the courtier is depicted was probably intended as the front.

The bamboo, heavily laden with snow and protected by a latticed enclosure, is one of a pair of such arrangements situated in front of the emperor's living quarters in the Imperial palace complex in Kyoto. The figure of the courtier represents one of the greatest poets of the Heian period, Fujiwara no Kintō (966–1041); according to tradition, the event that inspired this particular imagery took place one evening in early February, toward the end of the reign of Emperor Murakami (reigned 947–967). On that night, when a thick blanket of snow covered the entire grounds of the palace and a full moon seemed to brighten the area for a thousand miles around, the emperor commanded Kintō to bring him a branch of flowering plum. Every plum tree was in bloom, and it was difficult to distinguish the actual blossoms from what looked like "flowers" of snow. Kintō complied with the Imperial request, but without scattering any snow from his branch. He presented it with a poem that reads, in translation:

> Under the silvery, white shadow
> of a full moon
> I step into the gleaming white snow
> to break off a bough of plum.

The emperor was greatly pleased and amazed by Kintō's feat.

The crimson area in the upper part of the painting, with its decorative diamond patterns in delicate gold lines, may symbolize the royal blinds behind which the emperor sits. The poet, his face as white as the fresh snow around him, is dressed in silver grey except for the gleaming sleeves of his undergarment, glimpsed at the wrists and behind the neck, which echo the brilliant red cloud above. The long, slender bough of the plum tree is dotted with rose-colored blossoms.

This poetic episode is recorded in the *Senjūshō*, a collection of miscellaneous stories assembled by the monk-poet Saigyō (1118–1190).[1] The story is well suited to the life of the great *waka* poet, a courtier closely related to members of the royal family, among them the powerful Fujiwara no Michinaga (966–1027). There are, however, some historical inconsistencies in the tale, the most notable of which concerns the date on which the episode is supposed to have taken place. Kintō was born in 966, and was thus hardly capable of having composed a poem in 967, the last year of Emperor Murakami's reign. The validity of the story, regardless of the supposed date of occurrence, has also been disputed on both historical and literary grounds by a number of modern scholars.[2] Attribution of the poem to Kintō has been seriously questioned; this verse and three others in the *Senjūshō* are believed to be the work of other poets. Although the *Senjūshō* recounts such tales as though Saigyō himself had actually witnessed the events, many contain contradictions in matters of literary accuracy that most likely reflect the state of scholarship in Saigyō's time. It is not known why Saigyō cited these poems and related episodes in the *Senjūshō*, and lately questions have even been raised concerning his authorship of the book.[3]

These fan paintings bear neither seal nor signature. Their attribution to Okada Tametaka is made on the basis of their close stylistic similarity to a signed work by this artist that depicts the same two subjects. The painting, in a private collection, is a hanging scroll[4] in which pictorial elements are arranged in a vertical manner; three major components of the composition are placed within the snowy garden setting. These

Fall of Heian - Shogun in Power seize in [?]name of
Emperor
[?] move to bring Emperor back to power

Tokugawa decline
Matt Perry American
move to bring Emp Meiji to throne

Before
inspired by Classical literature
Story - Plum & Snow - Plum blossom peeking through
& Snow
Poetry sensitivity astonished Emperor
Harken back to Heian Period

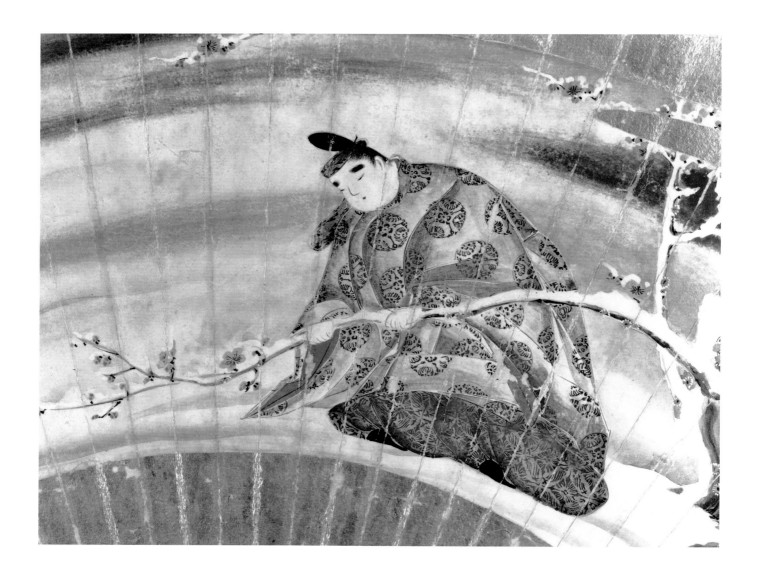

same elements are spread out horizontally in the fan versions, and, as though to tease and test the viewer, they are divided between the front and back images. The courtier depicted on the fan bends the plum-tree bough, while his counterpart in the hanging scroll holds a severed branch. It is likely that the same artist painted this theme in different painting formats, introducing a subtle shift in action and time in each rendition. Tametaka is known to have used the same subject in his paintings on numerous occasions.

Attribution of the fan paintings to Tametaka can also be made through a purely stylistic comparison. The round, youthful face of Kintō, depicted according to the traditional Heian convention of *hikime-kagihana* (dashes for the eyes, a hook for the nose), reflects Tametaka's obsession with preserving and reviving the techniques and methods of Heian-period painting. This concern is also evident in the carefully executed details of the courtier's costume. The delicate bamboo plant, bent under a blanket of snow, was one of Tametaka's favorite motifs, which he used in the manner of a theatrical prop in many of his images of courtly winter scenes. It appears, in an almost identical form, in the above-mentioned hanging scroll, and in a number of other paintings on unrelated subjects.

Okada Tametaka, also known as Reizei Tametaka,[5] was deeply preoccupied with the revival of classical, native *yamato-e* style of painting and the art of *emaki* (narrative handscroll) illustration, both of which were largely ignored by most Japanese artists of his time. He made efforts to re-introduce these indigenous artforms to the public by producing many copies of medieval

paintings. The third son of a Kyoto-based Kano-school painter, Kano Nagayasu, Tametaka was profoundly influenced by the volatile political climate of his youthful days, when the nation was divided between factions fighting to preserve the shogunal regime and those dedicated to restoring imperial sovereignty. His own admiration for ancient *yamato-e* may have been in part stimulated by his disillusionment with tradition-bound Kano-school training, regarded by most as the basic foundation for all painting styles. However, he was also affected by the political and artistic goals promoted by two older artists often cited in reference to *Fukko Yamato-e* (Revivalist *Yamato-e*): Tanaka Totsugon (1760-1823) and Ukita Ikkei (1795-1859). While still in his teens, Tametaka began to copy old *emaki*, portrait paintings, and Buddhist and Shinto icons; he also studied ancient costumes and other details found in early Japanese paintings. During his adult life it was these elements that formed the backbone of his artistic repertoire.

The *emaki* copied by Tametaka included such notable masterpieces as the scrolls of *Ippen*, the *Tenjin Engi*, *Nenjū Gyōji*, and *Ban Dainagon*. Tametaka himself was extremely prolific, copying *emaki* that consisted of many scrolls, such as the forty-eight-scroll set illustrating the life of the priest Hōnen—a work that he copied three times. In his studies, he is said to have become familiar with the minute details of as many as eighty-nine *emaki*,[6] and by his late teens he was regarded as an accomplished artist in his own right. In 1841 he was given the honor of joining a group of much older painters, including Ukita Ikkei, engaged in producing a copy of twenty scrolls of the *Kasuga Gonki* from the Imperial Collection.

Tametaka's work exhibited his knowledge of medieval painting, and the majority of his oeuvre—from 80 to 90 percent—centered around classical themes.[7] These fan paintings reflect not only his interest in, and knowledge of, ancient *waka*, but also his devotion to the courtly culture of the past. His craving for the courtly lifestyle of ancient Japan was satisfied in 1850 when he was adopted into the Okada family. This clan belonged to the noble class, and Tametaka was thus eligible to inherit its court title.

Tametaka's work was also influenced by the teachings of his religious mentor, the priest Gankai (1823-1873) of Mount Hiei, for whom he painted numerous Buddhist icons. Through his friendship with court nobles, he obtained commissions to execute large screen paintings for important Buddhist temples, as well as the Imperial palace. His patrons even included military lords in service to the shogun. Unfortunately, Tametaka's wide-ranging artistic and social contacts appear to have irked both the pro- and anti-shogun factions, and in 1862 he was forced to take refuge at Kokawadera, a Buddhist temple south of Osaka. He spent the remainder of his short life "underground," assuming several different aliases, until he was finally assassinated near Nara by a band of warriors sympathetic to the Imperial court.

These fans are rather unusual in that they bear no signatures, which Tametaka regularly altered to reflect his promotions in courtly rank.[8] He may have decided not to include them because of the small size and format of the paintings. The other extant painting on the same subject—discussed above—is a hanging scroll and is signed with the title of "senior sixth rank lower," which he held between 1855 and 1858. The fan paintings may be tentatively assigned to the same period, or perhaps to the earlier years of his youth, before he was granted a courtly title.

NOTES

1. For *Senjūshō*, see Ōta Tōshirō, ed., *Zoku Gunsho Ruijū* (The Sequel of the Collection of Various Books) (Tokyo: Zoku Gunsho Ruijū Kanseikai, 1927), vol. 953, bk. 8, which is devoted to stories related to famous poems.

2. Most recently by Yasuda Takako et al., eds., *Senjūshō* (Tokyo: Gendai Shichōsha, 1987), 1:3-4.

3. Today it is generally agreed that the majority of poems and tales in the *Senjūshō* were drawn from the *Wakan Rōeishū* and other anthologies. The book is now attributed to an unknown author who lived during the mid thirteenth century, after Saigyō's day.

4. This painting, in a private collection, is reproduced in Nakamura Tanio et al., *Reizei Tametaka* (Tokyo: Tokyo National Museum, 1979), no. 17; and Nakamura Tanio, *Reizei Tametaka to Fukko Yamato-e* (Reizei Tametaka and the *Yamato-e* Revivalist) Nihon no Bijutsu no. 261 (Tokyo: Shibundō, 1988), fig. 5.

5. His name is pronounced variously, but since he signed one of the paintings "Tametaka" in *kana* script, it seems correct to use this pronunciation. See Nakamura, *Reizei Tametaka*, no. 78; for his life also see Itsuki Seishō, *Reizei Tamechika no Shōgai* (Life of Reizei Tamechika) (Tokyo: Benridō, 1956).

6. Nakamura, *Reizei Tametaka*, 83.

7. Ibid., 80.

8. Matsumura Masao, "Tametaka Rakkan Nempu" (Chronology of the Signatures of Tametaka) *Kokka* 844 (July 1962): 318-28.

41.

Flowers and Birds of the Four Seasons

Edo period
Ikeda Koson (1801–1866)
Pair of hanging scrolls; ink, color, and gold on silk
H. 109 x W. 36.4 cm (43 x 14¼ inches) each
SIGNATURE: "Koson Ike Sanshin utsusu" (right scroll);
"Koson Songyō utsusu" (left scroll)
SEALS: "Kyūshō Dōjin"; "Renshinkutsu" (both scrolls)
PUBLISHED: Murashige Yasushi, ed., *Rimpa: Kachō I* (Rimpa:
Birds and Flowers, I), vol. 1 of *Rimpa* (Kyoto: Shikōsha, 1989),
pl. 84; Nakamura Tanio, *Hōitsu Ha: Kachō Gafu* (The Hōitsu
School: Bird and Flower Painting) (Kyoto: Shikōsha, 1979),
vol. 5, pls. 115-1, 115-2.

The aesthetic ideals and stylistic characteristics evolved by the founders of the Rimpa school in the early years of the seventeenth century were perpetuated by their followers for a period of over 250 years. A number of these later artists were, like their illustrious predecessor Hon'ami Kōetsu (1558–1637), members of the cultivated upper echelons of the merchant class. Some major eighteenth-century masters like Ogata Kōrin (1658–1716) and his younger brother Kenzan (1663–1743) pursued their careers for a time in Edo, the bustling urban center of shogunal government, but Kyoto, the old capital, served as Rimpa's "spiritual base," and most of Kōrin's disciples chose to work there. It was during the nineteenth century that the school was virtually transplanted to Edo, where it flourished under the leadership of Sakai Hōitsu (1761–1828) and the more talented of his students. Of the latter, Suzuki Kiitsu (1796–1858) is perhaps the most famous, but his younger contemporary, Ikeda Koson, was also an artist of great ability and dedication to ideals of the Rimpa tradition. Like numerous late Edo-period painters, Koson was also open to influences from other styles of painting, mingling Rimpa decorative taste with elements derived from *ukiyo-e*, *nanga* (literati painting), and even Chinese models.[1] However, this pair of hanging scrolls from the Burke Foundation owes much of its poetic appeal and its almost sensuous yet subtle use of color to Koson's Rimpa training and his profound admiration for the achievements of his predecessors.

The right-hand scroll depicts flowers of the spring and summer seasons; the left, flowers and foliage of autumn and winter. Both works are executed in subtle yet rich tones, and soft washes of color; leaves, branches, and flowers are rendered in the "boneless" manner, devoid of outline, that was typical of established Rimpa style. Brushstrokes are fluid and uninflected, and in numerous areas pigments are pooled or puddled together to create a marbled effect, a technique known as *tarashikomi*, allegedly devised by the Rimpa-school founder, Sōtatsu (d. ca. 1643). This mottled application of color is particularly evident on the foliage of the winter scroll, where gradations of light and dark, areas of red, green, and brown, and veins indicated by fine lines in gold create the impression of autumn leaves blighted by sudden frost. The small birds, also delineated with a soft brush and no outline, are effectively hidden among the greenery of both paintings.

In the spring and summer scroll, pictorial elements fill the lower half of the silk but are generally concentrated in the right side of the composition.[2] The image is dominated by the twisting branches and brightly colored blossoms of a young red plum tree whose limbs angle across the painting from right to left. The marbled effects of *tarashikomi* are visible on the sinuous, curving stalks of young fiddlehead ferns, a favorite delicacy in native cuisine. A small bird, possibly a sparrow, is almost invisible among the stalks of grass. The arrangement of motifs in the autumn and winter scroll is less scattered and the overall effect more lyrical, evocative of a rapid change from one season to the next. A light dusting of snow or frost lies upon a withering stalk of pampas grass, or miscanthus,

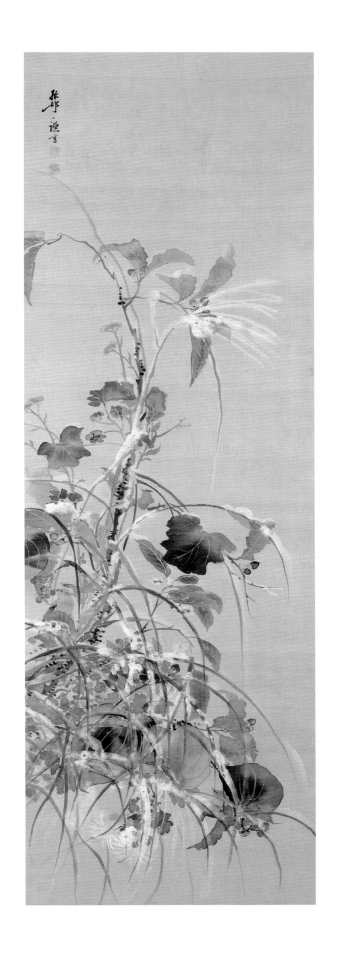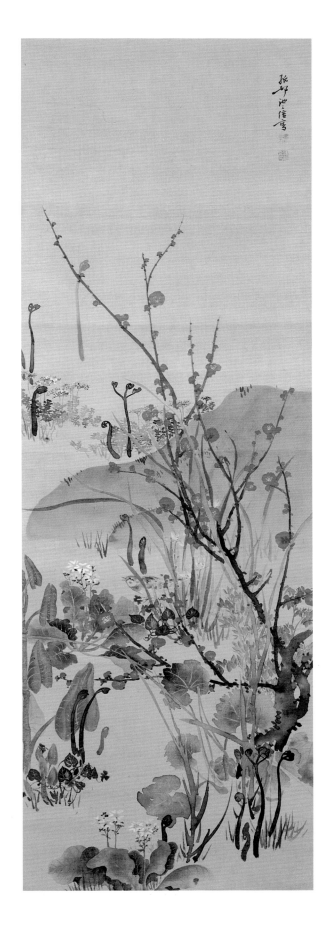

whose tassels have turned from golden to white. Leaves still bright with the rusty colors of autumn cling to slender branches, but the powdery white snow on bending grasses and the red berries and green leaves of spearflower plants presage the coming severity of winter. Oak leaves tinged with crimson have a frozen, brittle appearance; their edges are ragged as though tattered by wind and rain.[3] In the midst of the grass and snow, a bird, rendered in a "boneless" wash of light color, is neatly camouflaged.

Both paintings bear seals reading "Kyūshō Dōjin" and "Renshinkutsu." The signature on the right scroll, "Koson Sanshin utsusu" ("transcribed by Koson Sanshin"), written in semicursive script, is divorced from the image below, while the inscription on the left, "Koson Songyō utsusu," seems almost a continuation of the barren twig reaching up toward the left corner of the composition.

Relatively little is known about Koson's life, his patrons, and his artistic development. The establishment of a chronology for his work is hampered by his apparent lack of interest in dating his paintings. What biographical material is available comes primarily from printed books, containing copies of calligraphy and painting by well-known artists, published during Koson's own lifetime.[4] It is known that Koson's given name was Sanshin, and that he was born in Echigo province in 1801. He relocated to Edo to study painting under Hōitsu and took the "art name" of Shūji.[5] Reproductions of his works appeared in a number of printed books, and from comments in one of these, the *Shoga Kasui, Nihen* (*Selected Collection of Calligraphy and Painting, Second Series*) of 1859, we know something about Koson's idiosyncracies and personality.[6] He is said to have been a recluse and eccentric, but also an educated man of refined sensibilities with an appreciation and knowlege of such cultured pastimes as the tea ceremony and the composing of *waka* poetry. Such predilections may explain Koson's occasional use of the sobriquet "Chagasanmai-an Shu," or "Master of the Retreat of Tea, Painting, and Concentration"; a seal with this reading appears on another painting by Koson in the Burke Collection, a two-fold screen of cypress trees rendered in ink monochrome.[7]

Koson experimented with a number of different styles of painting and a wide variety of subject matter.

He once collaborated with Shibata Zeshin (1807-1891) (no. 54) in the production of a printed album,[8] and the influence of the *nanga* school is evident in two paintings he executed on the theme of the Sumida River.[9] He also produced paintings of beautiful women in the *ukiyo-e* mode, scenes from Noh plays, and works on traditional Buddhist subjects. However, his respect and reverence for his Rimpa-school predecessors is evidenced by his compilation of the *Kōrin Shinsen Hyakuzu* (*New Series of 100 Copies of Kōrin's Work*) in 1864, and the undated, two-volume *Hōitsu Shōnin Shinseki Kagami* (*Mirror of the Work of the Priest Hōitsu*), containing 113 printed copies of his teacher's paintings. His indebtedness to Hōitsu can be seen in a number of his richly colored polychrome works—for example, a hanging scroll of an autumn maple (in a private collection),[10] which is clearly based on a similar painting by Hōitsu in the MOA Museum, in Atami.[11] A painting in the Burke Collection that aptly demonstrates Koson's reliance on earlier Rimpa masters is a two-fold screen depicting the "Thirty-six Immortal Poets" in a compositional arrangement originated by Kōrin and copied by several of his successors, among them Hōitsu and Koson's fellow pupil, Kiitsu.

Among Koson's numerous plant and flower paintings are some executed in strong, bright colors with ink outlines and flattened, highly decorative forms, like his hanging scroll of flowers of the four seasons in the art museum of Tokyo National University of Fine Arts and Music.[12] This scroll features a rather hard-edged rendition of flowers, leaves, and grasses, and seems to have little in common with the more sensitive and poetic vision of nature offered by the Burke scrolls. In terms of design, palette, and brushwork, the Burke paintings are perhaps closest to a hanging scroll of chrysanthemums—an autumn theme—currently in a private collection.[13] This work, in color on silk, is also executed in a "boneless" style with soft colors and *tarashikomi* on the leaves, which are veined with fine gold lines like those in the Burke winter scroll. The chrysanthemum flowers are delineated in the same way as those in the Burke painting, with the petals formed by rather coarse, scrubby brushstrokes.

Similarities between the chrysanthemum painting and the Burke scrolls might provide some insight into the dating of the latter. The circular seal on the chrys-

anthemum painting reads "Kaikyū," or "Reminiscing about the Past," which may indicate that the work was executed in Koson's mature or later years. It has been thought that the rough, tactile brushwork used for the chrysanthemum petals represents Koson's blending of Rimpa tradition with elements of Chinese painting technique.[14] According to contemporary accounts, Koson was drawn to the study of Chinese Ming dynasty paintings in the later days of his career, and he altered his style to reflect this interest.[15] The brushwork visible in the Burke hanging scrolls, the relatively subtle palette, and the composition, which combines decorative effect with naturalism, suggest that these paintings are works from the artist's mature or late period. s w

NOTES

1. See Shimada Shūjiro et al., eds., *Zaigai Nihon no Shihō: Rimpa* (Japanese Art Treasures Abroad: Rimpa Painting) (Tokyo: Mainichi Shimbunsha, 1980), 110.
2. Most of the flowers and plants in both hanging scrolls are identified in Nakamura Tanio, *Hōitsu Ha: Kachō Gafu* (The Hōitsu School: Bird and Flower Painting) (Kyoto: Shikōsha, 1979), 5:147.
3. Ibid.
4. Biographical information is included in Volume I of the three-volume *Shoga Kasui* (Selected Collection of Calligraphy and Painting) written in 1859. For a summary of the contents of this compilation, see C. H. Mitchell, *The Illustrated Books of the Nanga, Maruyama, Shijō and Other Related Schools of Japan, a Bibliography* (Los Angeles: Dawson's Bookshop, 1972), 483-84.
5. Ibid., 110.
6. Ibid.
7. The Koson cypress screen is published in the following: Miyeko Murase, *Byōbu: Japanese Screens from New York Collections* (New York: The Asia Society, 1971), no. 7; Yamane Yūzō, ed., *Rimpa Kaiga Zenshū: Hōitsu Ha* (Tokyo: Nihon Keizai Shimbunsha, 1979), vol. 5, no. 214; Shimada, *Zaigai Nihon no Shihō: Rimpa*, no. 114; *Edo Kaiga II* (Edo Painting II), Nihon no Bijutsu no. 210 (Tokyo: Shibundō, 1983), pl. 113; *Nihon no Bijutsu Meihin Ten: New York Burke Collection* (A Selection of Art from the Mary and Jackson Burke Collection) (Tokyo: Tokyo National Museum, The Tokyo Shimbun, and The Chunichi Shimbun, 1985), no. 47.
8. This album, entitled *Ka-on Kyo* (The Sound of Sutras), was published in 1867; it contained verses by a number of poets and color illustrations by Koson and Zeshin. In spite of the title, the text does not contain any Buddhist sutras. See Mitchell, *Illustrated Books*, 342-43.
9. One of those, painted in a rather precise manner with ink and light color, is in the collection of the Edo-Tokyo Museum, Tokyo, and is reproduced in Kobayashi Tadashi, ed., *Rimpa: Fūgetsu, Chōjū* (Rimpa Painting without Flowers and Human Figures), vol. 3 of *Rimpa* (Kyoto: Shikōsha, 1991), no. 54. The other, executed in a "boneless" style, primarily in ink, is in a private collection; reproduced in Murashige Yasushi and Kobayashi Tadashi, eds., *Rimpa: Sōgō* (Rimpa: Assorted Themes), vol. 5 of *Rimpa* (Kyoto: Shikōsha, 1992), no. 75.
10. Reproduced in Nakamura, *Hōitsu Ha: Kachō Gafu*, pl. 116.
11. Ibid., pl. 90.
12. Reproduced in Murashige Yasushi, ed., *Rimpa: Kachō I* (Rimpa: Birds and Flowers I), vol. 1 of *Rimpa* (Kyoto: Shikōsha, 1989), pl. 53.
13. See Nakamura, *Hōitsu Ha: Kachō Gafu*, vol. 2, cat. no. 30; discussed p. 139.
14. Ibid.
15. See Shimada, *Zaigai Nihon no Shihō: Rimpa*, 163; also Mitchell, *Illustrated Books*, 110.

42.

Woman Walking under a Cherry Tree

Edo period
Komai Ki (known as Genki; 1747–1797)
Hanging scroll; ink, color, and gold on silk
H. 91.4 x W. 30.8 cm (36 x 12 inches)
SIGNATURE: "Genki utsusu"
SEAL: "Genki"
FORMER COLL.: C. D. Carter
PUBLISHED: Robert Moes, *A Flower for Every Season;
Japanese Paintings from the C. D. Carter Collection*
(New York: Brooklyn Museum, 1976), no. 20.

A young woman walks under a blossoming cherry tree; as though paying tribute to her beauty, a branch bends down almost to the point that it touches her tall chignon. The artist, a follower of Maruyama Ōkyo (1733–1795), the leading exponent of realism in the Edo period, took extraordinary care to depict her face and the kimonos that cover her in a realistic manner. Thread-thin ink brush lines define her hair, brows, and lashes. Her small lips are parted to reveal her blackened teeth, testimony to the longevity of the practice of *haguro* (tooth-blackening; see no. 69) and a sign that she is married. Her lower lip is painted green in accordance with the belief that the deep red gloss applied on lips was so red that it looked green. The contour of her face is first drawn in pale pink and then retraced in light brown ink; these shades, as well as the white pigment that is lightly applied on her facial skin and neck, enhance the soft, fleshy, sensual beauty of her countenance. The woman is caught in a tacit movement: her shoulders are unbalanced as she swivels to catch the end of her gold-colored obi with her left hand. Her legs are slightly parted. Her two undergarments, in red and blue, add brilliance to a painting that is dominated by muted colors—translucent ink wash on the tree trunk, pink-white blossoms, light beige leaves, and the color of her outer garment, which matches the silk background.

The decorative designs on her outer garment consist of miscanthus and bush clover, which are firmly embedded in Japanese pictorial tradition as symbols of autumn and thus give a jolting sense of incongruity. This element of surprise tempts us to suspect that all

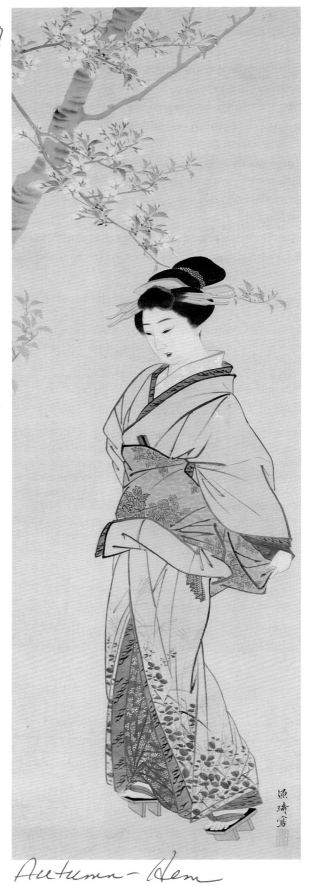

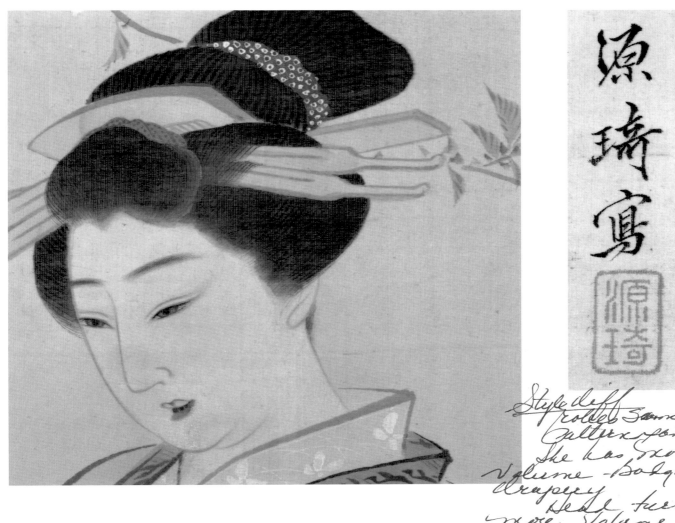

源琦寫

may not be quite well with this young woman, whose kimono is in slight disarray; even her vivacious pose becomes a cause for concern.

The artist of this lovely but somewhat enigmatic painting, Komai Ki, adopted the surname Minamoto, which is also pronounced Gen. Thus, he is commonly known as Genki. He is generally considered a faithful follower of the art of Maruyama Ōkyo and is believed to have made frequent use of Ōkyo's works as his models. Such assessment is partly endorsed by the fact that after the master's death in 1795 he devoted the last two years of his life to leading the Maruyama school, assisting Ōkyo's young son Ōzui. The traditional assessment of Genki's works is that they are indeed very closely based on Ōkyo's models, and contrast sharply with the more idiosyncratic works by Genki's slightly younger contemporary, Nagasawa Rosetsu (no. 58), Ōkyo's more obviously talented and independent pupil.

The traditional view of Genki as a mild and faithful keeper of Ōkyo's tradition, however, may require reconsideration. This painting of a beauty, for instance, deviates ever so slightly from the canon of aesthetics for the painting of beauties that Ōkyo established. All of Ōkyo's women are proper models of decorum who often look frozen in eternity; Genki's lady looks warm and gives off a sense of intimacy. Her untidy demeanor and the emphatic ink outlines that define the folds of her garments create in the painting a sense of liveliness. Is it possible that Genki was obliged to preserve Ōkyo tradition for the sake of the school, even against his true inclination? In this respect, a collaborative painting by Genki and Rosetsu that depicts two Chinese Taoist immortals, Gama and Tekkai (Hama and T'ieh-kuai, in Chinese) is most intriguing.[1] Although the painting is not dated, Rosetsu's signature in tightly controlled *kaisho* (standard script) style suggests that

this work dates from shortly before 1790. Genki's dramatic brushwork in this painting demonstrates fluidity and uninhibited energy, a far cry from the tightly controlled works that are based on his master's models.

Further studies based on heretofore undiscussed works may reveal a new aspect of this underrated artist.

NOTE

1. This painting is in the collection of the Itsuō Museum; see Sasaki Jōhei, ed., *Maruyama-Shijō Ha* (Maruyama-Shijō School from the Collection of Itsuō Museum) (Kyoto: Kyoto Shoin, 1984), fig. 60.

43.

Sparklers in Summer Evening

Edo period
Shiokawa Bunrin (1808–1877)
Hanging scroll; ink, light color, and gold on silk
H. 94.4 x W. 34.8 cm (37⅛ x 13⅝ inches)
SIGNATURE: "Bunrin"
SEALS: "Bunrin" (?), "Shion"

Chic, urbane, and sophisticated, this painting of sparklers and a fan evokes nostalgia for the summer evenings of the past. Sparks from the thin sticks emit intricate, almost imperceptible patterns in gold. The round white fan is decorated with a design of plovers flying over waves. The entire silk background of the painting is tinted in light and dark grays, sharply silhouetting the clay pot in dark black ink that partly rests on the fan. The artist's signature "Bunrin" in gold ink and his two seals, "Bunrin" (?) and "Shion," in red ink add further bright spots to the dark background. The painting captures a pleasant moment in a summer night, experienced perhaps near the riverbanks of the Kamo River in Kyoto.

The artist of this charming painting was one of the most prominent pupils of Okamoto Toyohiko (1773–1845), who in turn was a pupil of Matsumura Goshun (no. 32), and who helped to further the influence and fortunes of the Shijō school founded by Goshun in Kyoto. Bunrin was perhaps the most talented of Toyohiko's Kyoto students, while another pupil who became prominent in Edo was Shibata Zeshin (nos. 54

and 73). At the end of the Edo period, Bunrin was considered one of the four great masters of Kyoto, and he helped to lay the foundation for the great prosperity that the Shijō school would enjoy in the Meiji period, earning patronage from the aristocracy, Buddhist clergy, and the affluent merchant class.

Bunrin seems to have been especially fond of depicting scenes of summer evenings, an impressive example of which is a pair of six-fold screens in the collection of the Nelson Gallery-Atkins Museum in Kansas City, Missouri, which is dated to 1875.[1] Judging from the style of his signature in the Burke painting, which is written in a careful *kaisho* (standard script) mode, this work may date to his youthful period before the end of the Edo period.[2]

NOTES

1. Harold P. Stern, *Birds, Beasts, Blossoms, and Bugs: The Nature of Japan* (New York: Harry N. Abrams, 1976), no. 76.
2. For the examples of his signature, see Sasaki Jōhei, ed., *Maruyama Shijō Ha* (Maruyama and Shijō School Paintings from the Collection of Itsuō Museum) (Kyoto: Kyoto Shoin, 1984), nos. 108–109.

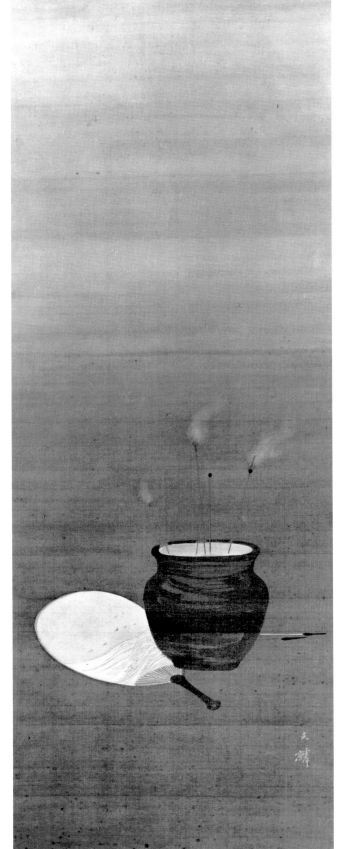

44.

Kambun Beauty

Edo period, second half of the seventeenth century
Hanging scroll; ink and color on paper
H. 63.6 x W. 25.6 cm (25 x 10 inches)
PUBLISHED: Miyeko Murase, *Urban Beauties and Rural Charms: Japanese Art from the Mary and Jackson Burke Collection* (Orlando, Fla.: Loch Haven Art Center, 1980), no. 1; Donald Jenkins, *Ukiyo-e Prints and Paintings: The Primitive Period, 1680-1745* (Chicago: The Art Institute of Chicago, 1971), no. 2.

Kambun Bijin (Beauties of the Kambun Era, 1661-1672) is a generic term that refers to paintings of beautiful women in solitary splendor against a neutral background. This type of figure painting apparently evolved from earlier group portraits depicting women of the pleasure quarters or theater, which in themselves derived from much larger compositions, such as the *Rakuchū-Rakugai* (Inside and Outside the Capital) screens, in which the entire city of Kyoto and its environs were shown. As interest focused on indoor scenes of the pleasure quarters or Kabuki theaters, such large compositions were gradually replaced by smaller paintings, which appealed to the affluent merchant patrons of the arts. Mass-produced by anonymous artists, these paintings of beautiful women portray their subjects clad in the most fashionable hairstyles and dresses, like fashion plates of our time.

At first glance, this painting of a solitary woman standing against a blank background seems typical. She is tall and slender, her long hair almost reaching her ankles. She places her left hand under her garment, while keeping the outer gown close to her body with her right hand. Her slightly bent head and gesture suggest a deeply pensive mood. The design motifs of her garments, one in crimson red and the other in white, are thematically united by a reference to the autumn season. The red kimono bears stylized designs of large chrysanthemums, linked diamond patterns, and crests of waves in white tie-dyed patterns, which emphasize the brilliance of the crimson. The white gown has an elegant, painterly design of miscanthus, chrysanthemums, and bush clover that sets the stage for two romping deer. Large maple leaves, also with white tie-dyed spots, seem to be blown by the wind.

The pose, hairstyle, and above all the rather incongruous inclusion of the motif of tall crests of waves on the kimono reveal that this lady is not one of the numerous dancers, actresses, or courtesans of the Kambun era. In a recent study, Okudaira Shunroku identified a group of images depicting similarly dressed women in identical poses as the mistreated heroine of a well-known episode from the tenth-century *Tales of Ise (Ise Monogatari)*.[1] In the tale, this woman's husband made frequent travels to Takayasu to see his new mistress. The wife knew of his infidelity, yet she never complained. Suspecting that she herself might be involved with another man, since she had not complained about his deception, the husband one evening hid behind some bushes after pretending to go off on his usual escapade. Unaware of his presence, the woman recited a poem:

When the winds blow
 White waves rise higher
 at Tatsutayama
Shall you be crossing it
 Quite alone by night?[2]

Impressed by his wife's faithfulness, the husband ceased to visit his mistress. Paintings that represent this charming episode usually depict the woman, either seated or standing alone on the veranda, staring into the darkness of the night and reciting a poem. Unbeknownst to her is her husband, who hides behind the hedge in the garden and overhears her poem.

The autumnal motifs that adorn the lady's garments in the Burke painting refer to Tatsutayama, where the Tatsuta River flows. This site, one of the best known places in ancient *waka*, is inseparably tied to the image

Inf by Classical

Mitate-e
 Story in story
 Tales of E
Lady's Husband
 unfaithful

Allude to
 (1) Maple Leaves
 River
 (2) Hem-pattern
 Waves.
 (3) Deer - cry
 sounds lonely
 suggests her
 loneliness
 Visual Pun —
 Fashionable
 early Edo — 17th
 not Heian Costume

of red maple leaves in autumn. This work, a kind of visual pun (*mitate*), is most likely based on a painting in the Tokyo National Museum collection, or a similar one commonly known as the *Ensaki Bijin* (Beauty on the Veranda). Although completely removed from its narrative context, this figure represents the solitary heroine of the tale looking into the void of night through which her husband is supposed to be traveling.

It is possible that many other so-called Kambun Beauties may prove to be similarly conflated images—characters derived from classical compositions, onto which the fashionable accoutrements of women of contemporary Edo-period society have been superimposed.

NOTES

1. Okudaira Shunroku, "Ensaki no Bijin: Kambun Bijin Zu no Ichi Shikei o megutte" (Beauty on a Veranda: One Form of Kambun *Bijin*, or Beauties of the Kambun Era), *Nihon Kaigashi no Kenkyū* (Studies in the History of Japanese Painting), ed. Yamane Yūzō Sensei Koki Kinenkai (Tokyo: Yoshikawa Kōbunkan, 1989), 646-90.
2. Episode 23 in Helen Craig McCullough, trans., *Tales of Ise; Lyrical Episodes from Tenth-Century Japan* (Stanford: Stanford University Press, 1968), 88.

45.

Courtesan Writing a Letter

Edo period
Kaigetsudō Doshin (active, early eighteenth century)
Hanging scroll; ink and color on paper
H. 49.4 x W. 60 cm (19½ x 23½ inches)
SIGNATURE: "Nihon Giga Kaigetsu Matsuyō Doshin koreo zusu"
SEAL: "Ando"

FORMER COLL.: Frank E. Hart
PUBLISHED: Miyeko Murase, *Urban Beauties and Rural Charms: Japanese Art from the Mary and Jackson Burke Collection* (Orlando, Fla.: Loch Haven Art Center, 1980), no. 3; Donald Jenkins, *Ukiyo-e: Prints and Paintings, The Primitive Period, 1680-1745* (Chicago: The Art Institute of Chicago, 1971), no. 108; *Japanese Paintings from the Frank E. Hart Collection* (Palm Beach, Fla.: The Society of the Four Arts, 1963), no. 17.

Since many paintings and woodblock prints with the signature "Kaigetsudō" also include a second name or seal, the word is believed to have been a studio name used by the artist Ando and his followers. Tall, majestic women are the favorite subjects of paintings and prints from this particular atelier. All Kaigetsudō courtesan pictures are remarkably similar in theme and style: a woman stands alone adjusting her hair or looking back over her shoulder. The faces are stereotypes, seldom revealing individuality or emotion. The costumes reflect popular fashions in textile design and are strongly outlined in rhythmic curving lines that set off the large, clearly defined patterns and lively color contrasts. Such paintings were mass-produced, and the same shop made even cheaper monochromatic versions of the painting designs in woodcut form.

The solitary Kaigetsudō courtesans mark the height of the development of a style of figure painting that began in the early seventeenth century. They continued a tradition established by anonymous painters of the Kan'ei (1624-1643) and Kambun (1661-1672) eras that was later refined by Hishikawa Moronobu (1618-1694). The Kaigetsudō women, however, seem prouder of their profession than their sisters in the earlier images.

Few things are known about the lives of the artists who signed the name "Kaigetsudō" on these large portrayals of courtesans. Various signatures and seals on paintings and prints enable us to differentiate six Kaigetsudō artists: Ando, Anchi, Dohan, Doshin, Doshū, and Doshu. Ando is generally credited with founding the Kaigetsudō studio.

Kaigetsudō Ando is said to have sold his pictures to visitors to the Yoshiwara. He seems to have been implicated in a scandal involving a love affair between one of the women serving in the Tokugawa government and a Kabuki actor—a relationship that was outlawed as a serious criminal offense. He was ordered into exile in

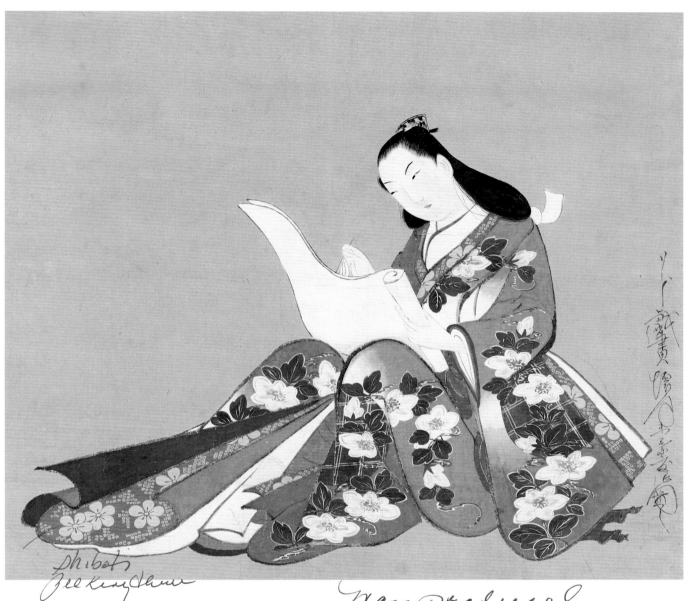

1714 and sent either to Niijima or Ōshima, one of the remote islands south of Edo, where he remained until 1722.[1] It is generally assumed that this incident ended Ando's career, and that his shop was continued by his pupils, who signed their names "Kaigetsu Matsuyō" ("the last leaf of Kaigetsudō").

The strong ink outlines distinctive of Kaigetsudō paintings and prints are sometimes attributed to the practice Ando had learned as a designer of votive tablets (ema). Since these tablets were hung high, near the eaves of temples and shrines, they required clear outlines. It is noteworthy, however, that the works of Kaigetsudō contemporaries like Torii Kiyonobu

(1664-1729), Torii Kiyomasu (active 1694-1716), and Okumura Masanobu (1686-1764) all feature strong lines and bold fabric patterns. Torii Kiyonobu is supposed to have originated a new style of actor print in which ink lines are exaggerated to express dramatic actions on stage. When woodblock printing was in its early stages of development and colors were added by hand to designs impressed in ink, artists relied solely on ink lines for expression. The vitality and dramatic quality of Kaigetsudō outlines became even more effective when their work was reproduced in ink monochrome prints.

Departing from the standard Kaigetsudō formula in this painting, Doshin depicts a woman seated in a relaxed pose while writing a letter, probably to her lover. This was a popular subject for *ukiyo-e* painting of the seventeenth and early eighteenth centuries, whose origins may be sought in scenes depicting various figures within the walls of the pleasure quarters. Brilliant aquamarine, crimson, and brown hues in the woman's clothes highlight the chalk-white color of the letter paper, her undergarment, her delicate hands, and the plump, concentrated face. She is almost overwhelmed by the large, striking patterns of camellia flowers on her outer garment. Her clothes are outlined in strong brushstrokes of dark ink. These features betray Doshin's dependence on the popular Kaigetsudō formula. As did all other successors of Kaigetsudō Ando, Doshin signed his name on this painting as the "Matsuyō" ("last leaf") of Kaigetsudō. The seal impressed here, not quite clear enough to be deciphered, seems to read "Ando," and indeed many Kaigetsudō artists continued to use their predecessor's seal.

NOTE

1. Narazaki Muneshige, ed., *Nikuhitsu Ukiyo-e* (Ukiyo-e Painting), Nihon no Bijutsu no. 248 (Tokyo: Shibundō, 1987), 42.

46.

The Brine Maiden Matsukaze

Edo period
Nishimura Shigenobu (active, mid eighteenth century)
Hanging scroll; ink and color on paper
H. 80.2 x W. 28.4 cm (31½ x 11¼ inches)
SIGNATURE: "Nishimura Shigenobu egaku"
SEAL: "Gessōshu Shūka Kōmansai"
FORMER COLL.: Frank E. Hart
PUBLISHED: Miyeko Murase, *Urban Beauties and Rural Charms: Japanese Art from the Mary and Jackson Burke Collection* (Orlando, Fla.: Loch Haven Art Center, 1980), no. 10.

A young maiden leans against a pine tree growing by the seashore. In her left hand is a black courtier's cap. A gentleman's gown in light blue is draped over a pine branch. The scene is readily recognizable as an illustration of an episode from the famous Noh play, *Matsukaze*.

The world-famous Noh plays of Japan originated as ritual dance-dramas performed as part of ceremonies and festivals dedicated to the Shinto gods of Japan's native religion (see no. 52).[1] As various features were adopted from other performing arts, the repertoire and techniques of performance were firmly established sometime between the late sixteenth and early seventeenth century and have been rigorously maintained. Among the libretti of these dramas, about 240 of which are known today, is the text of *Matsukaze*, upon which this painting is closely based. The play was written by Kan'ami (Kanze Kiyotsugu, 1333-1384), an actor and playwright, and was later reworked by his son Ze'ami Motokiyo (1363-1443?). It continues to be popular even today as a dance piece, especially in an avatar entitled *Shiokumi* (*Brine Gatherer*), which was choreographed for the Kabuki theater in 1811.

Matsukaze was most likely based on an old story included in the *Senjūshō*, a thirteenth-century collection of stories.[2] This in turn could have been inspired by the historical fact that the courtier-poet Ariwara no Yukihira (818-893) once spent a brief period of exile

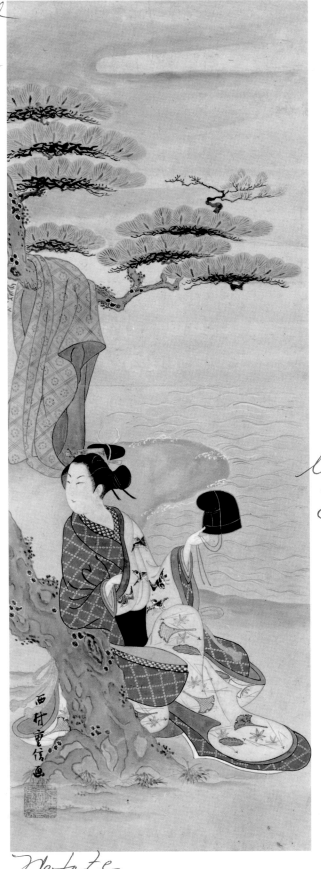

at Suma. While there, he is known to have composed the following poem:

> Should anyone by any chance inquire after me,
> Tell him, I am making salt,
> To while away melancholy days,
> at the beach of Suma.[3]

The exile of this famous courtier became a celebrated legend; it was embroidered with romantic episodes in later works of literature such as the *Tale of Genji* (nos. 36-38), in which the fictional protagonist, Prince Genji, is also banished to the seaside village of Suma, southwest of Kyoto.

The *Matsukaze* story tells of the undying passion of two sisters for the courtier-poet. The sisters, Matsukaze ("wind in the pines") and Murasame ("autumn showers over village"), brine-gathering maidens at Suma, both fell deeply in love with the exiled poet. When he was pardoned by the court, Yukihira returned to the capital, leaving his cap and gown with the maidens as mementos, along with a promise to send for them in the near future. Yukihira died shortly after his return and before fulfilling his promise. Distraught at the news of his death, the two sisters drowned themselves in the sea.

The play *Matsukaze* is realized as a type of flashback, a common device in Noh theater. It begins with the arrival at Suma of a travelling monk, who is told by a villager that a large pine tree marks the place where two sisters lived with their lover. Moved by the tale, the priest chants prayers for the souls of the brine maidens. When night falls, the ghosts of Matsukaze and Murasame appear to him, since they are still tied to the world through their passion for Yukihira. Matsukaze, in despair, puts on the robe and cap of her love and encircles and then embraces the pine tree, believing

it to be Lord Yukihira. When dawn arrives the sisters disappear, and the priest awakens not knowing whether his vision was a dream.

The tragic story of the brine maidens became popular among *ukiyo-e* printmakers, who often chose it as a subject for their prints and paintings. The painter of this work also seems to have been a printmaking artist, yet virtually nothing is known about his career. He signed this painting "Nishimura Shigenobu egaku" (painted by Nishimura Shigenobu) and impressed it with a large seal that may be deciphered as "Gessōshu Shūka Kōmansai" (Master of Moon Hut, Excellent Flowers Studio of Full Fragrance).

Shigenobu is sometimes said to have been the artist who used the name Ishikawa Toyonobu (1711-1785), although this claim is generally discredited today.[4] About thirty woodcuts bearing his signature are now known. In these prints, images of "female-impersonator" Kabuki actors all feature egg-shaped faces that bear distinct stylistic affinities with the figure type favored by Toyonobu.

NOTES

1. For a historical survey of Noh drama, see Shūichi Katō, *A History of Japanese Literature: The First Thousand Years*, trans. David Chibbett (London: Macmillan, 1979); Donald Keene, *Nō: The Classical Theatre of Japan* (Palo Alto and Tokyo: Kodansha International, 1966); and P. G. O'Neal, *Early No Drama: Its Background, Character and Development, 1300-1450* (Westport, Conn.: Greenwood Press, 1974).

2. This book is traditionally attributed to Saigyō (1118-1190), but this attribution is generally discredited today. Kojima Takayuki and Asami Kazuhiko, eds., *Senjūshō* (Tokyo: Ōfūsha, 1985), 247-48.

3. For another translation of this poem, see Laurel Rodd, *Kokinshū: A Collection of Poems Ancient and Modern* (Princeton: Princeton University Press, 1984), no. 962.

4. For Shigenobu, see *Ukiyo-e Shūka* (Collected Masterpieces of Ukiyo-e) (Tokyo: Shōgakkan, 1978-1985), 18 vols.

47.

Woman in a Black Dress

Edo period
Katsukawa Shunshō (1726–1792)
Hanging scroll; ink, color, and gold on silk
H. 85.1 x W. 28.5 cm (33½ x 11¼ inches)
SIGNATURE: "Katsu Shunshō egaku"
SEAL: *kaō*
PUBLISHED: Miyeko Murase, *Urban Beauties and Rural Charms: Japanese Art from the Mary and Jackson Burke Collection* (Orlando, Fla.: Lock Haven Art Center, 1980), no. 15.

This pensive woman, her head bent slightly and her left hand tucked into her obi, is dressed in kimonos of subdued gray and black decorated with small, delicate designs of white spring flowers. The red cuffs and hems of her undergarment provide the only bright spots of color in this otherwise restrained composition. With her mature appearance, she seems the antithesis of the younger and more ebullient—if sometimes clamorous—courtesan crowd usually inhabiting pictures of the pleasure quarters.

The painting is signed "Katsu Shunshō egaku" (painted by Katsukawa Shunshō) and followed by a handwritten seal (*kaō*), a practice that was very popular among contemporary *ukiyo-e* artists such as Kiyonaga, Shigemasa, and Toyoharu, as well as novelists like Santō Kyōden and Jippensha Ikku.

Today Shunshō enjoys great popularity as the designer of dramatic actor prints, which he began producing around 1765.[1] Yet other than the fact that he studied painting with Kō Sūkoku (1737–1811) and Miyagawa Shunsui (active 1744–1764), little is known about his life before this time. Shunshō is also remembered as the printmaking teacher of one of the greatest artists of this genre, Hokusai; his other pupils were Shunkō and Shunchō, who inherited the school name Katsukawa.

Shunshō's oeuvre is clearly divided into two categories: dramatic prints of actors and paintings of beautiful women. The work shown here is of the latter type, which he began producing quite late in his life (around 1780). Shunshō seems to have used his personal seal exclusively on his paintings. Since very few of his paintings are dated by inscription, a study of these handwritten seals helps establish a chronological framework

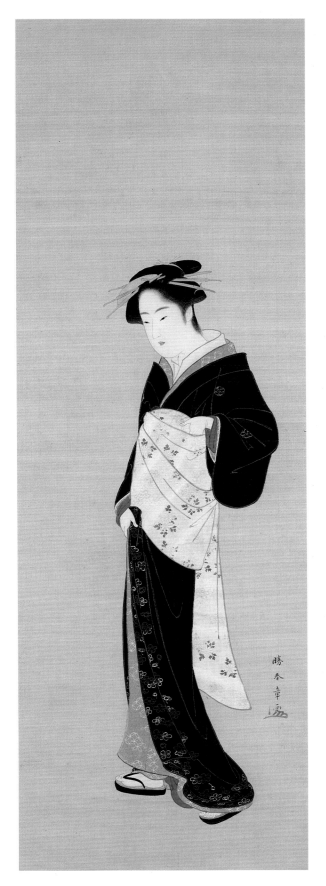

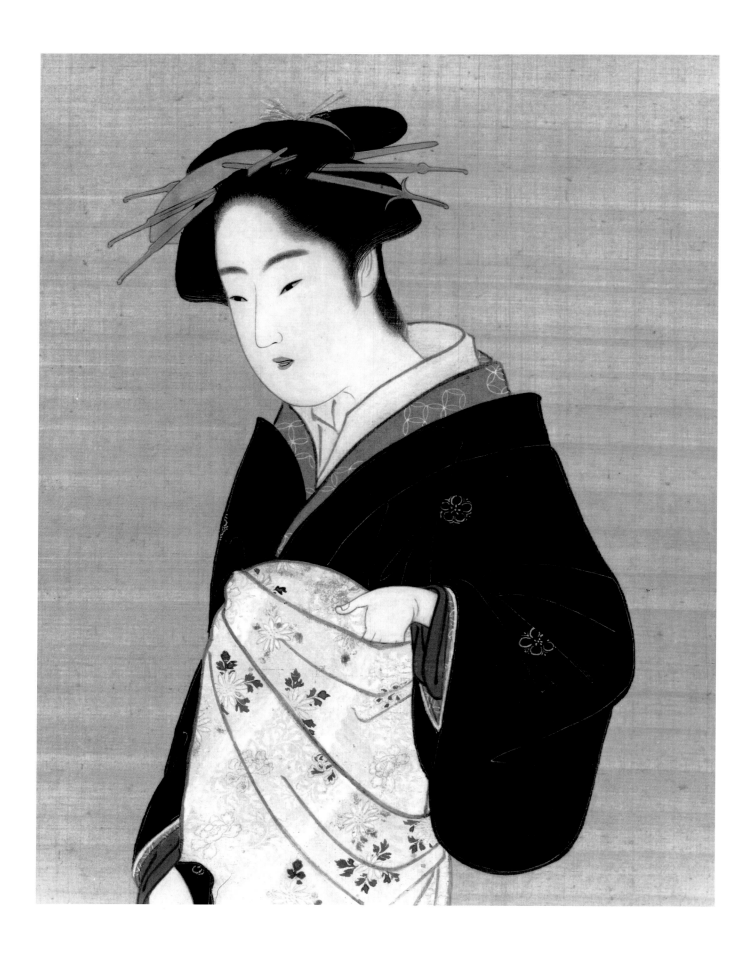

for them.[2] Around 1783, Shunshō began adding an upward flourish (as found here) to the vertical line of the left side of his *kaō*, and he maintained this mannerism until about 1789, when he abandoned *kaō* altogether and switched to the use of regular carved seals. At about the same time, he also changed the calligraphic style of his signature. The new signature was modeled after the writing style of the renowned, Late-Heian-period poet Fujiwara no Teika (1162-1241),[3] whose calligraphy had a powerful influence on the life of Edo residents—not only in the area of high art, but on the prosaic level of shop signs as well.[4] These changes in Shunshō's seal and signature coincided with the evolution of his style: from early portrayals of somewhat squat women he moved on to more attenuated and elegant depictions such as the figure in this painting.

All factors considered, this painting can be dated to the short period between 1783 and 1789.

NOTES

1. For his paintings and prints, see Narazaki Muneshige, ed., *Nikuhitsu Ukiyo-e* (*Ukiyo-e* Paintings) (Tokyo: Shūeisha, 1982), vol. 4; Gotō Shigeki, ed., *Ukiyo-e Taikei* (Compendium of *Ukiyo-e*) (Tokyo: Shūeisha, 1974), vol. 3; and Hayashi Yoshikazu, *Shunshō* (Tokyo: Yūkō Shobō, 1963).
2. Naitō Masato, "Katsukawa Shunshō no Nikuhitsu Bijinga ni tsuite" (On the Paintings of Beauties by Katsukawa Shunshō) *Bijutsu Shi* 125 (March 1989): 57-81.
3. Tanaka Tatsuya, *Nikuhitsu Ukiyo-e Meihin Ten* (Exhibition of Masterpieces of *Ukiyo-e* Paintings) (Nagoya: Asahi Shimbunsha, 1984), nos. 16-17.
4. *Teika-yō* (Teika: The Stylistic Legacy of a Master Calligrapher) (Tokyo: The Gotoh Museum, 1987).

48.

A Courtesan and Two Attendants

Edo period
Hosoda Eishi (1756-1829)
Hanging scroll; ink, light color, and gold on silk
H. 83.2 x W. 30.6 cm (32¾ x 12 inches)
SIGNATURE: "Chōbunsai Eishi hitsu"
SEAL: "Eishi".
PUBLISHED: Miyeko Murase, *Urban Beauties and Rural Charms: Japanese Art from the Mary and Jackson Burke Collection* (Orlando, Fla.: Lock Haven Art Center, 1980), no. 16.

A courtesan in full regalia and two youthful attendants, miniature replicas of the courtesan herself, walk past a cherry tree in full bloom. Their small powder-white faces and ethereal figures escape being smothered by the obligatory adornments of their profession—elaborate hair ornaments and layers of kimono and large obi—which are depicted primarily in subtle shades of gray-black ink. Colors are severely restricted: there are pale shades of pink and gold on the courtesan's hair ornaments, barely noticeable traces of pink on her lips, and bright red on the hem of her undergarment, which is just visible beneath the layers of gray kimonos.

The epitome of subtle elegance and refinement, such portrayals of courtesans truly suggest the exalted upbringing of the artist Hosoda Eishi. Eishi's family background was unusual among *ukiyo-e* artists, who were usually from the middle classes. He was born into a respected warrior family that included a number of high-ranking government officials. Eishi himself served shoguns from the age of sixteen until his voluntary retirement in 1789, after which time he devoted himself to painting. Eishi is believed to have studied painting with the leading Kano master of his time, Michinobu (Eisen-in, 1730-1790), but sometime later

he switched his artistic affiliations to the less academic style of *ukiyo-e*, specializing in paintings and woodblock prints depicting ethereal courtesans. Again diverting from the usual norm for *ukiyo-e* artists, Eishi seems to have produced as many paintings as woodblock print designs, if not more. Throughout his artistic career, Eishi appears to have used a fluid *gyōsho* (running script) signature on the prints he designed. But on most of his paintings he signed in a careful *kaisho* (standard script) style, as he did in this work.

Nearly monochromatic paintings such as this one, befitting Eishi's background, rely on subtle gradations of ink tonality as the major vehicle of expression. Known as *beni-girai* (evading red), this technique differs from traditional ink monochrome painting in that it may include some red, gold, purple, and yellow. Also different from ink monochrome painting is the extensive use of washes and shading in ink, which was used as if it were a color, without ever emphasizing the linear quality of brush lines. Use of a monochromatic palette was not limited to Eishi, nor was its use confined to painting. Some of Eishi's contemporaries produced paintings and prints of this type in the 1780s, and perhaps in the early 1790s. This group of artists included printmakers such as Kubo Shunman, Katsukawa Shunshō, Mizuno Rochō, Chōkyōsai Eiri, and Utamaro. It is well known that Sakai Hōitsu (1761-1829), a leading Rimpa artist, studied *ukiyo-e* painting in his youth under Utagawa Toyoharu (1735-1814). Hōitsu's oeuvre included *Matsukaze and Murasame* (see no. 46), a painting that employs this technique, dated by inscription to 1785.

The origin and practice of *beni-girai* painting and prints have long been attributed to a series of so-called sumptuary laws issued by the Edo government, which banned the use of red pigments and other rich colors in prints. This legislation was a part of the reform, known as the Kansei Reform, carried out during the period from 1787 to 1793. It was a puritanical policy formulated by Matsudaira Sadanobu (1758-1829), an enlightened scholar-statesman who served as regent during the period of minority of the shogun Ienari, from 1786 to 1793. Some scholars dispute this interpretation of the *beni-girai* technique. Instead, they view it as a reaction against the ever-increasing enrichment of the palette in *nishiki-e* (multi-colored brocade prints) by those who turned to self-imposed restriction of colors for more subtle effects.

A recent study suggests that Sadanobu referred to prints in *beni-girai* style in his memoir of 1787 as "a recent development" in printmaking and regarded them as just as sumptuously decorative as other types of prints.[1] It seems that monochromatic prints and paintings had already made their appearance prior to the Kansei Reform, at least as early as 1785, the date of Hōitsu's painting of *Matsukaze and Murasame*. Their popularity may be a result of artistic preference on the part of painters, or publishers in the case of woodblock prints. It has also been suggested that such a fad may have started with Hōitsu, as it reflects his high-class warrior birth, refined background, and discriminating aesthetic preferences.[2]

Judging from the short-lived vogue of the *beni-girai* technique, the Burke painting by Eishi may be dated prior to his retirement from his official position in 1789.

NOTES

1. Matsubara Shigeru, "Beni-girai to Kansei no Kaikaku" (Beni-girai and Kansei Reform), *Museum* 358 (January 1981): 27-33.
2. Matsubara Shigeru, "Beni-girai no Hassei to sono Haikei" (Emergence of Beni-girai and Its Background), *Museum* 408 (March 1985): 4-15.

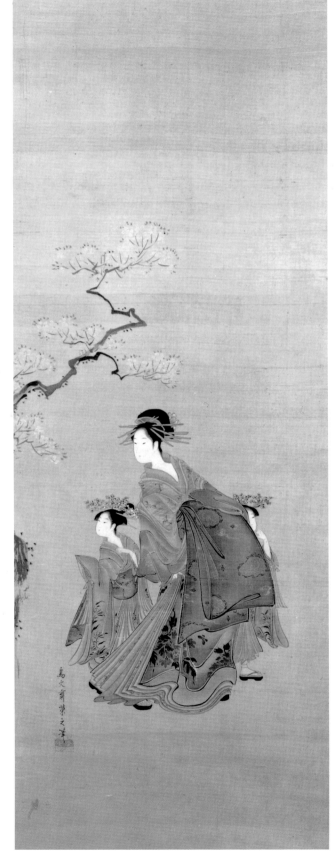

49.

Barley Field

Edo period, early seventeenth century
Six-fold screen; ink, color, silver, and gold on paper
H. 148.2 x W. 340.8 cm (58¼ x 134 inches)

In this single six-fold screen, an expanse of young spring barley plants is set against a sumptuous, flat background of gold leaf. The dark green, densely packed stalks form a rhythmic, gracefully criss-crossing pattern in the lower half of the composition, against which the dull white of the ears of grain seems almost luminous. A subtle use of *moriage* (built-up layers of pigment) for the grain provides a three-dimensional effect that contrasts with the flat, decorative rendering of the stalks and leaves. The edge of the field dips and undulates, creating a silhouette reminiscent of curving shorelines found in numerous depictions of beaches or cloud-shaped sandbars in *yamato-e* images of the Heian and Kamakura periods. The barley plants were painted over a silver ground that has oxidized and darkened over time to a dark bluish-grey hue. Nevertheless, the overall effect is striking, both for the dramatic simplicity of the composition and the elegant, schematized presentation of the single pictorial motif.

The theme portrayed here is also one that was not frequently depicted in Japanese art. Grown primarily as a winter crop and harvested in spring, barley was perhaps too homely and common a plant to appeal to the aesthetic sense of courtly artists or to inspire poets and painters of earlier classical times. The spring season was more lyrically represented by images of blossoming trees and plants, such as cherry, late plum, wisteria, and camellia, which had been extolled in verse and narrative from the earliest days of Japanese literature. Images of grain fields were rare prior to the sixteenth century, and usually comprised a minor component of the scenes in which they appeared. The Burke screen is one of the earliest examples of a large-scale painting devoted entirely to the barley motif, but in all likelihood it formed part of a pair, the second screen of which may have portrayed a different variety of plant life. A pair of *byōbu* (folding screens), comparable in date, from the Idemitsu Museum of Art in Tokyo, con-

sists of a right screen depicting a barley field while the left screen features a row of brilliantly colored poppies; the latter image was apparently intended to symbolize the summer season. The Idemitsu barley screen, attributed by tradition to Kano Sōgen (also known as Shigenobu, flourished early seventeenth century),[1] is quite similar in composition to the Burke painting, even to the meandering outline of the field, and it is not difficult to imagine the Burke screen paired with a scene of luxuriant blooms. Other paintings, later in date, pair barley with spring flowers; a pair of hanging scrolls by the Rimpa artist Sakai Hōitsu (1761-1828) features barley plants (in the left scroll) with yellow rapeseed flowers (in the right scroll).[2] In pairs of folding screens barley occasionally represents spring on one screen, while autumn plants ornament its mate. Perhaps the best-known example of this type of arrangement is a pair of

byōbu by Maruyama Ōshin (1790–1838) in the Shin'enkan Collection in Los Angeles, depicting a field of barley on the right screen, with a field of rice on the left. In this work, the rigid, upright stalks of barley, arranged in triangular "patches" against a gold background, contrast with the curves of rice plants bending in the autumn wind. Since both screens depict common, edible grains, they appear to symbolize not only spring and autumn but a fruitful harvest, and thus may reflect the interest in images of seasonal activities from the everyday life of the common man that developed during Momoyama and Edo times. Another instance of a spring-autumn use of the barley motif occurs in a two-fold screen by the renowned painter and lacquer craftsman Shibata Zeshin (1807–1891) (see no. 54). On one side, barley plants are surrounded by gold clouds, set against a background of gold, while the reverse side

of the screen offers an abbreviated hillside landscape with autumn plants and flowers silhouetted against a night sky with a rising moon.[3]

Although this evidence suggests that the Burke screen was originally paired with a screen of spring, summer, or autumn foliage, it is also possible that the second screen simply continued the theme of a barley field. One work whose overall design and treatment of pictorial motifs resembles that of the Burke screen is a rather unusual pair of *byōbu* in the collection of the Art Institute of Chicago. These screens, which have been dated to the late seventeenth century, depict millet fields under the sun and moon; in each, a curtainlike expanse of waving millet, ripening ears bending under the weight of the grain, is set against a flat backdrop of gold. A moon stands in a patch of dark blue sky in the right screen, a sun in a similar break in

the clouds in the left. If the mate to the Burke screen followed a similar thematic design, it may have featured a stand of barley beneath a sun or a moon.

In addressing the question of why the humble barley plant began to appear as the subject of screen painting in the late Momoyama-early Edo period, at least two factors may be considered. The first concerns the lack of interest in such crop plants as subjects of art during the formative years of the native *yamato-e* style of painting. Brought to Japan from China during the Kofun period, perhaps as early as the third or fourth century,[4] barley and wheat (*ōmugi* and *komugi*, both often simply referred to as *mugi*) were important staples of the Japanese diet from ancient times, but they were never accorded any particular poetic association or regarded as objects of great aesthetic appeal. Early depictions of grain in painting were mainly limited to rice, a food traditionally served to the gods as an offering at Shinto shrines. Among these early images are a late Muromachi-period fan dating from the fifteenth to early sixteenth century; painted in the colorful *yamato-e* manner, this work (in a private collection) shows a field of rice beneath a band of gold clouds, and green hilltops above which a flock of birds in flight is visible.[5] A rice field is also included in the left screen of the magnificent late Muromachi-period *byōbu* entitled *Sun and Moon* in the Tokyo National Museum.[6] It was during the late sixteenth and early seventeenth centuries that the interest in depicting mundane activities and aspects of popular culture (which gave rise to *fūzokuga*, or genre painting), combined with the centuries-old tradition of producing seasonal pictures, may have encouraged artists to single out such ordinary subjects as ripening field crops for the principal focus of a screen painting. For the decorative arrangement of pictorial elements in such works, they could rely on compositional precedents established by so-called autumn grasses screens, popular at least as early as the fourteenth century.[7] These images, executed on folding screens and sliding doors, consisted of a flat, foreground "band" of waving grasses with criss-crossing stalks, from which a moon—often rendered in silver—was sometimes shown rising. Autumn grasses screens continued to constitute an important staple of the screen painter's repertoire during the Momoyama and Edo periods, and they provided a design format for

such *byōbu* as the visually stunning *Musashino* (Musashi Plain) screens of the era, as well as objects like the Burke barley screen.

Paintings like the Burke barley screen may also have been in part the result of a process of lifting single motifs and pictorial elements from larger, more complex compositions in order to create simple yet monumental depictions of a single site, subject, or theme. If one examines the early sixteenth-century *Sun and Moon* screens in the Tokyo National Museum (cited above), one may identify at least two landscape elements that were later singled out as the sole themes of screen compositions—notably the arched bridge and willows in the left portion of the right screen, and the mountains laden with blossoming cherry trees to their right. The bridge-willow motif formed the basis for the "Uji Bridge" theme, reproduced on screens, lacquer works, textile designs, and other artistic media; the mountain-and-cherry image is clearly related to the scenes of blossoming cherry trees in the Yoshino mountains depicted on a number of Momoyama- and Edo-period *byōbu* (see no. 50). A field of grain does appear in the Tokyo National Museum *byōbu*, and it is possible that a similar process of "lifting" and enlarging a motif took place when artists, most likely *machi-eshi* (town painters of no particular artistic school) began to produce screens like the Burke painting. It is worth noting that the creation of pastichelike compositions, using pictorial elements lifted from other works of art, was practiced by a number of artists of the early Edo period, most notably early masters of the Rimpa school like Sōtatsu (d. ca. 1643). In a similar vein, Kano artists also relied on "pattern books," drawings made by their predecessors, from which they borrowed and then combined or enlarged motifs.

It is difficult to determine the studio that produced this barley screen. Its resemblance to the right-hand Idemitsu screen is tantalizing enough to suggest that the artists came from a similar training background and shared the same repertoire of decorative images. This painter appears to have been trained in the traditional native style of polychrome painting whose aesthetic evolved in the Heian and Kamakura periods; emphasis is placed on flat areas of color, simple yet dramatic handling of space, and lyrical treatment of subject matter. In all likelihood it was the work of a

machi-eshi painter active between the final years of the sixteenth century and the first half of the seventeenth. s w

NOTES

1. *Kaikan Gojū Shūnen Kinen Ten Zuroku* (The 15th Anniversary Catalogue) (Tokyo: Idemitsu Museum of Arts, 1981), 286. For reproduction of both screens, see fig. 83.
2. See Kobayashi Tadashi, ed., *Rimpa: Kacho II* (Rimpa: Birds and Flowers II), vol. 2 of *Rimpa* (Tokyo: Shikōsha, 1990), pl. 72.
3. Briefly discussed in *Shibata Zeshin Meihin Shū* (Masterpieces of Shibata Zeshin) (Tokyo: Gakken, 1981), 212; reproduced in pls. 229–30.
4. *Kōdansha Encyclopedia of Japan* (Tokyo: Kōdansha, 1983), 18:251.
5. *Muromachi Jidai no Byōbu-e* (Muromachi Period Screen Paintings) (Tokyo: Tokyo National Museum, 1989), 250; reproduced in pl. 96.
6. This pair of screens has been reproduced many times, most recently in *Muromachi Jidai no Byōbu-e*, pl. 14.
7. One of the earliest examples of such a screen is actually a *gachūga*, or picture-within-a-picture: a folding screen depicted in an interior scene in the fourth scroll of the *Ishiyamadera Engi Emaki* (Handscroll of the History of Ishiyama Temple), dated to ca. 1497. (Scrolls I through III of the handscroll set were executed in the early fourteenth century.) This small composition depicts a foreground of tall autumn grasses with a crescent moon overhead. See Nakamura Keiko, "Musashino-zu no Keifu" (The Genealogy of Musashino Paintings), in Kobayashi Tadashi and Murashige Yasushi, eds., *Kachōga no Sekai* (The World of Bird and Flower Painting) (Tokyo: Gakken, 1981), 5:125.

50.

Cherry Blossom Viewing at Yoshino and Itsukushima

Edo period, first half of the seventeenth century
Pair of six-fold screens; ink and color on gilded paper
H. 153.6 x W. 348.6 cm (60½ x 137 inches) each
PUBLISHED: Miyeko Murase, *Masterpieces of Japanese Screen Painting: The American Collections* (New York: George Braziller, 1990).

For centuries the image of the blossoming cherry has been nearly synonymous with the aesthetic and literary values of Japan. Often used as a literary metaphor for the evanescence of beauty in particular and life in general, it has become, perhaps, the most revered of all flowers, the subject of much poetic attention and a popular image in all aspects of the visual arts. In the eyes of most Westerners it is the very essence, or symbol, of the Japanese spirit. Landscapes resplendent with the pink and white of blossoming cherry trees were staples of the screen painter's repertoire in the Momoyama and Edo periods. Interestingly, it was the plum blossom, not the cherry, that was the favorite flower of poets and painters of the classical era, although the tradition of cherry-blossom viewing was certainly in practice during that time. It was Saigyō (1118–1190), the great *waka* poet and priest of the Shin-gon sect of Buddhism, who helped to initiate the cherry's rise to its present venerated status.[1] Many of Saigyō's verses on the beauty of cherry blossoms were inspired by the region of the Yoshino mountains, in central Nara prefecture (where he maintained at least one hermitage), renowned long before his time for its many cherry trees.

Dramatic panoramas of blossoming cherry trees at two famous scenic locations are spread out across this pair of six-fold screens. The rolling mountains of Yoshino, with their fabled tiers of *yamazakura* (mountain cherries), beloved of Saigyō, and the elegant architectural structures of the Itsukushima Shrine (in Hiroshima prefecture) appear according to a bird's eye view, through a framework of golden clouds. The clouds themselves are ornamented with floral motifs raised above the surface of the screen with *gofun*, a gessolike

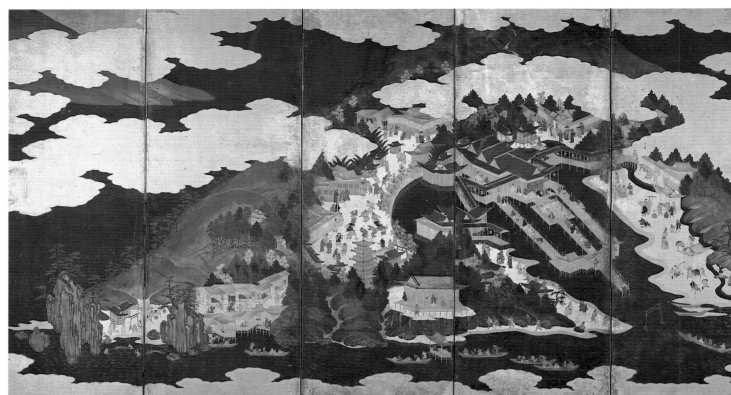

Performance on Floating Stage

Gallery Wall of Japan

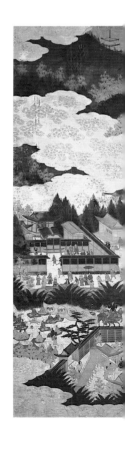

① Mts
② Flowering Cherry Trees,
 a Clouds textured c̄ Cherry Blossoms
③ Seasonal activities seen
④ Warfare 16 & 17th C — Emerge —
 Take interest in Genre Pt̲g
⑤ Commoners enjoy seasons & day activities
⑥ Meticulous, careful — heavily pigmented
 Style — Des'n Heian Period

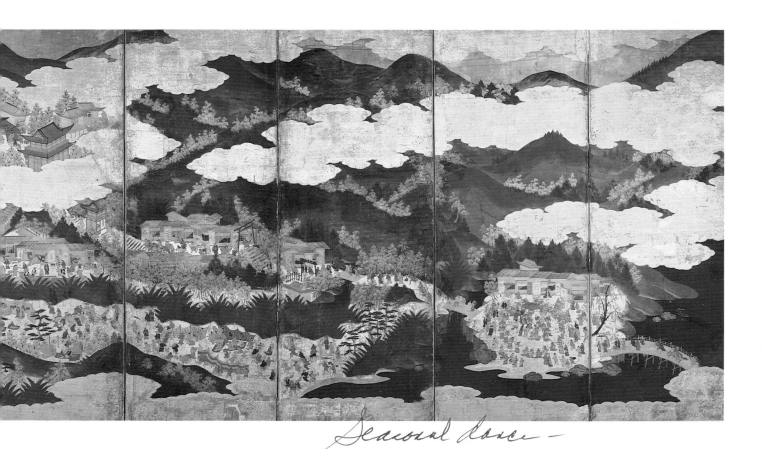

Seasonal Scene —

substance made from powdered sea shells, and covered with gold leaf. Both landscapes abound with colorful figures: pilgrims, merrymakers, dancers, picnickers, and groups of people from virtually all walks of life. Details of buildings and outstanding aspects of the landscape are carefully rendered, as are designs of clothing and textile patterns. These impressive vistas thus clearly belong to the area of painting generally classified as *meisho-e* (literally, pictures of famous places). At the same time, they contain elements of *fūzokuga* (genre painting) in their faithful depiction of various activities and customary practices carried out by people from contemporary society.

The concept of *meisho* as subject matter for art and literature evolved in Japan during the Heian period, and actual works of *meisho-e* may have begun to appear as early as the ninth century.[2] "Famous-place pictures" became an important category within the indigenous *yamato-e* painting tradition. However, it is from the Momoyama and Edo periods that the majority of extant *meisho-e* have survived. These later works frequently blend characteristics of classic *meisho-e*, which emphasized literary content and seasonal associations, with aspects of *fūzokuga* to depict everyday customs and activities drawn from folk and popular culture as well as ancient traditions. As many *meisho* are closely identified with certain human activities—usually seasonal in nature—the two modes of painting complemented each other and, when combined, produced lively, animated yet richly decorative images like the Burke Collection screens.

The two screens are connected thematically and compositionally by the profusion of pale pink and white blossoming cherry trees that extends from one scene to the next. Yoshino, which appears on the right, was eulogized for its blossoms from the time of the *Manyōshū*, the earliest extant collection of native poetry, compiled during the eighth century. Although the mountains were also famed for their winter appearance under snow,[3] by the sixteenth century images of Yoshino were devoted almost exclusively to the spring season. In addition to its poetic associations, the name Yoshino conjured up references to such important historical events as the fourteenth-century attempt by Emperor Go-Daigo (reigned 1318-1339) to wrest power from the shogunate and reinstate imperial

rule. It was also said to have been the place where the great twelfth-century warrior Yoshitsune and his lover Shizuka bade farewell to each other. The image that became the model for Yoshino screen paintings—rolling green hills covered with blossoming cherry trees—was established at least as early as the Momoyama period; one sixteenth-century pair, in a private collection in San Francisco,[4] was clearly the forerunner of the famous Yoshino screens by the much later Rimpa-school artist Watanabe Shikō (1683-1755), now in a private collection in Japan.

In the Burke Collection Yoshino screen, the landscape extends from the Yoshino River, in the first right-hand panel, to the Yoshimizu temple[5] and the Katsute, or Katte, Shrine in the fifth and sixth panels (moving from right to left). Numerous activities are in progress; in the second panel spectators from various classes of society ring a circle of dancers cavorting to the beat of *tsuzumi* drums. The dancers, costumed in crimson and gold, with headcloths wrapped around the lower part of their faces, tap sticks together in time to the rhythm. Several unusual examples of headgear are in evidence: one performer wears a tall headpiece crowned with flowers; another bears a huge bundle on his head; yet another balances a large box. A wildly gyrating male figure holds a sistrum similar to that used by *miko*, or Shinto shrine maidens, in their ritual dances. Another man flourishes an umbrella above his head. These celebrants are engaging in *fūryū-odori*— "fashionable" or "new" dances—which were in vogue during the late sixteenth and early seventeenth centuries. Paintings of similarly clad dancers appear in a number of genre screens from Momoyama and early Edo times; two Momoyama-period screens of merrymakers under cherry trees—one in the Kobe Municipal Museum, the other in the Suntory Museum in Tokyo— depict performers bearing similar objects and musical instruments.[6]

In the lower portion of the screen, smaller groups participate in impromptu dances to the music of transverse flutes and drums, brandish branches of cherry blossoms, or stroll past shops on their way to visit the shrines and temples of the area. A number of well-dressed ladies walk beneath tall umbrellas carried by attendants.[7] Other merrymakers enjoy outdoor meals screened from the view of passersby by fabric barriers

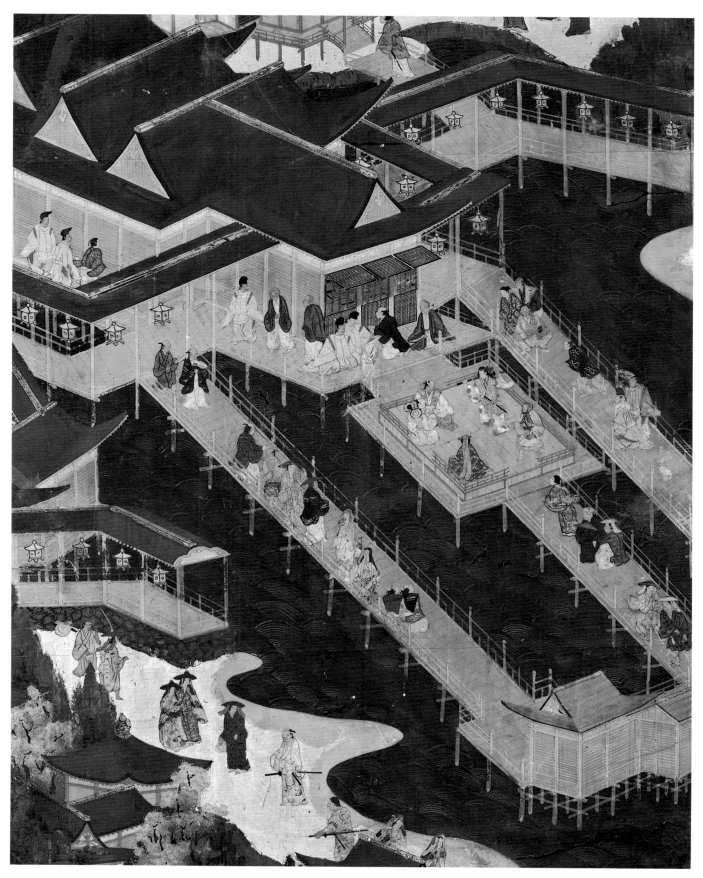

Detail, *Itsukushima* screen

raised on poles. The picnickers in the fourth panel, seated on crimson cloths, unpack their comestibles from tiered boxes similar in shape and design to the Ryūkyū Island lacquers that became popular in Japan during the early seventeenth century.[8] Their cloth barriers are decorated with the *mitsu-aoi* motif, a circular design of three hollyhock leaves adopted as a *mon* (family crest) by the Tokugawa clan. To the far left, a more aristocratic-looking gathering sits before cloth barriers marked with the paulownia crest, associated since the Heian period with the Imperial court, and, from the fourteenth century to the time of Tokugawa Ieyasu (1543–1616), with shogunal circles.[9] These individuals are more sedate in their bearing than the other revelers. It is likely that they are engaged in the composing of poetry, an occupation ideally conducted, in the spring, under blossoming cherry trees.[10] In their midst stands a *suhama* (literally, sandbar)—a tray often decorated with miniature plants or landscapes—an object sometimes employed as an accoutrement for poetry contests[11] as well as court ceremonies.[12] This group is thus clearly intended to represent the upper stratum of society.

The Itsukushima screen presents an even more striking vista with its undulating shoreline rendered in gold edged with white, and its dramatic depiction of the Itsukushima Shrine in the center of the composition. Much of this graceful structure was built in the twelfth century by order of Kiyomori (1118–1181), powerful head of the Taira clan, in order to attain the protection of Ichikishima Hime no Mikoto and two other female *kami* (Shinto deities) connected with the site. However, by the time these screens were painted, the shrine had also come to be associated with the Buddhist goddess Benzaiten, a result of the influence of Shinto-Buddhist syncretism.[13] Its buildings, constructed in the Late Heian-period palace style, feature symmetrical wings, lantern-hung galleries, connecting walkways, and a Noh stage built out over the water. Access to the compound was by sea from Hiroshima Bay; pilgrims arrived by boat, passing under the great red-painted *torii* (Shinto shrine gate) standing in the water before the shrine. Here, a boatload of visitors is about to enter the cove through the famous gate, watched by people on the shore, some of whom run toward the beach for a closer look. Spectators gather on the walkways of the shrine, looking out over the water or stopping to watch the performance of music and dance (which does not appear to be Noh) taking place on the stage. Directly behind this we see the principal buildings of the precinct: the *haiden* (hall for worshippers) with the *honden* (the main sanctuary in which the deities of the site were enshrined) directly behind it. Although the architectural structures had undergone renovations in the centuries since they were first erected (the main sanctuary was reconstructed in 1571),[14] their overall appearance is quite similar to the image of the shrine depicted in the *Ippen Hijiri-e* (Life of the Priest Ippen) handscrolls painted ca. 1299.

Pilgrims and tourists also wander along the beaches, or in the streets behind the shrine. Deer, sacred to the *kami*, regard them unconcernedly or approach them in the hope of being fed. A small gathering of masked dancers engage in a street performance to the left of the shrine compound. To the left of the shrine proper stands the Daikyōdō sutra repository; a five-storied pagoda can be seen in a grove of trees. Further to the left appears the small village of Ari-no-ura, several of whose buildings extend out over the water. Near a tiny shrine just beyond the village, nude pilgrims of both sexes purify themselves in the sea. The great rock looming above them, capped by pine trees, is the Hōrai-iwa (Hōrai Rock), named for the mythical island (Penglai in Chinese) in the eastern sea where, according to Chinese legend, immortal beings made their home.

Screens of famous places often depict two sites, one per screen. However, this is the only known instance in which Yoshino and Itsukushima are paired in this way.[15] Itsukushima did appear as the sole subject for a pair of screens, as the *Itsukushima Byōbu* by Kaihō Yūsetsu (1598–1677) indicate,[16] but as one of the *Nihon Sankei* (Three Scenic Places of Japan), it was frequently shown with one of the other two sites: Matsushima (in Miyagi prefecture) or Ama-no-Hashidate (in Kyoto prefecture). Yoshino was often depicted by itself on a pair of screens, as were other famous places—like Higashiyama in Kyoto—noted for their cherry blossoms. It is difficult to determine why these two sites were placed together in this instance; perhaps their significance as major pilgrimage sites influenced the decision of the anonymous artist or the individual who commissioned the screens. The Yoshino region was an important center and training ground for the Shugendō order of

Esoteric Buddhism, founded by the legendary seventh-century hermit En no Gyōja. Its peripatetic monks, the *yamabushi*, traveled among the Yoshino mountains as part of an austerity ritual known as Ōmineiri or *mineiri* (literally, "entering Mount Ōmine"),[17] and Yoshino marked one of the traditional starting points for the *yamabushi*'s pilgrimage to the sacred mountain of Ōmine. The Shugendō sect itself became tied to the Shinto-Buddhist syncretic system known as *honji-sui-jaku*. Itsukushima was also a well-known pilgrimage destination and center for *honji-suijaku* practices.

It is also likely, as a recent study has noted, that these two scenic locations were paired with an eye to the visual contrast between the rolling hills and mountains of Yoshino and the seacoast view offered by Itsuku-shima.[18] Most sixteenth- and seventeenth-century screens depicting famous places, shrines, or temples feature panoramic bird's-eye views with much attention devoted to topographical details, the layout of architectural structures, and their accurate placement within the landscape. The popularity of screen paintings of this type may have resulted in part from the publication of so-called *meisho-ki*, illustrated guidebooks and travelogues, along with the increasing interest in recording everyday customs or colorful festivals against the backdrop of familiar scenic settings. This pair of screens was probably created during the first half of the seventeenth century, as it bears a number of affinities to other works more or less firmly dated to that time. Costumes of the revelers, pilgrims, and townsfolk are commensurate with the early 1600s. The similarity of the dance scene in the Yoshino screen to depictions of dance in the Kobe Municipal Museum screen and the screen in the Suntory Museum has been noted above; the former is dated, on the basis of style, to the Keichō era (1596–1615).[19] Recent scholarship has also cited similarities to costumes and dance poses found in a pair of cherry-blossom-viewing and falconry screens attributed to Unkoku Togan (1547–1618), presently in the collection of the MOA Museum in Atami.[20] The six-sided, tiered lacquer boxes displayed by picnickers in the Yoshino screen also resemble the gold-on-red Ryūkyū lacquerwares admired in Japanese *daimyō* circles in the early years of the Edo period.[21]

The unknown artist of these *byōbu* may have been a *machi-eshi* (town-based painter with no formal affilia-

tion to any particular school). Bright colors, many of which have faded over time, and lavish use of gold are the most noticeable characteristics of both screens; the wave patterns in the Itsukushima screen are highly schematized and decorative, in the manner of lacquer decoration or textile design. However, the linear ink brushwork on the rocks and bolders of the same screen indicate that the artist (or artists) had some experience with the methods of ink-painting practiced by the Kano school.

These Burke Collection screens offer a tantalizing glimpse into the festive springtime activities of nearly all classes of early Edo-period society. For all the joyous celebration and lively hordes of people filling both landscapes, one may imagine how the haughty, sheltered aristocrats of earlier classical times—who originated the practice of cherry-blossom viewing—would have disdained to participate in events such as these. Their sentiments might have been much like those expressed by the fourteenth-century Buddhist priest and courtier-poet Yoshida Kenkō (1283–1350), who addressed the issue of flower-viewing parties thus:

> Are we to look at the . . . cherry blossoms with our eyes alone? . . .
>
> The man of breeding never appears to abandon himself completely to his pleasures; even his manner of enjoyment is detached. It is the rustic boors who take all their pleasures grossly. They squirm their way through the crowd to get under the trees; they stare at the blossoms with eyes for nothing else; they drink saké and compose linked verse; and finally they heartlessly break off great branches and cart them away. When they see a spring they dip their hands and feet to cool them; if it is the snow, they jump down to leave their footprints. No matter what the sight, they are never content merely with looking at it.[22]

SW

NOTES

1. Earl Miner, Hiroko Odagiri, and Robert E. Morrell, *The Princeton Companion to Classical Japanese Literature* (Princeton: Princeton University Press, 1985), 223.
2. See Kaori Chino, "Meisho-e no Seiritsu to Tenkai" (The Evolution and Development of Famous-Place Pictures), *Keibutsuga*,

Meisho Keibutsu, Nihon Byōbu-e Shusei (Selected Japanese Screen Paintings), no. 10 (Tokyo: Kodansha, 1977), 115-21.

3. See Yoshiaki Shimizu, "Seasons and Places in Yamato Landscape Painting," *Ars Orientalis*, no. 12 (1981): 1-14; also Kenji Toda, "Japanese Screen Paintings of the Ninth and Tenth Centuries," *Ars Orientalis*, no. 3 (1959): 153-65.

4. *Muromachi Jidai no Byōbu-e* (Screen Paintings of the Muromachi Period) (Tokyo: Tokyo National Museum and Asahi Shimbun, 1989), no. 40; also discussed in Miyeko Murase, *Masterpieces of Japanese Screen Painting: The American Collections* (New York: George Braziller, 1990), p. 72, and pls. on pp. 74-77.

5. Originally a temple of the syncretic Shugendō order of Esoteric Buddhism, now a Shinto shrine.

6. See *Odoru Sugata, Mau Katachi: Buyō-zu no Keifu Ten* (Dance Form, Circling Shapes: The Geneology of Images of the Dance) (Tokyo: The Suntory Museum, 1992), p. 69 and pls. 29 and 30.

7. During the early seventeenth century the umbrella functioned not only as a protection against the elements but as a "fashionable accessory among the common people." Julia Meech, "The Umbrella in Japanese Art," *Orientations*, vol. 24, no. 3 (March 1993): 45.

8. See James C. Y. Watt and Barbara Brennan Ford, *East Asian Lacquer: The Florence and Herbert Irving Collection* (New York: The Metropolitan Museum of Art, 1991), 334-35.

9. The paulownia was used as a symbol of shogunal status until 1611, when Ieyasu took the *mitsu-aoi* design as his personal crest. See Watt and Ford, *East Asian Lacquer*, 159.

10. Herbert Eugen Plutschow, "Japanese Travel Diaries of the Middle Ages" (Ph. D. diss., Columbia University, 1973), 100.

11. According to an eleventh-century document entitled *Reikeiden Nyōgo Uta-e awase* (The Poem-Picture Contest of Lady Reikeiden), *suhama* were also used as scoring boards in poem-picture competitions. See translation of the *Reikeiden* text in Joshua Scott Mostow, *"Uta-e" and Interrelations between Poetry and Painting in the Heian Era* (Ph. D. diss., University of Pennsylvania) (Ann Arbor: University Microfilms International, 1988), 75-80.

12. See Hidaka Kaori, *Shitsu Kazari no Shosō: Fūryū Tsukurimono kara Zashiki Kazari E* (Phases in the Development of Room Decoration from Fūryū Tsukurimono to Zashiki Kazari), Bijutsu Ronsō no. 6 (Tokyo: Tokyo University, 1990), 25-32.

13. See entry in *Kodansha Encyclopedia of Japan* (Tokyo: Kodansha, 1983), 3:357.

14. Mitsuo Inoue, *Space in Japanese Architecture*, trans. Hiroshi Watanabe (New York and Tokyo: Weatherhill, 1985), 89.

15. Murase, *Masterpieces of Japanese Screen Painting*, 128.

16. These works are currently in a private collection.

17. Plutschow, "Japanese Travel Diaries," 121-22.

18. Murase, *Masterpieces of Japanese Screen Painting*, 128.

19. *Odoru Sugata*, 69.

20. Murase, *Masterpieces of Japanese Screen Painting*, 129.

21. See Watt and Ford, *East Asian Lacquer*, 334-35.

22. Donald Keene, trans., *Essays in Idleness: The "Tsurezuregusa" of Kenkō* (New York: Columbia University Press, 1967), 118.

51.

Mountains and River in Autumn

Edo period, first half of the seventeenth century
Pair of six-fold screens; ink, color, and gold on gilded paper
H. 172.7 x W. 381 cm (50¼ x 150 inches) each
PUBLISHED: Gunhild Avitabile, ed., *Die Kunst des alten Japan: Meisterwerke aus der Mary and Jackson Burke Collection*, New York (Frankfurt: Kulturgesellschaft Frankfurt mbH, 1990), no. 51.

Of the four seasons, autumn and spring have long been regarded in Japan as the most moving and the most beautiful. Among poets, autumn was the favored time of year; in poetic anthologies like the early tenth-century *Kokinshū*, autumn verses often outnumber those dedicated to spring, summer, or winter. Their frequent metaphorical allusions to the evanescence of beauty and the briefness of human existence contribute to the aura of gentle melancholy associated with a season of falling leaves and changing hues of nature. As Yoshida

Kenkō (ca. 1283-1352) remarked in the *Tsurezuregusa* (*Essays in Idleness*), his book of personal reflections and anecdotes, "People seem to agree that autumn is the best season to appreciate the beauty of things."[1] Autumn foliage, frequently associated with particular scenic locations, or *meisho*, was a theme utilized by artists in various media. The famous *waka* poem written by Ariwara no Narihira (825-880) about crimson leaves floating on the *Tatsutagawa* (Tatsuta River) was allegedly composed about a screen depiction of the same subject,[2] and the image of autumn leaves—usually maple— drifting on a river current became a popular motif for lacquer, ceramic, and textile decoration as well as painting.

The autumn landscape in this stunning pair of screens recalls the scenery associated with the Tatsuta

River poem. In the left and right sectors of the continuous composition low, rolling hills and mountain slopes materialize out of a hazy curtain of gold mist. The folds and crevices of the mountains to the right are lined with red-gold autumn maples; those on the left are crowned with pines and the spire of a temple pagoda. A river, which begins as a series of waterfalls in the mountains on the right, wends its way across a valley at the bottom of the picture plane and into the left screen, where it vanishes in the mist. Both screens are brilliant with color which, although sensitively applied, is rich and vibrant. The edges of clouds are dusted with flaked and powdered gold, washes of green brighten the hills, and autumn leaves are carefully delineated in red and gold with delicate accents in fine lines of gold ink. The expanse of relatively empty space in the center of the composition, broken here and there by a rounded hillock and maple branches, creates a sense of depth in spite of the flat backdrop of gold leaf that would seem to belie any recession into distant ground. In both screens, rooftops of humble country dwellings are visible above the gold mist; these roofs and the surrounding trees and foliage are rendered in ink monochrome that contrasts with the bright colors dominating the scene. In the lower central area of the right screen a narrative element is introduced by the presence of two figures. One, leading a heavily laden packhorse, is crossing a rustic bridge built over the racing river; he appears to be a woodcutter or charcoal burner, and both the parcel slung over his back and the worn basket (filled with what may be charcoal) carried by the horse are adorned with sprigs of maple. The second man balances a pole over his shoulder, at each end of which a potted dwarf tree is suspended. Both men are poorly dressed and have the air of figures lifted from genre paintings of activities in the lives of the common people. Below the bridge, the river is churned into white-crested wavelets by the waterfall, and branches of crimson and gold leaves drift along the current.

Although the presence of maple leaves on the water seems to allude to the *Tatsutagawa* theme, it is not certain whether the screen painting is actually meant to depict the Tatsuta region. Celebrated for its springtime cherry blossoms in the days of the *Manyōshū*, the Japanese poetry anthology compiled in the late 700s,[3] the area along the river was singled out for the beauty of its autumn foliage by the following century and thereafter remained the subject of much literary attention. However, the river in this pair of screens is not the focal point of the composition, and other mountainous sites close to the old capital city of Kyoto became famous subjects of paintings because of their autumn colors. Perhaps one of the best-known autumn landscape screens of the sixteenth century, the *Kampū-zu Byōbu* (Screen of Maple Leaf Viewing) by Kano Hideyori (flourished ca. 1540) in the Tokyo National Museum, also depicts a river with scattered crimson leaves, surrounded by hills and brightly colored maples (with snow-covered winter mountains at the far left). A strong genre element is provided by the presence of various "commoners" and townsfolk enjoying an autumn outing. The setting for this lively scene is Mount Takao, to the northwest of the capital, perhaps best known as the location of the temples of Kōzanji and Jingoji. Although not as popular a subject for autumn poems as the Tatsuta River, it was apparently one of the most well-known places for maple-viewing among Kyoto townspeople by at least the late Muromachi period.

It is difficult to determine the site featured in the Burke screens—if indeed they are intended to represent an actual location—and the narrative, or genre, elements do not provide any clues to the matter. There are no known references in *Tatsutagawa* poems to figures like the ones depicted on the right screen, and the nature of the burdens they bear does not appear to have any relation to maple-viewing. Likewise, the charcoal in the basket on the horse's back has no apparent connection to the *bonsai* (dwarf trees) carried by the second man. Finally, *bonsai*—trained, miniature trees whose cultivation was introduced to Japan from China during the Kamakura period—were highly regarded objects more likely to be found in an upper-class home than in the possession of a humble peasant.

The identity of the figures, like that of the location, cannot be ascertained, but it is possible that this mysterious scene-within-a-scene is a parody of an historical legend about a young lord, an impoverished, dispossessed samurai, and the samurai's prized bonsai trees. According to the tale, a lord, referred to in certain versions as "the regent Tokiyori"[4] (the fifth shogunal regent, Hōjō Tokiyori, 1227-1263) disguises himself as a

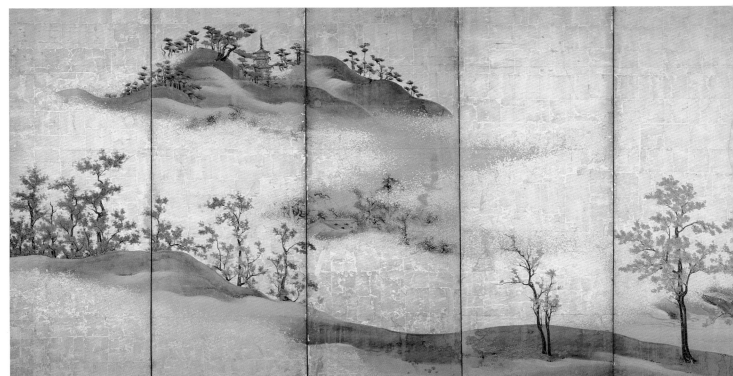

Chg Autumn
Temple in distance
Rustic Hut - [?]
[?] - Bl & white
Hut - [?] Jap
taste

wandering priest in order to mingle with his subjects and root out any injustices done to them. In the course of his travels he encounters a samurai and his wife living in dire poverty because they have been wrongfully stripped of their estates. The supposed priest spends a night with the couple and the samurai burns his three treasured bonsai, his only remaining possessions of worth, in order to warm the house for his guest. Later, the lord issues a summons to all of the samurai in the land, and when his former host arrives, he restores to him his stolen home and lands. This story, in which bonsai[5] are sacrificed for firewood, could conceivably have supplied the theme for a pastiche to be included in a landscape scene. It was the source for a Noh play of the Kanze school, *Hachi no Ki* (Dwarf Trees),[6] and later inspired woodcut-print parodies by the *ukiyo-e* artist Suzuki Harunobu (1724-1770).[7]

It is also difficult to assign any particular studio or school of painters to the autumn screens. Visual evidence indicates that the artist who produced this work was familiar with Chinese-inspired ink-painting

techniques as well as the native tradition of *yamato-e* polychrome painting. Most screen painters of the sixteenth and seventeenth centuries combined elements of ink painting with the use of gold leaf, gold pigment, and strong, rich colors. Some Kano painters and other late sixteenth to early seventeenth-century artists like Kaihō Yushō (1533–1615) executed a number of screens in this mode. Even highly individualistic, eclectic painters like Iwasa Matabei (1578–1658) often introduced motifs rendered in ink into scenes dominated by colors and gold. One set of narrative handscrolls by Matabei, entitled *Yamanaka Tokiwa Emaki* (*The Illustrated Story of Lady Tokiwa at Yamanaka*), contains passages of landscape in color in which the thatched roofs of country farmhouses, rendered primarily in ink, emerge from the mist surrounded by treetops in a manner reminiscent of the autumn screen's ink motifs.[8] However, the two peasants in the Burke screens are somewhat different from the heavy-jowled characters associated with Matabei's figure-painting style, and are perhaps closer in feeling to figures from Kano-school *byōbu* and other

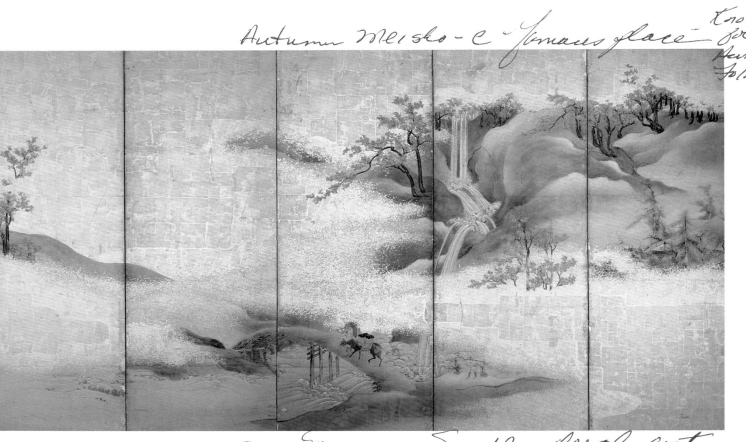

works. Whatever the background of the artist who painted the autumn screens, it is likely that his training was similar to that of the major masters noted above. At the same time, the refined, subtle quality found in the treatment of the landscape is evidence of a sensitive hand and an awareness that dramatic impact is not necessarily dependent on the strong outlines and large-scale pictorial elements that were general conventions of screen painting in the late sixteenth and early seventeenth centuries. sw

NOTES

1. Donald Keene, trans., *Essays in Idleness: The "Tsurezuregusa" of Kenkō* (New York: Columbia University Press, 1967), 18-19.
2. Translated in Helen Craig McCullough, *Kokin Wakashū* (Stanford: Stanford University Press, 1985), 72.
3. See the *Manyōshū* poem no. 660-1 by Takahashi Mushimaro (flourished early eighth century). Nippon Gakujutsu Shinkōkai, trans., *The Manyōshū: One Thousand Poems* (New York: Columbia University Press, 1965), 219.
4. Joanne P. Algarin, *Japanese Folk Literature: A Core Collection and Reference Guide* (New York and London: R. R. Bowker Company, 1982), 127.
5. In one version, the dwarf trees are pines; in another, a plum, a pine, and a cherry. Algarin, *Japanese Folk Literature*, 72, 127.
6. See catalogue entry no. 51 by Miyeko Murase, in Gunhild Avitabile, ed., *Die Kunst des Alten Japan: Meisterwerke aus der Mary and Jackson Burke Collection, New York* (Frankfurt: Kulturgesellschaft Frankfurt mbH, 1990), 92-93.
7. One print, known as *Courtesan with Bonsai in Snow*, was produced in the late 1760s. It depicts a young courtesan, cleaver in hand, standing before three potted dwarf trees. Reproduced in Richard Lane, *Images from the Floating World: The Japanese Print* (New York: G. P. Putnam's Sons, 1978), 106.
8. These elements are present in a passage, from Scroll III of the twelve-scroll set, depicting Lady Tokiwa and her female attendant making their way from Kyoto to Yamanaka (in Mino Province). See *Iwasa Matabei Emaki; "Yamanaka Tokiwa Emaki"; "Horie Monogatari Emaki"; "Joruri Monogatari Emaki"* (Illustrated Handscrolls of Iwasa Matabei) (Atami: MOA Museum, 1982), 22, 81.

52.

Scenes from the Noh Drama Takebun

Edo period, early seventeenth century
Pair of six-fold screens; ink, colors, and gold and silver leaf on paper
H. 156 x W. 362 cm (51³/₈ x 142³/₈ inches) each
PUBLISHED: *Nihon no Rekishi* (The History of Japan) (Tokyo: Asahi Shimbunsha, 1993), 5:22-23.

Noh, the earliest form of professional theater in Japan, developed from the dances and songs performed at temple and shrine festivals of the classical era. It initially flowered as an art form during the Nambokuchō and Muromachi periods, producing dramas that rank among the greatest literary achievements of Japan's feudal age. Many of these took their subject matter from courtly romances and turbulent war tales; in terms of format they combined acting, music, and dance to create a genre of theater characterized by carefully choreographed, stylized movement, an economy of presentation,[1] and the tendency to leave much to the imagination of the audience. During the Muromachi years, the principal patrons of Noh were *daimyō* and members of the shogunal circle (including the shogun himself), but by the late sixteenth and seventeenth centuries, much of the extant Noh repertoire had been codified and written down,[2] and devotees included not only the elite of warrior society but also wealthy merchants, tradesmen, and the old courtly aristocracy. Connoisseurs commissioned and collected handsomely produced volumes of Noh libretti (known as *utaibon*), and some themes from frequently performed plays became subjects for the painter's art (see also no. 46). This impressive pair of six-fold screens depicts a number of scenes from the Noh drama *Takebun*, a play of unknown authorship and date. These paintings are not only striking in their lively and episodic presentation

of dramatic action, but also unique in that they represent the only known illustrations of the *Takebun* story.

The plot of the play was derived from a minor incident recounted in Book Eighteen[3] of the monumental forty-book war tale known as the *Taiheiki* (literally, *Record of the Great Peace*), composed by a number of different authors and completed sometime around 1372.[4] The *Taiheiki* details the tumultuous events surrounding first the conflict between Emperor Go-Daigo (1288-1339) and the Kamakura *bakufu*, followed by the struggles of the contending Northern and Southern Courts, and the Ashikaga shogunate, which supported the Northern faction. The dramatis personae of the *Takebun* play are actually of little importance in this account of the bloody battles for supremacy that succeeded the end of aristocratic rule in Japan, but the single incident in which they figure involves kidnapping, suicide, supernatural powers, rescue, and the reunion of a pair of lovers—all the ingredients necessary for a moving stage drama.

In Noh, elaborate scenery and stage props are avoided, and the movements of the performers restrained and highly stylized; emotions are conveyed not by the face, which is often masked, but by the most minimal of gestures. The absence of realism is accentuated by the actors—all of them male—whose slow pace and ritualistic speech may strike the uninitiated as devoid of theatrical impact. In contrast, the scenes depicted on the *Takebun* screens are vibrant with action, expressive movement, and detail. The overall image is dominated by the sea, upon whose waves and coastline the events of the tale take place. The story begins at Amagasaki, near Osaka, in the far right of the right-hand screen. There, a rustic inn is under attack by a group of marauders, led by the pirate Matsuura. Staying in this inn are Takebun, a trusted retainer of Prince Takayoshi (d. 1337), and the beautiful young princess who is Takayoshi's consort.[5] A political casualty of the war of 1331, Takayoshi has been banished to Tosa, in a remote part of the island of Shikoku, and the princess—escorted by Takebun—has left the capital city, determined to join him in his place of exile.

Having become enamoured of the princess, Matsuura decides to kidnap her and take her to his home base in Tsukushi, northern Kyūshū, via the rough waters of the Naruto Straits. He attacks the inn, setting fire to its buildings. Takebun battles a host of Matsuura's cohorts, but recognizing the danger to the princess, leaves the inn and carries her on his back to the nearby seashore, where he places her in a boat. He goes back to the inn for their belongings and attendants, but when he returns to the beach he discovers that the boat bearing the princess out to sea actually belongs to Matsuura's brigands. In an effort to apprehend the kidnappers, he seizes a small skiff and sets out in pursuit. Realizing that he will not be able to overtake the pirate ship, he commits suicide in the hopes that his spirit will then accomplish what he could not.

In the screen, animated figures move and gesticulate; their faces are also expressive and characterized by a certain degree of individualization. Elements reminiscent of genre painting appear in the first three panels (counting from the right), where humble servants and their children flee from the burning inn. Foaming white-crested waves add to the atmosphere of fast-paced action; alone in his small skiff, Takebun, bare to the waist, waves his crimson fan defiantly at the pirate's boat. Golden clouds serve to separate one scene from the next, and the distant ground is also rendered in flat gold against which mountains outlined in ink are starkly silhouetted.

Events reach a fever pitch in the left-hand screen. Takebun's ghost has materialized in warrior guise, mounted on a richly caparisoned spirit-horse and flourishing the same crimson fan. He is accompanied through the turbulent waves by other supernatural figures, some clad in the garb of Shinto shrine attendants. Takebun calls upon the dragon king of the sea to stir up the already heaving waters, and on Matsuura's boat, where a banquet has been taking place, the pirates become violently seasick. They begin hurling valuables—including the princess's scarlet robe—into the waves in hopes of calming the storm. They consider throwing the princess overboard as well, but one of their number, a priest, identifiable by his shaven head and cleric's robe, stops them. Matsuura puts the lady and an oarsman into a small boat, which is set adrift, but they manage to make their way to the island of Awajishima where they are rescued and taken in by the inhabitants of the poor fishing village. In the meantime, Prince Takayoshi has heard of a lady's garment that was found in the sea, and believes that his love has

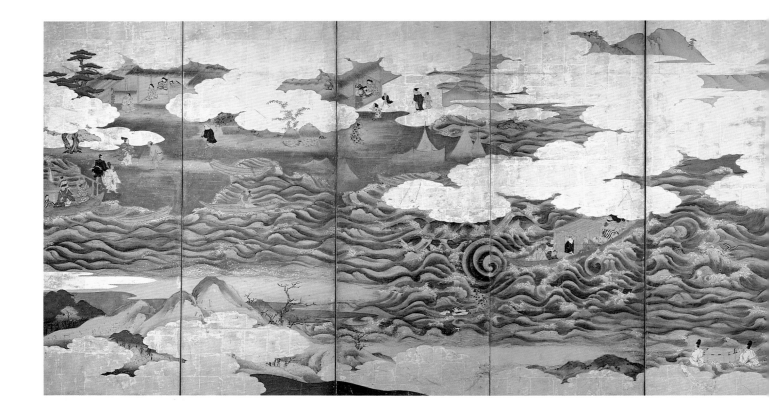

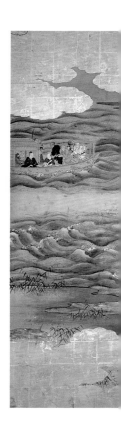

been drowned. When he finally discovers that she is
alive and safe, he sends for her, and the two are happily
reunited.

These dramatic events are vividly depicted in the
left-hand screen. Matsuura's boat is tossed by foaming
waves with claw-shaped crests, and the unhappy,
grimacing countenances of the seasick crew, some of
whom are doubled over with discomfort, add an almost
comic element to the scene. Several pieces of armor
and the princess's outer robe represent the objects
tossed into the sea to appease the dragon king. The
dragon himself is not visible, but is symbolized by the
spiraling whirlpool near the prow of the boat; this
motif is undoubtedly derived from the whirlpools or
vaporous whirlwinds that traditionally accompanied
dragon images in ink paintings from the Muromachi
period on.[6] The fearsome storm in the lower right por-
tion of the composition is offset by the tranquility of
the scenes in the upper left, where the princess is being
cared for by kindly villagers. At the far left, envoys of
the prince have arrived by boat and prepare to take the
princess to rejoin her lover.

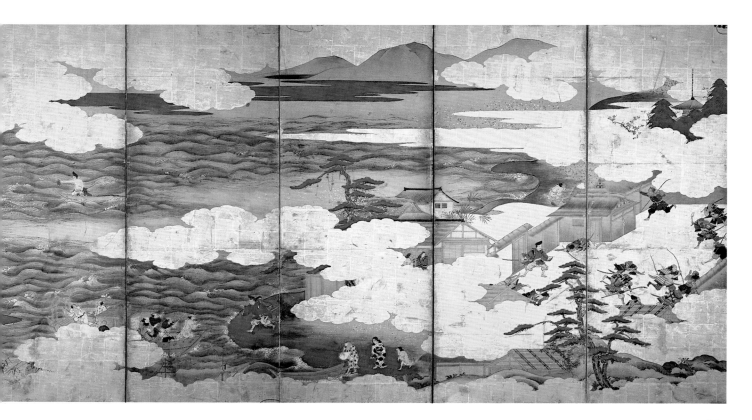

Element of Yamatoe

① Continuous Narrative
② Ly Screen Format
③ Decorated
④ Based on Class L. t
⑤ Sumptuous Jewel-like Colors

In addition to a highly dramatic composition, the *Takebun* screens exhibit a number of interesting stylistic features. Although color is often thickly applied, it is evident that the artist had considerable training in ink-painting technique. Figures—particularly those of the less high-ranking characters—are delineated with supple and fluctuating ink brushstrokes; on garments and draperies these frequently close with the angled hook or "nail-head" shape derived from Chinese brushwork. In the landscape elements near the bottom of the paintings, ink-wash is used to model the rocks and mountains, softening the effect of their sharp ink outlines. Of particular interest are the motifs of fishing nets stretched over poles to dry, visible in the center of the left screen, and another net half-concealed by reeds in the lower left segment of the right screen. These are strongly reminiscent of the famous *Drying Fishnets* screens executed by Kaihō Yūshō (1535–1615; see also no. 21) in the collection of the Imperial Household.[7] In Yūshō's work, the triangular shapes of fishing nets raised on tall, narrow poles are set against a flat

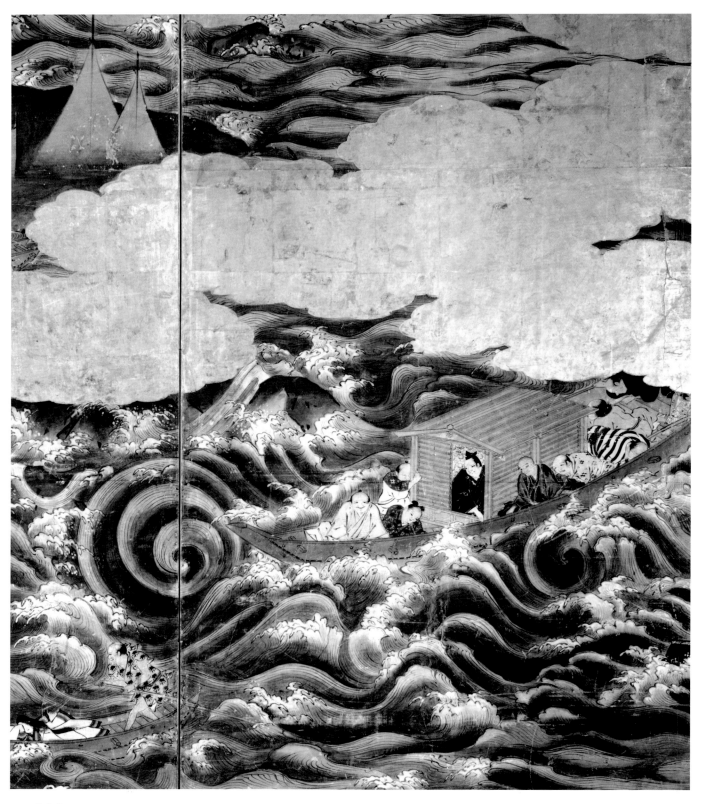

Detail, left screen

gold ground; above, spidery reeds create a pattern against the golden shoreline and an expanse of dark blue water. The motifs in the *Takebun* screens may or may not be a deliberate reference to Yūshō's painting—their presence is certainly in keeping with the fishing-village setting—but the resemblance is unmistakable. It is conceivable that the *Takebun* artist was a member of the Kaihō studio, led after Yūshō's death by his son Yūsetsu (1598–1677; see also cat. no. 22); whatever his affiliation, he was working with a type of subject matter that seems to have appealed to Kaihō painters. According to an Edo-period art-historical text, the *Honchō Gasan* of Tani Bunchō (1763–1840), Yūsetsu himself produced a thirty-scroll *emaki* of the *Taiheiki*, a claim upheld by other art-historical writings of a later date.[8] An unsigned set of three early seventeenth-century handscrolls illustrating a tale from which two Noh plays—*Hanjo* and *Sumidagawa*[9]—were derived, has also been linked to the Kaihō school;[10] this work, entitled *Umewaka-maru Emaki* (*The Illustrated Tale of Umewaka-maru*), depicts the succession of events in a lively and literal manner not far removed from that which appears in the *Takebun* screens.

The actual Noh play of *Takebun* has a number of variant texts[11] and consists of seventeen scenes, most of which are represented in the Burke screens. The drama begins with Takebun and the princess en route to Amagasaki and concludes with the vengeance that Takebun's wrathful ghost wreaks upon Matsuura. Little is known of the play's early history, as most documentation of performances dates to the Edo period.[12] A recently discovered early reference to *Takebun* occurs in the record of a banquet held in Kii (in central Honshū) in 1592, at which numerous Noh plays were staged for the entertainment of the guests.[13] Although the play's date of composition cannot be determined, its somewhat simple and unpolished quality suggests that it was not the work of a major playwright.[14]

The play follows events in the *Taiheiki* episode closely, although it embellishes the story with details and dramatic impact absent from the original. Both works take some poetic license with the facts of Prince Takayoshi's career: the *Taiheiki* notes that when the prince was made to committed *seppuku* (ritual suicide) in 1337, his consort died forty-nine days later; yet in actuality, the lady passed away prior to Takayoshi's exile

to Tosa. It has been theorized that the fiction was devised to pacify the soul of the dead prince;[15] certainly it gives a sense of poignancy to the story of his final days. In any event, *Takebun* was not the only literary work to draw upon the story of Takayoshi and his lady; during the feudal era the tale also spawned a romantic novel entitled *Chūshoō Monogatari* and a *kōwaka*, or dramatic ballad-and-dance piece, called *Shinkyoku*.[16]

The Burke screens may be the only known examples of painting to illustrate the *Takebun* story, but it is interesting to note that paintings of the *Taiheiki* itself are not common.[17] Of the few extant illustrated versions of the tale, none contains an image of the character of Takebun, and only one work exhibits any pictorial reference to the story of Prince Takayoshi and his consort. This piece, a set of two handscrolls dating to the late Edo period (now in the collection of the Tokyo National Museum), is clearly a copy of an earlier work; although the images are quite detailed, they are executed solely in ink, with sketchy dots applied to indicate the outlines of gold clouds, and notations, written in syllabic *katakana* characters, to indicate the colors that were used in the original. Short sections of text accompany the illustrations.[18] A single scene at the beginning of the first handscroll depicts the prince and his love prior to the events that take place in *Takebun*. According to the *Taiheiki*, Takeyoshi, not having been named to the position of crown prince, spent much of his time in gentlemanly pursuits; while participating in an *eawase*, or picture contest, he saw an illustration of the *Genji Monogatari* (*Tale of Genji*; see nos. 36, 37, 38, and 69) featuring a beautiful woman playing a koto. Some time later, while traveling to a shrine, he heard the sounds of the lutelike *biwa*, and found that the player, a sixteen-year-old girl, was the very image of the lady in the painting. In the ink illustration the prince is shown in his carriage, attended by a small entourage, approaching the building where the young girl sits near a veranda, playing the *biwa* and looking out over the garden.[19]

The *Takebun* screens are also fascinating in light of the interest that artists began to show in the *Taiheiki* around the middle of the seventeenth century,[20] when printed versions of the lengthy narrative, complete with illustrations, began to appear.[21] Their creation may also have to do with the rise in popularity of illustrated

versions of stories from the Noh theater, some of which were based on actual performances,[22] while others, like the *Umewaka-maru Emaki* mentioned above, took themes from a Noh play, or plays, and elaborated on them in both text and image. s w

NOTES

1. Shuichi Kato, *A History of Japanese Literature: The First Thousand Years*, trans. David Chibbett with foreword by Ronald Dore (Tokyo, New York, and San Francisco: Kodansha International, 1979), 309.

2. Ibid., 303.

3. See *Taiheiki* (Record of the Great Peace), vol. 2 of *Nihon Koten Bungaku Taikei* (Compendium of Japanese Classical Literature), no. 35 (Tokyo: Iwanami Shoten, 1961-1988), 247-50.

4. Earl Miner, Hiroko Odagiri, and Robert Morrell, *The Princeton Companion of Classical Japanese Literature* (Princeton: Princeton University Press, 1985), 243-44.

5. For a more detailed discussion of the *Takebun* story, see Matsuoka Shimpei, "Sakuhin Kenkyū: *Takebun*" (A Study of "Takebun"), in Kokuritsu Nōgakudō Chōsa Yōsei-ka, ed., *Kokuritsu Nōgakudō Jōen Shiryōshu 1, "Takebun"* (Collected Data on Performances at the National Noh Theater) (Tokyo: Kokuritsu Gekijō, 1987), 6-9. The author wishes to thank Hiroshi Onishi, Research Curator of Japanese Art at the Metropolitan Museum of Art, and his wife, Shoko Onishi, independent scholar of Japanese art, for sharing their insights into the *Takebun* screens and providing source materials for research. Thanks are also due to Miyeko Murase for assistance with translations.

6. For a Muromachi-period example of a dragon with spiraling mist or cloud, see the *Dragon and Tiger* screens by Sesson Shūkei (1504-after 1589), most recently reproduced in Miyeko Murase, *Masterpieces of Japanese Screen Painting: The American Collections* (New York: George Braziller, 1990), 209-14. For a late Momoyama-early Edo-period rendition, see the pair of *Dragon and Tigers* screens by Kano Sanraku (1559-1635) in Myōshinji temple in Kyoto, most recently published in Kawamoto Keiko, *Yūshō, Sanraku* (Yūshō and Sanraku), Meihō Nihon no Bijutsu no. 21 (Tokyo: Shogakukan, 1991), pl. 44-45; discussed, pp. 110-11.

7. Most recently published in Kawamoto, *Yūshō, Sanraku*, pl. 24, discussed pp. 65-66.

8. See Miyeko Murase, "The *Taiheiki Emaki*: The Use of the Past," *Artibus Asiae* 53, no. 1-2 (1993): 266-79.

9. The play *Hanjo* (Lady Han), by the great Noh playwright Zeami (1363-1443), focuses on a young woman driven to near-madness by her passion for her absent lover. *Sumidagawa*, written by Jūrō Motomasa (ca. 1394-1459), deals with the same woman's search for her missing child.

10. See Miyeko Murase, *Tales of Japan: Scrolls and Prints from The New York Public Library* (New York and Oxford: Oxford University Press, 1986), 153-56.

11. Matsuoka, "Sakuhin Kenkyū: *Takebun*," 3.

12. See ibid., 9-11.

13. Ibid., 11-12.

14. Yokomichi Maruyo, "*Takebun* no Enshutsu" (Productions of the Play *Takebun*) in Kokuritsu Nōgakudō Chōsa Yōsei-ka, ed., *Kokuritsu Nōgakudō Jōen Shiryōshu 1, "Takebun"* (Collected Data on Performances at the National Noh Theater) (Tokyo: Kokuritsu Gekijō, 1987), 6-9, 33.

15. Matsuoka, "Sakuhin Kenkyū: *Takebun*," 8.

16. Ibid., 9.

17. For a discussion of extant *Taiheiki* paintings and illustrations, see Murase, "The *Taiheiki Emaki*: The Use of the Past."

18. Miya Tsugio and Satō Kazuhiko, eds., *Taiheiki Emaki* (Illustrated Handscrolls of the *Taiheiki*) (Tokyo: Kawaide Shobō Shinsha, 1992). The ink illustrations are reproduced throughout the book, interspersed with paintings from other *Taiheiki* emaki.

19. Ibid., 89-90.

20. Murase, "The *Taiheiki Emaki*: The Use of the Past," 14.

21. Printed scenes from one such example are reproduced in Miya and Satō, *Taiheiki Emaki*, 184-203. The earliest version of a printed *Taiheiki* with illustrations is believed to date to the years between the Kan'ei (1624-1664) and Kambun (1661-1673) eras. Ibid., 5.

22. One such example is a handscroll version of the *Sumidagawa no Sōshi*, or *Tale of Sumidagawa*, dated to 1618. See Murase, *Tales of Japan*, 150-52.

Heian — yamato-e
zen — ink ptg

204

53.

Puppies in Snow

Edo period
Nagasawa Rosetsu (1754–1799)
Originally a set of four sliding panels, now hinged together as a pair of two-fold screens; ink and light color on paper
H. 93 x W. 170.5 cm (36½ x 67 inches) each
SEALS: "Ro," "Setsu," "Gyo"
FORMER COLL.: C. D. Carter
PUBLISHED: Mayuyama & Co., Ltd., *Ryūsen Shūhō* (Mayuyama, Seventy Years) (Tokyo: Mayuyama & Co., Ltd., 1976), vol. 2, no. 464; Nakamura Tanio, "Nagasawa Rosetsu hitsu Yūku Zu Fusuma-e" (Fusuma—Sliding Doors with Puppies by Nagasawa Rosetsu), *Kobijutsu* 18 (July 1967): 91.

Nine puppies romp by a frozen creek, which is bare except for a few hardy bamboos and a cluster of nandin whose red berries, the only bright spots in the painting, signal that the ground is covered with snow. Two puppies rush from the right to join the rest in the center area, where the curiosity of some in the group is aroused. One of their number, an adventurous sort, has strayed away and seems to be on an investigative tour at the far left. Remarkably facile brushstrokes in light ink define the shapes of the little creatures, and their "conversation" is almost audible. Such anthropomorphic depiction of canines reminds us of the well-known painting of the late twelfth century that depicts frolicking animals, the *Chōjū Giga* in the Kōzanji Collection.[1]

Nagasawa Rosetsu, the artist of this delightful painting, was born the son of a low-ranking *bushi* (warrior) in Hyōgo prefecture, but he is said to have been adopted by the Nagasawa family, from the suburbs of Kyoto. Sometime before 1778 he was living in Kyoto proper, studying with Maruyama Ōkyo (1733–1795), an extremely successful artist and leading realist painter of his era. Following in the footsteps of Ōkyo's style, especially the detailed, naturalistic depiction of reality, Rosetsu established a reputation as a popular painter. By the age of twenty-nine he was included among the important painters of the day listed in the *Heian Jimbutsu Shi* (*Biographies of Kyoto People*), the "Who's Who" of Kyoto notables published in 1782. Although enormously gifted, Rosetsu seems to have had a rebellious personality, and he is often said to have been expelled from Ōkyo's studio in his early career. Yet evidence suggests that his association with his teacher, who apparently regarded him as a talented artist, seems to have lasted most of his life. As late as 1790, Ōkyo sent Rosetsu as his substitute to complete assignments granted him in the provinces and collaborated with him on important projects. Most of Rosetsu's major works remain in the provinces where he was sent to complete such commissions.

Imaginative and creative, but often abrasive, Rosetsu died at the age of forty-six. His sudden and premature demise is sometimes attributed to suicide and sometimes to murder by poison at the hands of a jealous rival.

Because the number of dated paintings by Rosetsu is small, it is difficult to determine exactly when the artist developed his so-called eccentric, often turbulent style. It veers far away from the mild, respectable, and well-adjusted approach of Ōkyo. Rosetsu's individualism may have been encouraged by his association and friendship with a number of Zen Buddhist monks at the temples of Myōshinji and Tōfukuji in Kyoto.[2] In any event, his painting style underwent a profound transformation in about 1787, as is suggested by a number of large screen paintings that he executed at Buddhist temples in the Kii area (modern Wakayama prefecture, south of Kyoto), where he stayed for two years from 1786 to 1787.[3] These works represent Rosetsu's art at its mature stage: powerful and free in expression.

Although dated paintings are few, a study of stylistic changes in the calligraphy of his signature may help

to establish a general chronological framework for his oeuvre. His signature before about 1790 is written in careful *kaisho* (standard script) with sharp, thin strokes. After that time, the tight, text-book mode of calligraphy began to loosen, gradually evolving into a bolder, more individualistic script. Paintings assigned to the last several years of his life, when he was in his forties, are signed in a true cursive *sōsho*, or "grass style" hand.

These sliding panels, which are now hinged together to form a pair of two-paneled screens, originally were the reverse side of panels that depicted seven puppies in a bamboo grove. Obviously meant as a humorous reference to the ancient theme of the "Seven Sages of the Bamboo Grove," these screens are now in the collection of the Brooklyn Museum, New York.[4] One of the Brooklyn screens is signed and impressed with the seal "Gyo." The calligraphic style of his signature in *kaisho*,

but written with slightly loosening strokes, may be dated to Rosetsu's late thirties, that is, the early 1790s. The same "Gyo" seal is impressed on the right panel of the Burke set, but it is damaged and missing a large portion from its upper right area. This damage is believed to have been caused sometime between May of 1792 and the winter of 1794. It may mean, then, that these sets of screens were made precisely during that short period when this seal suffered the damage.

The screens, which are divided between the Brooklyn Museum and the Burke Collection, may have been executed by Rosetsu to fulfill one of the many commissions given to his teacher. Paintings of puppies by Ōkyo were apparently in great demand, judging from the large number of extant works showing them cavorting happily on large and small screens. Rosetsu's sliding panels, included here, were modeled after Ōkyo's popular formula, with a notable exception of the decidedly anthropomorphic nuance given to the puppies' gazes.

NOTES

1. Komatsu Shigemi, ed., *Nihon Emaki Taisei* (Compendium of Japanese Emaki) (Tokyo: Chūōkōronsha, 1977), vol. 6.
2. Yamakawa Takeshi et al., "Nagasawa Rosetsu to sono Nanki ni okeru Sakuhin" (The Special Number for the Studies of the Works of Nagasawa Rosetsu Remaining in the Kishū Province) *Kokka* 860 (November 1963): 59, 63.
3. Ibid.
4. Robert Moes, *A Flower for Every Season: Japanese Paintings from the C. D. Carter Collection* (New York: The Brooklyn Museum, 1976), no. 21.

54.

Ibaraki

Meiji period, 1881
Shibata Zeshin (1807–1891)
Pair of two-fold screens; ink, color, and gold on paper
H. 168.6 x W. 166 cm (66¼ x 65¼ inches) each
SIGNATURE: "Nanajūgo-ō Zeshin" (on the right screen)
　　　　　　 "Zeshin" (on the left screen)
SEAL: "Tairyūkyo" on both screens
FORMER COLL.: Roger and Kathleen Weston, Chicago
PUBLISHED: Miyeko Murase, *Masterpieces of Japanese Screen Painting: The American Collections* (New York: George Braziller, 1990), no. 33; Gōke Tadaomi, ed., *Shibata Zeshin Meihinshū* (Collection of Masterpieces by Shibata Zeshin) (Tokyo: Gakken, 1981), vol. 1, nos. 209 and 210; and Gōke Tadaomi, *Shibata Zeshin*, Nihon no Bijutsu no. 93 (Tokyo: Shibundō, 1974), fig. 78.

Zeshin is one of the few artists of Japan who became known in the West during his lifetime.[1] Today his works, particularly his lacquerware and the so-called *urushi-e* (lacquer painting), are admired throughout the world. Zeshin continued to work both as a painter and a lacquerer throughout his life, and one example of his lacquer work is included here (no. 73).

Zeshin was born in the downtown section of Edo to a family of small shop owners. His father, who was married to a former geisha, also doubled as a carver and studied *ukiyo-e* painting with Katsukawa Shunshō (no. 47). At age 11, in 1817, young Zeshin began an apprenticeship with Koma Kan'ya (Kansai II, 1767–1835),

a leading lacquer artist of his time. Zeshin began a serious study of painting in 1822 under Suzuki Nanrei (1795–1844), an artist of the Shijō school; and a few years later he traveled to Kyoto to improve his painting skill under Okamoto Toyohiko (1773–1845), a prominent pupil of Matsumura Goshun (no. 32). Zeshin's later reputation as an outstanding Shijō-school artist had its genesis in this four-year Kyoto sojourn.

Although he was already a successful artist in his teens, Zeshin's reputation somersaulted in 1840, when he was commissioned by an association of sugar wholesalers to paint an *ema*, a votive tablet to be dedicated to the Ōji Inari Shinto shrine in Edo. Zeshin, perhaps

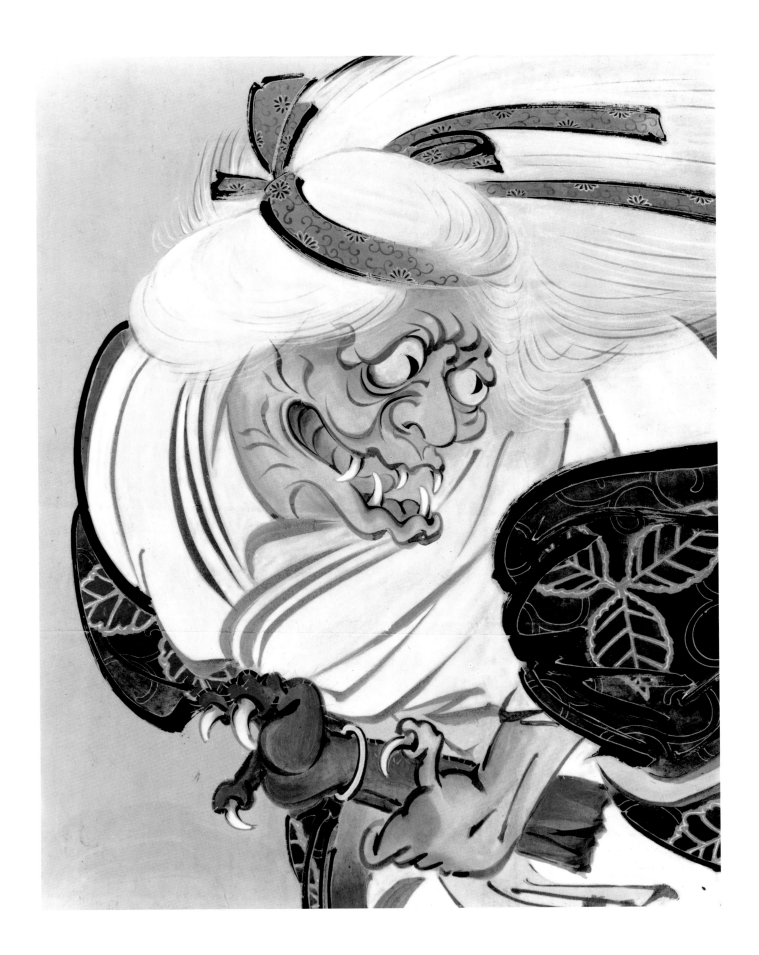

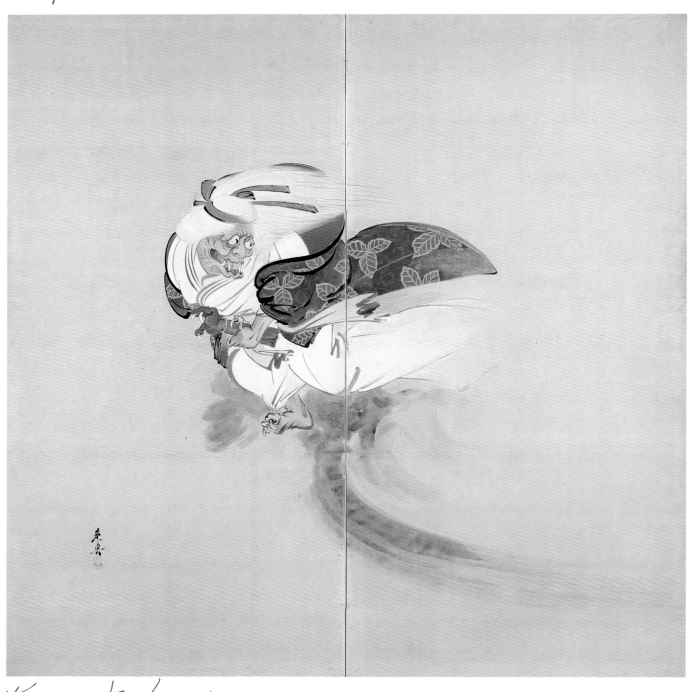

Known for lacquer
We have this artist
Based on Noh Play
Demon - Gate Kyoto. Steal. Murder
 Warrior sent to quell
 Cut off arm - Told back to
 house. Box told arm
Old aunt visit - Show Trophy
 Snatched flash - Demon disguised
Dramatic moment

Exact - Precise

at the suggestion of his sponsors, painted a startling image of a ghostly demon named Ibaraki, nearly identical to the figure depicted on the present screen.[2] The image is drawn from a well-known legend involving the exploits of a historical figure, a warrior named Watanabe no Tsuna (953-1024). According to legend, the Rashōmon Gate that once marked the southern entrance to the old capital of Kyoto was inhabited by a demon, who assaulted innocent passersby and hapless domestic animals. Tsuna was charged by his master, Minamoto no Raikō, with the task of slaying this evil creature; however, he was only able to cut off its hairy, claw-handed arm. Vowing that he would return to claim the stolen member, the demon escaped. Tsuna presented this arm to his master, who, in order to safeguard it, decided to lock it in a casket and recite Buddhist sutras for seven days. On the sixth day, Raikō's aunt came to visit him and begged to see the arm. Against his better judgment, Raikō complied. The aunt, who was actually the demon in disguise, seized the arm and flew away. The story became widely known through a popular Noh play, *Rashōmon*, which was based on episodes included in such works of classical literature as the *Taiheiki* (records of fourteenth-century political and military conflicts).[3]

More than thirty years after Zeshin's creation of the *ema*, Kikugorō, a leading Kabuki actor, was deeply impressed by the image and commissioned the playwright Mokuami to devise a script for the Kabuki stage based on this theme. The play, entitled *Ibaraki*, was first performed in May 1883, and Zeshin himself painted a theater billboard depicting the hideous demon. When the play closed, the painting was donated to the Sensōji temple, not far from the theater, where it remains today.

Zeshin returned to this subject more than once. He painted the demon story on hanging scrolls and *tsuitate* (small, freestanding screens);[4] the present pair of screens is the only known example to have been executed on folding screens. As is stated in his signature on the right-hand screen, "Nanajūgo-ō Zeshin," he painted this pair when he was "an old man of 75."

This work is also unique in that it depicts the entire setting of the narrative, featuring the casket—with purifying ropes around it—and the flickering flame of an oil lamp, which enhances the eerie atmosphere of the legend. While differences among Zeshin's versions of the tale are minimal, one technical element that distinguishes this version from the others is Zeshin's use of the *tarashikomi* technique, in which soft, blurred effects are produced by applying darker ink on a still-wet lighter wash; in this case, the dark ink forms the black cloud conjured up by the fleeing demon. An extremely prolific and versatile artist, Zeshin had an unquenchable appetite for new painting styles and techniques, all of which he tried to master. He copied Chinese paintings, Kano-school works, Muromachi-period ink paintings, and Rimpa images. He also produced a facsimile of a Kōrin-designed lacquer work. Zeshin's masterly use of the *tarashikomi* technique is simply another indication of his debt to the Rimpa school of painting and design.

Enormously talented and consistently inventive, Zeshin was an artist who ventured into many areas of creative endeavor; he even decorated ceramic ware and created designs for woodblock prints. Although the Meiji government lavished prizes and honors upon him in his old age, Zeshin's art remained true to the tastes and preferences of the mercantile population of Edo.

A painting of gingko leaves caught in the web of a spider appears on the back of this pair of screens. Its date of execution and the artist of the painting, whose undecipherable seals are impressed, remain unknown. Any thematic connection to Zeshin's *Ibaraki* scene on the front, if any, may be found in the story of another heroic exploit by Tsuna, which is known under the name of *Tsuchigumo (Earth Spider)*. In this celebrated story, which was a popular subject for illustrated handscrolls from the fourteenth century and later,[5] and in Noh, Kabuki, and other performing arts, Tsuna and Raikō scored another victory over an evil creature, a giant earth spider. The spider web depicted on the back of the screen might be a reference to this legend. It is intriguing in this connection that Zeshin once painted a screen depicting spider nets in which butterflies and other insects are caught.[6] There are some stylistic similarities between these two paintings of spider webs, suggesting that the painting on the back of the Burke screen may also be Zeshin's own work. However, the seal that is impressed here is not known to belong to the artist.

NOTES

1. His lacquer works were included in the Vienna World's Fair of 1873. For a detailed discussion of his life, see Gōke Tadaomi, *Shibata Zeshin Meihinshū* (Collection of Masterpieces by Shibata Zeshin) (Tokyo: Gakken, 1981); and Gōke Tadaomi, *Shibata Zeshin*, Nihon no Bijutsu no. 93 (Tokyo: Shibundō, 1974).

2. A preparatory drawing for this *ema*, in ink, is now in the collection of the Cleveland Museum of Art; see Gōke, *Shibata Zeshin Meihinshū*, 164, and *Shibata Zeshin*, fig. 31.

3. The story is included in the *Taiheiki*, chap. 32; see Gotō Tanji and Okami Masao, eds., *Taiheiki*, vol. 3 of *Nihon Koten Bungaku Taikei* (Compendium of Japanese Classical Literature) (Tokyo: Iwanami Shoten, 1988), chap. 32, 227-28.

4. Gōke, *Shibata Zeshin Meihinshū*, pls. 206-10; and *Shibata Zeshin*, figs. 1 and 30.

5. An early fourteenth-century *emaki* of this tale in the Tokyo National Museum is reproduced in Komatsu Shigemi, ed., *Zoku Nihon Emaki Taisei* (Compendium of Japanese Emaki, Supplement) (Tokyo: Chūōkōronsha, 1984), vol. 19.

6. Gōke, *Shibata Zeshin Meihinshū*, pl. 141.

4
Aesthetics and Function

In the West, artists traditionally express their creative abilities through the media of painting, sculpture, or architecture; some, like Michelangelo, worked with all three. In pre-modern Japan, however, architecture was a matter of little concern to the creative individual. Sculpture, a handmaiden of Buddhism, could not sustain its preeminence as an art form following the fourteenth-century rise of Zen, with its lack of emphasis on the worship of icons. However, one of the many factors that differentiates Japanese aesthetics from those of the West is the attitude held toward the so-called crafts. The Japanese have long regarded textiles, lacquerware, and ceramics as art forms of an importance nearly equal to that of the so-called fine arts. Evidence of this blurred distinction between "fine" and "minor" arts can be found, for example, in the careers of Hon'ami Kōetsu (1558-1637) and Ogata Kōrin (1658-1716). Kōrin's frequent involvement with the decoration of lacquerware and textiles is not surprising, considering his background as the son of a textile designer and his penchant for utilizing dramatic, schematized patterns in his paintings. Even Kōetsu, whose primary artistic concern was calligraphy, created a number of highly valued tea bowls. He is also believed to have provided designs for the ornamentation of lacquer pieces.

To a certain extent the cult of tea contributed to the breakdown of clear distinctions between "fine arts" and "crafts." In the context of the tea ceremony all forms of art, whether "fine" or "minor," were regarded on equal terms, including architecture, garden design, flower arranging, and cooking. The tea ceremony also helped to preserve and foster appreciation of objects of a strictly utilitarian nature, elevating them to the rank of "fine art" pieces. Several of the ceramics included in this section fall into that general category: the Jōmon, Yayoi, and Arita wares (nos. 55, 56, 59 and 60). The small incense box (no. 64) and drum core (no. 66) are examples of lacquerware raised to the level of "fine art," as are the Negoro lacquer vessels made for use in Buddhist temples (nos. 74 and 75).

Although the basic techniques of pottery-making were first brought to Japan from China and Korea, Japanese works exhibit distinctly indigenous attributes, a singular attitude toward allowing the material to "speak" for itself. A profound respect for the clay governed the craftsman's hands and is apparent even in early products like the Jōmon vase and *haniwa* sculpture (no. 57). This approach is perhaps most evident in tea ceramics of the sixteenth and seventeenth centuries, superb examples of which were featured in the 1975 Burke Collection exhibition. The tactile quality of the surface of these wares, something particularly appreciated by tea masters, was one of the results of this unique respect for medium and function. These ceramics were far better suited to the tea ceremony than any Chinese pieces. World-renowned Chinese porcelains, admired for their technical excellence and exquisite symmetry, were usually paper-thin, in defiance of the inherent quality of the clay; but they could not protect the hands from

Shibata Zeshin (1807-1891)
Lid from *Stacked Food Boxes* (no. 73)

215

the heat of the tea in the manner of the thick-walled Japanese bowls.

The Japanese porcelains included here (nos. 59-63) are a far cry from the technically perfect Chinese wares. However, as coveted items in the successful export trade, they were catapulted into the European arena where they exerted some degree of influence. Lacquerware, especially those known as "Kōdaiji-type" works (nos. 65-67), had enjoyed an even greater success earlier on, in the sixteenth-century European trade market. Kōdaiji pieces were products of Japan's first encounter with the Western world; many were fashioned to accommodate European tastes and religious practices, both totally alien to the craftsmen who produced them. The unfamiliar vessel shapes and design motifs became known to them through occasional contact with European traders. Under such circumstances Japanese craftsmen blended ancient traditions with foreign demands, successfully creating objects of unique beauty and charm.

A NOTE ON JAPANESE PORCELAINS

There have been many organized excavations of kiln sites at Arita in recent years, and chance discoveries of presumed sites of large-scale importers and consumers of these wares. Aided by such activities, scholars are proposing new interpretations of the development of Japanese ceramics, and these are summarized in the following paragraphs.

Although Japanese ceramic production strikes most people today—Japanese and Western—as an extremely creative and innovative industry, it was not until the late sixteenth century that it began to achieve a marked success in the areas of manufacturing techniques and surface decoration. In the prehistoric Japan of the Jōmon and Yayoi periods, the potter's art evolved over thousands of years. Even during the early historic era, Sueki ware served as the principal type of ceramic until about the thirteenth century, when it was replaced by the first Japanese high-fired stonewares, with their deliberately applied glazes. The old center of Sueki production, in the Nara-Osaka region, had lost its dominant position by the eleventh century, and the ceramic industry

spread to various parts of the country. The most important sites for pottery-making were the so-called Six Old Kilns at Seto and Tokoname (both in modern Aichi prefecture near Nagoya), Echizen (in Fukui prefecture, northeast of Kyoto), Shigaraki (in Shiga prefecture, southeast of Kyoto), Tamba (in Hyōgo prefecture, west of Kyoto), and Bizen (in Okayama prefecture, in western Japan). These six kilns played a major role in the development of Japanese ceramics, particularly during the sixteenth century with the arrival of Korean potters and the rise of great masters of the tea ceremony. The dramatic evolution of ceramic tea-ceremony utensils may be seen as one of the most memorable events in the history of Japanese art. The finest tea wares were created at the Six Old Kilns; at the same time, new kilns were opened for the explicit purpose of turning out tea wares. Among the latter, the Karatsu kiln merits special mention, as it can be credited with establishing northern Kyūshū as one of the most important locations for later ceramic manufacture. In the beginning of the seventeenth century, the industry made another dramatic leap forward, this time in the area of porcelain production.

During the first half of the seventeenth century, the area around Arita (modern Saga prefecture) in Kyūshū witnessed epoch-making developments in ceramic production, under the enlightened sponsorship of the lords of the fief of Nabeshima. The remarkably rapid pace of technological innovation in the field of porcelain stands in sharp contrast to the painstakingly slow progress of the potter's craft in earlier centuries. Arita kilns were the first in Japan to manufacture true porcelains; they also created brilliantly colored glazes that glowed against the smooth, milky-white surface of the new wares. The porcelains were produced in large quantities, following division-of-labor procedures similar to those by which the modern industry mass-produces ceramic pieces today. Arita soon became one of the largest porcelain manufacturing centers in the world, turning out everyday wares used throughout the entire country. At the same time, it made highly profitable export items, sold in Asia and Europe with the help of Dutch and Chinese traders. Trade with

Europe was facilitated by the activities of the Dutch East India Company, founded in 1602, which established its headquarters in Batavia (modern Jakarta), Indonesia, in 1622.

Numerous factors contributed to the sudden and surprising success of the Arita kilns, and the great variety of their porcelain wares was clearly one of them. Porcelains of different shapes, color schemes, and quality have been staples of Arita ware from the early seventeenth century to the present day. The many different names by which these pieces came to be known are, however, confusing to all but the most knowledgeable connoisseurs. "Imari," the most widely used appellation for Arita ware, was derived from the name of the nearby port from which porcelains were shipped to Southeast Asia, Europe, and even other parts of Japan. Europeans in particular apply the name "Imari" to enameled porcelains imported from Japan during the seventeenth and eighteenth centuries. The designation does not, however, cover Kakiemon wares, created—according to widespread belief—by the potter Sakaida Kakiemon (active late seventeenth century) and his descendants. Arita kilns also produced Nabeshima wares, made not for export but reserved for the exclusive use of the lords of Nabeshima. Recent scholarship also indicates that Arita kilns may have produced what have been known traditionally as Ko-Kutani (literally, "Old Kutani") wares. These porcelains had, until recently, been associated with Kutani kilns in the Kanazawa region northeast of Kyoto, a great distance from Arita.[1]

The porcelain medium itself had enjoyed a long history of production in mainland Asia. Porcelain wares, made from kaolin clay and fired at temperatures above 1,300 degrees centigrade to produce hard, almost translucent, white-bodied ceramics, were made in China as early as the sixth century, and in Korea as early as the tenth century. Porcelains were known to the Japanese by the ninth century, when some half-hearted attempts to imitate them were made, but for some unexplained reason Japanese potters made no serious effort to produce true porcelain until the early 1600s. The sudden rise of interest in the medium is traditionally attributed to efforts made by the lord of Nabeshima who, in 1616, resettled several Korean potters in his domain. These craftsmen were headed by a certain Ri Sampei, extradited from his homeland after Toyotomi Hideyoshi's infamous second invasion of Korea. The lord of Nabeshima was only one of many vassals who accompanied Hideyoshi to Korea and returned with "kidnapped" Korean craftsmen.

Although it was long maintained that Ri Sampei first discovered kaolin in the Arita area, this belief has recently been challenged. It has been pointed out that Arita was not a newcomer to the ceramics industry, and that Korean craftsmen had helped to construct kilns in the nearby Karatsu area during the Momoyama period. Excavations of kiln sites in Arita, conducted between 1965 and 1970, as well as the study of extant pieces, indicate that porcelain manufacture in the region may predate 1616. At first, production was limited to white wares decorated with cobalt blue—known as *sometsuke*, or blue-and-white—and celadons, but in the 1640s potters succeeded in producing brightly colored enameled wares. These potters used red glaze as a main palette, combined with greens, blues, yellows, purples, and later, even gold, applied to already fired vessels which they then refired at lower temperatures of around 950 degrees centigrade. Popular legend associates this important innovation with Kakiemon, whose family documents date the event to 1647.

It is now believed that a variety of factors contributed to the invention of enameled ware. Contemporary Kyoto wares, for example, were decorated with bright colors even though they were not porcelains. There were also attempts to copy enameled porcelains of Ming China. Documentary materials provide evidence for the existence of pre-Arita colored wares, although exact dates of manufacture and the name of the first potter to succeed in producing them are not known. The *Kakumei Ki*, a diary kept by Hōrin, abbot of Rokuonji (popularly known as Kinkakuji) in Kyoto, is an often-quoted source on the subject of early colored porcelains. It refers to a blue-and-white Imari piece that Hōrin came across in 1639, and the gift of a *nishiki-e* (enameled or more literally, "brocade-picture") bowl from Imari, recorded in 1652.[2]

It is thus likely that enameled wares were being produced prior to the time that they caught the attention of this Kyoto connoisseur. Some scholars believe that such early enameled, so-called Imari ware, pre-dating 1652, could actually have been works in the Ko-Kutani style, but with darker glaze applied thickly, as was common with Ko-Kutani ware.[3] On the other hand, the piece seen by Hōrin might have resembled a small, well-known dish with a paulownia design, whose date, corresponding to 1653, is written on its base.[4]

The presence of the Dutch East India Company in Asia at this time cannot be overemphasized as an important influence. The Dutch had made handsome profits from the export of a large quantity of Chinese porcelains to Japan in the 1630s. These pieces had included both blue-and-white and enameled wares. In 1644, however, the political turmoil that witnessed the close of the Ming dynasty brought an end to this phase of the company's trading activities. The Dutch shifted their attention to the Arita kilns, to which their first large-scale documented order came in 1653. Their official business dealings can be reconstructed from company records,[5] but private business deals are believed to have actually surpassed the officially recorded orders.[6] "Just like Japanese lacquer cabinets, Japanese porcelains became standard requisites of great houses in Europe,"[7] where they were used to decorate large interior spaces. Thus began the golden age of the Arita porcelain industry. The general affluence enjoyed by the Japanese of this era also helped to promote Arita products as domestic demands for porcelains increased, due in part to the cessation of ceramic trade with China.

Successive leaders of the Nabeshima clan were not slow to recognize the economic possibilities inherent in the work of their local kilns, and they provided potters with encouragement while maintaining strict quality control over their work. At some point during the Kambun era (1661–1672), eleven kilns were assembled in Arita to produce enameled wares and soon became known as *Aka-e machi* (red painting shop, enamelers' quarters).[8]

Dutch sales of Arita wares to Europe reached their height in the 1680s, but continued well into the mid

eighteenth century. The last official order for Arita wares—only three hundred pieces—was issued in 1759. Rising prices of Japanese products, and resumption, in the 1670s, of operations at the large Ching-te-chen kilns in China (which had ceased production almost entirely in 1644) contributed to the decline in Dutch-Japanese trade. The Dutch East India Company, too, was in its final days of existence; it was dissolved in 1799. It has been estimated that by this time more than ten million Arita pieces had been sold to the Dutch,[9] the majority of which went to Europe, although a large number were also deposited in Southeast Asia. In addition, an unrecorded number of pieces were traded by the Chinese. Today, these so-called Imari wares—sometimes labeled Ko-Imari (Old Imari) to distinguish them from later products—are proof of the unprecedented activity in pottery-making that catapulted Arita and its products to world notice and gave rise to Europe's longstanding fascination with Japanese ceramics. It was this obsession with Japanese wares that subsequently served as a catalyst to the production of imitation-Imari porcelain in Europe.[10]

Numerous new studies of Arita porcelains have been undertaken in recent years, prompted by excavations of both old kiln sites in the Arita region and locations quite distant from the kilns, where Arita wares were used and eventually discarded. Many efforts have been made to establish a chronology for the development of Arita wares; recent investigations in this area were summarized at an exhibition held in 1991 at the Kyūshū Ceramics Museum in Arita, and published in the catalogue *Polychrome Porcelain in Hizen*.[11] The studies steadfastly avoid the use of such traditional designations as "Kakiemon" and "Ko-Kutani" (although the name "Nabeshima" is retained), and attempt to view Arita wares within the context of a continuous, if complex, line of evolution.

Included in this catalogue are five different types of Arita wares. Two pieces—the large blue-and-white apothecary jar (no. 62) and the enameled plate with a design of a courtesan (no. 63)—belong to the rather well-known export category. Two others—a bottle decorated with a lion and peonies (no. 60) and a celadon plate (no. 61)—may recall the traditional designa-

tions of "Kakiemon" and "Nabeshima," respectively. The large, handsome plate with a design of pumpkins (no. 59) belongs to the category traditionally known as "Ko-Kutani," the most controversial of the enameled-ware appellations, which has fallen into disuse in recent years. Although, in keeping with recent scholarship, traditional designations are generally avoided here, they are referred to from time to time for the sake of convenience.

NOTES

1. Ishikawa-ken Kyōiku Iinkai, *Daiichi, Niji Kutani Koyō Chōsa Gaihō* (Reports on the First and Second Investigations of Old Kilns at Kutani) (Ishikawa: Ishikawa-ken Kyōiku Iinkai, 1971 and 1972).

2. Akamatsu Toshihide, ed., *Kakumei Ki* (Kyoto: Rokuonji, 1958-1967). The entry for the thirteenth year of the Kan'ei era (1639), leap eleventh month, thirteenth day, is in vol. 1, p. 195; for the fifth year of the Keian era (1652), first month, second day is in vol. 3, p. 116.

3. Yabe Yoshiaki, *Nihon Tōji Taikei* (Survey of Japanese Ceramics) (Tokyo: Heibonsha, 1989), 20:97.

4. *Hizen no Iro-e: Sono Hajimari to Hensen Ten* (Special Exhibition: Polychrome Porcelain in Hizen: Its Early Type and Change of Style) (Arita: Saga Prefectural Museum of Kyūshū Ceramics, 1991), pl. 22.

5. Volker, T., *Porcelain and the Dutch East India Company* (Leiden: Mededelingen van het Rijksmuseum voor Volkenkunde, 1954), vol. 2.

6. John Ayers et al., *Porcelain for Palaces—The Fashion for Japan in Europe: 1650-1750* (London: Oriental Ceramic Society, 1990), 17.

7. Ibid., 24.

8. Excavations suggest that other kilns also produced enameled wares, *Hizen no Iro-e*, 173.

9. Nishida Hiroko, *Nihon Tōji Zenshū* (Compendium of Japanese Ceramics) (Tokyo: Chūōkōronsha, 1976), 23:54.

10. For example, copies of no. 63. See C. J. A. Jörg, *Pronk Porcelain: Porcelain after Designs by Cornelis Pronk* (Groningen: Groningen Museum, 1980).

11. *Hizen no Iro-e*.

55.

Deep Bowl

Middle Jōmon period, 2500–1500 B.C.
Jōmon ware
H. 53.1 cm (20¾ inches)

[handwritten annotations: "oldest — inch. b how" and "Jomon — Cord markings"]

Japan's first ceramic culture, the Jōmon, produced the world's wildest-looking pottery. The name Jōmon, which means "cord markings," was given to this period's ceramics because the majority of its vessels bear marks made by rough ropes pressed directly on the still wet and soft body or by rolling sticks wound with ropes against the clay. These cord markings often cover the body of the entire vessel, as can be seen on the strange pot shown here. Such markings were also combined with geometric designs of grooves or raised bands, which the potter made by dipping his fingers in water and running them over the clay body, vividly reminding us of the presence of its maker.

Like many Jōmon vessels of a similar shape, this one consists of two distinct parts: a tall body with a flat bottom that slightly flares out toward the top, and a flaring mouth, which (except for rare examples) consists of four groups of abstract sculptural decorations. These flamboyant decorations are made of coils of clay that encircle the top part of the vessel, rising and falling, projecting forward, and pierced by large and small openings. Rims sculptured in this way are known as the "fire-flame" type (*ka'en-shiki*), because the most extreme examples strongly remind one of leaping flames. These characteristics are what distinguish Jōmon vessels as truly unique among the world's prehistoric pottery cultures. The meaning, origin, and function of these powerful but bizarre-looking rim decorations are not known, but they are vivid reminders of the malleable quality of the material with which the vessel was constructed.

Although the majority of Jōmon wares are large, deep pots made for the utilitarian function of cooking, such a lavishly decorated piece was probably used for boiling food at special religious ceremonies. The soot that has blackened the upper half of this vessel's body suggests that it was placed over a vigorous fire that later died down.[1] The sculpted rims and large size of pots such as this made them unfit for everyday use. Such pieces are far rarer than those that are smooth and plain-rimmed, and they have been in a better state of preservation when excavated.

Jōmon vessels have been found from sites almost all over the Japanese archipelago, but the most spectacular specimens are from concentrated sites in eastern Japan. It is generally agreed that fire-flame type vessels were produced in the northeastern regions of Japan, from the Japan Alps to the area north of the Kantō plain. The most dramatic of all examples come from the Shinano-gawa river basin in Niigata prefecture facing the Sea of Japan. The bowl in the Burke Collection resembles pieces excavated in the Fukushima areas northeast of Tokyo.

All Jōmon pots were made by hand, with the craftsman building up coils of soft clay from the bottom. The clay was mixed with a variety of adhesive materials, such as mica, lead, fibers, or crushed shells. After the vessel was formed, tools were employed to smooth the outer and interior surfaces. When completely dry, it was fired in an outdoor bonfire at a temperature of no more than about 900 degrees centigrade. It is generally agreed today that these vessels—which were hand-built, without the aid of the wheel—were made by the women of a food-gathering society whose male kinfolk hunted and fished. In other parts of the world, the food-gathering people of the Paleolithic era evolved into food producers during the Neolithic period. But the Jōmon people continued to follow their older lifestyle and methods of food gathering, even though they lived mostly in settled communities. Their pit dwellings were arranged around a central open space, and there seems to have been an increasing emphasis on shamanism in their society. Their clay figurines, called *dogū* (literally, earthen idols), were also decorated with Jōmon patterns and look as dark and mysterious as the larger vessels. The *dogū*, which are slightly later in date

than the decorated pots, were probably fertility-cult objects and may hold the key to the symbolic meaning of the fantastic decorations on Jōmon vessels.

Jōmon vessels fascinated even the Japanese of the early Edo period,[2] yet serious studies of this culture did not begin until American biologist Edward S. Morse (1838-1925) excavated shell mounds at Ōmori, south of Tokyo, and found a number of specimens. Even today, our knowledge of the evolution of Jōmon pottery is inconclusive and in a state of flux. Carbon-14 testing gives the stunning date of 10,500 B.C. for the oldest types of Jōmon vessels. As this date falls outside of the generally accepted chronology of pottery development elsewhere in the world, it is not accepted universally. According to this early date, the chronology of the Jōmon culture can be divided into the following six phases:

(1) Incipient Phase 10,500-8000 B.C.
(2) Initial Phase 8000-5000 B.C.
(3) Early Phase 5000-2500 B.C.
(4) Middle Phase 2500-1500 B.C.
(5) Late Phase 1500-1000 B.C.
(6) Final Phase 1000-300 B.C.

While many scholars seek and suggest continental connections to Jōmon culture,[3] many others prefer to see it as the result of indigenous evolution from Paleolithic to Neolithic times. Based on this hypothetical

chronology, ka'en-shiki vessels began to make their appearance in the Kantō region at the beginning of the Early Phase, and reached the height of development in the Middle Phase, when the Burke bowl may have been made.

In the Late Phase, the strong plastic designs began to lose their energy and were supplanted by more functional Yayoi vessels. This trend first became apparent in western Japan, where the dramatic designs were never fully appreciated.

NOTES

1. Richard J. Pearson et al., *The Rise of a Great Tradition: Japanese Archaeological Ceramics from the Jōmon through Heian Periods (10,500 B.C.-A.D. 1185)* (New York: Japan Society, 1991), 26. It is also suggested that some Jōmon vessels were used for the burial of human remains, and the small holes at the bottom were made as passages through which the deceased's soul could be released. See Richard J. Pearson et al., *Ancient Japan* (Washington, D.C.: Arthur M. Sackler Gallery, Smithsonian Institution, and Tokyo: Agency for Cultural Affairs, Government of Japan, 1992), 103.
2. The first reference to Jōmon pottery is dated to the ninth year of the Gen'na era (1623), in the *Anroku Nikki*, a chronicle kept by the Tsugaru Lord's family in Aomori prefecture in the northernmost province of the Honshū Island. See Kobayashi Tatsuo, ed., *Jōmon Doki* (Jōmon Potteries), Nihon no Bijutsu no. 145 (Tokyo: Shibundō, 1978), 17.
3. Okamoto Tōzō, ed., *Jōmon Jidai I* (Jōmon Period I), Nihon no Bijutsu no. 189 (Tokyo: Shibundō, 1982), 28.

56.

Red Jar with a Flaring Mouth

Yayoi Culture, fourth century
Yayoi ware
H. 40.5 cm (16 inches)

[handwritten annotations: "More utilitarian / Cooling Method / Smooth surface - / Low fired / Sometimes slipped + dipped" "more shapes than Jomon / monumental / Jien-De"]

Totally devoid of the feeling of dark mystery that envelops Jōmon pottery, this jar belongs to a new type of ceramic first discovered in 1884. This pottery, and the culture that produced it, were named Yayoi after the discovery site, in Tokyo near the campus of Tokyo University. Yayoi pieces have complex profiles. For example, this jar swells from a small base to a bulbous body

and then sharply veers toward a narrow neck. This supports a boldly flaring mouth decorated simply with four sets of triple parallel clay strips. The surface is smooth and the bright red coloration was produced by the oxidizing iron. At first sight, the vessel looks urbane, like the product of a technically advanced society that preferred functional shapes to objects

intended for shamanistic rituals. Yet the basic technique of making Yayoi pottery did not change from the method used in the Jōmon period; women probably continued to be the main producers of pottery using the coil method rather than potters' wheels. However, unlike the Jōmon pots, the fine clay surface of these vessels was carefully smoothed, and sometimes clay slip was applied over the body to make it less porous.

A great variety of shapes suitable for the cooking, storage, and serving of food were created, and this suggests a more affluent society. These vessels are the products of a civilization that was dependent on the cultivation of rice, thought to have been introduced to Japan from Korea or southeast China. Scholars suggest disparate dates for this momentous event, anywhere from 1000 B.C. to the first century A.D.[1] As surplus food was accumulated, storage jars made up nearly half of the vessels produced.

In the Yayoi culture, people lived in thatched houses clustered to form villages, and a class society began to emerge. This was also an important epoch in Japan's overall history, as it was during Yayoi times that the knowledge of metallurgy was introduced from the Asian continent. In fact, many Yayoi vessels resemble pots found in Korea, leading to a theory that the Yayoi style might have been introduced from there, arriving in northern Kyūshū and then gradually moving northeastward. However, some pieces show striking evidence of the residual influence of Jōmon ceramics, leading other scholars to speculate that Yayoi wares were the product of an indigenous evolution from the less-decorated Jōmon wares of northern Kyūshū.[2] Knowledge of Japan's archaeological periods is still open to question, and a compromise view is that the indigenous pottery tradition was profoundly modified by an influx of new technology from abroad in the last years of the Late Jōmon Phase (1500–1000 B.C.).[3]

Although many recent excavations in South Korea and Japan have brought to light an enormous number of new materials, there is still much to be learned by future excavations in both countries. New pottery shapes, which were functional as well as sophisticated and refined, spread to the rest of Japan, except for Hokkaidō in the north and Okinawa in the south. A variety of regional styles evolved: the most extensively decorated Yayoi vessels were produced in areas where

the most heavily decorated Jōmon wares had been made, suggesting the lingering influence of the earlier pottery tradition.

This smooth-walled vessel with its simple yet powerful shape was probably made as a storage jar for grains or liquids. However, a black scorch mark on its lower part suggests that like many other storage jars it was placed over a fire for ceremonial cooking purposes. A large hole at its bottom might give a clue as to its former use: some scholars believe that Yayoi vessels with holes at the bottom were placed on tall stands. These, in turn, were placed atop tomb mounds, eventually evolving into the earliest haniwa,[4] a type of funerary object that is discussed in greater detail in no. 57. This piece may have been one such precursor of haniwa. Similar jars with flaring mouths also come from sites belonging to the last phase of the Yayoi culture, in the fourth century A.D. At these sites, which include the Nara area, new pottery wares called Hajiki were found.

NOTES

1. For example, Richard Pearson dates it to 1000 B.C., in Richard J. Pearson et al., *The Rise of a Great Tradition: Japanese Archaeological Ceramics from the Jōmon through Heian Periods (10,500 B.C.–A.D. 1185)* (New York: Japan Society, 1991), 15. But in his most recent book, Richard Pearson et al., *Ancient Japan* (Washington, D.C.: Arthur M. Sackler Gallery, Smithsonian Institution, and Tokyo: Agency for Cultural Affairs, Government of Japan, 1992), 23, he dates it to ca. 400 B.C. On the other hand, Gina L. Barnes, in *The Rise of a Great Tradition*, 28, places it at ca. 350 B.C. Scholars like Kinoshita Masashi date it to the first century A.D.; see the introduction to *Yayoi Jidai* (Yayoi Period), Nihon no Bijutsu no. 192 (Tokyo: Shibundō, 1982), yet the same author places it at the second to third century B.C. in the same book, p. 17. Recently some scholars hold that the beginning of the Yayoi culture did not necessarily coincide with the introduction of rice cultivation. They believe that it overlapped with the fading out of the Jōmon culture.
2. Kuraku Yoshimichi, *Nihon no Genshi Bijutsu* (Early Arts of Japan) (Tokyo: Kodansha, 1979), 3:6; Tsuboi Kiyotari, *Nihon Tōji Taikei* (Survey of Japanese Ceramics) (Tokyo: Heibonsha, 1990), 2:86; and Harunari Hideji, *Yayoi Jidai no Hajimari* (The Beginning of the Yayoi Period), Kōkogaku Senshō no. 11 (Tokyo: Tōdai Shuppankai, 1990).
3. Kinoshita, *Yayoi Jidai*, 20.
4. For example, see Murai Hanao, *Kofun* (Ancient Tombs), Nihon no Bijutsu no. 57 (Tokyo: Shibundō, 1971), 84; and his *Nihon no Genshi Bijutsu* (Early Arts of Japan) (Tokyo: Kodansha, 1979), vol. 3, figs. 76 and 85; or Miki Fumio, *Haniwa*, Nihon no Bijutsu no. 19 (Tokyo: Shibundō, 1967), 22; and Kobayashi Yukio, *Nihon Tōji Taikei* (Survey of Japanese Ceramics) (Tokyo: Heibonsha, 1990), 3:122.

57.

Haniwa *Figure of a Young Woman with a Large Chignon*

Late Kofun period, sixth century
Pottery with polychrome traces
H. 31.5 cm (12¼ inches)

This fragment of a figurine portrays a young maiden, so identified by the large chignon hairstyle that resembles a mortarboard. The face bears a guileless, childlike expression; the hair piled high atop her head is tied in two parts by a ribbon that is visible when viewed from above and by indentations detected from the underside of the disc showing the parting of the hairknot. A comb-like hair ornament decorates the center of the hairdo like a medal of honor, and a hair band with a triangle pattern, partially painted in red, completes her hairstyle. Directly below the hairline is a long straight ridge, also painted in red, probably indicating eyebrows. The facial features, rendered with no attempt at modeling, are expressed by the simplest means—two almond-shaped slits for the eyes, a chunk of clay for the nose (partly restored), and another opening for the mouth. Such facial features, which indicate no differentiation in gender, age, or individuality, remind us of the much later painting technique called *hikimekagihana* (dashes for the eyes, a hook for the nose) of the Heian period. The girl wears heavy rouge on her cheeks, and her jewelry consists of earrings covering most of her ears and a beaded necklace adorning her neck. She is dressed in a high-necked tunic, with tight-fitting sleeves decorated with dots, suggesting deerskin. She also wears what seems to be a shawl-like cloth, which covers her right shoulder. She raises and pulls back her right arm, which tapers off to an ill-defined and damaged hand. Her left arm, now lost, may have held offerings or been raised in the same manner as her right arm. Unfortunately, her body below the chest is now completely lost, but it is likely that the figure originally wore a flared jacket over a skirt, ending rather abruptly above a clay cylinder. Her identity and her station in society are uncertain. Some scholars believe that because of the rouge on her cheeks, her earrings, and her necklace, she was meant to represent a participant in a funeral ceremony, since such adornment was the custom of the day.[1] Others speculate that the makeup and ornaments indicate she was a sorcerer, while still others think that the painting on the face may represent a tatoo.[2] In spite of differences in the interpretation of such facial makeup, the general agreement is that it does have a ceremonial significance.

Such figurines, representing either males or females placed atop clay cylinders, are called *haniwa* (literally, planting cylinders), which were the important funeral furnishings of ancient Japan. Male and female *haniwa* figures have similar faces, making their identification difficult. In most cases, clothing and hairstyles do help to distinguish males from females. Men wear hats, helmets, and tie their long hair in two ponytails. Women, such as this figure, pile their hair high atop their heads.

Even though basic information—such as gender, clothing, and even profession—are indicated, the figurine, as a sculpture, is far from a realistic or sophisticated representation. Its special charm comes from the abstraction of detail, with no attempt made at modeling the face or the body. Simple holes carved into the flat plane of the face, however, seem to change the facial expression of *haniwa*, depending on the angle and position of the viewer. It is doubtful that the creators of these simple, engaging figures intended to portray emotion; the perception of a particular mood is in the mind of the beholder. These charming figurines appeal to modern taste precisely because of such disregard for realism, which gives them a sense of vivid immediacy.

Haniwa, which are placed on tall and hollow clay cylinders, were planted outside large tomb mounds, unlike the Chinese practice of burying funeral figurines inside the tombs. This practice in Japan began with the inception of enormous tomb mounds in the third century A.D. These large tombs, built for political leaders during the Kofun (Tomb) period, are the

legacy of a society that was moving toward national unification. The bodies of the dead were interred in large wooden coffins, and burial goods accompanied the coffins in the tomb chambers. The earthen mound was lined on the outside with stones, and *haniwa* were planted on the crest of the knoll or on the sloping sides of the mound over the burial chamber. *Haniwa* of humans or other living creatures were placed so that they faced outward with their backs to the mound. As they stood tall on the sloping sides of the burial mounds, they could be seen from a great distance—an impressive sight for the living. Even though the way in which they were situated on the tomb is now known, the true meaning and function of *haniwa* are still debatable. It is possible that they were used to mark a sacred site, or to protect the site from evil spirits; but they were definitely not considered replacements for human sacrifices, as is often erroneously claimed.

Haniwa were made in large quantities, sometimes in the thousands, to be planted outside large tombs of powerful political leaders. They were fired in kilns called *anagama* (see no. 58), at a low temperature of only about 600 degrees centigrade. As a result, they are either reddish or buff-colored, like this example. Sometimes, when almost identical figures are found in groups of twos or threes, they can be attributed to the same craftsman. Also, differences in regional styles have recently been recognized.[3]

As organized scientific excavation on a large scale is a fairly recent practice in Japan—where it began only after World War II—the study of *haniwa* is still in its infancy. Many questions still remain unanswered, or only tentative hypotheses are available. Until recently, it was thought that simple cylinders made of clay, like planters without bottoms, were the earliest type of *haniwa*. More recently, however, this view has been reconsidered. A large Yayoi pot, like the one in this catalogue (no. 56), which may have contained offerings, was placed on a stand and may have evolved into *haniwa*.[4] It is also a matter of dispute as to where this first stage in the evolution of *haniwa* might have taken place. Some place it in Kibi (modern Okayama region), in western Japan;[5] some others, in Kinki (Osaka-Nara area).[6] Apparently, the practice soon spread to almost all parts of the country. What is generally accepted is that, after the initial stage of the *haniwa's* evolution from either cylinder or pot-atop-cylinder, representational objects, such as shields, boats, and houses, were placed above tall cylinders. This development is thought to have taken place during the second half of the fourth century A.D. In the fifth century, these objects were replaced by representations of animals, and then of humans. The human *haniwa* was especially popular in the Kantō region in eastern Japan. *Haniwa* production stopped in the late sixth century in the Kinki area, and in the rest of the country in the seventh century. This piece may come from the Kantō region, where many fine human *haniwa* were created in the sixth century.

NOTES

1. Richard J. Pearson et al., *The Rise of a Great Tradition: Japanese Archaeological Ceramics from the Jōmon through Heian Periods (10,500 B.C.-A.D. 1185)* (New York: Japan Society, 1991), no. 56.
2. Kobayashi Yukio, *Nihon Tōji Taikei* (Survey of Japanese Ceramics) (Tokyo: Heibonsha, 1990), 3:100.
3. Inokuma Kanekatsu, *Nihon no Genshi Bijutsu* (Early Arts of Japan) (Tokyo: Kodansha, 1979), 6:15-18; and Kobayashi, *Nihon Tōji*, 3:101.
4. Kobayashi, *Nihon Tōji*, 3:122; Inokuma, *Nihon no Genshi*, 6:46; and Miki Fumio, *Haniwa*, Nihon no Bijutsu no. 19 (Tokyo: Shibundō, 1967), 22.
5. Inokuma, *Nihon no Genshi*, 6:46.
6. Kobayashi, *Nihon Tōji*, 3:122.

58.

Yokobe *(Barrel-shaped Recumbent Bottle)*

Late Kofun period, sixth century
Sue ware (Sueki)
H. 37 x W. 44 cm (14½ x 17½ inches)

Looking like a watermelon, this large vessel is impressive because of its unusual shape, rough dark-gray body, and horizontal streaks of glaze that look as though they were blown onto the surface by a high wind. Recumbent bottles, called *yokobe*, have openings on their sides unique to this type of Sue ware, which were first produced in the mid fifth century. Known as Sueki—from *sueru* (offering) and *ki* (ware)—they were usually made of blue-gray clay and are often thin-bodied and hard, since they were fired at temperatures of about 1100 to 1200 degrees centigrade, a range similar to that used to produce modern stoneware and porcelain. Unlike earlier Jōmon or Yayoi pots, these were fired in Korean-style kilns, which were introduced to Japan sometime in the late fourth or early fifth century. These kilns, known as *anagama*, consisted of single tunnel-like chambers half-buried in the ground along the slope of a hill.

The ultimate ancestry of Sueki lies in the Lungshan pottery of ancient China (ca. 3200-1850 B.C.), and its direct precursor is the gray ware of Korea.[1] Sueki production marks a turning point in the history of Japanese ceramics, as Sueki were technically more advanced than the Jōmon, Yayoi, or Hajiki wares of a slightly later date. The wheel was used for the first time, although only to create smaller pieces and to finish the shapes of larger vessels. From the second half of the seventh century, glaze (green glaze) was applied intentionally only on ceremonial pieces; but natural ash glaze often decorated the wares intended for everyday use, like the *yokobe* shown here. It is not known where the new technique was first employed in Japan, because many villages with kilns and kiln sites are named Sue-mura (Sue villages). Scholars generally agree that the first kiln to produce Sueki may have been located south of Osaka—the political and cultural nerve center of fifth-century Japan—where more than five hundred kiln sites have been discovered behind a cluster of tombs.[2] At first these kilns must have been operated by Korean immigrant potters, since the earliest Sueki look very much like Korean wares. In their casual appearance and the asymmetrical placement of the neck on the body, they most closely resemble Korean pieces from the Kingdom of Kaya. By the end of the fifth until the early sixth century, the new technique spread to many other areas of Japan, and more than two thousand Sueki kiln sites have been discovered so far. Even after production at Sue-mura kilns in the Osaka area declined in the tenth century, Sueki kilns in other provinces continued to turn out pots as late as the fourteenth and fifteenth centuries. The manufacturing technique of Sueki was also different from that of the Jōmon and Yayoi in another respect: it was the product of a systematic, organized official effort, enjoying court and temple support, and professional male workers were involved.[3]

A large variety of shapes were created for everyday use, for the ceremonial functions that evolved in a more complex and advanced society, and for burial of the dead. Many cultural changes took place during this time, and it is particularly remarkable that Sueki adapted itself to the needs of the newly introduced Buddhist ceremonies.

A *yokobe* such as the one shown here, a barrel-shaped recumbent bottle with the neck on its side, is the most basic type of storage jar for liquids like sake, and it was in use from the beginning of Sueki's history.[4] This piece, like many other *yokobe*, was formed in sections by the coil method. The neck was also made separately and later attached to the opening on the side. Three disks, one of which is still attached, were used to finish and close a hole at one end. This part of the vessel might have been finished on a wheel, as it bears whirl lines left by a turning motion. The rest of the vessel

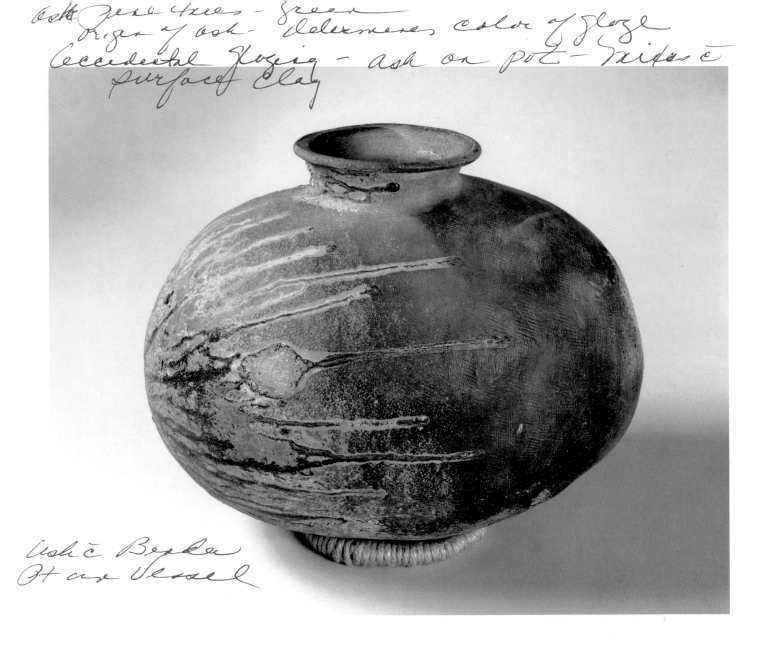

Ash — pine trees — green
origin of ash — determines color of glaze
Occidental glazing — ash on pot — mixes c̄
surfaces clay

Ashē Bizen
Jar Vessel

was smoothed on both exterior and interior by beating it with wooden tools, with care taken to keep the two tools from meeting through the relatively thin body. The exterior was then smoothed with a wooden tool that was carved with checkered patterns, while the interior was finished with a tool carved with wave patterns. The finished vessel was made to stand on its end in the kiln, and ashes from burning embers fell upon it during the firing, creating the random, vitreous glaze that ran down along the body. This technique for "applying" a natural ash glaze has continued into modern times.[5] The vessel with its simple yet well-formed body of iron-rich clay and horizontal green-brown natural glaze vibrates with a sense of raw energy

and has a strangely vivid quality. These qualities all reflect the technique with which it was made and are singularly appealing to modern taste.

NOTES

1. Richard J. Pearson et al., *The Rise of a Great Tradition: Japanese Archaeological Ceramics from the Jōmon through Heian Periods (10,500 B.C.–A.D. 1185)* (New York: Japan Society, 1991), 53.
2. Narazaki Shōichi, *Nihon no Tōji* (Japanese Ceramics) (Tokyo: Chūōkōronsha, 1990), 1:92.
3. Tanabe Shōzō, *Nihon Tōji Taikei* (Survey of Japanese Ceramics) (Tokyo: Heibonsha, 1989), 121.
4. Narazaki, *Nihon no Tōji*, 108.
5. Tanabe, *Nihon Tōji*, 97–99.

59.

Plate with Design of Pumpkins

Edo period, ca. 1650–1660
Arita ware, porcelain with overglaze enamels
Diam. 37.8 cm (14⅞ inches); Rim W. 4.8 cm (1⅞ inches)

This large, impressive plate bears a striking design of pumpkins and leaves, the pumpkins rendered in deep aubergine and the leaves in luminescent green. Set against a grain-patterned background of a warm, yellow earth color, the plant elements extend across the entire plate and appear almost to overflow beyond its borders; the serpentine tendrils of the vines are vibrant with life. In its simplicity and boldness the design has a powerful appeal and a "modern" appearance, yet at the same time it is strongly reminiscent of decorative and dramatic Momoyama-period screen paintings. Indeed, in a recent study, one scholar has attempted to interpret this mode of ceramic design in relation to the arts and craft of the Momoyama era.[1]

Perhaps one of the most controversial questions in the history of Japanese art concerns the attribution of a large number of similar plates and other vessels to the Kutani kilns in Kaga (modern Ishikawa prefecture), northeast of Kyoto. These pieces, traditionally labeled Ko-Kutani (Old Kutani) wares in an effort to distinguish them from later, revivalistic works of the nineteenth century, have become the center of a baffling and tantalizing mystery. Unique among the enameled wares of the early Edo period, the so-called Ko-Kutani porcelains—most of which are large plates like the Burke Foundation piece—feature bold and sensuous designs rendered in a limited palette of blue, green, yellow, aubergine, and touches of red. The pigments are so thickly applied that they often form deep, glossy pools of color. Decorative elements deviate from the Chinese-influenced bird-and-flower motifs typical of enameled Arita porcelains; their free and bold execution also differs from the cool, restrained treatment of line and color that characterizes, for example, official wares of the Nabeshima kilns. In addition, no two Ko-Kutani pieces bear identical designs. It is not difficult to distinguish them from other porcelains produced in northern Kyūshū, with

the exception of what are now regarded as the earliest works from the Arita kilns.

Edo-period documentary materials on the manufacture of Ko-Kutani wares in Kutani are scarce, and scholars long desired to examine kiln sites in the area. When the Kutani region was designated as a dam site, which would result in its eventual submersion, the examination of kiln sites became a matter of some urgency. Three controlled excavations were carried out in 1970, 1971, and 1974,[2] and, as though to confound the expectations of scholars intent on solving the mystery of Ko-Kutani wares, the investigations yielded material that appeared to have no relationship to so-called Ko-Kutani porcelains. However, since excavated objects do corroborate some of the claims made in literature concerning the inception of porcelain production at the Kutani kilns, the most often-quoted claims are summarized below.[3]

The earliest reference to ceramic manufacture at Kutani connects the lord of the Maeda clan from Kaga fief to Arita porcelain production. It is in the family document of Sakaida Kakiemon of Arita that we read of Kakiemon selling enameled wares to an official from Kaga visiting nearby Nagasaki to purchase rare objects for his master. This sale apparently took place in 1646 or 1647. Other documents in Kaga attribute the founding of the Kutani kilns to Maeda Toshiharu (1618–1660), third son of the third-generation of the Maeda family, who branched away from his kinsmen and established a small subfief called Daishōji. Toshiharu was known as a cultivated man with a keen interest in the welfare of his tiny domain, and at some time during the Meireki era (1655–1657) he purportedly instructed a certain Gotō Saijirō to travel to Arita for the express purpose of learning the techniques of porcelain production. This action is supposed to have been prompted by the discovery of kaolinite in the Kutani area and the subsequent establishment of a kaolinite mine. The *Hiyō Zasshū*, an essay written in 1784, gives a somewhat later

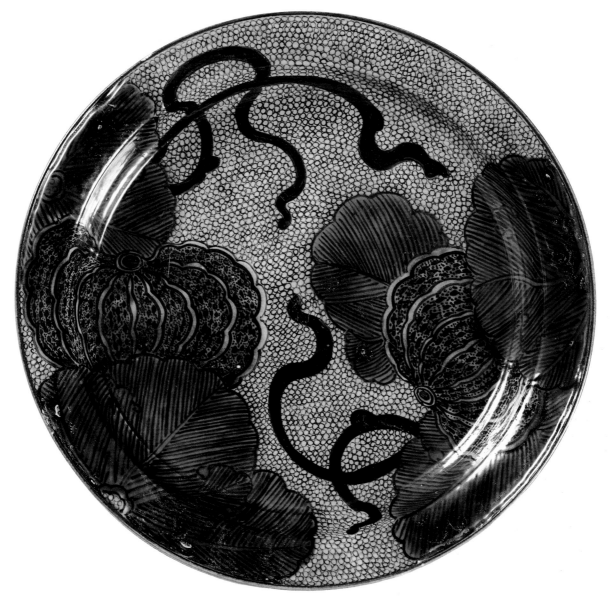

date for the inception of the Kutani kilns, attributing their opening to the second lord of Maeda, Toshiaki (1637-1693). To complicate the issue, another essay, the *Bakkei Kibun* of 1803,[4] claims that the first Kutani potter to study porcelain-making in Arita was Tamura Gonzaemon, not Gotō Saijirō. Basic to all of these records are the assertions that it was the lord of Kaga who took the initiative to establish the kilns and that, from the beginning, the Kutani kilns were closely tied to the kilns in Arita. Excavations at Kutani produced materials suggesting that the oldest kiln in the area—Kiln Number One—began operation around 1656; the oldest sherds found at the site are quite similar to those found

at early Arita kilns. Kiln Number One was also found to have been constructed in a manner identical to that used for the earliest kilns at Arita, the Tengudani kilns (known as *noborigama*, or climbing kilns).

Excavations indicated that Kiln Number One ceased operation around 1670, but other kilns continued to function at Kutani. Their products evidently caught the attention of some connoisseurs, for Kaga records like the *Kaga Ōrai* of 1672 refer to the tea bowls known as Daishōji ware as Kaga region specialties. The *Sanshū Meibutsu Ōrai* of 1688-1740[5] also mentions Daishōji tea bowls as local specialties.

Neither the sherds found at kiln sites nor these literary references give evidence of any characteristics that

231

definitely distinguish Ko-Kutani porcelains from all other ceramics. On the other hand, unenameled porcelains used as base vessels for Ko-Kutani wares have been discovered regularly at Arita kiln sites, and fragments of enameled Ko-Kutani pieces have also been found there. The current, generally accepted hypothesis is that Ko-Kutani wares were actually produced in Arita, and that they were probably among the first enameled wares to be made there. Included in this group of porcelains is the well-known plate with a paulownia design—previously designated as Ko-Kutani—which bears a dated inscription of 1653.[6]

The deep plate from the Burke Foundation belongs to a subgroup of Ko-Kutani known as Aode Ko-Kutani (Blue-type Ko-Kutani). Unlike most vessels, which leave a portion of their surface uncolored to serve as background for a design, these pieces are completely covered with glaze in two or three colors: deep green, yellow, blue, or aubergine. Aode porcelains were once thought to be a later development in the history of Ko-Kutani, but it is now believed that they were made from the earliest days of Ko-Kutani production, and that they flourished alongside other types of Ko-Kutani ware. Aode seems to have been particularly popular in Indonesia, where a number of pieces have been rediscovered in recent years.[7] They were also favored by the Dutch and Chinese as export items, carried by traders of both countries for the Indonesian market (not to Europe in the seventeenth century). Many Aode wares, with their dramatic designs derived

from common garden vegetables and their warm, earthy colors, actually bring to mind the lush, tropical Indonesian kingdoms that treasured them in the past.

The body of this particular dish is rather thick, and its rim is rounded and covered with an iron glaze. The underside is decorated with whorl-like patterns covered by a thin green glaze, which is also applied inside the foot. The ring foot is quite large; in fact, its diameter is more than half of that of the plate itself.

NOTES

1. Arakawa Masa'aki compares Aode Ko-Kutani (see below) designs to Momoyama gold screens and kimono patterns of the early seventeenth century. See his article, "Kan'ei Baroque Bunka to Ko-Kutani Ishō" (Baroque Culture of the Kan'ei era and Designs on Ko-Kutani Wares), *Kobijutsu Rokushō* 6 (1992): 50–63.
2. Ishikawa-ken Kyōiku Iinkai, *Daiichi, Niji Kutani Koyō Chōsa Gaihō* (Reports on the First and Second Investigations of the Old Kilns at Kutani) (Ishikawa: Ishikawa-ken Kyōiku Iinkai, 1971 and 1972).
3. For a convenient listing of these documentary materials, see Nakagawa Chisaki, *Kutani-yaki* (Kutani Wares), Nihon no Bijutsu no. 103 (Tokyo: Shibundō, 1974), 18.
4. Ibid.
5. Nishida Hiroko, *Nihon Tōji Taikei* (Survey of Japanese Ceramics) (Tokyo: Heibonsha, 1990), 22: 95–96.
6. *Hizen no Iro-e: Sono Hajimari to Hensen Ten* (Special Exhibition: Polychrome Porcelain in Hizen: Its Early Type and Change of Style) (Arita: Saga Prefectural Museum of Kyūshū Ceramics, 1991), pl. 22.
7. National Museum of Jakarta has several pieces that have been excavated there. Also see Nishida, *Nihon Tōji Taikei*, 115.

60.

Bottle with Design of Peonies and a Chinese Lion

Edo period, ca. 1660
Arita ware, porcelain with overglaze enamels
H. 28.3 cm (11⅛ inches)

The elegance of this bottle comes from its pear-shaped body and long, tapering neck, which are decorated with a motif of peonies and an imaginary Chinese lion: the king of flowers and the king of beasts, a popular

combination in Chinese design. Brilliantly enameled wares of this type have been variously labeled Ko-Kutani (Old Kutani), Imari, Early Enameled Ware, and Kakiemon-style porcelains. All porcelain scholars and connoisseurs emphasize that it is extremely difficult to distinguish products of the various kilns that operated in the Arita area, and indeed, designations have been changed periodically, sometimes even from scholar to scholar. Today, the tale of the potter Kakiemon and claims regarding his role in the development of

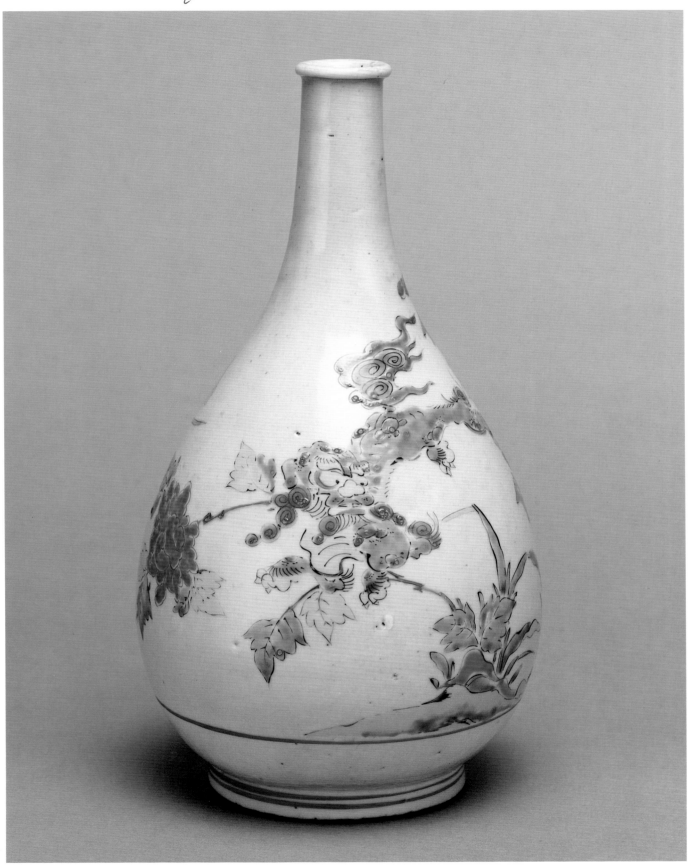

enameled wares are seriously questioned, and many pieces like this bottle, decorated with yellow, green, blue, and matte red with black outlines, are now given the name "Ko-Imari," while the term "Kakiemon" or "Kakiemon-style" is reserved for wares whose bodies are covered with a colorless "white" glaze, perfected some time after 1660.[1]

NOTE

1. John Ayers et al., *Porcelain for Palaces—The Fashion for Japan in Europe: 1650-1750* (London: Oriental Ceramic Society, 1990), no. 139. Ayers defines "Kakiemon" wares as porcelains that are generally finely potted, with refined white bodies covered in a remarkably colorless "white" glaze over which a sparse, painterly decoration is painted in delicate, translucent overglaze enamels without the use of underglaze blue.

61.

Deep Dish with Design of Chrysanthemum in a Stream

Edo period, second half of the seventeenth century
Arita ware, porcelain with celadon glaze and a design in *sometsuke*
Diam. 30.4 cm (12 inches)

This deep dish is heavily potted and fluted on the sides. It is covered with a celadon glaze, except for the central area, on which white glaze serves as a background for the decorative motif, in blue, of a large chrysanthemum blossom half submerged in a flowing stream. Simple, charmingly unpretentious brushwork defines the plants, water, and two flying geese. This delightful, minimalistic design appeared frequently on contemporary textiles, which may have served as inspiration to the potter.

The application of *sometsuke*, or blue-and-white underpainting, was common among Arita wares, and this decoration was probably created by scraping off a portion of the iron glaze that covered the entire piece, painting the design in blue, and finally applying a clear glaze to cover the entire vessel. The dish is supported by three short, rather stubby curled feet. An identical dish is currently in the collection of the Kyūshū Ceramic Museum (Saga prefecture).[1]

NOTE

1. *Nihon no Seiji: Kinsei kara Gendai made* (Japanese Celadon to Modern Times) (Arita: Saga Prefectural Museum of Kyūshū Ceramics, 1989), pl. 25.

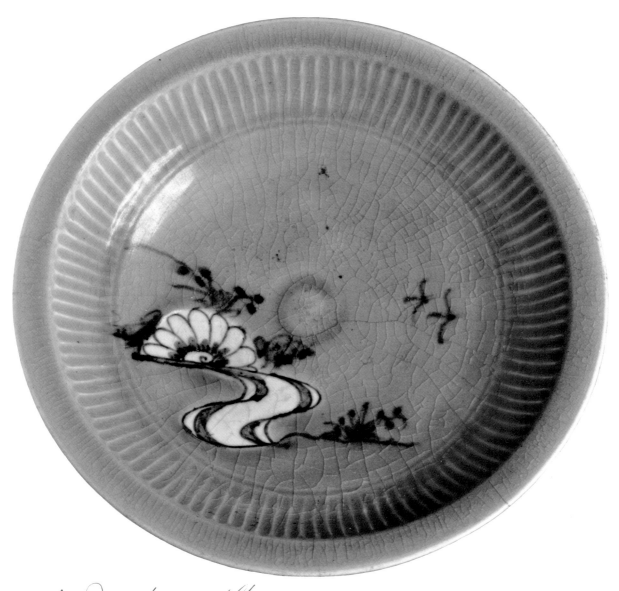

Motif Japonais a fleurs

Large Apothecary Bottle with Design of Myna Birds and Peonies

Edo period, 1660–1680
Arita ware, porcelain decorated in underglaze blue
H. 51 x Diam. (lid) 8 cm (20⅛ x 3⅛ inches)

The bulbous body of this large bottle is decorated with four white shield-shaped panels, each of which encloses the motifs of peonies and a single myna bird. Two of the birds are depicted in flight, while the other two perch on the peony plants. The entire design is executed in brilliant shades of light and dark blue glaze. Spaces between the panels and the border areas at the base, shoulder, and neck of the bottle are ornamented with scrolling patterns known as *karakusa* (T'ang-dynasty Chinese grasses) or "octopus tendrils." A sense of symmetry is evident in the overall design scheme. The wide shoulder area is filled with *karakusa*, enriched by large peony blossoms placed above the stationary birds in two of the panels. The two birds that flutter about in the same shoulder area appear to be looking downward at their two flying companions within the cartouches. This type of design scheme with cartouches enclosed by ornamental borders is derived from Chinese blue-and-white ware, produced at the Ching-te-chen kilns in the second half of the sixteenth century especially for the Portuguese market, and known to the Dutch as *Kraak porselein* (Carrack porcelain).[1] The shape, size, and design of this bottle must have been specified by the Dutch East India Company.[2] Such large, perfectly shaped wares are believed to have become numerous in Japan by the second half of the seventeenth century. Among the many examples extant today, it is rare to find ones with lids like this one, although unfortunately its top knob has broken off.

NOTES

1. John Ayers et al., *Porcelain for Palaces—The Fashion for Japan in Europe: 1650-1750* (London: Oriental Ceramic Society, 1990), no. 91.
2. Dutch East India Company's orders after 1675 specified liquid volume for these bottles. See Nishida Hiroko, *Nihon Tōji Zenshū* (Compendium of Japanese Porcelain) (Tokyo: Chūōkōronsha, 1976), vol. 23, pl. 41. Almost identical bottles have been published in Nishida, *Nihon Tōji Zenshū*; Ayers, *Porcelain for Palaces*, no. 54; and Yabe Yoshiaki, *Imari*, Nihon no Bijutsu no. 157 (Tokyo: Shibundō, 1979), fig. 75.

Blue & White
Chinese Style
Well potted
diff Blues.
Rem of Chinese Ware
Survives c lid – Knob lost
Kusha Bottles learned

63.

Plate with Pronk Design of a Courtesan and Attendant with an Umbrella

Edo period, early eighteenth century
Arita ware, porcelain with overglaze enamels and gold
Diam. 23.5 cm (9¼ inches)
PUBLISHED: Julia Meech, *Rain and Snow: The Umbrella in Japanese Art* (New York: Japan Society, 1993), no. 123; Miyeko Murase, *Urban Beauties and Rural Charms: Japanese Art from the Mary and Jackson Burke Collection* (Orlando, Fla.: Loch Haven Art Center, 1980), no. 52.

Decorated in polychrome enamel and gold, this plate features a design of a courtesan with an attendant holding an umbrella above her head as they stroll toward several exotic-looking birds. This theme is an oddity within the repertoire of Japanese decorative motifs. The courtesan wears her kimono with a bold decolletage, and one of the birds confronting her in a somewhat aggressive manner has a fluffy collar around its neck. These particular fowl have been identified as wading birds native to the Netherlands.[1]

However odd it may seem, this plate design was actually quite common in the eighteenth century, and an exhaustive study of its history has been published.[2] According to this investigation, the Dutch East India Company commissioned an Amsterdam artist named Cornelis Pronk (1691-1759) to produce a number of ceramic designs in 1734 and 1737. These designs were meant to be copied by Chinese and Japanese potters, and Pronk accordingly created a series of "chinoiseries" depicting figures that are, strictly speaking, neither Chinese nor Japanese in appearance. His drawings, now in the Rijksmuseum in Amsterdam, were sent to China in 1736 to be copied in three different color schemes: blue-and-white, polychrome enamel, and "color and gold."[3] Only one of the drawings of the "ladies with a parasol" was sent to Japan, where it was scheduled to be copied in both enamel with gold and blue-and-white. The official record of the company notes that Japanese prices were too prohibitive to allow for sufficient profit, and the order was cancelled in 1740. Apparently, however, the plates were produced on a purely private basis. The "lady with a parasol" design

enjoyed a long-lasting popularity in Europe, where it was imitated by Dutch enamelers on imported porcelains and Delft wares, and later copied at various porcelain factories.

The singular history of this type of plate explains the rather un-Japanese appearance of the courtesan, the rigid, almost humanlike stance of the birds, and the schematized decoration of the two border areas. The inner border is ornamented with sprays of flowers and rosettes, while the outer border, with its honeycomb ground, consists of four cartouches enclosing wading birds and framed in scroll work that alternates with shield-shaped panels. The panels display the figures of two courtesans and two attendants with parasols. On the back of the plate is a motif of seven insects in red glaze, another anomaly among Japanese ceramic designs. Japanese versions of this plate, executed in blue-and-white or with enamel decoration, were produced in a variety of sizes. This example is slightly smaller than other, similar pieces that are still extant.

NOTES

1. John Ayers et al., *Porcelain for Palaces—The Fashion for Japan in Europe: 1650-1750* (London: Oriental Ceramic Society, 1990), no. 70.
2. C. J. A. Jörg, *Pronk Porcelain: Porcelain after Designs by Cornelis Pronk* (Groningen: Groningen Museum, 1980); and *Kobe Shiritsu Hakubutsukan Kaikan Kinen Tokubetsu Ten, Umi no Silk Road* (In Commemoration of the Opening of the Kobe City Museum, The Silk Road on the Sea) (Kobe: Kobe Shiritsu Hakubutsukan, 1982), pls. 135-37.
3. One of them is reproduced in Julia Meech, *Rain and Snow: The Umbrella in Japanese Art* (New York: Japan Society, 1993), no. 123a.

Cornelius Jancks design
Dutch post this design for production to
Japan — Too expensive to do in
Neckline too low
Waterhoet . Netherlands
Arabesque shapes · European

Cobalt Blue Imari
Overglaze Red

64.

Kōgō (Incense Box) with Design of Cart Wheels Half-submerged in Water

Muromachi period, fifteenth century
Gold *maki-e* on black lacquer
H. 2.2 x W. 5.7 x L. 7.7 cm (³⁄₄ x 2¹⁄₄ x 3 inches)

Lacquer, a viscous substance obtained from the sap of the lacquer tree in central and southern China and Japan, was used in those countries as a coating and as an adhesive for binding. In prehistoric times, lacquer was combined with pigments while still in a liquid state, which helped enhance the aesthetic effect of painting, inlays, and other techniques. Examples of ancient lacquer-decorated Chinese objects in wood, metal, and textile have been excavated in great numbers in recent years.

The greatest Japanese contribution to the art of lacquering was the refining of the *maki-e* technique, in which minuscule flakes of gold and silver foil are sprinkled and scattered (*maki* or *maku*) to create effects similar to painting (*e*) on the lacquered surface. This is a time-consuming and exacting technique. Where decorative patterns are desired, finely ground metallic dust or pigments are first sprinkled on a lacquered surface that has not yet hardened. In the oldest *maki-e* technique, which is the most difficult but produces the most durable wares, several coats of black lacquer are then applied over the gold- or silver-filled areas of the designs and charcoal is used to gently scrape off the lacquer layers until the "sprinkled" picture (*maki-e*) reappears. Finally, a protective coating of clear lacquer is applied.

The technique was most likely imported from China, but Japanese lacquerers "exploited every physical property of lacquer . . . and developed this to the highest order."[1] The Japanese applied the *maki-e* technique not only to small personal belongings but also to the interior walls of palaces. *The Tale of the Bamboo Cutter* (*Taketori Monogatari*), dated sometime between the early ninth and the tenth century, describes a sumptuous house decorated in *maki-e*.[2] Other documentary sources indicate that *maki-e* was a popular lacquering technique that enriched the everday life of the Heian aristocracy in the tenth century.[3] *Maki-e*-ornamented Japanese lacquers soon became coveted gifts to the Chinese and Korean courts of the late tenth and eleventh centuries.[4]

In the late sixteenth century, when the Portuguese and Spanish began trading in Japan, Japanese lacquer became an export item as important as ceramics. In 1610, a company was established in Amsterdam to handle lacquer imports.[5] The use of the term "japanning" for varnish done in imitation of Japanese or Chinese lacquer vividly recalls the enormous popularity that lacquer, especially Japanese lacquer with *maki-e* designs, enjoyed in Europe.

A series of technical and stylistic innovations marks the history of *maki-e*. Especially noteworthy is the development of the so-called Kōdaiji *maki-e* that was produced in the sixteenth and early seventeenth centuries; three examples of this type are included here.

Originally, this small box held articles used for *haguro*, a curious custom of blackening one's teeth with a liquid usually obtained by immersing heated iron filings in thick tea (see no. 69). The origin of *haguro*, an important mark of beauty for both men and women of ancient Japan, is obscure. It seems to have originated even before the Nara period, and during the Heian period it was regarded as a sign of sophistication and gentility. Its symbolic application formed an important part of the maturity ceremony for boys and girls at the age of nine. Nobles at the court of Kyoto continued to use *haguro* through the Edo period. Because it symbolized fidelity, young women of that period usually applied *haguro* on their teeth only after marriage, and an example of this practice is found in a painting included here (no. 42).

Although it is now customary to use these small *kōgō* at tea ceremonies, such boxes were originally part of a large set of toiletry articles, distinguished from other

types of containers by their rectangular shape. Extant examples of complete sets of cosmetic boxes indicate that two of each of three different kinds of boxes were usually placed in a large container, including square-shaped boxes for face powder, round and rectangular ones for incense, and rectangular ones for *haguro*. This *kōgō* was separated from its set and used in the tea ceremony. Before the late sixteenth century, when the Japanese began making small pottery boxes specifically designed for incense, such small lacquer vessels were often substituted for extremely popular but rare and expensive porcelain containers imported from China.

The lead rims of the lid and base of this box meet at the sides, and the gently curving top of the lid rises from the indented ledge. The lid and four sides of the

base are decorated with wheels shown half-submerged in water, which depicts the ancient and common practice of immersing wooden ox-cart wheels in water to prevent them from drying out. At the same time, the design must have been inspired by the frequent references to wheels made in Buddhist scriptures and paintings, where they appear as metaphors for the law of Buddha that turns and reaches out to the wide world. This motif was especially popular during the Heian period, when it was used on bronze mirrors, lacquerware, and paper. A twelfth-century example of a large box with this design in the Tokyo National Museum is well known. The motif continued to be popular in the Kamakura period when another famous box with this pattern was made (also in the Tokyo

241

National Museum).[6] In the Burke piece, the background of this design is covered with fine gold speckles, producing an effect known as *nashiji* ("pearskin") because it resembles the spotted skin of Japanese pears. On the inside of both lid and base are small butterflies and birds fluttering among spring and autumn flowers that were also common motifs of the Heian period.

Although the decorative designs on this *kōgō* are based on earlier Heian motifs, the shape of the box points to a Kamakura or later date, as does the vigorous and lively depiction of the waves that break against the wheels. Many Heian-period design motifs were also used within revivalistic trends of the Muromachi period. This box reflects that spirit.

NOTES

1. James C. Y. Watt and Barbara Brennan Ford, *East Asian Lacquer: The Florence and Herbert Irving Collection* (New York: The Metropolitan Museum of Art, 1991), 7.
2. Donald Keene, "The Tale of the Bamboo Cutter," *Monumenta Nipponica* 11, no. 4 (January 1956): 341.
3. These include the *Tales of Ise*; see Helen Craig McCullough, *Tales of Ise: Lyrical Episodes from Tenth-Century Japan* (Stanford: Stanford University Press, 1968), episode no. 78, p. 122; Arakawa Hirokazu, ed., *Maki-e*, Nihon no Bijutsu no. 35 (Tokyo: Shibundō, 1969), 48.
4. These appear in history books of the Sung and Koryo dynasties; see Arakawa, *Maki-e*, 48.
5. Yabe Yoshiaki, *Nihon Bijutsu Zenshū* (Survey of Japanese Arts) (Tokyo: Kodansha, 1991), 15:188.
6. Both are reproduced in Nishikawa Kyōtarō et al., eds., *Kokuhō* (National Treasures) (Tokyo: Mainichi Shimbunsha, 1984), vol. 6, no. 61 (Heian piece) and no. 62 (Kamakura piece).

65.

Sumiaka Tebako *(Red-Cornered Accessories Box) with Design of Chrysanthemums and Autumn Grasses*

Momoyama period, sixteenth century
Gold *maki-e* on black lacquer; red lacquer over coarse cloth
H. 19 x W. 29 x L. 33 cm (7½ x 11½ x 13 inches)
PUBLISHED: Yoshimura Motoo, *Maki-e* (Kyoto: Kyoto Shoin, 1976), pl. 2; Kyoto Furitsu Sōgō Shiryō-kan, ed., *Maki-e* (Kyoto: Kyoto Furitsu Sōgō Shiryō-kan, 1967), pl. 34.

This large box, a *tebako*, was used to store personal accessories. It contained a tray and smaller boxes for combs, mirrors, and utensils for *haguro* (teeth-blackening; see no. 69), among other objects. Many examples of *tebako* exist, including a famous twelfth-century example, in the Tokyo National Museum, decorated with a design of half-submerged wheels. Such boxes were usually placed on a shelf, as can be seen in many interior scenes depicted in *emaki* (or *emaki-mono*, narrative handscroll painting). The most instructive scene for the study of this particular type of *tebako*, known as *sumiaka* (red-cornered), appears in the *Boki Ekotoba* of 1351 and depicts a monk's quarters in a temple.[1] A box,

possibly a prototype for a *sumiaka tebako*, but without *maki-e* ("sprinkled picture") designs, stands on a shelf next to a folding screen.

Sumiaka tebako, commonly made in sets of different sizes to hold cosmetics and other personal effects, became part of bridal trousseaux, which were standardized toward the beginning of the Edo period. Examples of sumptuous trousseau sets prepared for shoguns' daughters are still preserved: one of them, probably made in 1628, is in the Okayama Museum, and the other, made between 1637 and 1640, is in the Tokugawa Museum.[2] A complete trousseau was placed on three sets of shelves. *Sumiaka tebako* were part of a large group of lacquered items, which suggests that a rather strict code regulated what they contained. A manual on their content published in 1793 lists, illustrates, and gives the dimensions of each of the 300 items to be included in a trousseau set.[3] It stipulates that *sumiaka tebako* should be made in two sizes; a larger one, 36 cm in length, 28 cm in width, and 25 cm in

242

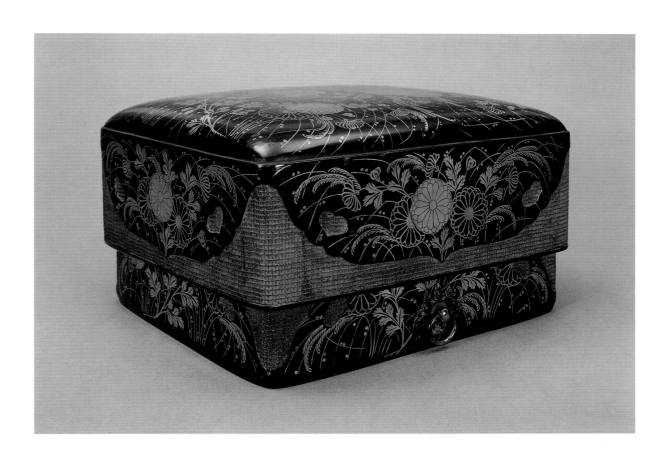

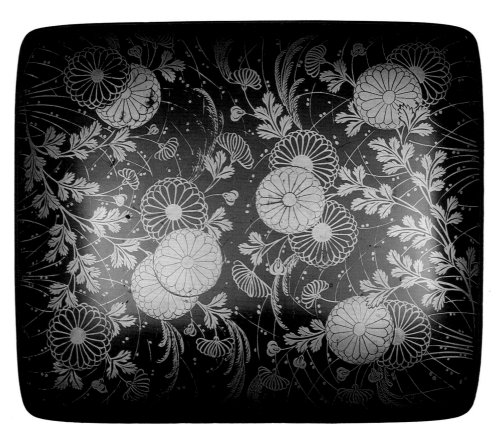

height; and a smaller one, 24 cm in length, 18 cm in width, and 15 cm in height.[4]

Interestingly, the *Teijō Zakki* (*Miscellaneous Notes*),[5] a record kept by Ise Sadatake in the form of a diary from 1763 until his death in 1784, does note that anything of a personal nature for everyday use could be stored in a *sumiaka tebako*, and that no specific rule as to its contents was to be observed. Furthermore, Sadatake notes that by his time *sumiaka tebako* were out of fashion, except as decorative pieces in trousseaux.

The present box is one of the earliest known examples of *sumiaka tebako*. Its dimensions roughly fit the larger size specified in the *Chōdo Zue*, except for its height. The ample lid that deeply overlaps the base has an elegant design of chrysanthemums and autumn grasses gently swaying in wind. Variations in the color of the gold were created by the different *maki-e* techniques used. But the most dramatic color is the red lacquer, applied to the coarse cloth surrounding parts of the lid and base and also visible through two small heart-shaped cutouts. On the long sides of the base are metal knobs in the shape of flowering paulownia, which held a silk cord. The paulownia, a symbol of royal power, had long been associated with the Imperial court, which began the custom of bestowing pictorial use of this symbol upon shoguns in the early fourteenth century. Hideyoshi had a particular fondness for it,[6] and this motif appears regularly on so-called Kōdaiji lacquerwares, discussed in greater detail below.

The origin of the *sumiaka* box is unclear. In the past, scholars suggested that the red cutout areas imitated metal fittings.[7] The idea of contrasting elegantly lacquered areas with undecorated portions in coarser material may have been inspired by Chinese or Ryūkyū baskets with lacquered panels, some of which have cutout areas similar to those found on *sumiaka* boxes.[8] Although the Chinese or Ryūkyū pieces are finely woven bamboo baskets, and *sumiaka* boxes are cloth-covered wood, the contrast created between the two different materials and colors in each case is dramatic.

The shape of this box is strong. The gently curving top and slightly swelling sides on the overlapping lid suggest a sixteenth-century date. This relatively early date is also suggested by the freedom of the drawings of autumnal grasses and chrysanthemums. Large, round floral forms are depicted either in flat gold *maki-e*,

with details scratched out by needles, or in gold outlines, a simple yet effective technique to create a variation in color against a black, lacquered background. Tiny dots of gold depicting autumn dew are paired along the delicate stems of miscanthus plants, some of which are eared. The large floral patterns arranged in this simple composition and the free, relaxed execution of designs suggest that this box was created sometime before Kōdaiji-type lacquerworks reached the full maturity reflected in the Drum Body (no. 66) and Table (no. 67).

The best Momoyama-period lacquer depicts a simple bold motif, with the design reduced to essential features to create a striking contrast of gold against black. The techniques used to produce these dramatic-looking objects signal a complete departure from the older *maki-e* technique.

The name given to these lacquerwares, Kōdaiji, is derived from the name of a small building built in Kyoto by the widow of Hideyoshi (d. 1598) as a mortuary temple for her husband and herself.[9] The interior ornament of the chapel of this temple, Mitamaya, and various utensils (probably favorites of the couple) are decorated in the *maki-e* technique; their designs are very similar to those found on the Burke box. Decorating the interiors of buildings with *maki-e* was not unique to this temple; the practice actually goes back to the Heian period. Other large structures of the Momoyama period, such as Nobunaga's Azuchi Castle, were extensively decorated with lacquer. Tradition also has it that the Mitamaya of Kōdaiji was built in 1608 from materials removed from Hideyoshi's own Fushimi Castle, built between 1594 and 1597 (demolished in 1622). There are also similarly ornamented lacquerwares in other Kyoto temples traditionally associated with Hideyoshi. The term *Kōdaiji maki-e* is applied to all these objects.

Apart from featuring large decorative motifs like autumn grasses, Kōdaiji lacquers differ from traditional *maki-e* in that a much simpler method of *maki-e* was employed to produce them. Gold or silver dust was often left exposed, and without a protective coating of shiny, clear lacquer; it produced a soft, subtle effect. Delicate details, like the veins of leaves, were simply incised into lacquered areas, while in traditional *maki-e* these elements were delineated carefully by finely

lacquered lines. Some design motifs were filled in with fine gold speckles, creating an effect known as *nashiji* ("pear-skin"), which can be observed on the Drum Body and Table, but was also applied to background areas on traditional *maki-e* objects. The use of *nashiji* within design motifs was called *e-nashiji* (picture *nashiji*) to distinguish it from the traditional method; it facilitated variations in gold hues and was an efficient and innovative method for creating dramatic contrast with a plain black background.

A dated inscription and signatures of the artist are found on the lacquered wood parts of the Mitamaya of Kōdaiji. It is generally agreed that the inscription refers to "Kōami" and to the year corresponding to 1596.[10] The Kōami were members of the leading lacquer-making family active from the Muromachi through the Edo period. The decoration on some of the utensils preserved in Kōdaiji combines the new innovative techniques of the so-called Kōdaiji style with the more elaborate traditional *maki-e* technique, a blending of styles which strongly resembles that used on some lacquerwares firmly attributed to Kōami artists. On the other hand, the so-called Kōdaiji style is strikingly similar to the decoration applied to a number of lacquerwares known as *Namban* lacquer. The term *Namban* ("Southern Barbarians") referred to European visitors, mostly Portuguese and Spaniards, who were viewed with curiosity in sixteenth-century Japan. These foreigners purchased large quantities of Japanese lacquerware to decorate their European homes, and in 1610 a lacquer company was established in Amsterdam for the purpose of acquiring more pieces.[11] Letters from these visiting merchants to their friends and colleagues often refer to the progress being made on their purchases.[12] These records suggest that some large workshops in Kyoto, employing as many as fifty artisans, labored to meet their demands.[13] These shops may have specialized in export wares, mass-producing them in simple, quick techniques, which led, perhaps unwittingly, to a direct, vivid and sensuous style. It has been speculated that in order to complete large commissions from Hideyoshi, the Kōami family employed unknown artisans, thus injecting into their own traditional style a freedom and vitality that characterize works made outside their own official atelier.

NOTES

1. Scroll II of this *emaki*, in the Nishi Honganji Collection, is published in Komatsu Shigemi, ed., *Zoku Nihon Emaki Taisei* (Japanese Handscroll Painting, Continued) (Tokyo: Chūōkō-ronsha, 1985), 4:16.
2. For the examples of trousseaux including *sumiaka* boxes, see Yoshiaki Shimizu, ed., *Japan: The Shaping of Daimyo Culture: 1185-1868* (Washington, D.C.: National Gallery of Art, 1988), nos. 227-28.
3. Saitō Gyokuzan, *Konrei Dōgu Zushū* (Illustrated Guide to Trousseaux), vol. 2 of *Nihon Koten Zenshū* (Japan's Classical Material) (Tokyo: Nihon Koten Zenshū Kankōkai, 1937), 346-47.
4. *Chōdo Zue* (Pictorial Guide to Furnishings) of 1804 also gives similar stipulations. See Yoshimura Motoo, *Maki-e* (Kyoto: Kyoto Shoin, 1976), 1:147.
5. "Teijō" is another reading of his name. His notes were published in 1843. Ibid.
6. James C. Y. Watt and Barbara Brennan Ford, *East Asian Lacquer: The Florence and Herbert Irving Collection* (New York: The Metropolitan Museum of Art, 1991), 159.
7. Yoshimura, *Maki-e*, 1:146; Beatrix Von Ragué, *A History of Japanese Lacquerwork*, trans. Annie R. de Wasserman (Toronto and Buffalo: University of Toronto Press, 1976), pl. 142; Watt and Ford, *East Asian Lacquer*, no. 103.
8. James C. Y. Watt, *The Sumptuous Basket* (New York: China House Gallery, 1985).
9. Kyoto National Museum, ed., *Kōdaiji Maki-e* (Kyoto: Kyoto National Museum, 1971).
10. Ibid., 31 ff; Arakawa Hirokazu, *Namban Shitsu-gei* (Lacquerworks of Namban) (Tokyo: Bijutsu Shuppan, 1971).
11. Yabe Yoshiaki, *Nihon Bijutsu Zenshū* (Survey of Japanese Arts) (Tokyo: Kodansha, 1991), 15:188.
12. Arakawa, *Namban*, 124-28.
13. Ibid.

66.

Body of Large Drum (Ōtsuzumi) with Design of Tigers and Pines

Momoyama period, late sixteenth century
Gold *maki-e* on black lacquer
L. 27.8 x D. 11.2 cm (11 x 4¼ inches)

The earliest examples of hourglass-shaped hand drums that have wood cores decorated in *maki-e* ("sprinkled picture") are from the fourteenth century. Later, in the Momoyama period, the decoration on these hand-held drums became more elaborate, reflecting the spirit of the time. Large drums (*ōtsuzumi*) like the piece shown here, and slightly smaller ones, about ten inches in length, were originally used in religious ceremonial concerts dedicated to temples, but they later became one of the most important musical instruments used on the secular stages of Noh and Kabuki theaters. Generally made of cherry or zelkova wood, these drums are held over the left shoulder of the player, who strikes a horsehide-covered end with his or her right hand. The horsehide covers at both ends are lashed onto the richly ornamented core.

A distinguishing mark of the large drum core is the carved ring in the middle of the shaft; it tapers slightly outward, whereas the shaft of the smaller drum (*kotsuzumi*) is smooth and straight. On the two end portions of this drum core, tigers are shown among pines and bamboos (one of the most popular combinations of motifs used to decorate palace and castle walls during the Momoyama period). The animals and plants are arranged so that the pictorial motifs can be viewed from a "correct" angle, regardless of the way in which the drum is made to stand when not in use. On one end, a tiger stalks with its legs splayed wide, while on the opposite end another tiger is shown lying down and scratching itself. The only animal that will be seen upside down when the stalking tiger is properly positioned is depicted in a running pose on the shaft—the part most likely to be damaged because the player's left hand is placed there while the right hand strikes the horsehide. It is difficult to determine whether the design was intended to depict a family of tigers or a single animal in three different poses.

The design is a typical example of fully evolved Kōdaiji-style *maki-e*: a combination of gold *maki-e*, *nashiji* (for the ring on the shaft), and *e-nashiji*, that is, *nashiji* (fine gold speckles, also known as "pear-skin") confined within small areas of the pictorial motif like the rounded hillocks, where the pine trees stand, the cavities in the tree trunks, and the wheel-like circular forms of pine needles. These areas received only a sparse application of gold powder, which produced a reddish glow. The simple and bold designs of animals and plants cover the surface of this small object and create the illusion of a monumental composition.

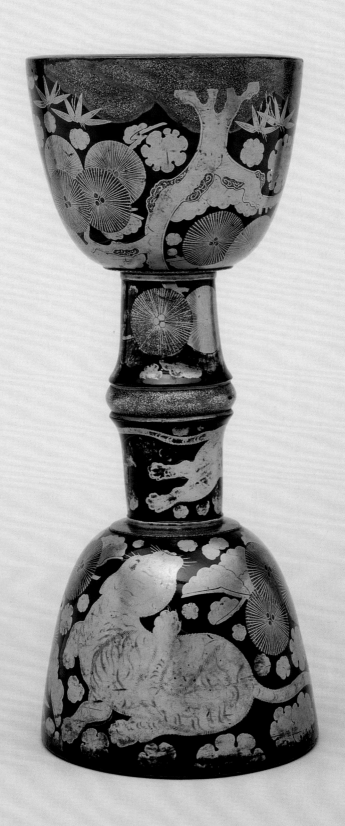

67.

Table with Design of Autumn Flowers

Momoyama period, late sixteenth century
Gold *maki-e* on black lacquer
H. 45.8 cm; shelves, 25.6 x 24 cm (18 inches; 10 x 9½ inches)

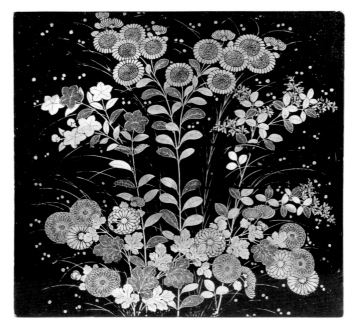

This slender and elegant table, originally placed in front of Buddhist icons to hold incense burners and other small objects, may have been converted later for use in the tea ceremony. The top shelf shows greater wear than the middle shelf. The bottom shelf is covered by plain black lacquer, while the top and middle shelves are decorated with similar designs of autumn grasses—chrysanthemum, Chinese bell-flower, and miscanthus, with the addition of bush clover on the top shelf and wild pink on the middle shelf. The slim, delicate plants sway gently in an autumn breeze that scatters pearls of dewdrops. The edges of the shelves and the vertical posts are covered with a design of pine seedlings.

The variation in the *maki-e* ("sprinkled picture") technique makes up for the limited design vocabulary. As in the large *sumiaka* box (no. 65), the black ground is left undecorated, drawing our eye to the gold-filled leaves and flowers executed in the technique called *e-nashiji* (picture *nashiji*; *nashiji*, or "pear skin," is the effect created by fine gold speckles).[1] Further color contrast is produced by the areas packed with fine gold powder. Other portions are covered only sparsely with coarser, flat particles of gold, which create a reddish tinge. Extremely fine gold powder was sprinkled directly over the carefully applied wet lacquer to delineate the threadlike leaves of miscanthus, the small dewdrops that dance around them, and the thinly executed stems and veins of other plants. Gold-filled lines created in this way intensify the reddish color of some *e-nashiji* motifs, producing a sharp and dramatic contrast of color and texture within small flowers and leaves. Negative outlines are created by the *kakiwari* ("dividing drawing") technique, in which black areas of ground are kept in reserve during the sprinkling of gold filings. The most time-saving and daring innovation made in the production of export items, popularly called *Namban* lacquer (lacquer for the *Namban*, the

"Southern Barbarians" from southern Europe), was to scratch out gold-filled areas with a needle to create extremely thin lines, a method known as *harigaki* (needle drawing). This facilitated the delineation of such fine detail as the contours of individual petals of chrysanthemum flowers and veins of leaves.

The technique of Kōdaiji *maki-e* was greatly influenced by techniques of *Namban* lacquer, which was produced in great quantity. This resulted in a certain paring of processes, and one perhaps unintentional by-product was a freer, uninhibited style of decoration. For example, unlike traditional *maki-e*, Kōdaiji *maki-e* made no use of preliminary drawings. The designs were drawn directly onto the lacquered surface. No final coating of clear lacquer was applied over the sprinkled gold filings, and this produced a warm, intimate effect. Above all, no *maki-e* was applied on the background, allowing the *e-nashiji* to provide not only texture but also color contrast.

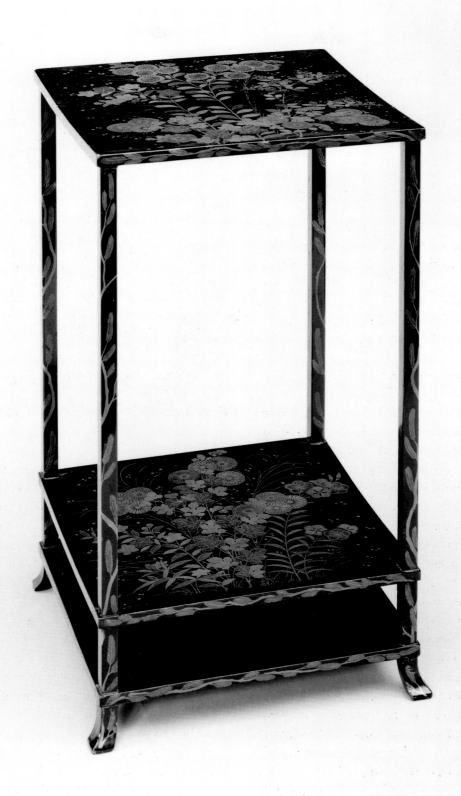

Design motifs were also limited in an attempt to facilitate production. As on this table, autumn grasses or family crests dominate the design vocabulary. Yet these objects are also imbued with a sense of fresh energy by the technique of *maki-e*. This table typifies the Kōdaiji *maki-e* style at its best, especially in the choice of motifs and technique of execution. On the back of the bottom shelf is a hand-written seal, which probably belonged to the unidentified previous owner of this object.

NOTE

1. For a detailed discussion of various *maki-e* techniques, see James C. Y. Watt and Barbara Brennan Ford, *East Asian Lacquer: The Florence and Herbert Irving Collection* (New York: The Metropolitan Museum of Art, 1992), 154-60.

68.

Mirror with Handle, with Design of Copper Pheasant on Chestnut Oak Tree

Edo period, mid seventeenth century
Silver *maki-e* and red lacquer on bronze
Diam. 13.6 cm; Handle L. 23.4 cm (5¼; 9¼ inches)
SIGNATURE: "Tenka Ichi Inbe no Kami"

Mirrors, indispensable items of practical use today, were endowed in ancient times with many spiritual and mystical qualities. They were thought to possess magical powers that could ward off evil influences, and were thus regarded as potent guardians. Metal mirrors were in use in ancient Egypt and China, and bronze mirrors have been excavated regularly with other metal artifacts from Shang dynasty and later Chinese tomb sites. In Buddhist practice, mirrors were placed in front of Buddhist icons or interred with other objects beneath pagodas. In time they came to symbolize power and authority, and in Japan, where Chinese mirrors were introduced during the Yayoi period, a mirror was chosen as one of the three sacred objects to symbolize the legitimacy and authority of the emperor. The other two were a sword and *magatama* (curved jewel).

Japanese mirrors made prior to the Late Heian period were modeled closely after Chinese prototypes.[1] However, new types evolved during the Late Heian period as indigenous tastes and temperament asserted themselves in the creation of a native aesthetic.

The prototypical Chinese mirror had a knob set in the center of its back (that is, its decorated side). A silken cord was put through this knob so that the mirror could be hung. The introduction of a new type of Southern Sung mirror in the late Muromachi period brought an end to this traditional mirror shape. For the new mirror, a short handle was attached to the circular section, rendering the knob obsolete. This new type achieved a much-desired unity of design for the decorated side by eliminating the interruption of the knob. Handled mirrors were small at first, with narrow handles that were generally longer than the mirror's diameter. The circular sections gradually became larger in diameter and, in reverse proportion, the handles became shorter in the late seventeenth century.[2]

The example shown here belongs to this new type. A copper pheasant rests on a chestnut oak tree that bends its trunk and branch to follow the contour of the mirror. Tiny silver particles were applied to some leaves of the tree, feathers, and tails of the bird, which were rendered in red lacquer. The bold simplicity of the design echoes the brilliant decorative style that was the hallmark of the Momoyama period. On the left side is a signature in relief that reads "Tenka Ichi Inbe no Kami" (Number One under the Sky, Lord of Inbe Province). This brazen proclamation "Tenka Ichi" was the title devised by Oda Nobunaga (1534-1582) during the short

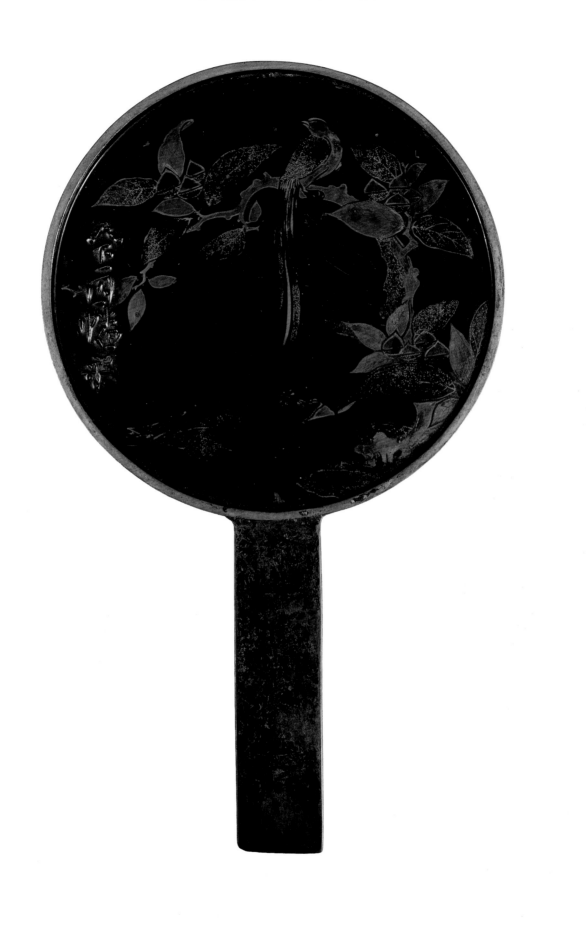

period of his dominance over the country, in order to encourage and advance the cause of craftsmen such as lacquerers, potters, Noh mask carvers, and metal workers. One craftsman who was considered the best in his chosen field was allowed to proclaim himself with this title. This well-meaning policy, however, soon came to be abused and its indiscriminate use made it meaningless; in 1682 its use was banned altogether.[3]

Bronze mirrors with *maki-e* ("sprinkled picture") decoration, such as the one shown here, are extremely rare. Only one other example is known. Almost identical in design, it is also signed "Tenka Ichi Inbe no Kami."[4] This signature is known to have been used only on mirrors that date from the Kambun era (1661-1672).[5]

NOTES

1. For a general discussion of Japanese mirrors, see Nakano Masaki, ed., *Wakyō* (Japanese Mirrors), Nihon no Bijutsu no. 42 (Tokyo: Shibundō, 1969), and Tanaka Taku, ed., *Kokyō* (Old Mirrors), Nihon no Bijutsu no. 178 (Tokyo: Shibundō, 1981).
2. Nakano, *Wakyō*, 62.
3. Ibid., 60-61.
4. This mirror is in a Japanese collection; see Narukami Yoshio, *Ekagami Hyakusen* (One Hundred Selected Masterpieces of Handled Mirrors) (Tsu, Mie prefecture: Ekagami Sansō, 1968), no. 1. The artist who signed his mirrors with the name "Tenka Ichi Inbe no Kami" is known to have been active around the mid seventeenth century. See Nakano, *Wakyō*, 110. Inbe (or Inaba) is a part of the modern Tottori prefecture. This name, however, does not mean that the artist had any territorial claim there. Such names were often chosen at random.
5. Nakano, *Wakyō*, 110.

69.

Tebako *(Accessories Box)*

Edo period, seventeenth-eighteenth century
Rectangular box with drawer and interior fitted tray; lacquer on wood, with decoration in gold *maki-e*, silver flakes, and inlay
H. 19.1 x W. 25.4 x L. 20.3 cm (7½ x 10 x 8 inches)

Visualization of episodes and motifs from the eleventh-century classic, the *Genji Monogatari* (*Tale of Genji*) was not limited to painting. From at least the thirteenth century on, pictorial references to chapters or poems from the tale appeared in a variety of artistic media. In a diary kept between the years 1271 and 1306, Lady Nijō, an aristocratic woman in attendance at the court of ex-emperor Go-Fukakusa (reigned 1247-1259), described one of her garments as being ornamented with motifs meant to call to mind a specific verse from the novel.[1] Lacquerwares became a popular vehicle for *Genji* images, often rendered as simple combinations of pictorial elements intended to invoke a certain chapter, event, or character from the narrative. Extant lacquer pieces from the Muromachi period on bear *Genji*-related designs, some as minimalistic as a bush warbler

on a prunus branch—a reference to the "Hatsune" ("First Warbler") chapter[2]—and others more detailed, with landscapes, figures, and architectural structures. During the Edo period, *Genji* scenes were frequently used to decorate sets of lacquer objects provided as part of the dowry goods taken by brides to their new homes and subsequently exhibited on tables, stands, or cabinets made especially for that purpose.[3]

This elegant *tebako* (box for personal accessories and toiletry articles) has metal fittings on the front and back and a small drawer on one side. It may have once belonged to a set of lacquer pieces produced as a portion of the trousseau of a young girl from either an aristocratic or affluent samurai family. The sumptuous nature of its decoration indicates that it was probably intended for show rather than common, everyday use.

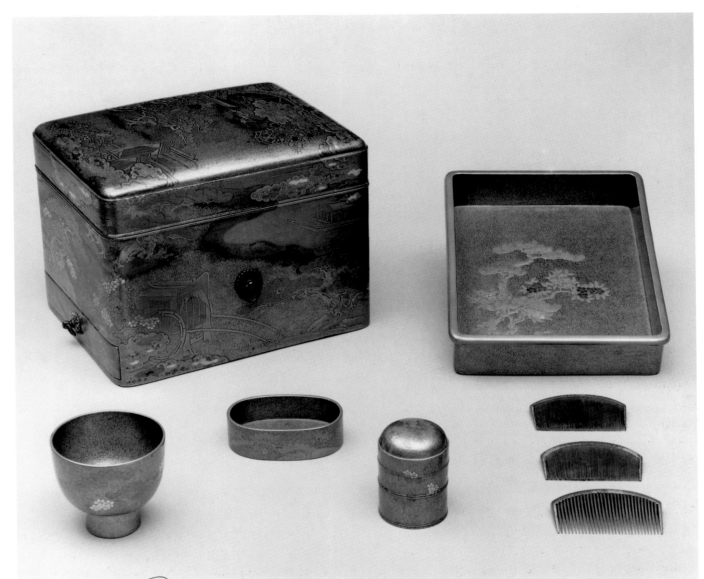

Tale of Sagi
Ch. After Suglas - see Lody's boat
Humble Family

Other objects included in such dowry sets often included letter boxes, incense containers and utensils, a mirror stand, comb boxes, and a variety of toiletry articles, clothing cases, and implements for serving food and drink.

Lacquer pieces made for a single trousseau often featured the same ornamental theme. The pictorial elements that appear on the lid of the Burke Collection *tebako* derive from "Miotsukushi" ("Channel Buoys"), the fourteenth chapter of the *Genji Monogatari* (see also no. 37); they consist of an arched bridge, *torii* (a gatelike structure with two horizontal rails, used to mark the entry to a Shinto shrine precinct), two carriages, pine trees, blossoming cherry trees, and a fruit tree enclosed by a low fence. The four sides of the box are also decorated with pines, cherry trees, and carriages; in the distance several boats—small sailboats and one larger, more elaborate vessel—can be seen. These motifs are all rendered in gold and silver *maki-e* ("sprinkled picture"); the silver has oxidized over time to a dark grayish tone. In the billowing clouds, a pictorial convention derived from painting, miniscule inlays of cut gold and silver in both geometric and irregular shapes create tiny points of light on the already glowing surface. A variety of *maki-e* techniques add to the overall impression of richness: *nashiji* (fine gold speckles, also known as "pear-skin") forms the backdrop to shapes built up in low relief through the application of gold *takamaki-e* (raised sprinkled designs). Patterns of swirling and rippling water were rendered by *tsukegaki*, a method in which metal filings are dusted over fine brushstrokes of liquid lacquer applied to an already decorated surface; the result is a pattern of slightly raised lines in gold or silver.[4]

As is often the case in illustrations of episodes from the *Genji Monogatari*, symbolic representation takes precedence over a realistic depiction of events. The high *torii* gate on the lid represents the famous Sumiyoshi Shrine in Osaka prefecture, to which Prince Genji has made an autumn pilgrimage. Elaborately ornamented carriages indicate the presence of Genji and his lavishly caparisoned retinue of attendants, which includes his son Yūgiri. The high, curved bridge and large pine tree are also emblematic of the Sumiyoshi Shrine; without them, the scene could be mistaken for an illustration of a segment of the "Nonomiya"

("Shrine in the Field") chapter, which also features a carriage and a *torii* gate.[5] The boats on the sides of the Burke Collection box refer to the arrival of the Akashi lady, a young girl with whom Genji became romantically involved during a period of exile earlier in the tale. Having spent her life in country seclusion, she is overawed and dismayed by the imposing magnificence of Genji's entourage, and departs without so much as seeing her splendid lover.

Certain decorative elements have no particular relevance to this "Miotsukushi" episode. Although Genji's pilgrimage to Sumiyoshi takes place in the autumn, cherry blossoms appear in profusion on the lid and sides of the *tebako*. The fence-enclosed fruit tree on the lid also seems out of place, although it may be a reference to an earlier incident in the chapter in which Genji pays an evening visit to the "lady of the orange blossoms"—another woman who has been the subject of his liberal affections. It is likely that these incongruous motifs are meant to refer to other *Genji* chapters, although their identity cannot be ascertained without further evidence.

The *tebako* contains a number of implements essential to the toilette of a young girl of the upper classes.[6] A set of three combs, or *mitsugushi*, consists of a *tokigushi* (detangling comb), *sukigushi* (fine-toothed comb), and *nadegushi* (smoothing comb). The triple-tiered, cylindrical *aburaoke*, which bears a motif of pine and blossoming cherry trees, contained oil for cosmetic use. The oval basin (*bin-mizuire*) held water for dressing the sidelocks (*bin*) of a lady's coiffure. A small, footed bowl, called a *jōzu*, was employed in the preparation of liquid applied to the teeth in the process known as *haguro* (tooth-blackening). Small slivers or pieces of iron, to which gallnut was sometimes added, were soaked in tea, vinegar, or sake to produce a dark dye with which the teeth were colored. This practice, used since Heian-period times to indicate a girl's coming of age, was also believed to enhance a woman's beauty. In the *Makura no Sōshi* (*Pillow Book*) written by Sei Shōnagon in the early eleventh century, well-blackened teeth are listed under the category of "Things That Give a Pleasant Feeling."[7] Conversely, the twelfth-century story of *The Lady Who Loved Insects* features an eccentric young lady who refuses to pluck her eyebrows or blacken her teeth; her "strange, white gleaming smile"[8] is regarded

as frightening and barbaric by all who behold her. It is possible that the *jōzu* bowl from this box was originally kept in another container from the trousseau set made specifically to hold the bowl, a miniature ewer, and a decorated metal plate called the *watashikane*; the latter was balanced across the rim of a basin during preparation of the liquid stain.

The tray fitted into the top of the *tebako* is ornamented, like the objects inside, with pine and cherry trees in gold and silver *maki-e*. The underside of the lid, however, exhibits the motif of a branch of flowering camellia, wrapped with a blossoming cherry branch. The camellia is not connected to any incident in the *Genji* tale, but it is a plant (indigenous to most of Japan) which was popular not only for its beauty and its association with the spring season, but as a source of oil used to dress the hair.

The *tebako* probably contained other objects meant to hold cosmetics, as well as implements used to apply or prepare them. These might have included boxes for powder used to whiten the complexion, rouge, and pigment for painting false eyebrows. A small razor for shaving the real eyebrows may have accompanied these.

Numerous Edo-period lacquer items that once belonged to the elaborate assemblages of objects taken by brides to their new homes are extant today. Examples of complete or nearly complete sets include the group of lacquerwares known as the "Hatsune no Chōdo" ("Hatsune Furnishings"), presently in the Tokugawa Art Museum in Nagoya; these were made for the trousseau of Chiyohime, oldest daughter of Iemitsu (1604-1651), third shogun of the Tokugawa line. Pieces from the set made for Kanehime, Iemitsu's adopted daughter, are also preserved in the same collection. sw

NOTES

1. Wilfred Whitehouse and Eizo Yanagisawa, *Lady Nijō's Own Story: The Candid Diary of a Thirteenth-Century Japanese Imperial Concubine* (Rutland, Vermont, and Tokyo: Charles E. Tuttle, 1974), 137.

2. One such example is the fifteenth-century incense burner in the collection of Tōkeiji temple in Kanagawa; see *Courtly Splendor: Twelve Centuries of Treasures from Japan* (Boston: Museum of Fine Arts, 1990), no. 52.

3. See *Konrei: Tokugawa Bijutsukan Zōhin 7* (Dowry Items: Treasures from the Tokugawa Art Museum, no. 7) (Nagoya: Tokugawa Art Museum, 1991).

4. For a comprehensive description of *maki-e* techniques, see James C. Y. Watt and Barbara Brennan Ford, *East Asian Lacquer: The Florence and Herbert Irving Collection* (New York: The Metropolitan Museum of Art, 1991), 154-60.

5. An example of this scene in lacquer decoration appears on a *suzuribako* (inkstone case), dated to the seventeenth century, in the collection of the Suntory Museum of Art.

6. *Hatsune no Chōdo: Tokugawa Bijutsukan Zōhin 3* (Hatsune Furnishings: Treasures from the Tokugawa Art Museum, no. 3) (Nagoya: Tokugawa Museum, 1985), 122.

7. Sei Shōnagon, *The Pillow Book of Sei Shōnagon*, trans. and ed. Ivan Morris (New York: Columbia University Press, 1967), 32.

8. Donald Keene, *Anthology of Japanese Literature* (New York: Grove Press, 1960), 170.

70.

Bundai *(Lacquer Writing Table)* with Design of Melons and Squirrels

Momoyama-Edo period, late sixteenth-early seventeenth century
Gold *maki-e* on black lacquer
L. 59 x W. 39 x H. 10 cm (23¼ x 15⁶/₁₆ x 3¹⁵/₁₆ inches)
PUBLISHED: Gunhild Avitabile, ed., *Die Kunst des Alten Japan: Meisterwerke aus der Mary and Jackson Burke Collection, New York* (Frankfurt: Kulturgesellschaft Frankfurt mbH, 1990), no. 113; Doi Kumiko, *Urushi Kōgei no Bi* (The Beauty of Lacquer Arts and Crafts) (Osaka: Osaka City Museum, 1987), no. 10.

Small, low tables (*bundai*) were originally used by those engaged in writing or viewing scrolls while seated on the floor. Eventually *bundai* evolved into a type of ornamental furniture used to display a lacquer writing box (*suzuribako*), whose design was repeated on the writing table with which it formed a set. The pictorial motifs applied to the top of the *bundai* were usually oriented to the left to leave a relatively free, undecorated surface on the right, where the writing box would be placed.

The design for this writing table is derived from the broad category of Chinese Ming-dynasty subjects that include bird-and-flower painting and depictions of insects and grasses.[1] In China, this taste for naturalism in the representation of plants and animals has a long tradition that goes back to the Sung dynasty. Included in this generic classification is the pictorial theme of squirrels with melons that was incorporated, along with many other Chinese subjects, into the repertory of Japanese Muromachi-period artists.[2] The artist who conceived the design for this table skillfully adapted this pictorial tradition with some modifications (the squirrels, for example, are less actively engaged in predation than those found in some paintings) to the lacquer medium. Among lacquerwares this motif is also related to a more common design of grapevines and squirrels that was employed by Kōdaiji lacquer artists.

The designs for the top of the table were deftly executed through the use of various *maki-e* ("sprinkled picture") techniques. *Hiramaki-e*, or "level sprinkled picture" (powdered gold sprinkled over the design and raised only by the amount of lacquer with which it was drawn),[3] was used to delineate the forms of the melons and squirrels. *E-nashiji* (picture *nashiji*; *nashiji*, or "pear-skin," is an effect created with fine gold speckles) was ingeniously incorporated to represent parts of melon leaves eaten by the insects or squirrels, the reverse sides of the leaves, and some sections of the melons. Other details of the ornamentation include gilt bronze metal fittings on the legs, the edges of the tabletop, and at either end of the *fudekaeshi* (literally "brush-returning": strips of wood attached to the short sides of the top of the *bundai* to prevent the writing brush from rolling over the edge).[4] The vine motifs on the *fudekaeshi* were created with a dense application of *kinji* (gold powder), a detail that enhances the subtle elegance of the object. GWN

NOTES

1. Yoshioka Yukio, ed., *Nihon no Ishō* (Design in Japanese Art) (Kyoto: Kyoto Shoin, 1986), 14:178.
2. A six-panel screen dating from the Muromachi period in the collection of The Virginia Museum of Fine Arts includes one panel with a delightful depiction of a single squirrel who has eaten through a melon. See Michael R. Cunningham et al., *The Triumph of Japanese Style: Sixteenth-Century Art in Japan* (Cleveland: The Cleveland Museum of Art in cooperation with Indiana University Press, 1991), no. 17, pp. 52-53.
3. Andrew J. Pekarik, *Japanese Lacquer, 1600-1900* (New York: The Metropolitan Museum of Art, 1980), p. 137.
4. Doi Kumiko, *Urushi Kōgei no Bi* (The Beauty of Lacquer Arts and Crafts) (Osaka: Osaka City Museum, 1987), 109.

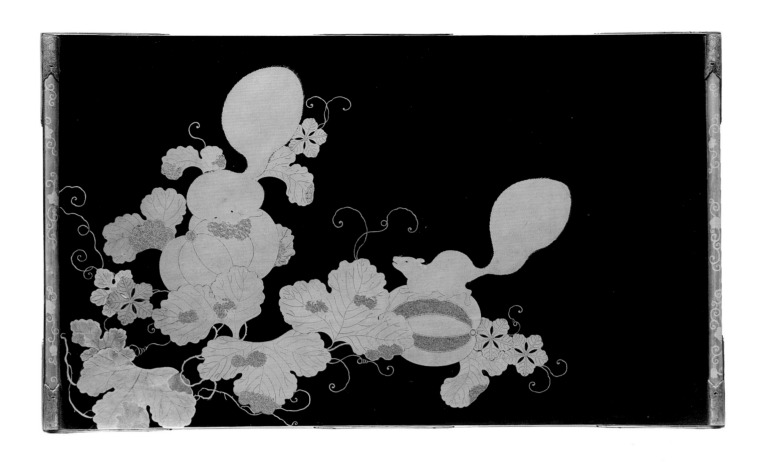

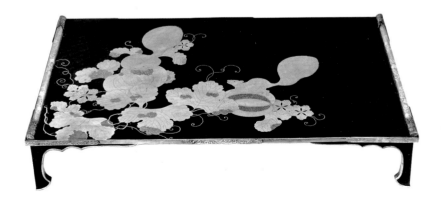

71.

Kesabako
(Storage Box for a Monk's Robe)

Nineteenth century, Edo-Meiji periods
Black lacquer with lead inlay and gold *maki-e*
H. 40 x W. 33.1 x D. 15 cm (15¾ x 13¹/₁₆ x 5⅞ inches)
PUBLISHED: Gunhild Avitabile, ed., *Die Kunst des Alten Japan: Meisterwerke aus der Mary and Jackson Burke Collection*, New York (Frankfurt: Kulturgesellschaft Frankfurt mbH, 1990), no. 127.

The dramatic design on the lid of this *kesabako* (storage box for a monk's robe) represents a *hossu* (fly whisk) made of animal hair. The whisk is held by a Buddhist monk who uses it to touch the head and body of a disciple: with this gesture the monk symbolically rejects any obstacle to the path of enlightenment. The whisk also reflects the attitude of obedience to the Buddhist law, in particular the concept of not harming even the smallest creature that can be cautioned away by the motion of the whisk.[1]

Black lacquer was applied to the surface of the box in a technique known as *saya-nuri* (scabbard painting), which was developed in the Edo period as a lacquer coating for sword scabbards. The small cracks that were deliberately made in the lacquer surface are one characteristic of this technique and create a softly textured effect. The base and lid of the box have tin rims, and inlaid lead was employed to define the animal hair of the whisk. The tassels and the design of the handle were delineated with gold powders in the *takamaki-e* (raised sprinkled design) technique, and *e-nashiji* (picture *nashiji*; *nashiji*, or "pear skin," is an effect created with fine gold speckles) was applied between the out-

lines of the design elements of the handle. The artisan displayed his technical virtuosity by extending the whisk design over the front edge of the box.

The use of lead inlay as a contrast with lacquer and other decorative materials was a technique favored in the seventeenth and eighteenth centuries by Rimpa artists who created designs for various types of lacquer objects. In this sense, the box possesses an element of Rimpa taste. Its overall decorative aesthetic, however, is characteristic of the nineteenth century and not directly linked to the Rimpa school.[2] A *kesabako* of this type was probably commissioned for use in a temple to store the treasured robe of a Buddhist master who had lived in earlier times. GWN

NOTES

1. E. Dale Saunders, *Mudrā: A Study of Symbolic Gestures in Japanese Buddhist Sculpture*, Bollingen Series no. 58 (New York: Bollingen Foundation, 1960), p. 153.
2. Akio Haino of the Kyoto National Museum provided information regarding the lacquer techniques employed for this object. He also kindly offered his interpretation of the stylistic influence reflected in the design of this lacquer.

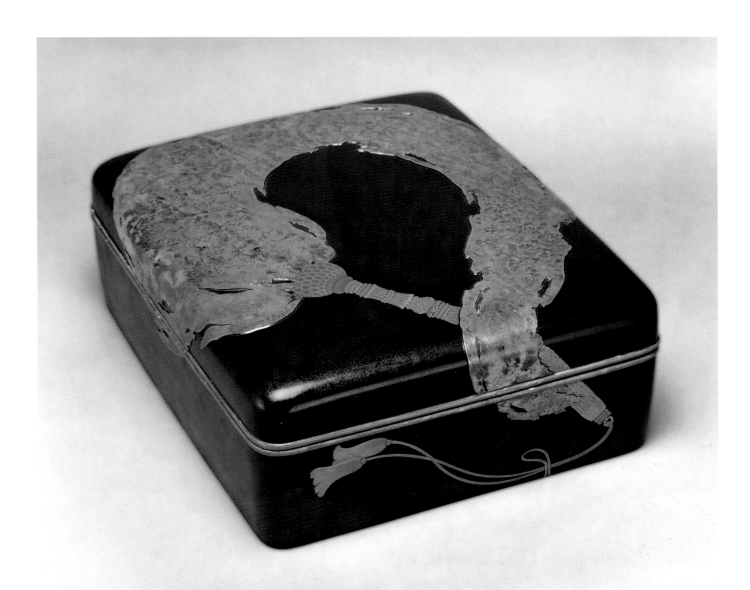

Fly Wisk - horse hair - sweep area in
front of them - brush away insects
Buddhist vow - not to kill
Became Scepter of State

Score -
Ancient priest

Inlaid Lead
Mother of [Pearl?] Teeth
Cracks Prob leather - hoah

72.

Yuoke *(Hot-Water Ewer)* with Wisteria Design

Momoyama–early Edo period, late sixteenth–early seventeenth century
Black lacquer with silver and gold *maki-e*
H. 19 (without handle) x D. 23 cm (7½ x 9⅟₁₆ inches)
PUBLISHED: Gunhild Avitabile, ed., *Die Kunst des Alten Japan: Meisterwerk aus der Mary and Jackson Burke Collection, New York* (Frankfurt: Kulturgesellschaft Frankfurt mbH, 1990), no. 117; Carolyn Wheelwright, ed., *Word in Flower: The Visualization of Classical Literature in Seventeenth-Century Japan* (New Haven: Yale University Art Gallery, 1989), fig. 61.

Antecedents for this type of *yuoke* (hot water ewer) can be found among the lacquer food vessels, such as *Negoro*-ware utensils (see no. 75), that were used by Buddhist monks. However, during the Momoyama period, members of the nobility began to use these objects as part of their elegant tableware, and the production of lacquer ewers expanded accordingly.[1] More recently, this ewer may have been utilized during the light meal that accompanies a formal Japanese tea ceremony.

The design of wisteria blossoms and leaves was first executed by freehand drawing in red lacquer (a few traces of red outlines are still visible on the surface) on the already hardened black lacquer ground. Silver and gold powders were then sprinkled over the wet lacquer outlines using the *hiramaki-e* ("level sprinkled picture") technique. The manner in which the metallic powders were blended produced subtle tonal contrasts in the design which appears to be predominately silver.

The wisteria plant, a climbing shrub with thin leaves that produces clusters of lavender flowers, has been a pervasive decorative motif in Japanese painting and design. The representation of this plant evokes both poetic and aristocratic connotations that have ancient origins; there are countless poems included in early imperial anthologies of verse that describe the beauty of the wisteria plant growing amid the branches of a pine tree.[2] In the context of seasonal imagery, wisteria was incorporated into verse as corresponding to the third month in spring. The Japanese word for wisteria, *fuji*, forms part of the word Fujiwara, the surname of aristocrats who were influential at court in the Heian period and adopted this flower as a family emblem. The graceful articulation of this ewer echoes the refined sensibilities embodied in the wisteria design.

GWN

NOTES

1. Akio Haino of the Kyoto National Museum kindly provided information regarding the origin and function of lacquer *yuoke*.
2. Yoshioka Yukio, ed., *Nihon no Ishō* (Design in Japanese Art) (Kyoto: Kyoto Shoin, 1985), 9:158. Another lacquer ewer with a wisteria design is very similar to the Burke *yuoke* (see pl. 72, pp. 80 and 177).

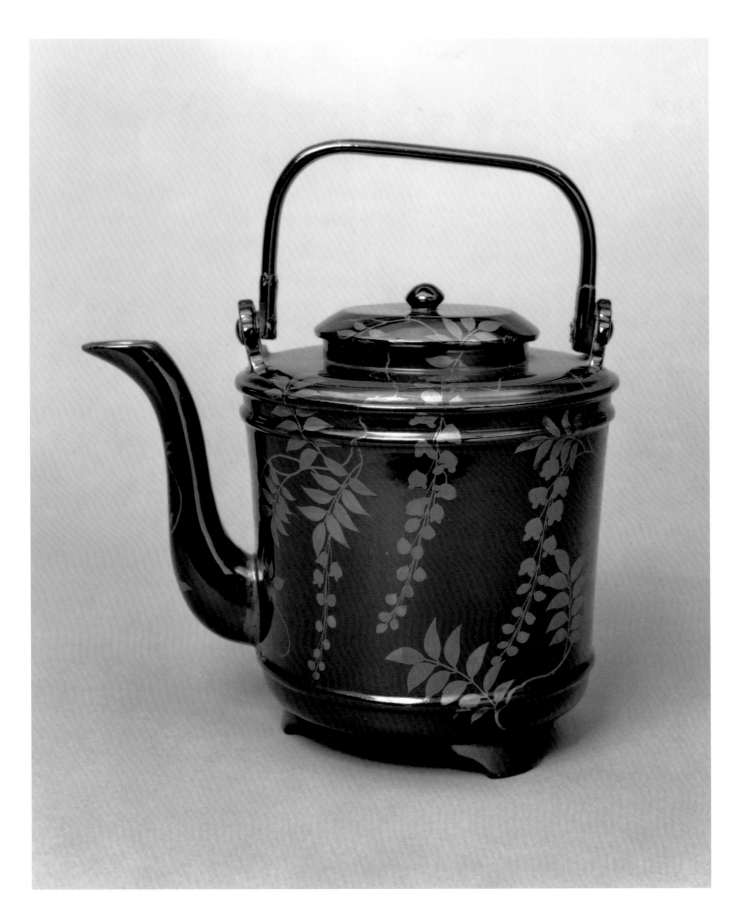

73.

Jūbako (Stacked Food Boxes) with Design of a Taro Plant

Late Edo or Meiji period, nineteenth century
Shibata Zeshin (1807–1891)
Colored lacquer, gold and silver *maki-e*
H. 42 x W. 23 x D. 24.5 cm (16⁹/₁₆ x 9¹/₁₆ x 9¹¹/₁₆ inches)
PUBLISHED: Gunhild Avitabile, ed., *Die Kunst des Alten Japan: Meisterwerk aus der Mary and Jackson Burke Collection, New York* (Frankfurt: Kulturgesellschaft Frankfurt mbH, 1990), no. 126; Gōke Tadaomi, ed., *Shibata Zeshin Meihinshū* (Collection of Masterpieces by Shibata Zeshin), vol. 1 (Tokyo: Gakken, 1981), no. 8.

This elegant *jūbako* (stacked food boxes) was made by the lacquer master and painter Shibata Zeshin, who is celebrated for the originality of his designs (no. 54). Zeshin began his study of lacquermaking at the age of eleven in Edo (present-day Tokyo). His teacher was Koma Kansai II (1767–1835), a member of the well-known Koma school, one of the oldest families of traditional lacquermakers that served the Tokugawa shogunate (military government). In 1822 Zeshin entered the circle of the artist Suzuki Nanrei (1775–1844), who had studied painting under a pupil of Maruyama Ōkyo.[1] And in 1830, Nanrei introduced Zeshin to the Kyoto Shijō artist Okamoto Toyohiko (1773–1845), with whom he studied for three years.[2] The training Zeshin received in the naturalistic style of painting promoted by Maruyama-Shijō artists and his own interest in producing sketches from nature[3] are reflected in the detailed depictions of flowers and plants that appear in much of Zeshin's art. Zeshin was innovative in his use of the lacquer medium for painting as well as for the production of functional and decorative objects. He added the unusual and difficult *urushi-e* (lacquer painting) technique to his repertory during the 1870s and 1880s.

Zeshin's career as an artist spanned the closing years of the Tokugawa regime and the beginning of a new age initiated by the restoration of Imperial rule in 1868. After this shift in government occurred, there was an increased interest in cultural and economic exchange with the West. Zeshin benefited from this climate of openness and was encouraged to exhibit abroad. A prolific artist, he gained national prestige and, later

in his career, he earned international recognition with the lacquer plaques that were exhibited at expositions in Vienna (1873), Philadelphia (1876), and Paris (1899).[4]

This *jūbako* was used to store delicacies specially prepared for celebratory occasions, like New Year's Day, or for outings, such as cherry-blossom viewing, a beloved Japanese pastime. These boxes are equipped with two lids so that they can, when necessary, be separated into two groups. The design of one repeats the motif of taro leaves and the other features a full moon with leaves; the name "Zeshin" is engraved on the reverse sides of both lids. The use of a taro as the principal motif reflects the artist's interest in using a common plant to inspire an exuberant design that graces the surface of the boxes. In contrast to the expansive, heart-shaped leaf forms, small chrysanthemums embellish the lower tiers of the *jūbako*. Zeshin's ability to create a dramatic effect with bold forms against a neutral background was inspired by his absorption of stylistic techniques used for Rimpa lacquers.[5]

Zeshin experimented with colored lacquers to develop new effects for lacquer base coats. This *jūbako* was covered with an olive-green base coat of lacquer that has a slightly grainy surface (instead of the more traditional black lacquer coating).[6] A textured effect was also created to simulate weathered and insect-ravaged sections of leaves. Gold and silver powders were used in the *takamaki-e* (raised sprinkled design) technique to delineate some leaves and the stems of the plant. And colored lacquer mixed with charcoal powders was used to create raised designs of portions

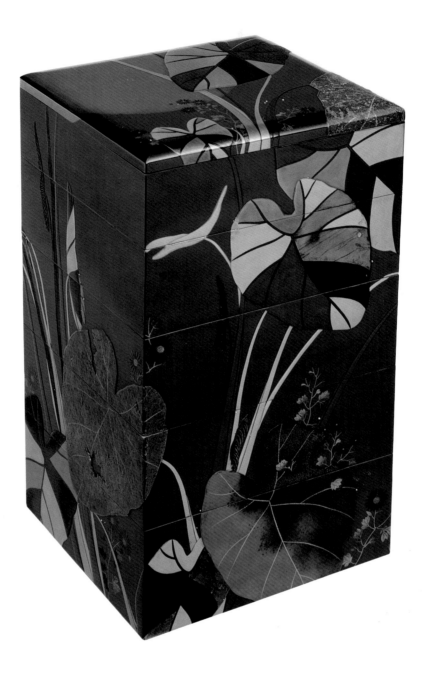

of leaves and other pictorial details. Several leaves that are completely gray were depicted by yet another technique in which thin sheets of lead were applied over a raised ground. Minute pieces of glass representing dew drops add a delicate nuance that further evokes the varied aspects of nature. The subtle contrasts in color tones and surface textures that appear in Zeshin's lacquerwares are hallmarks of his ingenuity.

GWN

NOTES

1. Gōke Tadaomi, ed., *Shibata Zeshin Meihinshū* (Collection of Masterpieces by Shibata Zeshin) (Tokyo: Gakken, 1981), 1:159.
2. Ibid., 161.
3. Ibid., 164–65.
4. James C. Y. Watt and Barbara Brennan Ford, *East Asian Lacquer: The Florence and Herbert Irving Collection* (New York: The Metropolitan Museum of Art, 1991), 219.
5. Ibid., 285.
6. Kōgei Shuppan Henshūbu, ed., *Urushi Kōgei Jiten* (Dictionary of Lacquer Arts and Crafts) (Tokyo: Kōgei Shuppan, 1978), 35.

74.

Heishi *(Sake Vessel)* *with Design of Butterflies*

Muromachi period, fourteenth century
Negoro ware, black and red lacquer with gold leaf
H. 32.5 cm (12³/₁₆ inches)

Negoro-ware *heishi* (sake vessels), often made in pairs, were used in Shinto shrines to hold sake (rice wine) as an offering for native deities. *Heishi* were also utilized in a Bugaku dance (see no. 4) known as *Kotokuraku* in which one of the performers is a Wine Bearer.[1] Typically, *Negoro* ware utensils were decorated with a base coat of black lacquer over which red lacquer was applied (see no. 75). This example, however, is classified as black *Negoro* ware since black lacquer is the predominate coloring, with a design of butterflies in red.

The origins of *heishi* are varied. An extant Persian-style lacquer vase with a spout and slender neck in the shape of a bird's head, which is listed in the record of precious objects donated by the Empress Kōmyō in 756 to the Shōsōin treasury at the Tōdaiji temple (in Nara), may be one ancient prototype for Japanese versions of *heishi*.[2] Moreover, in early times many types of Chinese utensils and vessels fashioned in metal or ceramic had a significant influence on the production of lacquer objects in Japan. The graceful *heishi* form, for instance, was inspired by the shape of Chinese Sung-period celadon porcelain vases[3] known as *mei-p'ing*.

The earliest record of a *heishi* of Japanese manufacture appears in the *Engishiki* (*Procedures of the Engi Era*), a collection of governmental regulations from the early tenth century that includes numerous details regarding ritual objects. Two pairs of *heishi* are cited in this text without, however, a description of the shapes and materials of the vessels, so it is not possible to know if these objects were lacquerwares.[4] Since other Heian-period documents do not record lacquered wood sake vessels, it is speculated that the production of *Negoro* ware *heishi* began in the early Kamakura period.[5] From that time on the aesthetic of a red design on a black background, which was favored for various types of lacquer utensils used by members of the warrior class, was adopted for the decoration of ceremonial vessels

including *heishi*,[6] a practice that continued in the Muromachi period.

The body of this vessel, which features a small spout at the top, swells at the shoulders and from there narrows in an S-curve to the bottom where the contour fans outward to create a base. The construction technique and shape of the Burke *heishi* are generally consistent with other examples of *Negoro* ware sake vessels. X-ray photography has revealed that the wooden core consists of two parts that were cut and hollowed on a lathe and then joined at the shoulders.[7] The spout was carved separately and inserted in a hole made in the top. The raised chrysanthemum pattern that radiates from the spout and the design on the shoulders of two facing butterflies are unusual ornamental features.[8] Most extant *heishi* are red *Negoro* ware, and few of these examples have designs.[9] The attractive motifs of butterflies with hooked antennae are subtle contrasting

decorative elements. One butterfly was outlined in red lacquer and filled in with short strokes to represent patterns for the wings and body, while the other was rendered in a comparatively simplified manner in which the contours are defined by a field of red lacquer. Gold leaf was applied to highlight each insect, although more of this material remains on the latter.

GWN

NOTES

1. In this dance there are three categories of performers: the *Kotokuraku* (Barbarian Youth), *Kempai* (Host), and the *Heishitori* (Wine Bearer); see Nishikawa Kyōtarō, *Bugaku Masks*, trans. Monica Bethe (Tokyo: Kodansha, 1978), 44-45. Although the Burke *heishi* was once part of a pair implying its use for a shrine altar (c.f. no. 8), since it is light-weight and thus easily carried, it is possible that this example may have been used for dance performances. A Kamakura period example of a *heishi* made for the *Kotokuraku* dance, which is also black *Negoro* ware, is preserved at the Tamekuyama Shrine in Nara (see Nishikawa, *Bugaku Masks*, no. 33, p. 59).

2. Kawada Sadamu, *Negoro* (Kyoto: Shikōsha, 1985), 311.

3. Ibid., 312.

4. Ibid., 311.

5. Ibid., 312.

6. Tanaka Hisao, ed., *Meihō Seishō* (Treasures from Private Museums of Art in Japan) (Tokyo: Mitsui Seimei Hoken Sōgo Kaisha, 1987), 233.

7. An x-ray photograph of a typical *heishi* and a discussion of the construction technique is provided in Kawada, *Negoro*, 307.

8. *Heishi* with butterfly designs are relatively rare. The mate to the Burke *heishi* is reproduced in Tanaka, *Meihō Seishō* (Treasures from Private Museums of Art in Japan), 191, 233. Another example of a *heishi* with a butterfly design is reproduced in Yoshioka Toshio, ed., *Nihon no Ishō* (Design in Japanese Art) (Tokyo: Kyoto Shoin, 1984), vol. 5, no. 62, pp. 53, 181.

9. For reproductions of other *heishi*, see Kawada, *Negoro*, 2-11.

75.

Tarai *(Ritual Washbasin)*

Muromachi period, fifteenth century
Negoro ware, red and black lacquer with exposed *keyaki* wood
H. 14.2 x Diam. 35.7 cm (5⁹/₁₆ x 14¹/₁₆ inches)
PUBLISHED: Gunhild Avitabile, ed., *Die Kunst des Alten Japan: Meisterwerke aus der Mary and Jackson Burke Collection, New York* (Frankfurt: Kulturgesellschaft Frankfurt mbH, 1990), no. 109; Kawada Sadamu, *Negoro* (Kyoto: Shikōsha, 1985), fig. 39.

[handwritten annotation: Red lacquer over Black Chinese in nature Carve bottom → bonsai motif]

This *Negoro*-ware *tarai* (basin) was used to hold water for rinsing the hands in preparation for the *fusatsu-e*, a Buddhist ritual ceremony performed in repentance for religious transgressions that was held on the fifteenth day of each month. The term *Negoro* was derived from the name of Negoroji, a temple in Kii province (present-day Wakayama prefecture), where lacquer objects are thought to have been produced by Buddhist monks. The founding of Negoroji is associated with the influential Shingon monk Kakuban (1095-1143), who left the temple Kongōbuji on Mount Kōya (south of Osaka) and settled in Negoro, but Imperial sanction for the establishment of the temple was not received until 1288.[1] At the height of its prosperity in the sixteenth century, Negoroji was a vast complex of more than two thousand buildings and remained active until it was destroyed in 1585 during Toyotomi Hideyoshi's (1537-1598) Kii peninsula campaign. Although many extant red and black lacquer objects are classified as *Negoro* ware, a *tarai* that is dated 1352 can be identified as a product of Negoroji,[2] and a few others can be attributed to manufacture in the region where the temple complex was located.

Heian-period documents mention certain red and black lacquerwares that may have been ancient prototypes for lacquer objects currently classified as *Negoro* ware.[3] Moreover, extant handscroll paintings of the late Heian and Kamakura periods depict red and black lacquer utensils that were used in aristocratic apartments.[4] Both the textual and the visual evidence are valuable

documentation that red and black lacquerwares were produced prior to the official establishment of Negoroji. And the word *Negoro*, used in reference to lacquer objects, has been expanded to include red and black lacquer objects made in various areas of Japan.[5] Other than the dated *tarai*, no documents survive to prove definitively that lacquerwares were made at Negoroji or in its immediate environs. Nonetheless, in theory the term *Negoro* became popular as a result of the distribution of large quantities of high-quality lacquerwares from the temple complex to various regions of Japan.[6] Since the Edo period, *Negoro-nuri* (*Negoro* lacquer) became a common general term used to refer to high-quality lacquerwares that are characterized by a simplicity of design and ornamentation—functional

267

objects primarily intended for daily or ceremonial use in Buddhist temples.[7] *Negoro* ware was also made for Shinto shrines (see no. 74). A standard feature of *Negoro* decoration was the application of red lacquer over a base coat of black lacquer that becomes exposed through the repeated use of an object. The resulting effect of random areas of black that contrast with the red is highly valued by connoisseurs, including tea masters who have used *Negoro* lacquer objects for the tea ceremony.

Although ritual basins without legs were also produced, the earliest example of the type represented by the Burke *tarai* is the basin dated 1352 (preserved at the temple Rokujizōji in Ibaragi prefecture) that was inscribed with the name of Shigemune of Negoroji.[8] Artisans continued to produce this style of basin later in the Muromachi period; the Burke basin is inscribed in red lacquer on the bottom with a cyclical date that probably corresponds to one of two years in the fifteenth century.[9] The elegant carving of the legs as well as the design of the paired open volutes—literally defined as a "boar's eye" pattern—that was repeated along the bottom edge of the *tarai* reflect Chinese influence. After the beginning of the Kamakura period, *Negoro* craftsmen used native forms and also imitated the shapes and designs of various ceramic and lacquer objects imported from China. Another handsome fea-

ture of the Burke example is the side panel with raised edges (reminiscent of the strips of metal or wood used to bind wooden buckets and barrels)[10] which was coated with a translucent lacquer that allows the natural grain of *keyaki* (zelkova) wood to be visible in subtle contrast to adjacent areas of red and black lacquer.

GWN

NOTES

1. Kawada Sadamu, *Negoro* (Kyoto: Shikōsha, 1985), 287.
2. James C. Y. Watt and Barbara Brennan Ford, *East Asian Lacquer: The Florence and Herbert Irving Collection* (New York: The Metropolitan Museum of Art, 1991), 184.
3. Kawada, *Negoro*, 300-301.
4. Ibid., 301. For example, scenes from several famous handscrolls that are dated prior to 1288, such as the early twelfth-century *Tale of Genji* and the late twelfth-century *Gaki Zōshi* (*Hungry Ghosts Scroll*), depict black and red lacquer utensils (see pls. 411, 413).
5. Ibid., 282.
6. Ibid., 295.
7. Ibid., 7.
8. Ibid., 322, 348, pl. 169.
9. Ibid., 338. Kawada suggests that the cyclical date read as *mizunoto-mi*, which is repeated every sixty years, should in this case be considered as corresponding to either 1413 or 1473. An inscription also written on the bottom of the basin, *san shitsu bō*, is literally translated: *san* (cedar), *shitsu* (room), *bō* (monk's quarters). This may indicate the location in a particular temple where the basin was stored.
10. Watt and Ford, *East Asian Lacquers*, 183.

Glossary of Religious and Technical Terms

COMPILED BY MICHIO HAYASHI

RELIGIOUS TERMS

Amida: Name of the Buddha in the Western Pure Land or Paradise; or Amitābha or Amitāyus in Sanskrit. Amida is the principal Buddha worshipped in the various Jōdo ("Pure Land") sects. In Esoteric Buddhism, where he is one of the five Buddhas in the five cardinal regions, Amida represents the western region.

Benzaiten: Also known as Benten. Sarasvatī in Sanskrit. A goddess of music, eloquence, wealth, and wisdom. Since she was originally a deified river, her shrines are often built by the sea, rivers, and lakes.

Bosatsu: Bodhisattva in Sanskrit. The term used in Buddhism for one who aspires to *bodhi* (enlightenment), i.e., a future Buddha. Since a Bodhisattva seeks enlightenment not only for himself but also for others, the term also came to be used as a title, given by the emperor, for a monk of outstanding virtue.

Dainichi: Mahāvairocana in Sanskrit. The transcendental Buddha, or Buddha of Universal Light. The foremost deity of Mikkyō (Esoteric Buddhism), Dainichi appears as the central figure in many of the mandalas (diagrammatic representations in painting or sculpture) produced to illustrate the unity of the physical and spiritual worlds, and the belief that the numerous Buddhas of different eras are all manifestations of one absolute principle.

Darani: *Dhārāni* in Sanskrit. Literally, that by which something is sustained. The mythic phrases that sustain the religious life of one who recites them. A mystical power is supposed to be embodied in their syllables.

Daruma: Bodhidharma in Sanskrit, Ta-mo in Chinese. The founder of Zen (Ch'an in Chinese) Buddhism. According to tradition, he was the third son of the king of Koshi, a country in South India, and came to China in 520 when he was more than sixty years old. He settled at Shaolin-ssu (Shōrinji in Japanese), a temple on Mount Sung, and practiced meditation with his face to the wall for nine years. During this time he took as his first disciple a Chinese priest, Hui-ke, who thus became the second patriarch. Daruma died in 528 or 536 and was posthumously given the title of Yüanchüeh-tashih (Engaku-daishi in Japanese) by Emperor Tai-tsung of the T'ang Dynasty.

Fudō: Acala in Sanskrit. Literally, "The Immovable One." He is, for the Japanese Buddhist, an emanation of Dainichi and assumes a frightful form, holding a sword with which to sever evil in his right hand and a rope with which to arrest it in his left.

Fugen (Fugen Bosatsu): Samantabhadra in Sanskrit. Traditionally shown mounted on a white elephant, he is the right-hand attendant of Shaka (Śākyamuni Buddha), symbolizing his teaching, meditation, and the universal virtue of Buddhist practice. He is usually contrasted with Monju (Mañjuśrī), the left-hand attendant (although their positions are sometimes reversed), who represents knowledge, wisdom, and enlightenment.

Gozan: Literally, "The Five Mountains"; this is the term used to designate the five most esteemed temples of the Zen school. In China, the *Gozan* were founded during the Southern Sung dynasty. In Japan, the Kamakura-gozan (Five Temples of Kamakura) were designated by the Hōjō family in the thirteenth century, and in the following century Kyoto-gozan were selected by the emperor.

Jittoku (Shih-te in Chinese): An eccentric T'ang-dynasty priest who lived on Mount T'ien-t'ai (Tendai in Japanese). According to legend, Jittoku was abandoned as a baby but was found by a Zen monk and raised in the monastery. Together with his friend Kanzan, he vanished into the mountains to live the life of a recluse. Both came to be regarded as sages by later Zen monks. The exact dates of his life are unknown.

Kannon: Literally, "One Who Observes the Sound (of the World)." Avalokiteśvara in Sanskrit. The Bodhisattva of great compassion, mercy, and love. As one of the attendants of Amida, he bears an image of Amida in his crown. In East Asia, he is often regarded as a female deity.

Kanzan (Han-shan in Chinese): A T'ang-dynasty poet and monk who lived on Mount T'ien-t'ai (Tendai in Japanese). Although Kanzan, like Jittoku, was considered to be an eccentric, it is generally believed that he had a profound understanding of the principles of Buddhism. Later generations held him to be a reincarnation of Monju.

Mahāyāna Buddhism: One of the two main traditions of Buddhism; literally, "The Great (*mahā*) Means of Salvation (*yāna*)." In contrast to the other tradition, Hinayana ("The Small Means of Salvation") Buddhism, Mahāyāna advocates a universalist appeal to promote the means to salvation. This difference is reflected in the former's emphasis on the virtue of wisdom as compared to the latter's emphasis on that of compassion. The date of the emergence of Mahāyāna Buddhism is generally believed to be sometime between the first century B.C. and the first century A.D. It spread mainly to China, Korea, and Japan.

Mandara: Mandala in Sanskrit. A diagrammatic representation used in Mikkyō to indicate the cosmic nature of the relationship among Buddhas and other divine beings. It is regarded as a symbol of the universe, and is employed as an aid in rituals.

Mikkyō: The esoteric teaching, as opposed to Kengyō, the exoteric aspect. The doctrine is said to have been directly revealed by Mahāvairocana (Dainichi in Japanese) to only those who went through special initiation (hence, the "esoteric" aspect). Mikkyō developed in India during the seventh and eighth centuries and was much influenced by the rituals of Hinduism. It was transmitted to China during the T'ang dynasty, and then to Japan by Kūkai, Saichō, and others in the early ninth century.

Miroku: Maitreya in Sanskrit. Literally, "benevolent." A Bodhisattva who will appear in this world to become the next Buddha after 5,670,000,000 years. This future Buddha is presently living a supernatural existence in the Tusita Heaven.

Monju: Mañjuśrī in Sanskrit. A Bodhisattva who represents the wisdom and realization of all Buddhas, as contrasted with Fugen, who represents the intrinsic principles of Buddhism, meditation, and practice. He is the left-hand attendant of Shaka, forming a counterpart to the right-hand attendant Fugen, and is often portrayed mounted on a lion.

Nichiren sect: The sect of Buddhism that claims Nichiren (1222-1282) as its founder. Also known as the Hokke sect. Like the Tendai sect, it regards the *Saddharma-pundarīka-sūtra* (*Lotus Sutra*, or *Myōhō Rengekyō* in Japanese) as its basic scripture. The ultimate aim of this sect is the immediate attainment of enlightenment in the very body of the believer through the invocation of the title of the sutra with the formula, "namu-myōhō-rengekyō." Throughout his life, Nichiren fought government suppression of his doctrine. He was arrested and exiled repeatedly, but found many followers.

Niō: Literally, "Two Kings"; a pair of fierce-looking deities who protect Buddhism. Their statues are often placed at the entrance to a temple.

Rakan: Abbreviation of arakan (*arhat* in Sanskrit), which is the general title for persons who attained the highest stage of Buddhist practice. The term "rakan" is thus popularly used to refer to the advanced disciples of Buddha.

Rinzai sect: One of the major Zen sects, founded by Linchi I-hsüan (Rinzai Gigen in Japanese) in T'ang dynasty China. This sect was transmitted to Japan by the monk Eisai (or Yōsai, 1141-1215) in 1191 and prospered in later periods, as its teaching and practice were highly esteemed by the samurai class.

Shakamuni: Śākyamuni in Sanskrit. Also known as Shaka or Shakuson in Japan. Meaning literally "The Sage of the Śākya clan," this is the name of the historical Buddha, the founder of Buddhism. His family name is Gautama and his given name is Siddhārtha.

Shingon sect: The most important sect of Esoteric Buddhism in Japan. Founded by Kūkai (774-835) at the beginning of the ninth century. The full name is Shingon-darani-shū, "the sect of true words and spells." Shingon doctrine is primarily based on two sutras: the *Dainichi-kyō* and *Kongōchō-kyō*. Kūkai received the esoteric teachings from Hui-kuo (Keika in Japanese) and systematized them. He established Mount Kōya in 816 as a center for Shingon practice and later, in 823, was given Tōji, a temple in south Kyoto, which he transformed into another center for Shingon teaching. Shingon practice is characterized by elaborate rituals, the recitation of *darani*, and contemplation of mandalas.

Shugendō: A Buddhist order which, rather than teaching doctrine, focuses on ascetic practices in the mountains in order to attain mystic powers. The founder is said to be En-no-Ozunu (active in the Nara period); and the followers are called *yamabushi* or *shugenja*. Its syncretic beliefs incorporate ancient Shinto elements of mountain worship.

Tendai sect: A Mahāyāna sect founded in China by Chih-i (538-597) based on the *Lotus Sutra* (*Myōhō Renegekyō*, or *Hokekyō* in Japanese) and the philosophical views of Nagarjuna (Ryūju in Japanese). Tendai teaching was first brought to Japan by Chien-chen (Ganjin in Japanese) in the middle of the eighth century, but was not widely accepted. Then, in 805, Saichō brought back the Tendai tradition from China and founded Enryakuji, a center for the study and practice of Tendai on Mount Hiei. What he had learned in China, however, was not limited to the pure Tendai doctrine and in fact included Esoteric teachings together with elements from Zen and Ritsu, a sect that stresses the importance of rules and regulations for the clergy. There is thus some esoteric tendency in Saichō's doctrine, and this was further developed by disciples such as En'nin and Enchin.

Yakushi: Bhaisajyaguru in Sanskrit. The Buddha of Healing. The Lord of the World of Pure Emerald in the East, who made a vow to cure diseases. He was very popular in Japan before the Nara period, and is also worshipped as a god of longevity.

Yuima: Vimalakīrti in Sanskrit. A wealthy man in ancient India, renowned for his profound understanding of Mahāyāna. When he became ill, the Buddha sent to him his disciples, headed by Monju, to whom he revealed the profound Mahāyāna teaching.

Zen (Ch'an in Chinese) sect; the school of Buddhism based primarily on the practice of meditation, from which the name Zen derives. It is taught in this sect that the true nature of one's mind can be realized or attained only through meditation and self-training. This type of practice was transmitted by Bodhidharma (Daruma in Japanese) to China about 520, and it prospered during the T'ang dynasty. Bodhidharma is regarded as the founder of the Chinese Ch'an sect. Ch'an flourished, especially after the time of the sixth patriarch, Hui-neng, and eventually split into five sects and seven schools. Among them, three sects were transmitted to Japan—the Rinzai by Eisai in 1191, the Sōtō by Dōgen in 1227, and the Ōbaku by Ingen in 1654.

TECHNICAL TERMS

Arita ware: A type of porcelain ware produced in Arita and its vicinity in Saga prefecture in Kyūshū. Since the early Edo period the Arita kiln has produced various kinds of porcelain ware, including *sometsuke* (blue-and-white porcelain), *aka-e* (polychrome overglaze enamels), and *seiji* (green glaze).

Bugaku: A dance form which, introduced to Japan from the Asian continent, became closely associated with Nara-period court ceremonies and Shinto shrine rituals.

Daimyō: Literally, "Great (*dai*) Name (*myō*)." This term usually refers to feudal lords or barons who governed the provinces of Japan from the Kamakura period through the Edo period.

Eawase: A game held among the nobles in the Heian period, with participants divided into two teams, one on the left and one on the right. Each member of the two teams presents a small picture to compete with other entries in terms of its aesthetic appeal.

Emaki (or *Emaki-mono*): Illustrated narrative handscrolls made from joined sheets of paper or silk. Changing scenes can be enjoyed as the scrolls are unrolled from right to left. *Emaki* normally consist of illustrations and text, but sometimes there is no text. Subjects include classical literature, historical events, biographies of religious figures, legends, and folk tales.

Genji Monogatari (*The Tale of Genji*): A fifty-four chapter novel written in the early eleventh century by Murasaki Shikibu. It recounts the life and loves of Prince Genji and his family in a subtle, sensitive literary style. Although written as a fictional narrative, *The Tale of Genji* is said to reflect aspects of the court life of late Heian Japan, from the tenth century to the eleventh. During the centuries following its creation, many variations, parodies, and plays based on the original were written. In addition, various scenes from the *Genji Monogatari* remained important subjects for painting and crafts.

Haiku: Also *haikai*. A native Japanese form of verse consisting of seventeen syllables. Haiku reached its peak during the late seventeenth and eighteenth centuries, especially in the work of Matsuo Bashō and Yosa Buson.

Kabuki: A form of theater popularized during the Edo period. Although originally performed by all-female groups, a government edict of 1629 transformed Kabuki acting into an all-male profession. Kabuki plays combine elements of dance, drama, and song, and are highly stylized. Their subjects include legends, historical events, and classical or popular tales.

Kaigetsudō school: A school of *ukiyo-e* painting that flourished in the eighteenth century. Following the style of the founder, Kaigetsudō Ando, artists of this school specialized in the depiction of the beautiful women of the pleasure quarters.

Kano school: A school of painting, begun during the Muromachi period, which rose to prominence during the Momoyama and Edo periods. In the history of Japanese painting, no other school has ever dominated artistic circles over such a long period of time. Although begun as a school specializing in Chinese-inspired painting, Kano artists soon incorporated the more decorative coloristic elements of Japan's native *yamato-e*. During the Edo period, while serving as official painters to the Tokugawa shogunate, they systematized their studio organization and way of teaching so that their school remained a constant source of influence for artists outside Kano circles as well as for their own colleagues.

Kasen-e: Paintings portraying master poets (*kasen*) such as the *Rokkasen* (The Six Immortal Poets) and the *Sanjūrokkasen* (The Thirty-six Immortal Poets). *Kasen-e* usually consist of the portrait of a poet and an inscription, including his or her name, social standing, and a representative poem. They became especially popular in the Kamakura period.

Kōwaka: A genre of dramatic ballad-and-dance pieces dating from the fifteenth century. Also known as *kōwaka-mai* (*kōwaka* dances). Their contents consist mainly of accounts of military episodes from war tales such as the *Heike Monogatari* (The Tale of Heike). In the late sixteenth to seventeenth centuries, *kōwaka* was, along with Noh, very popular among the warrior class and was patronized by prominent figures such as Oda Nobunaga, Toyotomi Hideyoshi, and Tokugawa Ieyasu.

Maruyama school: An Edo-period school of painting founded by Maruyama Ōkyo (1733-1795). Ōkyo worked in a style that combined elements of ink painting with the colorful, decorative style of Chinese Ch'ing dynasty bird-and-flower painters. Ōkyo also incorporated elements of Western perspective and realism, emphasizing the practice of sketching from nature, which marked a break from traditional pictorial training in Japan. Maruyama painters were especially favored by citizens of the Kyoto-Osaka area, where Ōkyo remained active throughout his life.

Nagasaki school: The term covers various schools of painting (Ōbaku school, Shen Nan-p'in style, Western style) that originated in the Nagasaki area during the Edo period. Painters of the Nagasaki school, taking advantage of the open port of Nagasaki, played an important role in introducing new modes of painting from China and the West to the artists of Edo.

Nanga school: Literally, "Southern School"; also known as *bunjinga* (literati painting); flourished during the eighteenth and nineteenth centuries. Attracted to the ideals of Chinese literati painters—scholar-gentlemen who painted to express their lofty ideals—*nanga* artists looked primarily to Ming and Ch'ing dynasty painting for inspiration. Although the *nanga* artists of Japan were not scholar-gentlemen officials like their Chinese counterparts, they avidly emulated aspects of Chinese paintings and blended them with elements of native Japanese decorative style.

Nise-e: Literally, "likeness pictures." A type of realistic portraiture allegedly originated by Fujiwara no Takanobu (1142-1205). *Nise-e*, which includes individual and group portraits, flourished in the Kamakura period.

Noh: A classical form of theater whose origins date back to the beginning of the Muromachi period. Noh combines song, dance, music, and mime, and its actors perform with stylized masks. Plays center around themes drawn from classical literature, mythology, and ancient folk tales. In Noh, unlike Kabuki, the visual appeal of the play is subdued, and the actors' movements are more stylized. Noh therefore came to be regarded as the theater of the upper class.

Rimpa (Rin school): Literally, school of Kōrin. Founded by the calligrapher-artist Hon'ami Kōetsu and painter-designer Sōtatsu in the Momoyama period, this school later flowered with the works of Ogata Kōrin (1658-1716), Sakai Hōitsu (1761-1829), and their followers. Rimpa artists frequently took their inspiration from classical literature and Heian-period painting traditions. Rimpa paintings are often rich in color and striking in their compositions and reinterpretations of classical motifs. Artists of this school also produced works in other media such as lacquer and ceramic. Their patrons were primarily members of the Kyoto nobility and the upper levels of the merchant class.

Shijō school: Founded by Matsumura Goshun (1752-1811) as an offshoot of the Maruyama school; named after Shijō street, where its studio was located. Reflecting the master Goshun's training under Yosa Buson (1716-1783) and Maruyama Ōkyo, Shijō painters combined traditional elements of ink painting (which includes *nanga* influences) with elements of Western-style perspective and pictorial motifs drawn directly from life.

Tosa school: A school of painting specializing in the traditional style of *yamato-e*, firmly established by Tosa Mitsunobu in the mid Muromachi period. During the Edo period, Tosa artists perfected a miniaturist painting technique, which they used to illustrate such classical narratives as *The Tale of Genji*.

Tarashikomi: A pooled-pigment technique used mainly by painters of the Rimpa school. It is said to have been invented by Sōtatsu. For a *tarashikomi* effect, ink, pigment, or water was applied to a still-wet surface, producing a mottled or "marbled" pool of color.

Ukiyo-e: Literally, "pictures of the floating world." This term is broadly applied to the mid to late Edo-period paintings and mass-produced woodblock prints made in urban centers for the pleasure of working-class people. As the term indicates, the imagery of *ukiyo-e* first focused on scenes of the "pleasure quarters" or the Kabuki theaters of Edo and Kyoto, but later came to include landscapes, birds, and flowers.

Waka: A native Japanese verse form of thirty-one syllables that evolved during the Nara period and was perfected in the Heian period.

Yamato-e: Literally, "Japanese painting." This term refers to a distinctly native style of painting that came into being in the Late Heian period. Unlike *kara-e* (Chinese-style painting or, more literally, "T'ang-style painting"), *yamato-e* generally features purely Japanese subject matter, often drawn from poetry, romantic narratives, and themes associated with the four seasons or famous scenic locations. Painters working in *yamato-e* style eschewed the brushwork and spatial depth of *kara-e* in favor of flat dramatic compositions and a bold isolation of, or emphasis on, certain major pictorial motifs.

Biographies of Artists and Historical Figures

COMPILED BY MICHIO HAYASHI

ARTISTS

Editor's Note: In general, biographical information about the artists whose work is featured in this book is contained in the catalogue entries that represent them. The following list provides information about those artists whose work is not otherwise featured in the catalogue proper, but mentioned therein.

Hon'ami Kōetsu (1558-1637): One of the greatest aesthetes of the early Edo period, Kōetsu was an accomplished calligrapher, potter, tea master, and lacquerware designer. Little is known about his early life, but as the son of a professional sword polisher and connoisseur in Kyoto, he was raised in an artistic environment and engaged in the family business. He enjoyed a large circle of acquaintances, including men of the nobility, upper-class merchants, and military leaders. It was through these connections that he found support for his aesthetic activities. One particularly important friendship involved Suminokura Soan (1571-1632), a wealthy merchant and cultivated connoisseur, who seemed to have relied heavily on Kōetsu's calligraphy and artistic direction when he published a deluxe edition of books, called *Sagabon*. Of major significance was Kōetsu's connection to Sōtatsu, a distinguished designer and painter. Together they produced many scrolls and paintings that revived elements of the *yamato-e* of the Heian and Kamakura periods; they are also regarded as the founders of the Rimpa School.

Itō Jakuchū (1716-1800): Jakuchū, son of a greengrocer, was born and worked in Kyoto. He turned the family business over to his younger brother and devoted his whole life to painting. Jakuchū first studied Kano-school technique but soon came under the influence of Chinese Yüan and Ming paintings. In addition, he also emphasized the importance of direct observation from nature. Thus his mature style shows a peculiar combination of exceedingly realistic detail and a colorful decorative arrangement of overall composition. He also painted in ink, in a style of deliberate distortion and daring brushwork. Although his painting style was truly unique, it should be noted that several other "eccentric" painters emerged in the late eighteenth century, and this phenomenon of individualism might well be a reflection of the generally repressive political climate of the time.

Kano Eitoku (1543-1590) The eldest son of Shōei (1519-1592), patriarch of the Kano family, Kano Eitoku was said to have been the favorite of his grandfather Motonobu. Blessed with extraor-

dinary genius as well as a proper family background, Eitoku overshadowed his father and became the successful leader of the country's largest school of painters. Almost all of his works were executed on the walls and screens of palaces and castles, and by their very nature were short-lived, so that only a handful of his paintings remain today. But what does remain amply testifies to his genius as the innovator of screen paintings made to decorate enormous spaces on a grand scale. While his screen compositions were based on the formula established by ink painters more than a half century earlier, they were greatly simplified: pictorial elements were fewer in number but larger in form, executed with broad, sweeping brushstrokes. Eitoku was the favorite painter of Oda Nobunaga (1534-1582), but his patrons included other military lords like Toyotomi Hideyoshi (1536-1598), as well as members of the Imperial family.

Kano Motonobu (ca. 1467-1559): A painter of the Muromachi period and son of Kano Masanobu, Motonobu received Zen instruction at the Reiun-in but remained a layman, and in later years was given the honorary Buddhist rank of *hōgen*. Possessed of outstanding talent, he succeeded his father as an official painter to the Muromachi shogunate and also executed commissions for the Imperial court, members of the aristocracy, temples, shrines, and townsmen of the Kyoto area. As the basis of his style, Motonobu used the Chinese techniques that he not only inherited from his father but also studied directly from newly imported Sung-dynasty works. At the same time, perhaps through his purported marriage to a daughter of Tosa Mitsunobu, he learned traditional techniques of *yamato-e* and incorporated them into his style of painting. The result is the synthesis of Chinese and Japanese styles that became the basis of the later Kano painting. Through various commissions, he also established a formula for grand-scale works such as *fusuma* (sliding panel) paintings, which were to become a Kano specialty. Thus Motonobu is considered a true founder of the Kano school, which continued to flourish during the Momoyama and Edo periods. His best known works can be found in Daitokuji (Daisen-in) and Myōshinji (Reiun-in) in Kyoto.

Kano Tan'yū (1602-1674): Painter of the early Edo period. Born in Kyoto, Tan'yū was the eldest son of Kano Takanobu and grandson of the distinguished painter Kano Eitoku. Having displayed artistic talent as a child, he was made an official painter for the Tokugawa shogunate at the age of fifteen and participated in or

directed numerous commissions from the shogunate including castle decoration, temple decoration, and portraiture. As an official connoisseur, he also made sketches of Chinese and Japanese paintings, which are known as *Tan'yū Shukuzu* (literally, "Tan'yū's reduced sketches"). In his work, Tan'yū succeeded in adapting traditional Kano style to the tastes of a new age dominated by the Tokugawa shogunate, giving a clean, refined, or ordered tone to the more expressive style of the previous generation. In 1662, in recognition of his efforts on behalf of the shogunate, he was given the honorary rank of *hōin*, the highest title that can be bestowed upon a painter. In terms of both organization and pictorial style, Tan'yū established a firm basis for the success of the Kano school throughout the Edo period.

Maruyama Ōkyo (1733-1795): Painter of the mid Edo period and the founder of the Maruyama school. Ōkyo was born in Tamba province near Kyoto (present-day Kameoka city). Around the age of fourteen, he went to Kyoto to study painting under Ishida Yūtei (1721-1786), an artist trained in the Kano school who specialized in highly decorative works. In his youth, Ōkyo produced pictures for *nozoki karakuri* (a viewing device similar to a stereopticon), and through this experience he learned techniques of Western perspective. He also placed great emphasis on drawing from nature, which he commended to his followers in later years. In time, Ōkyo combined the use of perspective and life drawing with elements from the classical styles of Chinese and Japanese painting to create a new type of decorative art that was marked by simplicity and a pervading feeling of realism. He found supporters of his art mainly in the newly established merchant class. The nature of his style is particularly evident in his large-scale works, such as screens and wall paintings.

Ogata Kōrin (1658-1716): Although not the actual founder of the Rimpa tradition, Kōrin was so highly regarded that the entire school was named after him. He was the second son of a leading Kyoto textile shop, the Kariganeya, and, as a young man, lived the life of a wealthy dilettante. Reflecting this upbringing, many of his later works show the influence of kimono designs in their decorative arrangement of motifs and compositions. He is said to have studied under Yamamoto Soken, a popular Kyoto painter affiliated with the Kano school. Following the loss of the family fortune in the 1690s, Kōrin was obliged to paint professionally. He frequently collaborated with his younger brother, Kenzan, providing designs for Kenzan's pottery. In 1701 he received the honorary title *hokkyō*, indicating that he was, at the age of forty-three, already recognized as a highly established painter. Around 1704 Kōrin moved to Edo in search of more lucrative commissions but returned to Kyoto in 1709 without attaining financial success. In addition to his Kano school training, he made an intensive study of the style of Sōtatsu, some of whose works were in the possession of his family. In time he combined Sōtatsu-type decorative style with the rapid brushstrokes he learned from Kano paintings to create dramatic and richly decorative works. In addition to painting, Kōrin showed great originality as a designer of ceramics and lacquerwares.

Sakai Hōitsu (1761-1828): Born in Edo, the second son of Sakai Tadazumi, lord of Himeji castle. Hōitsu grew up to be a gentleman of taste and refinement but in 1797 he took the tonsure under Bunnyo Shō'nin, a priest from the Nishi Honganji temple in Kyoto who had come to Edo. Hōitsu studied the painting of the Kano school and the school of the Chinese artist Shen Nan-p'in, as well as *ukiyo-e*-style painting. Later he came under the influence of Tani Bunchō and borrowed techniques from the Maruyama and Tosa schools. But Hōitsu was above all an admirer of the work of Ogata Kōrin and devoted his efforts to the revival of Kōrin's style. Hōitsu published books of woodcut reproductions of the works of Kōrin (*Kōrin Hyaku Zu*, 1815) and Kōrin's brother, Kenzan (*Kenzan Iboku*, 1823), as well as a book of his own paintings (*Ōson Gafu*, 1817). He had many disciples, including Suzuki Kiitsu (1796-1858), by whom the Rimpa tradition was carried further into the mid nineteenth century.

Sesshū Tōyō (1420-1506): Zen monk-painter of the late fifteenth to early sixteenth century; arguably the greatest ink painter in the history of Japanese art. Little is known about his life before the age of forty. He was born in Bitchū province, but as a child entered Shōkokuji, one of the major Zen temples of the time in Kyoto. While pursuing Zen training, he is believed to have studied painting under Shūbun, who was a monk-painter at the temple; when he was in his thirties, he moved to Yamaguchi in the province of Suō (modern Yamaguci prefecture). There he set up a studio, the Unkoku-an, under the patronage of the powerful Ōuchi family. In 1467, he went to Ming-dynasty China along with an emissary sent by the shogun Ashikaga Yoshimasa. There he became familiar with various schools of Chinese painting and studied Zen for three years. After returning to Japan, he settled in Ōita in Kyūshū, in order to avoid the Ōnin War in Kyoto. He traveled widely in Japan, making drawings and paintings from native landscapes, before returning to the Yamaguchi area. Sesshū mastered Chinese Sung and Yüan painting methods as well as the styles of Ming bird-and-flower paintings, but developed his own style by painting not only Chinese but also actual Japanese landscapes. In that sense, it can be said that Sesshū freed ink painting from a dependence on Chinese themes, while assimilating Chinese elements into his own mode of pictorial expression. His best-known works include the *Sansui Chōkan* ("Long Landscape Scroll") in the Mōri Museum, painted in 1486 in the manner of Hsia Kuei, the *Haboku Sansui* ("Splashed-Ink Landscape") in the Tokyo National Museum, painted in 1495 in the manner of Yü-chien, and *Ama-no-hashidate* ("View of Ama-no-hashidate") in the Kyoto National Museum, painted around 1502 from an actual landscape in Japan.

Shen Nan-p'in (eighteenth century): A Chinese painter who visited Japan and lived in Nagasaki from 1731 to 1733. Nan-p'in was a native of Wu-hsing in Chekiang province. During his brief stay in Japan, he taught a highly realistic style of bird-and-flower painting to Kumashiro Yūhi. Even after his return to China, Nan-p'in continued to send his paintings to Japan in response to Japanese requests, and his realistic style was disseminated in

Japan by Yūhi and his disciples. In Kyoto his work inspired the realistic style championed by Maruyama Ōkyo, and led to the establishment in Edo of a new Chinese-style painting school, initiated by Sō Shiseki and carried on by Tani Bunchō and Watanabe Kazan. Likewise Nan-p'in's work affected the school of Western-style painting in the Akita area (known as the *Akita Ranga*), as well as the style of many *nanga* painters. It is undeniable that Nan-p'in's work, together with imported Western paintings, played a seminal role in the development of the realistic style of the late Edo period.

Shōkei: (d. ca. 1508): Also known as Kei Shoki and Kenkō Shōkei. A Zen monk-painter, he worked as a scribe (*shoki* in Japanese) at the temple of Kenchōji in Kamakura, where he may have studied ink-painting technique under Chūan Shinkō (active mid fifteenth century), one of the leading masters of his time. In 1478 he traveled to Kyoto where he received instruction from Geiami (1431-1485), ink-painter, connoisseur, and advisor to the shogun on art and cultural matters. It was Geiami who enabled Shōkei to study and copy many of the Chinese paintings in the shogunal collection. Upon his return to Kamakura in 1480, he may have established a studio and become a teacher himself, but in 1493, for reasons unknown, he again moved to Kyoto where he lived and taught for the remainder of his life.

Shūbun (fifteenth century): Zen monk-painter active in the fifteenth century. In 1423-24, when Shogun Ashikaga Yoshimochi sent an emissary to Korea, Shūbun accompanied the party. At this time he was a monk-painter affiliated with Shōkokuji, one of the major Zen temples in Kyoto. During the era of Shogun Ashikaga Yoshinori, Shūbun served as an official painter for the shogunate, probably executing landscape and bird-and-flower screens for temples and mansions of the nobility. According to a temple document, he was also involved in the production of Buddhist sculptures, applying colors to the completed pieces. As the teacher of the famous painter Sesshū and possibly of Sōtan, another distinguished painter of the time, Shūbun played a central role in the development of ink painting during the fifteenth century. Like his teacher Josetsu, he adopted as his foundation the Southern Sung style of painting, but imbued it with his own distinctive characteristics. Because of Shūbun's eminence, a large number of works are attributed to him, but none of them can be authenticated as actual works from his hand.

Suzuki Harunobu (1725-1770): An *ukiyo-e* painter and print designer. He lived in Edo. His early works show the influence of Ishikawa Toyonobu, Nishikawa Sukenobu, and artists of the Torii school rather than of his reputed master, Nishimura Shigenaga. Around 1765 he is believed to have perfected the technique of making polychrome prints called *nishiki-e* (brocade pictures), which he produced in a delightful and delicate palette. The subject matter of those prints included young girls, men, and charming courtesans that captivated the Edo public. In the five remaining years of his life, Harunobu published over five hundred prints and dominated the *ukiyo-e* world. In terms both of technique and choice of subject matter, he is considered one of the most influential artists in the history of *ukiyo-e*.

Suzuki Kiitsu (1796-1858): Rimpa painter of the late Edo period, Kiitsu was born in Ōmi but soon moved with his family to Edo. His father was a dyer who is said to have invented *murasaki zome* (a purple dye obtained from the *murasaki* plant). From 1813 on, Kiitsu studied under the Rimpa-school master Sakai Hōitsu (1761-1828). In 1817, Hōitsu arranged for his pupil to marry into and be adopted by the Suzuki family, whose members were retainers of Hōitsu's family. Kiitsu worked with Hōitsu until the latter's death, after which he continued to serve the Sakai family for the rest of his life. He was the last important painter of the Rimpa school, but at the same time his paintings, like those of Hōitsu, show influences from various other schools.

Sōtatsu: Painter of the Momoyama and early Edo period; the exact dates of his birth and death are not known. Sōtatsu is considered one of the founders of the Rimpa school. He was the owner of a painting workshop in Kyoto called Tawaraya, which specialized in producing fans and other ready-made paintings. Biographical details about him are obscure. From about 1605 to 1615 he worked with the calligrapher, potter, and tea master Hon'ami Kōetsu (1558-1637), who may have been his relative by marriage. The two collaborated on a number of poetry scrolls, with calligraphy by Kōetsu and gold and silver underpaintings by Sōtatsu. Sōtatsu's paintings on themes from classical Japanese literature became popular among the Kyoto nobility, and during the 1620s he was awarded the honorary title of *hokkyō*. Sōtatsu freely adapted classical subjects to the flamboyant taste of Momoyama- and early Edo-period patrons, often experimenting on large-scale screens in addition to fans and scrolls. His mature style is characterized by soft, flowing lines; large, flat areas of bright color in highly decorative compositions; and frequent use of innovative techniques such as *tarashikomi* (the carefully controlled pooling of layers of wet ink or watercolor pigments). Because Sōtatsu's followers are known to have used his seals, correct attribution of paintings is often difficult.

Tosa Mitsunobu (ca. 1469-1523): An artist of the Tosa school who served as superintendent of the Imperial court's painting bureau. He is traditionally viewed as one of the greatest masters of the Tosa school, whose prestige and influence reached its height during Mitsunobu's lifetime. He produced a number of illustrated handscrolls in the native tradition of *yamato-e* as well as portraits and Buddhist images.

HISTORICAL FIGURES

Kūkai (773/774-835): Buddhist monk of the Early Heian period, founder of the Shingon sect in Japan; his posthumous title is Kōbō Daishi. After studying various religious doctrines—including Confucianism, Taoism, and Buddhism in Kyoto and Shikoku—he traveled to China in 804 with an official Japanese embassy. In 805 he received instruction in Esoteric Buddhism from Hui-kuo (746-805), a distinguished disciple of Amoghavajra (Fukū in Japanese), the Indian monk who played a major role in introducing Esoteric Buddhism to China. Kūkai returned to

Japan in 806 and introduced the doctrines and practices of Esoteric Buddhism when he established the Shingon sect. In 816 he founded a temple, Kongōbuji, on top of Mount Kōya as a center for Shingon teachings. In 823 he converted the temple of Kyōōgokokuji, popularly known as Tōji, into a Mikkyō temple. These two temples served in the following centuries as the headquarters of the Shingon sect. Kūkai's teachings stressed that all the phenomena of the physical universe are manifestations of the cosmic Buddha Mahāvairocana (Dainichi in Japanese) and that human beings can attain unity with Dainichi through mystical ceremonies and meditation. Kūkai also claimed that buddhahood can be achieved in one's present bodily form (*sokushin jōbutsu*). In addition to his importance as a religious thinker and leader, Kūkai also contributed to other aspects of Japanese culture by introducing trends in Chinese poetry and calligraphy. He was especially celebrated as a calligrapher and was listed among the *Sampitsu* (Three Masters of Calligraphy) of the period, the other two being Emperor Saga and Tachibana no Hayanari. The collection of his writings known as the *Fūshinjō* is particularly renowned as an example of Kūkai's skill as a calligrapher.

Oda Nobunaga (1534–1582): A powerful military leader, he played a large role in unifying Japan after decades of civil strife and opened the way for the modern era. He was born the second son of Oda Nobuhide, lord of Nagoya castle, in the province of Owari (present-day Aichi prefecture). Succeeding his father at the age of seventeen, Nobunaga quickly attacked several castles in the province and gained control of its western region by 1559. In 1560 he defeated Imagawa Yoshimoto—a powerful figure who presided over Suruga province to the east of Owari—in a surprise attack at Okehazama and earned wide renown for his daring skill in battle. As he became more powerful, he engaged in a series of battles against surrounding warrior-lords as well as antagonistic religious sects and movements. By the mid 1570s he had established himself as the most powerful military figure in Japan, and in 1576 he built a magnificent castle in Azuchi, on the eastern shore of Lake Biwa, from which he planned to exercise his domination over the entire country. His ambition to unify the country was, however, abruptly ended by the rebellion of Akechi Mitsuhide, one of his own generals, at Hon'nōji, in Kyoto, in 1582. Surrounded and attacked by a large force led by Mitsuhide, Nobunaga was driven to commit suicide in the temple.

Tokugawa Ieyasu (1542–1616): An outstanding military leader and founder of the Tokugawa shogunate, which ruled Japan for two and half centuries from its headquarters in Edo. Ieyasu was born into the Matsudaira family in the province of Mikawa (present-day Aichi). In his youth he was sent as a hostage to Imagawa Yoshimoto, a ruler of Suruga just east of Mikawa, but in 1560, when Oda Nobunaga defeated Yoshimoto at Okehazama, Ieyasu

was freed and allowed to return to his family castle at Okazaki. In the following years, he formed an alliance with Oda Nobunaga and supported him in many battles until Nobunaga was killed in Kyoto in 1582 by one of his own generals. After Nobunaga's death, Ieyasu patiently negotiated and collaborated with Toyotomi Hideyoshi, Nobunaga's successor, in his campaign against other remaining powers and established himself as the most powerful leader under Hideyoshi's command. When Hideyoshi died of illness in 1598, Ieyasu took the responsibility of directing the nation's affairs in the name of Hideyoshi's heir, Hideyori. His conduct aroused antagonism among Hideyoshi's former supporters, splitting the entire nation into two factions; one under Ieyasu, the other under Ishida Mitsunari. The two parties fought a decisive battle at Sekigahara in 1600, which turned out to be a complete victory for Ieyasu. In 1603 Ieyasu was appointed shogun by the emperor and officially established his government in Edo. Although he turned over the position of shogun to his son, Hidetada, in 1605, he retained control behind the scenes. In 1614–15, Ieyasu led two campaigns against Hideyoshi's son, Hideyori, in Ōsaka, which ended in Hideyori's death and the total defeat of Ieyasu's opponents, bringing the entire nation under Tokugawa rule.

Toyotomi Hideyoshi (1536–1598): A military and political leader who united Japan, bringing an end to the turbulence of the so-called Sengoku (Warring States) era. He was born in Owari (present-day Aichi prefecture), the son of a farmer. In 1558 Hideyoshi entered the service of Oda Nobunaga, a young powerful military leader of the region, and gradually established himself as one of his most powerful generals, until Nobunaga was assassinated in 1582 by Akechi Mitsuhide. Soon after the assassination, Hideyoshi defeated Mitsuhide at the battle of Yamazaki and established himself as the successor to Nobunaga. Through various negotiations and battles, Hideyoshi brought the entire country under his control by 1590. In order to secure social order, Hideyoshi took three important political measures, partly inspired by Nobunaga. First, he established a system for land surveys and set up a formula for collecting taxes directly from farmers. Second, he conducted a *katanagari* (sword hunt), confiscating all swords and other weapons from the peasants in order to prevent their revolt and to establish a clear distinction between the warrior class and the peasantry. Third, he promoted the use of a uniform currency throughout the country by taking various gold and silver mines under the direct supervision of the government. He also encouraged overseas trade, issuing official patents to powerful merchants. In his later years, after having completed the task of unifying the country, Hideyoshi turned his eye to foreign conquest and sent his troops to Korea in 1592 and 1597. His plans to conquer Korea and eventually China ended when he died of illness in 1598.

Selected Readings

COMPILED BY GEN SAKAMOTO

ENGLISH-LANGUAGE PUBLICATIONS

Addiss, Stephen. *Tall Mountains and Flowing Waters: The Arts of Uragami Gyokudō.* Honolulu: University of Hawaii Press, 1987.

———. *The World of Kameda Bōsai: The Calligraphy, Poetry, Painting and Artistic Circle of a Japanese Literatus.* New Orleans: New Orleans Museum of Art and University Press of Kansas, 1984.

———, and Hurst, G. Cameron, III. *Samurai Painters.* New York: Kodansha International, 1983.

———, et al. *Japanese Quest for a New Vision.* Lawrence, Kans.: Spencer Museum of Art, 1986.

Aikens, C. Melvin, and Higuchi, Takayasu. *Prehistory of Japan.* New York: Academic, 1982.

Akiyama, Terukazu. *Japanese Painting.* Lausanne: Skira, 1961.

Barnet, Sylvan, and Burto, William. *Zen Ink Paintings.* New York: Kodansha International, 1982.

Brinker, Helmut. *Zen in the Art of Painting.* Trans. George Campbell. London: Arkana, 1987.

Cahill, James. *Scholar Painters of Japan: The Nanga School.* New York: Asia Society, 1972.

———. *Sakaki Hyakusen and Early Nanga Painting.* Berkeley: Institute of East Asian Studies, 1982.

———. *Yosa Buson and Chinese Painting.* Berkeley: Institute of East Asian Studies, 1982.

Cunningham, Michael R., et al. *The Triumph of Japanese Style: Sixteenth Century Art in Japan.* Cleveland: The Cleveland Museum of Art, in cooperation with Indiana University Press, 1991.

Deutsch, Sanna Saks, and Link, Howard A. *The Feminine Image.* Honolulu: The Honolulu Academy of Arts, 1985.

Doi, Tsugiyoshi. *Momoyama Decorative Painting.* Trans. Edna B. Crawford. New York: Weatherhill, 1977.

Elison, George, and Smith, Bardwell I., eds. *Warlords, Artists, and Commoners: Japan in the Sixteenth Century.* Honolulu: University of Hawaii Press, 1981.

Fister, Pat. *Japanese Women Artists: 1600-1900.* Lawrence, Kans.: Spencer Museum of Art and University of Kansas, 1988.

Fukuyama, Toshio. *Heian Temples: Byōdō-in and Chūson-ji.* Trans. Ronald K. Jones. New York: Weatherhill, 1976.

Harris, Victor, and Matsushima, Ken. *Kamakura: The Renaissance of Japanese Sculpture, 1185-1333.* London: The British Museum, 1991.

The Heibonsha Survey of Japanese Art. 31 vols. Tokyo and New York: Heibonsha, 1972-79.

Hempel, Rose. *The Golden Age of Japan: 794-1192.* Trans. Katherine Watson. New York: Rizzoli International, 1983.

Hillier, Jack. *The Art of the Japanese Book.* 2 vols. London: Sotheby's, 1987.

Kanazawa, Hiroshi. *Japanese Ink Painting: Early Zen Masterpieces.* Trans. and adapt. Barbara Ford. New York: Kodansha International, 1979.

Kanda, Christine Guth. *Shinzo.* Cambridge, Mass.: Council on East Asian Studies, 1985.

Kidder, Edward J., Jr. *The Art of Japan.* New York: Park Lane, 1985.

Kurata, Bunsaku. *Hōryū-ji: Temple of the Exalted Law: Early Buddhist Art from Japan.* Trans. W. Chie Ishibashi. New York: Japan Society, 1981.

Link, Howard A., and Tōru, Shimbo. *Exquisite Visions: Rimpa Paintings from Japan.* Honolulu: The Honolulu Academy of Arts, 1980.

Mason, Penelope. *History of Japanese Art.* New York: Harry Abrams, Inc., 1993.

Miyajima, Shin'ichi, and Satō, Yasuhiro. *Japanese Ink Paintings.* Los Angeles: Los Angeles County Museum of Art, 1985.

Momoyama: Japanese Art in the Age of Grandeur. New York: The Metropolitan Museum of Art, 1975.

Murase, Miyeko. *Emaki: Narrative Scrolls from Japan.* New York: Asia Society, 1983.

———. *Iconography of The Tale of Genji: Genji Monogatari Ekotoba.* New York and Tokyo: Weatherhill, 1983.

———. *Japanese Art: Selections from the Mary and Jackson Burke Collection.* New York: Metropolitan Museum of Art, 1975.

———. *Masterpieces of Japanese Screen Painting: The American Collections.* New York: George Braziller, 1990.

———. *Tales of Japan: Scrolls and Prints from the New York Public Library.* New York and Oxford: Oxford University Press, 1986.

———, et al. *Court and Samurai in an Age of Transition: Medieval Paintings and Blades from the Gotō Museum, Tokyo.* New York: Japan Society, 1990.

Nishikawa, Kyōtarō, and Sano, Emily. *The Great Age of Japanese Buddhist Sculpture, A.D. 600-1300.* Fort Worth, Texas: Kimbell Art Museum, 1982.

Ōkyo and the Maruyama-Shijō School of Japanese Painting. St. Louis: St. Louis Art Museum, 1980.

Paine, Robert T., and Soper, Alexander C. *The Art and Architecture of Japan.* Rev. ed. Baltimore: Penguin Books, 1975.

Pearson, Richard J. *Ancient Japan.* Washington, D.C.: Smithsonian Institution, and Tokyo: Agency for Cultural Affairs, Government of Japan, 1992.

Pearson, Richard J., et al. *The Rise of a Great Tradition: Japanese Archaeological Ceramics from the Jōmon through Heian Periods (10,500 B.C.-A.D. 1185).* New York: Japan Society, 1991.

Pearson, Richard J., et al., eds. *Windows on the Japanese Past.* Ann Arbor: University of Michigan Press, 1986.

Pekarik, Andrew J. *Japanese Lacquer, 1600-1900. Selections from the Charles A. Greenfield Collection.* New York: The Metropolitan Museum of Art, 1980.

———. *The Thirty-Six Immortal Women Poets.* New York: George Braziller, 1991.

Piggott, Juliet. *Japanese Mythology.* Rev. ed. New York: Peter Bedrick Books, 1983.

Roberts, Laurance P. *A Dictionary of Japanese Artists: Painting, Sculpture, Ceramics, Prints, Lacquer.* New York: Weatherhill, 1990.

Rosenfield, John M. *Song of the Brush.* Seattle: Seattle Art Museum, 1979.

Rosenfield, John M.; Cranston, Fumiko E.; and Cranston, Edwin A. *The Courtly Tradition in Japanese Art and Literature: Selections from the Hofer and Hyde Collections.* Cambridge: Fogg Art Museum, Harvard University, 1973.

Rosenfield, John M., and Grotenhuis, Elizabeth ten. *Journey of the Three Jewels.* New York: Asia Society, 1979.

Rosenfield, John, and Shimada, Shūjirō. *Traditions of Japanese Art: Selections from the Kimiko and John Powers Collection.* Cambridge: Fogg Art Museum, Harvard University, 1970.

Saunders, E. Dale. *Mudra: A Study of Symbolic Gestures in Japanese Buddhist Sculpture.* Bollingen Series, no. 53. New York: Pantheon, 1960.

Seattle Art Museum. *Ceramic Art of Japan: One Hundred Masterpieces from Japanese Collections.* International Symposium on Japanese Ceramics. Seattle: Seattle Art Museum, 1973.

Shen Fu; Lowry, Glen; and Yonemura, Ann. *From Concept to Context: Approaches to Asian and Islamic Calligraphy.* Washington, D.C.: Freer Gallery of Art, 1986.

Shimizu, Yoshiaki, ed. *Japan: The Shaping of Daimyo Culture, 1185-1868.* Washington, D.C.: National Gallery of Art, 1988.

Shimizu, Yoshiaki, and Nelson, Susan E. *Genji: The World of a Prince.* Bloomington: Indiana University Art Museum, 1982.

Shimizu, Yoshiaki, and Rosenfield, John M. *Masters of Japanese Calligraphy: 8th-19th Century.* New York: The Asia Society Galleries and Japan House Gallery, 1984.

Shimizu, Yoshiaki, and Wheelwright, Carolyn, eds. *Japanese Ink Paintings from American Collections: The Muromachi Period.* Princeton: The Art Museum, Princeton University, 1976.

Snellgrove, David L. *The Image of the Buddha.* New York: Kodansha International, 1978.

Sugiyama, Jirō. *Classic Buddhist Sculpture.* Trans. and adapt. Samuel Crowell Morse. New York: Kodansha International, 1982.

Takeda, Tsuneo. *Kano Eitoku.* Trans. and adapt. H. Mack Horton and Catherine Kaputa. New York: Kodansha International, 1977.

Takeuchi, Melinda. *Taiga's True Views: The Language of Landscape Painting in Eighteenth-Century Japan.* Stanford: Stanford University Press, 1992.

Tanabe, Willa J. *Paintings of the Lotus Sutra.* Tokyo: Weatherhill, 1988.

Watanabe, Akiyoshi. *Of Water and Ink: Muromachi Period Paintings from Japan, 1392-1568.* Detroit: Detroit Institute of Arts, 1986.

Watson, William, ed. *The Great Japan Exhibition: Art of the Edo Period, 1600-1868.* London: Royal Academy of Arts, 1981.

Watt, James C., and Ford, Barbara Brennan. *East Asian Lacquer: The Florence and Herbert Irving Collection.* New York: The Metropolitan Museum of Art, 1991.

Weidner, Marsha, ed. *Flowering in the Shadows: Women in the History of Chinese and Japanese Painting.* Honolulu: University of Hawaii Press, 1990.

Wheelwright, Carolyn, ed. *Word in Flower: The Visualization of Classical Literature in Seventeenth-Century Japan.* New Haven: Yale University Art Gallery, 1989.

Zolbrod, Leon M. *Haiku Painting.* New York: Kodansha International, 1982.

JAPANESE-LANGUAGE PUBLICATIONS

Akiyama Ken and Taguchi Eiichi, eds. *Gōka "Genji-e" no Sekai: "Genji Monogatari"* (A World of Splendor in Genji Illustrations: *The Tale of Genji*). Tokyo: Gakken, 1988.

Akiyama Terukazu. *Heian Jidai Sezoku-ga no Kenkyū* (Secular Painting in Early Medieval Japan). Tokyo: Yoshikawa Kōbunkan, 1964.

Bunjinga Suihen (Selected Literati Painting). Vols. 11-20. Kyoto: Tankōsha, 1974-5.

Doi Tsugiyoshi. *Kinsei Nihon Kaiga no Kenkyū* (Study of Japanese Painting of Recent Period). Tokyo: Bijutsu Shuppansha, 1970.

Doi Tsugiyoshi, Tanaka Ichimatsu, and Yamane Yūzō, eds. *Shōhekiga Zenshū* (Collection of Sliding Screens). 10 vols. Tokyo: Bijutsu Shuppansha, 1966-72.

Etō Shun, ed. *Sesson Shūkei Zen Gashū* (Complete Works by Sesson Shūkei). Tokyo: Kodansha, 1982.

Hayashiya Seizō, ed. *Nihon no Tōji* (Japanese Ceramics). 14 vols. Tokyo: Chūōkōronsha, 1971-90.

Hirayama Ikuo and Kobayashi Tadashi, eds. *Hizō Nihon Bijutsu Taikan* (Japanese Art: The Great European Collections). Tokyo: Kodansha, 1992-.

Hōitsu Kachōga Fu (Edo Rimpa and Artists Surrounding Sakai Hōitsu). 5 vols. Kyoto: Shikōsha, 1979.

Hōryūji no Shihō: Shōwa Shizaichō (Treasures of Hōryūji: Shōwa-era Record of Temple's Assets). Tokyo: Shōgakkan, 1985-.

Iijima Shunkei. *Zusetsu Nihon no Sho* (Illustrated History of Japanese Calligraphy). 2 vols. Tokyo: Shogei Bunka-in, 1970.

Ishino Hironobu, eds. *Kofun Jidai no Kenkyū* (Study on Kofun Period). 11 vols. Tokyo: Yūzankaku, 1990.

Kanazeki Hiroshi and Sahara Makoto, eds. *Yayoi Bunka no Kenkyū* (Study of Yayoi Culture). 10 vols. Tokyo: Yūzankaku, 1985.

Kinsei Fūzokuzu Fu (Genre Painting of Recent Period). 13 vols. Tokyo: Shōgakkan, 1982.

Kokkasha, ed. *Kōetsu sho Sōtatsu Kingin-dei-e* (Kōetsu's Calligraphy and Sōtatsu's Painting in Gold and Silver Ink). Tokyo: Asahi Shimbunsha, 1978.

Komatsu Shigemi, ed. *Nihon Shoseki Taikan* (Japanese Calligraphy). 25 vols. Tokyo: Kodansha, 1978-80.

———. *Nihon Meiseki Sōkan* (Masterpieces of Japanese Calligraphy). 100 vols. Tokyo: Nigensha, 1976-86.

Koshinaka Tetsuya, Tokuyama Hikaru, and Kimura Shigekazu, eds. *Nagasaki Ha no Kachō-ga: Chin Nanpin to sono Shūhen* (Bird-and-Flower Painting of Nagasaki School: Shen Nan-p'in and His Followers). 2 vols. Kyoto: Fuji Art Shuppan, 1981.

Kyoto National Museum. *Momoyama Jidai no Kōgei* (Handicrafts of the Momoyama Period). Kyoto: Tankōsha, 1977.

Maruo Shōzaburō, et al., eds. *Nihon Chōkoku-shi Kiso Shiryō Shūsei: Heian Jidai — Zōzō Meiki-hen* (Source Materials on Japanese Sculpture: Heian Period — Inscriptions on Sculpture). 8 vols. Tokyo: Chūōkōron Bijutsu Shuppan, 1966-71.

Ministry of Culture, Japan, ed. *Kokuhō* (National Treasure). 16 vols. Tokyo: Mainichi Shimbunsha, 1984.

Murashige Yasushi, ed. *Rimpa* (Rimpa painting). 4 vols. Kyoto: Shikōsha, 1989-.

Narazaki Muneshige. *Ukiyo-e Taikei* (Complete Works of Ukiyo-e). 17 vols. Tokyo: Shūeisha, 1974.

Narazaki Shōichi, ed. *Nihon no Tōji: Kodai, Chūsei-hen* (Japanese Ceramic: Ancient and Medieval). 6 vols. Tokyo: Chūōkōron-sha, 1971-76.

Nihon Bijutsu Zenshū (Survey of Japanese Arts). 23 vols. Tokyo: Kodansha, 1990-.

Nihon Tōji Zenshū (Compendium of Japanese Ceramics). 30 vols. Tokyo: Chūōkōronsha, 1976-81.

Nihon Tōji Taikei (Survey of Japanese Ceramics). 28 vols. Tokyo: Chūōkōronsha, 1989-90.

Nihon Ukiyo-e Museum, ed. *Nikuhitsu Ukiyo-e Senshū* (Selection of Ukiyo-e Painting). 3 vols. Tokyo: Gakken, 1985.

Nikuhitsu Ukiyo-e (Ukiyo-e Painting). 10 vols. Tokyo: Shūeisha, 1983.

Osaka Municipal Museum. *Chūsei Byōbu-e* (Folding Screen Painting of Medieval Japan). Kyoto: Kyoto Shoin, 1979.

Sengoku Kassen Byōbu-e Shūsei (Folding Screen Painting of Battle Scenes). 6 vols. Tokyo: Chūōkōronsha, 1980.

Shimada Shūjirō, ed. *Zaigai Hihō* (Japanese Paintings in Western Collections). 3 vols. Tokyo: Gakken, 1969.

Shimada Shūjirō, ed. *Zaigai Nihon no Shihō* (Japanese Art Treasures Abroad). 10 vols. and 1 supplement. Tokyo: Mainichi Shimbunsha, 1980.

Shimada Shūjirō and Iriya Yoshitaka, eds. *Zenrin Gasan: Chūsei Suibokuga o yomu* (Painting Colophon from Japanese Zen Milieu). Tokyo: Mainichi Shimbunsha, 1987.

Shizuoka Prefectural Art Museum. *Kano-ha no Kyojin Tachi* (Great Masters of the Kano School). Shizuoka Prefecture, 1989.

Takeda Tsuneo, ed. *Nihon Byōbu-e Shūsei* (Collection of Japanese Screen Paintings). 18 vols. Tokyo: Kodansha, 1977-81.

Takeda Tsuneo and Tsuji Nobuo, eds. *Kachō-ga no Sekai* (Flower-and-Bird Paintings of Japan). 11 vols. Tokyo: Gakken, 1983.

Tanabe Shōzō, ed. *Sueki Taisei* (Collection of Sue Ware). Tokyo: Kadokawa Shoten, 1981.

Tanaka Ichimatsu, ed. *Nihon Bijutsu Kaiga Zenshū* (Collection of Japanese Painting). 25 vols. Tokyo: Shūeisha, 1977-81.

Tanaka Ichimatsu, ed., *Shinshū Nihon Emaki-mono Zenshū.* 30 vols. (New Collection of Japanese *Emaki*). Tokyo: Kadokawa Shoten, 1976-81.

Tanaka Ichimatsu and Yonezawa Yoshiho, eds. *Suiboku Bijutsu Taikei* (Ink Monochrome Paintings). 17 vols. Tokyo: Kodansha, 1975-77.

Tanaka Migaku. *Kodai Nihon o Hakkutsu suru* (Excavating Ancient Japan). 6 vols. Tokyo: Iwanami Shoten, 1984-1991.

Tanaka Taku and Sahara Makoto, eds. *Kodaishi Fukugen* (Restoration of Ancient Japan). 10 vols. Tokyo: Kodansha, 1988-90.

Tokyo National Museum. *Kano-ha no Kaiga* (Painting of the Kano School). Tokyo: Tokyo National Museum, 1981.

———. *Muromachi Jidai no Bijutsu* (Art of the Muromachi Period). Tokyo: Tokyo National Museum, 1989.

———. *Muromachi Jidai no Byōbu-e,* (Screen Paintings of the Muromachi Period). Tokyo: Tokyo National Museum, 1989.

———. *Nihon Bijutsu Meihin Ten: New York Burke Collection* (A Selection of Art from the Mary and Jackson Burke Collection). Tokyo: Tokyo National Museum, The Tokyo Shimbun, and The Chūnichi Shimbun, 1985.

———. *Nihon no Suibokuga* (Japanese Ink Painting). Tokyo: Tokyo National Museum, 1989.

———. *Nihon no Tōji* (Japanese Ceramics: Commemorative Catalogue of The Special Exhibition). Tokyo: Tokyo National Museum, 1987.

Tsuboi Kiyotari. *Nihon no Genshi Bijutsu* (Early Arts of Japan). Tokyo: Kodansha, 1977-79.

Yamamoto Kenkichi and Hayakawa Monta. *Buson Gafu* (Paintings by Yosa Buson). Tokyo: Mainichi Shimbunsha, 1984.

Yamane Yūzō, ed. *Rimpa Kaiga Zenshū* (Paintings of Rimpa). 5 vols. Tokyo: Nihon Keizai Shimbunsha, 1977-80.

Yamane Yūzō and Yonezawa Yoshiho, eds. *Shimpen Meihō Nihon no Bijutsu* (New Edition Masterpieces of Japanese Art). 33 vols. Tokyo: Shōgakkan, 1990-.

Index

Note: Artists are listed according to their family names.